# Scottish Writing After Devolution

Scottish Writing After Devolution

# Scottish Writing After Devolution

Edges of the New

Edited by Marie-Odile Pittin-Hedon,
Camille Manfredi and Scott Hames

EDINBURGH
University Press

Edinburgh University Press is one of the leading university presses in the UK. We publish academic books and journals in our selected subject areas across the humanities and social sciences, combining cutting-edge scholarship with high editorial and production values to produce academic works of lasting importance. For more information visit our website: edinburghuniversitypress.com

Edinburgh University Press Ltd
The Tun – Holyrood Road
12(2f) Jackson's Entry
Edinburgh EH8 8PJ

First published in hardback by Edinburgh University Press 2022

Typeset in 11/13 Adobe Sabon by
IDSUK (DataConnection) Ltd, and
printed and bound by CPI Group (UK) Ltd,
Croydon, CR0 4YY

A CIP record for this book is available from the British Library

ISBN 978 1 4744 8617 0 (hardback)
ISBN 978 1 4744 8618 7 (paperback)
ISBN 978 1 4744 8619 4 (webready PDF)
ISBN 978 1 4744 8620 0 (epub)

# Contents

# List of Illustrations

# Acknowledgements

The editors would like to thank the research centres LERMA (University of Aix-Marseille) and HCTI (University of Western Brittany) for the support they provided. They would also like to pay a debt of gratitude to Glenda Norquay, without whom this volume would not have existed, and to Michelle Houston for her constructive recommendations on this project.

# Marie-Odile Pittin-Hedon, Camille Manfredi and Scott Hames

This book probes an elusive, in-between moment in Scottish literature and cultural politics. Completed between 2018 and 2020, many of these essays are caught between established settlements (critical, cultural, political) and their surpassing. This is not only a Scottish condition, of course. Since the global financial crisis of 2007–8, Gramsci's over-used quip about 'morbid symptoms' has enjoyed a grim revival across the globe (Babic 2020). With the tottering of the liberal world order, billions feel a new resonance in his forecast that 'the old is dying and the new cannot be born'. A brief symptomology of the past decade would include the swift rise and brutal collapse of the Arab Spring, escalating climate and refugee crises, the rise of mass hyper-surveillance, and galloping online conspiracism – both the cause and consequence of normalised 'post-democracy' and a splintered public episteme. Indeed, it becomes difficult to articulate any general pattern as fervent online groupings choose and define their own news, knowledge and reality. Since 2015 the rise of populist, nationalist and far-right politics has delivered Brexit, Trump and a fierce backlash against anti-racist, progressive or 'woke' identity politics.

So dramatic have been Scotland's internal political developments over the past decade, they are seldom related to these broader currents in a sustained way. This is not the occasion to attempt that synthesis, but if we return to Gramsci's prison note of 1930 we may note that he treats the zone of morbidity both as 'crisis' and 'interregnum': a moment of decision and calamity, but also the gap between distinct regimes. As this book attempts a provisional re-mapping of Scotland's post-devolution literary culture, the tension between these temporalities – suggesting change, stasis and exhaustion all at once – speak clearly to us in local accents. As critics we reach forward, stretching for the sharp edges of the new, while conscious that the unfinished business of the present is not finished with us yet.

The worn edges of an earlier 'new' – the 'new Scotland' promised by devolution – have grown familiar to our touch, shaping our coordinates in ways these essays seek to examine as well as refresh. Over two decades of devolution, the critical paradigms of the 1990s became hegemonic in the growing field of Scottish literary studies (an expansion this book carries forward). Those models emerged within a clear narrative of democratic emergence, mapping the confident 'new politics' heralded by the new parliament onto the nation's literary culture. In this story, Scottish literature would recover its canon, infrastructures and public standing within a broader renovation – and imaginative re-founding – of national life (Craig 2016). Often working in tandem with the boom in Scottish historical scholarship, the renewed currency and cachet of Scottish literature was celebrated alongside a Booker Prize (James Kelman in 1994), the re-homing of the Scottish Poetry Library (installed in its prized Edinburgh building in 1999) and the establishment of a National Theatre in 2006.

In the decade after 1999, the launching of new research centres, journals, postgraduate courses, book series and scholarly associations – both within and outside Scotland – saw the growth of the field chime with devolution's own accumulation of institutional clout. Landmarks along the way include major research editions of Scott, Hogg and Burns (and more recently Stevenson, Allan Ramsay and John Galt), several multi-volume national literary histories, surging scholarly interest in Scottish women's writing, song-culture, Celticism and Scots translation, and the ongoing rediscovery of Muriel Spark, Nan Shepherd and pre-Enlightenment intellectualism. Many of these projects have benefited from the support of devolved bodies, funders and Scottish-national advocacy groups – e.g. the new Robert Burns Birthplace Museum, opened by the National Trust for Scotland in 2010 – though Scottish academic life remains highly enmeshed in the UK research funding economy. As with devolution itself, the growth and advancement of Scotland-centred humanities research has often relied on public funding from outside Scotland. In the reverse pattern, growing international interest in the field – notably in France, Germany and Italy, via the Scottish Writing Exhibition (2004–19) promoting the field to North American literary scholars, and more recently in India and China – has strengthened its claims at home. While the Bibliography of Scottish Literature in Translation (1994–2018) has ceased to gather citations, the National Library of Scotland has expanded its collection of Scottish literary manuscripts, and is now a key research collaborator for the field. The footprint and industry of Scottish literary studies has never been greater, though it

could be argued its critical exchanges are today marked less by intellectual advance or generative disagreement than by patient consolidation (of canonical editions, of recovered authors and traditions, of the field's value within shrinking university and public arts budgets).

Tracing several of these developments in a 2007 collection, Berthold Schoene used the term 'post-devolution Scottish Writing' to capture Scotland's 'transition from subnational status to devolved home-rule independence' (Schoene 2007: 1). This slightly blurred chain of political descriptors – 'devolved home-rule independence' – captures precisely the difference between Schoene's 'post-devolution' and our own. 'POLITICS WILL NOT LET ME ALONE', says the anti-hero of Alasdair Gray's *1982 Janine* (Gray 1984: 231–2). While the politics of nationhood have always been a constitutive factor in Scottish literature (whether conceived as a critical, educational or publishing endeavour), never before has public constitutional debate tugged so insistently at the field's collective sleeve, and at times its collective unconscious. The hallmark of our own scholarly moment is to feel an uncanny continuity between the arguments of politicians, campaigners and online echo-chambers and the stakes and subtexts of Scottish literary criticism. The weekend this introduction was completed, the novelist William McIlvanney's contribution to home-rule politics in the 1980s–1990s made the front page of *The National*, the pro-independence newspaper established in late 2014.

Until recently, Scottish literary nationalism viewed itself in the vanguard of a broad civic movement which moved outside and ahead of party politics (when McIlvanney altered his party allegiance from Labour to SNP in 1996, it was front-page news in a more established newspaper). Today its cause and domain have been reclaimed by a truly mass nationalist movement quite different from the 1980s republic of letters evoked by *Cencrastus* magazine, Edwin Morgan's *Sonnets from Scotland* and the rediscovery of democratic intellectualism in the work of George E. Davie. Joan Cocks notes 'two vexing predicaments for the intellectual in the nationalist context': alienation from the people 'on the part of intellectuals who align themselves with popular causes while criticising nationalism for being based on illusion, self delusion, ressentiment' – that is, honouring the myth-puncturing critical impulse in ways that 'put them at odds with the people on behalf of whom they think and act' (Cocks 2002: 20). The second predicament concerns 'alienation from politics on the part of intellectuals who appreciate, defend, and even celebrate the popular resonance of the national narrative, or fiction, or myth, without believing in that myth'. Intellectuals in

this second category, Cocks argues, 'are as unable to be out-and-out nationalists as they are unwilling to be out-and-out anti-nationalists' (2002: 20). It will suffice to note the strong resonance of these passages in Scotland today, where critical explorations of Scottish cultural identity advanced in universities over the past three decades are being displaced by a more assertive and populist orientation to the iconography of nationhood. Whether the large nationalist street demonstrations of 2017–20 (interrupted only by the COVID-19 pandemic) signify amnesia or conscious rejection of that earlier critical movement, it seems unlikely that writers and intellectuals will shape its future direction (as opposed to cheering or booing from the sidelines, in varying degrees of enthusiasm, anguish or half-belief). What is clear is that literary nationalism is being overtaken by the mass-movement politics of independence – both 'taking it over' in the sense of determining the political and social frames in which literary criticism operates, thus altering its public meaning, and 'overtaking' in the sense of surpassing and leaving behind. Where stands Scottish Lit (and Crit) on this shifting ground?

The field's 'structural nationalism' (Connell 2003) takes on a new valence in the charged constitutional debates of post-indyref Scotland, drawing the field into new modes of national relevance (some productive and exciting, some more ambivalent). How, if it all, should the specialist knowledge of the ScotLit scholar figure in political debate today? There is the clear potential to educate and refine popular discourse: many kitsch symbols and narratives of Scottishness laid waste by Hugh MacDiarmid, Tom Nairn and Colin McArthur in the last century are enjoying partisan resurgence today, altering their traction in the critical field as well as the political. On the other side of the ledger, fine work has been done popularising Scottish literary history – and Scots prose writing – for its expanding audience of Scotland fans, including via *The National*. But caution is required when plugging the high-voltage energy (and rancour) of constitutional politics into the finer circuitry of literary scholarship, and there may be hazards in aligning the cultural authority of Scottish literature with any governing outlook within these debates. Though not without its moments of intellectual bravery, aligning the field with the upbeat confidence of the 1990s 'new Scotland' – in tune with a broad cultural and political consensus – was a less nervy affair.

The impossibility of skirting these questions is a key lesson of our times, and this collection aims to confront directly the political field in which it is located. Since Schoene's 2007 description of 'devolved

home-rule independence', the rigours of intense constitutional debate have taught us what is incompatible among these terms, while also exaggerating the distance between them. Arguably there are only modest differences between 'home-rule within the UK' and the form of independence contemplated in 2014 (retaining the UK's monarchy, currency, television, NATO alignment, and so on), though 'the Vow' pledged by unionist party leaders just prior to the vote made a stark choice of this debatable land. As for devolution itself, the fierce polarities of constitutional debate since 2014 have devalued its constructive ambiguity. In the ears of 2020, devolution is mainly a synonym for stopping independence, a strategy that could only cease with nationalism itself. (And the defeat of Scottish nationalism, one leading novelist suggested in 2014, could mean the end of Scottish literature itself.) In this sense, to be 'post-devolution' in 2020 means not simply 'after 1999', but after everything the new parliament made possible: after 2011 (and the SNP's mandate to call an independence referendum); after 2014 (and indyref's remaking of cultural and political debate, both creative and destructive); after the SNP surge of 2015 (and the growing hegemony of Team Scotland arguments from identity, prominent in the field's own history); and after the Brexit shock of 2016 (eclipsing the dream-horizon of 'Scotland in Europe', while underscoring its appeal). As critics today, our devolutionary belatedness amounts to feeling, reading and writing somewhat 'stuck' within a framework tending both to entropy and repetition. Scottish culture and society in 2020 are defined by intractable political division *and* a sense of dynamic slippage, as the nation's 'settled will' for devolution crumbles into open fractures (including within the pro-independence movement), and sediments in new or newly visible forms of populist anger and intolerance.

So the 'edges of the new' pursued in these chapters are also new horizons of memory, looking back on devolution from points 'beyond' its 1990s paradigms (political, cultural, intellectual), but also caught within them. If ScotLit's narrative of emergence and 'ImagiNation' had a clear teleology of fresh growth (new parliament, new confidence, new possibility), today we handle the blunted edges of devolution as an established and somewhat fatigued condition, while wondering how it might lead beyond itself. In one sense, the constitutional logic of devolution 'ended' with indyref 2014, having been devised as a means of preventing just such an open contestation of UK state sovereignty. But Scotland voted No, and so poor old devolution limps onward, a bruised political narrative struggling for traction and credibility, but still the master logic (and financial underpinning) of most

really-existing Scottish national institutions. On the eve of full Brexit in January 2021, with independence around 55 per cent in the polls and the SNP on course for a Holyrood majority in May's elections, the political commentator Jamie Maxwell observed that the present situation looks 'a bit like Ireland at the start of the twentieth century. You just feel like Scotland is heading towards some sort of denouement' (Ramsay 2020). Perhaps that destination will be clearer – or the anticipation keener – by the time this book reaches print.

But the critical moment is always now. How might writers and critics begin to think beyond the devolutionary moment, or inherited models in which Scotland's literary culture is tightly bound to political developments? In *Aesthetics and Its Discontents*, Jacques Rancière argues that

> [a]rt is not, in the first instance, political because of the messages and sentiments it conveys concerning the state of the world. Neither is it political because of the manner in which it might choose to represent society's structures, or social groups, their conflicts or identities. It is political because of the very distance it takes with respect to these functions, because of the type of space and time that it institutes, and the manner in which it frames this time and peoples this space. (Rancière 2009: 23)

What Rancière is calling for is a literature that does not have to address political 'issues' to be political; a literature that 'does' politics not by reproducing political discourse, but by aesthetically reconfiguring 'the given perceptual forms' already embedded in that discourse (2009: 63): in our context, a literature that avoids the pitfall of being 'about the nation' all the time. These questions are in the field's past as well as its future. In *Literature as Intervention: Struggles Over Cultural Identity in Contemporary Scottish Fiction* (1999), Jürgen Neubauer opposes those he calls 'the nationalist critics' and borrows Habermas's concept of the 'postnational constellation' to show that with the erosion of national boundaries, there has been a move in Europe which he describes as transnational as well as local: 'Scottish writers are beginning to imagine life in postnational constellations in which interactions and relationships are both more local and more global than the nation' (Neubauer 1999: 12).

Partly echoing this critique, Eleanor Bell was perhaps the first to problematise 'post-devolution' in the nationalist frame. Drawing on Irish critics such as Richard Kearney, her *Questioning Scotland* (2004)

suggests that 'shap[ing] Scottish culture in direct alignment with politics at a national level' was 'becoming anachronistic':

> It could be argued that in post-Devolution Scotland such formulations are not as convincing as they perhaps once were, where renewed political confidence has weakened the previous dependency between culture and politics. (Bell 2004: 140)

Here it is the growing strength of Scottish political identity that makes cultural nationalism increasingly redundant – an inversion of Tom Nairn's earlier diagnosis – inviting a turn to 'post-national' critique. In 2020's hindsight, it was always unlikely that we could map a critical through-line from devolution to the post-nation which did not pass directly through a nationalist moment. Or to put it another way, the cultural nationalist moment that produced devolution was also *reproduced* by it, in expansive ways that made its earlier avatars (e.g. hostile critique of Nairn for being the wrong sort of nationalist (Beveridge and Turnbull 1989)) feel like a prelude rather than a declining force. The post-national moment has been repeatedly deferred and revived within the intellectual culture of devolution, a staging 'post' by which the determinations of nationalism are resisted but never surpassed. If you cannot get past it, you can try to go around it, and Berthold Schoene has mounted an ambitious cosmopolitan agenda for Scottish literary studies running counter to its centring principles. This cosmopolitanism

> repudiates reductions of 'society' and 'the public' to what inhabits or evolves within a neatly staked-out homogeneous realm. [. . .] In fact, cosmopolitanism's greatest strength lies in defusing the undesirable side-effects of globalisation by working to deconstruct neo-imperial hegemonies, champion transnational partnership, and project the world as a network of interdependencies. (Schoene 2008: 75–6)

The 'network of interdependencies' invites us to interrogate borders and national sentiment in our own 'post-devolution' Scotland, exploring – in the shadow of Brexit – the ways recent Scottish writing 'reconfigures the possible' (Brown and Nicholson 2007: 262). *Edges of the New* includes contributions by academics and writers from Italy, England, France and Switzerland as well as Scotland, hoping to cast fresh light on these familiar problematics.

We have selected contributions which both map and scrutinise the shifts that have taken place post-devolution. Our task is to examine Scotland's cultural discourses as 'political' apparatuses, with

literature allowing, in Rancière's words, 'self-interpretation' and the 'self-poeticization of life'; to interrogate their aesthetic politics, mechanisms and flexible means of expression, by taking into consideration various art forms, languages and genres in the dialogue between artists, texts and contexts. The volume assembles original insights into post-1999 works ranging from fiction, science fiction, poetry and drama to audio-poetry and word-image relationships, and reflections on the contemporary life of several earlier artworks. We offer an examination of the interactional aesthetics of post-devolution Scottish culture, and an enquiry into the ways these interactions play out politically. We seek to demonstrate how the dialogue conducted between spaces and forms enacts and re-acts what Alan Riach terms the 'idea of home' and 'the unfinished business of self-determination' (Riach 2004: 242) – the operative word being 'unfinished'. Despite the various determinations outlined here, Scottish culture (and criticism) is continually remodelling spaces and temporalities through freedom of tone, genre, language and art form. These chapters offer a timely and critical exploration of political and aesthetic processes, an enquiry into Scotland's 'communal invention of discourse' (Rancière 1995: 85): they look into the unfinished business of politics and art.

In order to open this investigation, **Glenda Norquay** looks at fiction by Kate Atkinson, A. L. Kennedy, Ali Smith and Louise Welsh, and at their preoccupation with what Smith calls the 'annoying' fact of temporality. For Norquay, the four writers challenge temporality politically, in order to contest conventional narratives around romance – in Smith's and Atkinson's case by making use of queer temporality – and ultimately to address the gendering of history. By looking at the past and its relationship to the future, the novels examined by Norquay challenge heteronormative futurity to destabilise familiarity, either with the present, or with the dominant discourse associated with it. Writers historicise our notion of history by fiddling with the structure of their novels which emphasise re-iterated now-ness (Atkinson, Smith and Kennedy), or more generally by offering a criticism of history as a linear narrative by way of typography as well as textuality. Norquay also re-examines the notion of queer temporality and its connection with a particular historical moment, showing that similarly to the way that theoretical thinking around queer temporality developed in the 1980s around the AIDS crisis, the current focusing on World War II (in *Life after Life* or *Day*) performs the function of looking at the present as crisis, which in turn shapes a different future.

**Marie-Odile Pittin-Hedon** and Fiona McCulloch take up Norquay's argument of building a new future on the ruins of time by focusing on some of the authors Norquay's chapter brings up. Pittin-Hedon reads contemporary women's fiction in the light of theories of biopolitics with a view to uncovering an ethics of storytelling which can by no means be limited to the fiction produced by women writers, but which nevertheless is an integral part of many of their works. She focuses more particularly on Kirstin Innes, Leila Aboulela, Alice Thompson and Kirsty Logan to show how they venture into in-between spaces (delineated by fantasy, fairy tale, folklore and the supernatural, but also the post-apocalyptic or the virtual space of online communication) to turn them into crucial spaces from which the laws of our world can be described. For Pittin-Hedon, Leila Aboulela's *The Kindness of Enemies* (2015) and Kirstin Innes's *Fishnet* (2015) can be characterised as neo-dystopian, or as 'empty utopias' (to borrow Ricœur's terminology); they prompt an examination of fiction's responsibility to create new paradigms, by being a return to discourse, as opposed to the empty slogans that characterise the contemporary world, emphasising the connection between discourse and ethics. The chapter argues that what those writers share is therefore their capacity to enrol narrative and generic conventions, what Pittin-Hedon calls 'a distortion of the language of literature,' to engage with the world and bring a new ethics of interpretation to it.

**Fiona McCulloch** turns to a novel which is up against a very specific type of political evil: Ali Smith's *Autumn* (2016), described as the first Brexit novel and an important exemplar of 'BrexLit', offers a powerful counter discourse that exemplifies Scotland's desire to remain in the EU despite the dominant rhetoric of British nationalism. McCulloch's geopolitical reading of *Autumn* (2016) and *Winter* (2017) and *There But For The* (2011) places Scotland within a (problematic) British, European, global context, with particular emphasis on the growing discrepancy between the two definitions of cosmopolitanism – Zygmunt Bauman's, which sees cosmopolitanism as an elitist beneficiary of globalisation, and emphasises the privileged citizen's capacity to live in space, and travel, and Ulrich Beck's, in which cosmopolitans are described as 'spatiotemporal victims'. In Smith's novels, those are characters marginalised or isolated by neoliberalism and neoconservatism, who challenge that state of affairs and produce a counter-voice to British hegemony. McCulloch describes what she identifies as Smith's new ethics, which offers a new, alternative trajectory that can counter globalisation's temporality and, in the process, resist global disempowerment. The chapter also shows

how Scotland offers an alternative to Conservatisms, and to a Brexit-style return to colonial expansion, describing the novels' focus on a sense of 'geogendered otherness', and their production of a wounded cosmopolitanism, an 'ethical glocalism'.

**Scott Hames** examines the first wave of indyref novels, register-ing the passions and divisions of 2014. Drawing on Amanda Anderson's *Bleak Liberalism*, he examines fictions by Allan Cameron, Effie Deans, Kirstin Innes, Mary McCabe and Craig Smith, arguing that the modes of social representation we encounter in these texts mir-ror the plebiscite which inspired them. These novels tend to repro-duce indyref's tendencies towards massified speech and reified group identity, and their novelistic failures are as interesting as their his-torical content. Though indyref was made possible through the suc-cess of Scotland's admirably inclusive strain of liberal nationalism, the culture of argument that defined the political novel in English – argument as a 'lived relation' between liberal political subjects, com-promising and compromised – is seldom to be found in this fiction. Instead, dramatic interest centres on the instrumental chessboard and its word-games, a Great Debate elevated to its own discursive 'sovereignty', unmarked by human dialogue or ethical doubt. Strain-ing for narrative and emotional resolution, indyref fiction mirrors the echo-chambers of contemporary social media even as they resort to weak allegory and didactic archetypes drawn from the pre-history of the modern novel.

**Silke Stroh** explores the role played by writers of colour on the Scottish literary scene during the first two decades of the twenty-first century, and discusses their potential role in changing concep-tions of Scottish literature in the decades to come. Her chapter begins by reviewing some essential conceptual and terminological issues, before moving on to a survey of important elements of the literary infrastructure that have provided dedicated platforms for writers of colour and form good starting points for further explorations in this field. These include theatre companies, bursaries, writers' groups, events and anthologies. This selective overview is followed by slightly more detailed case studies of four individual authors: Bashabi Fraser, Tendai Huchu, Raman Mundair and Chin Li. The discussion con-siders the writers' engagement with themes of diasporicity, identity (Scottish and otherwise), racism, locality and translocality. In addi-tion, it highlights other important themes in these authors' works, as well as selected formal and stylistic issues. The texts and issues discussed in this chapter can also provide points of departure for more general critical reflections about categories of Scottishness,

inclusivity and canon (re)formation, 'burdens of representation', the problems of ethnic, racial or national ascriptions, and the question whether it is possible to speak of an increasing cosmopolitanisation of Scottish writing.

**Timothy Baker's** chapter returns to the managing of space. Baker approaches women's fiction through their depiction of and connection with landscape, making use of Westphal's theory on geocriticism, as well as Braidotti's re-reading of Deleuze on maps, and his notion of nomadism. Focusing mainly on recent fiction by Laura Marney, Jeni Fagan, Linda Cracknell, Sarah Moss, but also crime novels by Karen Campbell, Denise Mina and Shona MacLean, Baker tackles the question of spatial identity, showing how the various authors create Gothic landscapes that defamiliarise the familiar, or use the generic codes of crime to reach a similar goal. The real and the imaginary therefore interact, with the map seen as a tool of interaction, a way to chart not a real, fixed place, but a network of possibilities.

**Amy Player's** chapter on Kathleen Jamie draws mostly on the writer's prose writing (three prose collections – *Findings* (2005), *Sightlines* (2012), *The Bonniest Companie* (2014) – as well as a review of Robert McFarlane's *Wild Places* and an essay written after an archaeological expedition in Alaska in 2014) and discusses the broadening of Jamie's spatial but also temporal horizons, her engagement with our necessary connectedness to the land in a non-anthropocentric way, and with deep time. Land ownership, one of the issues at the core of Jamie's writing, is to be seen in a relative framework, which emphasises humans' transience and belonging, a far cry from Robert Macfarlane's perspective, which Jamie sees as I-centric. Player shows that Jamie's wish to move away from centred or singular perspectives turns her into a mediator and enables her to produce a wider narrative and a broader temporal spectrum. The notion of 'shared values', which is central to Jamie's writing, is discussed, along with the connection between nature writing, environmental concerns and nationalism, and Jamie's engagement, which is situated in opposition to nationalist politics. Jamie's concerns, by moving away from Scotland and by encompassing an ever-broader range of topics, by also shifting to new hybrid forms such as the film-poem, lead her to produce an in-depth examination of notions such as here and elsewhere, near and far, local and global, giving new depths to the concept of *home*.

Another poet, Lewis-born **Kevin MacNeil**, also addresses the complex notion of home, by examining the way in which the Scottish islands are presented in literature, when they are presented at all.

In a chapter which, in its conclusion, reminds its readers that 'place is character', he contrasts insiders' and outsiders' perspectives on islands and island lives, and shows that although both approaches are valuable, the former has a responsibility not just to the island itself, especially in case of isolated and overlooked communities, but to something larger which he sees as disconnected from the burden of representing one's community. The dual perspective offered by the insider-outsider dialectics is related to issues of cultural appreciation and cultural appropriation. MacNeil examines crime fiction by 'outsiders' set on Scottish islands, wondering about its relevance to the actuality of island life and islanders' identity. This examination brings him to offer a careful, thoughtful investigation of the intersections of narrative and meaning, what he calls its 'real life impact', and of the pitfalls of false cognition and cultural reinforcement. MacNeil values fiction ultimately for its capacity to reveal truth, a truth that goes beyond the accuracy of representation of place. It is this concept of truth, 'a bigger truth' as he puts it, that governs the poetry and prose fiction that endures.

**Harry Josephine Giles's** provocative contribution brings together an analysis of the use of Scots in twenty-first-century prose fiction with postcolonial approaches to science fiction, with a view to assessing what postcolonial and indigenous studies might offer the novel in Scots. Their chapter critically reads Scots science fiction as a project of creating language and nation and argues that the science fictional approach is at once necessary to the problem of the Scots language novel and an illustration of its (post)colonial limits. By analysing the use of temporality in the Scots of Matthew Fitt's *But n Ben A-Go-Go* (2005) and Wulf Kurtoglu's *Braken Fences* (2011), as well as the role of the indigenous in the science fiction of James Leslie Mitchell and in Kurtoglu's novel, Giles demonstrates that language is a temporal ligature, binding past, present and future together, and that this ligature brings both the potential and the limits of Scots as a language.

**Maggie Scott's** chapter then examines some of the ways that Scotland's languages are used in twenty-first-century fiction to undermine 'metrovincial' perspectives. With reference to Paul Gilroy's concepts of postcolonial melancholia and conviviality, Scott analyses how the multiplicity of voices in post-devolution Scottish fiction provides examples of local cultural references, knowledge – and especially language – that refute standard linguistic and cultural hegemonies and establish narratives within their own self-determined centres of power and place. She then demonstrates how the works of a growing number of contemporary writers engaging with many of the

varieties of language found in modern Scotland reposition the local as the international and invert traditional metrovincial paradigms, where the provincialism of the metropolis is allowed to dominate unchallenged and where the cultures, languages and practices of 'the faraway' are dismissed, stigmatised or ignored. Scott argues that multilingual practices including 'broader' varieties of Scots, 'prestigious' forms of Scottish English but also elements of Scottish Gaelic, Urdu, Panjabi and diverse English dialects have the potential to act for under-represented or marginalised identities in order to, in the words of Suhayl Saadi, 'enact both a progressive politics and a meaningful literature [that] must be about enabling the possibility of dissent against the sources of power'.

Drawing from the great many audio-texts that have contributed to disseminating the variety of Scottish languages and voices since the nineties, **Camille Manfredi** reflects on the explosion in sound and video recordings of poetic works and the proliferation of cross-media practices in Scotland since the turn of the century. She examines how contemporary Scottish film-poets Alastair Cook, Roseanne Watt, Callum Rice and Susan Kemp cement their practice within the disjunction between visual and sonorous dimensions, and play out the contrapuntal relationship between moving image and poetry to elicit new forms of cooperation between the audience, the text and its performance. She argues that twenty-first-century Scottish film-poetry contributes to inventing another sense of locale grounded on the evocative power of the Scottish voice, accents and languages, as well as on their ability to break open the canon. Manfredi's contribution thus approaches some of the many possibilities offered by text-sound and moving word-moving image relationships to imagine, re-imagine and behold contemporary Scotland's cultural soundscapes, at the same time as these new aesthetic possibilities partake in the reconfiguration of both traditional and non-traditional, local and global paradigms of identity.

Continuing on the issue of performance, **Jeanne Schaaf's** chapter demonstrates how the contemporary Scottish stage, in the dialogue it initiates between art and politics, constructs and deconstructs representations of the nation. While reflecting the tensions around the very idea of nationhood that are exacerbated by the recent geopolitical context, the Scottish stage reinvents its relationship to the national space by playing with scale – the scale of space, place and community – and by travelling freely between the local to the global. As a building-less national theatre, the National Theatre of Scotland reinvests all types of spaces, be they

real or virtual, asking us to rethink the presence and absence of the body on stage, and fostering new transnational communities of 'spect-actors'. Schaff argues that this theatre without walls is a metonymy for the radical opening up of Scottish theatre itself, which invites post-national and horizontal representations of identity. Through an analysis of four recent productions of the Scottish stage (*The Events*, 2013; *The Great Yes No Don't Know Five Minute Theatre Show*, 2014; *The Suppliant Women*, 2016; and *Adam*, 2017) her chapter presents us with a productive paradigm to explore new understandings of the way communities are fostered by post-national polyphonies on stage.

The next chapter examines word-image relationships through the collaboration between contemporary Scots artist Will Maclean and the poets Sorley MacLean, Angus Martin, Kenneth White, Douglas Dunn and John Burnside, more specifically Maclean's artistic response to two particular poems in the Scots/Irish word and image publication, *An Leabhar Mòr*. **Lindsay Blair and Donald Blair** first demonstrate how the relationship between word and image in these poetic collaborations sits in sharp contradistinction to the modernist grid with its 'hostility" to literature as defined by Rosalind Krauss. They then examine how Maclean's different kinds of framing device can be related to the concept of the 'framing' of reality as advanced by Jacques Rancière, while reaching for historical antecedents in Maclean's orientation – his peculiarly 'aletheic' gaze – to early Medieval Scots carvings and illuminated manuscripts, through different concepts of Scottish 'enlightenment' to the metaphorical imaginings of French and American Surrealism, to the images and poems of the collaborations themselves.

Also in the field of word-image studies, **Rodge Glass's** chapter focuses on Alasdair Gray's visual practice. Here, Glass argues that in the late twentieth century, unlike his widely celebrated literary output, Gray's art has consistently suffered erasure of various kinds and has been largely neglected, replaced or destroyed. Using Gray's murals – now an integral part of today's Glasgow – as case studies, he then traces how the twenty-first century has seen a radical reinstatement of Gray's visual practice into the urban and cultural landscape. This has been done through the rediscovery and restoration of murals, a significant amount of recent critical works that focus on Gray's visual art, and Sorcha Dallas's successful endeavours to exhibit the artist's visual practice in Glasgow and beyond, which resulted in him being featured in galleries where previously he had been unwelcome.

In the concluding chapter, **Carla Sassi** offers a rich overall commentary on the role of the literary and ways of rethinking and remediating

nationalism. Her contribution assesses how post-devolutionary texts engage with and reconfigure – possibly dissolve – conventional ideas of the nation, with reference to recent reconceptualisations of the notion of cultural memory. Sassi turns her attention to a number of Scottish contemporary literary texts that signal a meaningful new paradigmatic shift in their relation to Scotland's cultural memory, and indeed to ideas of Scottish national identity – a shift that, she argues, may be seen equal in its importance to that marked in 1981 by the publication of Alasdair Gray's *Lanark*. Through an analysis of works ranging from James Robertson's historical novels, David Greig's stage adaptation of *Lanark* and Kathleen Jamie's non-fiction to the recent publications of Malachy Tallack, Amy Liptrot and Ian Stephen, Sassi focuses on what she presents as two specific trends of twenty-first-century Scottish writing: the shift from a memory-as-history paradigm to a markedly literary one, and a new commitment to the materiality of the local – a celebration of ecological immanence – both of which may have important repercussions on ideas of Scottishness.

## References

Babic, M. (2020), 'Let's talk about the interregnum: Gramsci and the crisis of the liberal world order', *International Affairs* 96.3: 767–86. https://doi.org/10.1093/ia/iiz254

Bell, E. (2004), *Questioning Scotland: Literature, Nationalism, Postmodernism*, Basingstoke: Palgrave.

Beveridge, C. and R. Turnbull (1989), *The Eclipse of Scottish Culture: Inferiorism and the Intellectuals*, Edinburgh: Polygon.

Brown, I. and C. Nicholson (2007), 'The border crossers and reconfiguration of the possible: poet-playwright-novelists from the mid-twentieth century on', in *Edinburgh History of Scottish Literature Vol. III. Modern Transformations: New Identities (from 1918)*, Edinburgh: Edinburgh University Press, 2007, pp. 262–72.

Cocks, J. (2002), *Passion and Paradox: Intellectuals Confront the National Question*, Princeton, NJ: Princeton University Press.

Connell, L. (2003), 'Modes of marginality: Scottish literature and the uses of postcolonial theory', *Comparative Studies of South Asia, Africa and the Middle East* 23.1 and 2: 41–53.

Craig, C. (2016), 'Unsettled will: cultural engagement and Scottish independence', *Observatoire de la société britannique* 18: 15–36.

Gray, A. (1984), *1982 Janine*, Harmondsworth: Penguin.

Neubauer, J. (1999), *Literature as Intervention: Struggles Over Cultural Identity in Contemporary Scottish Fiction*, Marburg: Tectum Verlag.

Ramsay, A. (2020), 'It's time to break up Britain', *OpenDemocracy.net* (11 December). https://www.opendemocracy.net/en/opendemocracyuk/its-time-to-break-up-britain/

Rancière, J. [1990] (1995), *On the Shores of Politics*, trans. Liz Heron, New York: Verso.

Rancière, J. [2004] (2009), *Aesthetics and Its Discontents*, trans. Steven Corcoran, Cambridge: Polity Press.

Riach, A. (2004), *Representing Scotland in Literature, Popular Culture and Iconography: The Masks of the Modern Nation*, Basingstoke: Palgrave Macmillan.

Schoene, B. (ed.) (2007), *The Edinburgh Companion to Contemporary Scottish Literature*, Edinburgh: Edinburgh University Press.

Schoene, B. (2008), 'Cosmopolitan Scots', *Scottish Studies Review* 9.2: 71–92.

Chapter 1

# Temporal Deconstructions: Narrating the Ruins of Time
*Glenda Norquay*

In her imaginative experiment in literary reflection, *Artful* (2012), Ali Smith toys with E. M. Forster's observation: 'In a novel there is always a clock.'[1] This 'annoying fact', she observes, means 'the short story can do anything it likes with notions of time; it moves and works spatially regardless of whether it adheres to chronology or conventional plot' (Smith 2013: 29). *Artful*, with its ghostly and ghosted re-enactment of lectures on literature conducted through the processes of memory and mourning, is itself an example of the elasticity Smith attributes to the short story form: 'it can be as imagistic and as achronological as it likes and will still hold its form. In that it emphasizes the momentousness of the moment. At the same time it deals in, and doesn't compromise on, the purely momentary nature of everything, both timeless and transient' (Smith 2013: 29). The novel, by contrast, is 'bound to and helplessly interested in society [. . .] and society is always attached to, in debt to, made by and revealed in the trappings of its time'. It is 'bound to be linear [. . .] even when it seems to or attempts to deny linearity' (Smith 2013: 29). Yet Smith is one of a number of Scottish women novelists who have butted against Forster's 'annoying' assertion that 'It is never possible for a novelist to deny time inside the fabric of his novel' (Smith 2013: 32). In fiction by Kate Atkinson, A. L. Kennedy, Ali Smith and Louise Welsh relationships between past, present and future are challenged by the reshaping of narrative linearity and through a broader engagement with the forces of history and change.

These writers are not alone in their preoccupation with temporality. There has been a growing fashion in fiction and film for playing with time, creating alternative chronologies and parallel narratives. In cinema, *Sliding Doors* (1998) offers an early instance; *About Time* (2013)

a more recent one.[2] Films based on books, such as *One Day* (2011), adapted from the novel by David Nicolls (2009) and *The Time Traveler's Wife* (2009), drawn from Audrey Niffenegger's 2003 novel also manifest this fascination.[3] In fiction, Laura Barnett's well-marketed *The Versions of Us* (2015) challenges the reader to piece together three alternative scenarios, different life narratives for her main characters: 'what if you had said yes? Some moments change everything' shouts its cover (Barnett 2015). Like *Sliding Doors*, *About Time* and *One Day*, Barnett's novel focus on heterosexual romance and relationships: what would have been 'right', what would have led to the happiest life, with happiness expressed in terms of finding the right partner, sustaining the most solid relationship and formulating the 'best' future for the self in an existing social order. Although experimental in their thematic playing with time and narrative structures, these challenges to linearity are ultimately conventional in their endorsement of an intimate public sphere, in which the 'core context of politics' is assumed to be 'the sphere of private life' (Berlant 1997: 8). Their temporal experimentation reinforces a fantasy in which the redrawing of chronology serves to affirm the realisation of self in the context of romance and family.

In contemporary Scottish women's fiction, challenges to temporality and linear thinking take a rather different turn. In their combination of 'historical' narratives and textual experimentation, Atkinson, Kennedy, Smith and Welsh, produce fiction with a more challenging ideological force. This essay investigates their dialogues with 'the ruins of time' as political engagements with temporality. It suggests that their writing can be understood as addressing Walter Benjamin's call to conceptualise a 'materialist' history which captures agency in the moment of the now, challenging the 'eternal' image of the past embodied by historicism and instead striving 'to blast open the continuum of history' (Benjamin 2007: 262). Playing with plot, agency and history, all the novels discussed reconfigure the pressures of the past and the possibilities of the present.

In their experiments with chronology, Atkinson and Smith in particular also address the gendering of history, engaging with Julia Kristeva's notion of 'women's time' and its challenge to linear thinking. But reading their work and that of A. L. Kennedy through the lens of 'queer temporality' offers further illumination of their questioning of the absolute value of 'reproductive futurism'.[4] In its dystopian vision, Louise Welsh's trilogy presents a more apocalyptic challenge to 'future-thinking'. All these novels use temporal experimentation to present a powerful challenge to conventional narratives around romance and reproduction. Yet they do so with a cautious but curiously optimistic

and redemptive emphasis on love which invests their formal experimentation with emotional affect.

Through choice of the historical periods they revisit or imagine, all the novels discussed operate in dark worlds that might be called death inflected. Kennedy and Atkinson focus on war and the repetition of deathly action in bombing; Smith's novel is shaped by death in both personal and structural terms; Welsh, influenced by her knowledge of the Black Death, re-imagines a contemporary plague scenario. Yet while each novel is drawn again and again to endings and darkness, each – in its challenge to conventional temporalities – performs a positive, even joyful, interrogation of dominant modes of thinking about history and agency. This chapter investigates how, by refusing future-centred narratives, by turning to different pasts, by allowing death to drive their novels, they produce a precarious *jouissance*, described by Ali Smith as 'that shout, that upward spring, that staircase ladder thing' and by Atkinson as that feeling 'as if one's living on the forward edge of one's life, as if one never knows whether one is going to fall or fly' (Smith 2015: 172; Atkinson 2015: 190). Through their interest in the 'now' of the past or future and their exploitation of its potentially explosive relationship to the dynamics of history, these novels challenge heteronormative futurity, confronting the very genres in which they are working. Each text is, in one way or another, a romance but the 'hope' it engenders through love is not, as in Barnett's novel, directed towards a future, or used to determine a conclusion; rather each creates 'a resolution' presented as provisional, fragmentary and tentative. Redemption – of various kinds – occupies the space of the 'now'.

In her World War II novel *Day* (2007) A. L. Kennedy, a writer constantly experimenting in form and genre, confronts linearity in her exploration of a specific historical moment. Kate Atkinson's acclaimed *Life After Life* (2013) structures its parallel chronologies of World Wars I and II around the idea of chance. *A God In Ruins* (2015), her subsequent experiment with narrative chronology and the notion of 'what if', also focuses on World War II and its legacy, returning to many of the same characters. In *A God in Ruins* Atkinson suggests that the world in which time was 'dependable', where 'the tenses that Western civilization was constructed on' were secure, belongs firmly to the past (Atkinson 2015: 73). In both novels the iterative return to that past serves to shatter its security and question the ways in which we narrate our relation to time and to history. Ali Smith begins *How to be Both* (2014), partly set in Renaissance Italy and her most explicit confrontation with

historicity, by using Hannah Arendt's introduction to Benjamin's *Illuminations* as epigraph: 'Although the living is subject to the ruins of time, the process of decay is at the same time a process of crystallization.' She immediately alerts readers to her own chronological experimentation (Smith 2015: ix). Inspired by her interest in medieval history and the Black Death, Louise Welsh set her most recent genre foray in a dystopian, end-stopped future for the 'Plague Times' trilogy. *A Lovely Way to Burn* (2014), *Death is a Welcome Guest* (2015) and *No Dominion* (2017) question 'deceived notions' (Smith 2015: 172) of narrative linearity and historical determinism. In their turn to historical moments each of these novels is executing what Walter Benjamin described as a 'tiger's leap' into the past in order to question assumptions of the present and about the future.

Benjamin drew on this striking image of ferocious energy in the 'tiger's leap' to describe how fashion (although 'working in an arena in which the ruling class gives the commands') has a 'flair for the topical, no matter where it stirs in the thickets of long ago' (Benjamin 2007: 261). He argued that because 'History is the subject of a structure whose site is not homogeneous empty time, but time filled by the presence of the now', a historical materialist should be equally aggressive, recognising 'a revolutionary chance in the fight for the oppressed past', and take 'cognizance of it in order to blast a specific era out of the homogeneous course of history' (Benjamin 2007: 263). In their fixation on present-centred pastness, the novels by Kennedy, Smith and Atkinson try to blast past and present worlds into a different recognition; Welsh challenges through a present-shaped engagement with an apocalyptic future.

They flag their intentions in each case. In Kennedy's text this is achieved through her title. Smith, as ever deploying the epigraph to potent effect, quotes Arendt on Benjamin but also a range of other speculations on time and the novel including Giorgio Bassani (Smith 2015: ix). Atkinson draws on Plato's thought on time in her epigraph to *Life After Life* but also quotes Heraclitus. Atkinson and Smith's fictions are particularly striking in their deployment of quotation. Welsh meanwhile frames her fiction with reference to both a medieval past and the dystopias that shaped her 1960s childhood. In the accumulation of such fragments they deploy Benjamin's strategy of using quotations 'like robbers by the roadside who make an aimed attack and relieve an idler of his convictions' (Arendt 2007: 571). As Arendt suggests, this became for Benjamin 'the only and possible way of dealing with the past without the aid of tradition' (Arendt 2007: 49). Paratextual strategies

of confronting and rupturing time are reinforced by the 'historical' nature of the fiction and the anti-linearity of their narratives. Combined they challenge – in different degrees – future-based thinking. For Kennedy and Welsh the knowing movement between different moments in time and the clash of discourses this produces also serves to destabilise familiarity. The fiction of all four offers a further engagement with Benjamin, encouraging readers into that 'tiger's leap' created by fierce destruction of assumptions around past, present and future.

Yet while these literary tactics serve to disrupt complacency, a notable feature of all these texts, death-focused, textually and thematically challenging as they are, is their capacity to engage readers with narratives around love, hope and redemption. In so doing they invoke emotional effects as intense as the more popular fictions described earlier. The novels achieve versions of the political challenge to future-centred thinking expressed through the theoretical queering of time, identified by Lee Edelman as the 'determined opposition to the underlying structures of the political'. An opposition to 'the governing fantasy of achieving Symbolic closure through the marriage of identity to futurity in order to realize the social subject' can be read into each of these novels (Edelman 2004: 13–14). Yet while they rupture conventional expectations of the novel form, of closure, of pleasure, these novels still sustain a remarkable level of emotional engagement.

When the young artist at the centre of Smith's novel *How to be Both* paints one of her first subjects, she invites her to 'relax', orders her 'Don't move', then asks apologetically, 'Can you do both?' (Smith 2015: 267) These novels produce similarly contradictory effects. They allow readers to relax into narratives of linear time and the flow of feeling: they demand the empathy and attention more commonly associated with realism. But they also ask us to be tensile in engagement with the movements of time when linearity is disrupted, as achieved in Smith's text by typographical experimentation and a diptych structure or in Atkinson's by repetition of a plot line until it loses all familiarity. Each writer in their own way achieves, within the novel form, that elasticity of the imagination that Smith identified with the short story while producing successful novels that speak to wider audiences than the more rarefied genre. Such a combination of metafictional experimentation and more conventionally realist affect as seen in Smith most obviously but also in Atkinson, Kennedy and Welsh is itself strategic, allowing the reader to be 'both' – i.e. involved and abstracted, in the now and in the beyond now. This combination

creates one aspect of the distinctive nature of their explorations of temporality and makes their writing so compelling.

The precarious balance of absorption and rupturing these novels achieve is most evident in their conclusions. *Day* ends with a moment of hope but in a future tense and a precarious situation;

> And you will tell him, "Yes. I'll see her again."
> And you will feel like laughing. (Kennedy 2007: 280)

While the idea of Alfie Day being reunited with his beloved is affirmative in the context of his story, the ending presents it as provisional at best, if not imaginary.

In *How to be Both* one of the novel's paired narratives concludes with George 'For now, in the present tense', contemplating a painting and future affirmative action, but thinking 'it's definitely something to do. For the forseeable' (Smith 2015: 186). The conditional conclusion of George is not the novel's only resistance to the sense of an ending: the fifteenth-century painter who haunts the other narrative cannot remember 'ending', refusing conclusion even in typography:

> But how did I then / End?
>     I can't recall an end at all, any end I ever, can't, any, demise, no-
> (Smith 2015: 202)

*Life After Life* closes with yet another version of its narrative beginning on 11 February 1910, and a discussion of time, 'We could all be stuck here for days' (Atkinson 2013: 477), while *A God in Ruins* concludes with 'please stop reading now' (Atkinson 2015: 384). Louise Welsh's powerful conclusion to the 'Plague Times' trilogy ends with a moment between father and adopted son, poised between life and death, in ambiguously concluded conversation: 'his son was crying and Magnus could not be sure that he had heard him' (Welsh 2017: 372). In each case, the novels resist an ending which affirms an achieved present or points into a secure future. Rather they remain poised in moments of the 'now' which are both positive and precarious. In this respect they resist notions of political action which celebrate transition into an imagined future. When Edelman critiques the dominant idea of change effected through the myth of 'one day more', he notes, 'we are no more able to conceive of a politics without a fantasy of the future than we are able to conceive of a future without the figure of the Child' (Edelman 2004: 11). Such thinking, Edelman and others have argued, subsumes action in the moment to

sacrifice for what might come. Precariously, tentatively, these novels seek to break patterns of future-centred thinking, combining historical specificity with the moment of the now.

Each novel achieves this in different ways and through a range of effects. In *Life After Life* Atkinson signals the nature and the structure of her experiment from the outset, in an epigraph voiced by one of its characters: 'What if we had a chance to do it again and again until we finally got it right?' (Atkinson 2013: 7). With its beginning in 1910 and putative ending in 1967 the novel's fragmented narrative reworks the possibilities of Ursula Beresford Fox in a range of stories that demonstrate the impact of historical forces but also of chance. Ursula's own increasing sense of having lived these events before, a kind of déjà vu, also becomes a driver of the different plots. This device provokes questions not just about temporality or the nature of time but also around agency and the capacity to live a 'good' life. The novel thus challenges both the observation of Ursula's friend, Klara, that 'Hindsight is a wonderful thing. If we all had it there would be no history to write about' (Atkinson 2013: 327), and the claim by Sylvie, Ursula's mother, that 'we all end up in the same place' (Atkinson 2013: 240). Ursula instead suggests that time 'isn't circular, it's a palimpsest' (Atkinson 2013: 456).

Through these constant references to competing concepts of temporality and through its structure, of repeated but different versions of events, the novel asks two questions: Can one change history? And can the understanding of history be altered? When a war co-worker during an air raid misquotes John Donne (Holy Sonnet 13), 'What if this were the world's last night', Ursula corrects him 'What if this present were the world's last night?' and reflects: 'The word "present" makes all the difference, don't you think? It makes it seem as if one's somehow in the thick of it, which we are, rather than simply contemplating a theoretical concept' (Atkinson 2013: 375). This statement drives much of the novel: in terms of history what does it mean to be 'in the thick of it'?

As *Life After Life* covers a period of striking development of women's roles in the public sphere, questions of how agency may be achieved, and the larger concern with what agency and history might actually mean, are inevitably articulated through an awareness of gender and the 'historicised' acquisition by women of the power to change events. In the section entitled 'A Lovely Day Tomorrow', the sixteen-year-old Ursula has to experience, in reiteration, sexual assault by a visiting American: each time her rejection of it is more vigorous and her subsequent life becomes less one of oppression,

passivity and unhappiness as her increasingly forceful challenge to the aggressor helps her avoid an unwanted pregnancy, disastrous marriage and alcoholism.

The novel poses the same questions around agency on a larger scale when Ursula tries to alter the course of political rather than personal history. Impelled by the question of 'what if?' the novel confronts, through Ursula, the question 'what if someone shot Hitler?' Through establishing a personal friendship with Eva Braun in one of her repeated 'lives', Ursula becomes part of Hitler's inner circle. When she has the opportunity to shoot Hitler it is in the feminised context of a German cafe, where everyone is indulging in hot chocolate and luscious cakes. Ursula's actions – producing a gun out of her handbag, having just dabbed at her lips with a lacy handkerchief – offers a powerfully gendered moment, bringing together the domestic and the political spheres. This instance of female action changing the course of history challenges dominant models of female passivity and male agency.

The refocusing of history through a gendered lens in the novel's events is parallelled by its narrative structure and explicit observations on time which reinforce Virginia Woolf's rejection of life as a 'series of gig lamps symmetrically arranged'.[5] The novel questions dominantly gendered versions of history but also interrogates progressional versions of temporality as articulated through its central character: the past 'is a straight line for Pamela but a jumble for Ursula' (Atkinson 2013: 70), leading Ursula to reflect in Woolfian tones: 'Her memories seemed like a cascade of echoes. Could echoes cascade?' (Atkinson 2013: 156).

Ali Smith's *How to be Both* also reconfigures the gendering of public and private histories, most obviously through the novel's subject and structure. By re-imagining a fifteenth-century painter as a woman and juxtaposing her life story with a contemporary companion narrative around recently bereaved George, the engagement with particular versions of feminism is evident in its rethinking of 'history'. Both narratives are framed by feminist comments from the contemporary heroine's dead mother. The challenge to gender categorisation produced by the ambiguity around each central character – boy or girl, both? – is mirrored in the diptych device which allows the two narratives to be published and read in different orders. Two stories, two lives, intersect across time. In *How to be Both* and *Life After Life* the overall structuring of the novel – and the spiralling and fragmented nature of typography and text, often resisting even the linearity of a sentence – challenges conventional ways of organising gender, time and experience.

In both novels then we might discern the melding of the various responsive phases of women to history identified by Julia Kristeva in her essay *Women's Time* (Kristeva 1981: 19, 20, 34). The novels acknowledge the early attempts of the women's movement to gain a place in linear time by their very subject matter. Kristeva's second phase in which 'linear temporality has been almost totally refused, and as a consequence there has arisen an exacerbated distrust of the entire political dimension' informs the narrative strategies of each. The third phase of mixing the two attitudes – 'insertion into history and the radical refusal of the subjective limitations imposed by this history's time on an experiment carried out in the name of irreducible difference' – emerges from their combination of experimentation, versions of historical specificity and thematic concerns (Kristeva 1981: 19–20).

Yet in their narrative structures, in their refusal of anything but the most precarious of endings, each novel also presents, in its own distinctive way, a further challenge to what Judith Halberstam has described as 'the force of middle-class logic of reproductive temporality'. Halberstam suggests that 'in Western culture, we chart the emergence of the adult from the dangerous and unruly period of adolescence as a desired period of maturation; and we create longevity as the most desirable future [. . .] and pathologise modes of living that show little or no concern for longevity' (Halberstam 2004: 4). In their refusal to adhere to that model of temporality, in their playing with 'then and now', with the dissolving of those separations, these writers partake in the 'difficult work of thinking outside narrative history, reworking linear temporality'– in order to see experiences 'not regulated by "clock time" or a conceptualisation of the present as singular and fleeting; experiences not narrowed by the idea that time moves steadily forward, that it is scarce, that we live on only one temporal plane' (Dinshaw 2007: 186). They likewise challenge that assumption identified by Edelman 'that time is historical by "nature" and history demands to be understood in historicizing terms' (Edelman in Dinshaw et al. 2007: 181).

The novelists considered achieve this in various ways. Most obviously Atkinson, Smith and, to a lesser extent, Kennedy do so through the structure of their fictions. In its emphasis on a reiterated now-ness *Life After Life* can be read as a manifestation of Benjamin's challenge to understand history as 'time filled by the presence of the now' (Benjamin 2007: 252). Smith acknowledges this concept through her parallel narratives and textual disruptions of linearity. Atkinson's most recent novel, *A God in Ruins*, appears to move back and forwards in

time but comes to rest in a moment of present which dissolves and to an extent denies everything that has gone before. Kennedy's novel occupies a series of moments in the past, narrated in the tenses of past, present and future. Welsh, in some respects the least experimental of these writers, transposes a narrative from the past – plague – into the form of contemporary thriller and dystopian world, forcing her reader to reconfigure their notions of history.

Secondly, in most cases these writers offer explicit critiques of 'history as linear narrative' in which, as Edelman describes, 'meaning succeeds in revealing itself – *as itself* – through time'. In *How to be Both* George reflects that: 'History is horrible. It is mounds of bodies pressing down into the ground below cities and towns in the unending wars.' George is appalled by history: 'It's only redeeming feature is that it tends to be well and truly over' (Smith 2015: 104). This version of history, however, is subverted by the whole narrative impetus of the novel, with its intertwining stories and typographical and textual attacks on linearity. George's initial observation that 'That was then. This is now. [. . .] That's what time is' falls apart in the context of the novel's events (Smith 2015: 103). *How to be Both* is founded on the premise that this is NOT what time is; George, like the reader, has to move on from linear ways of thinking. Is there, the novel asks, a different way in which we can configure being in time?

*Life After Life* likewise challenges assumptions about history and time in terms of a political imagination. Ursula critiques the deployment of teleological narratives in politics when she realises that 'most people muddled through events and only in retrospect realized their significance; the Führer was different, he was consciously making history for the future. Only a narcissist could do that' (Smith 2015: 324). Hitler himself can be read as embodying an extreme version of 'the coercive belief in the paramount value of futurity' (Edelman 2004: 6).

In *Day*, a novel whose temporal 'nowness' is embodied by its title, A. L. Kennedy also explores the fantasies of futurity offered by World War II through her account of Alfie, a member of a bomber-crew brotherhood, mingling memories of his early life with an abusive father, the intensity of his war experiences and his disillusioning return to civilian life. *Day*, as Petra Rau notes, is one of the few British novels to engage with the moral complexity of the Strategic Air Offensive over Germany (Rau 2016). In its masculine focus, it might seem removed from Kristeva's engagement with women's time. But the novel also initiates a conversation around temporality and agency which has relevance beyond the context of war or masculinity and is continued in the other novels explored

here. As evident in its engagement with the temporal, flagged by the constant punning around its hero's name – e.g. 'Let's call it A. Day' (Kennedy 2007: 35), Kennedy's novel is consistently concerned with the processes of time, with the dynamic between the individual life and its broader historical context, and with the simultaneously comforting and estranging nature of repetition.

While the novel, as with most of Kennedy's fiction, plays with and challenges linearity, the more complex engagements with time emerge from the responses of Day to his experiences of the war and afterwards. Even his reflections on his own impenetrable accent are couched in the language of past, present and future tenses: '*Yo bin and yo bay. Yo doe and yo day. You are, or you have been, and you aren't or you haven't been. You do or you don't or you didn't*' (Kennedy 2007: 8). As a character hurled into history, Day is interested in the possibilities of change while also recognising its apparent impossibility. Early in the novel he articulates a tension between the fact that 'a man had to imagine he'd get a chance at freedom, a bit of space. The interval between alternatives, that gave you space' (Kennedy 2007: 2) and the 'trouble' being 'that you had so much to do: breathing, sleeping, waking, eating: you couldn't avoid them, were built to need them and so they just went on and on. Where were the other possibilities, the changes you might want to make [. . .]?' (Kennedy 2007: 2). The war experience represents an extreme example (and in some respects a resolution of) these challenges. While exposure to death and to grand narratives attenuates time – 'Infinity is fond of wars, they give it a way to come in' (Kennedy 2007: 10) – war conversely produces (and can only operate through) a welcome present-centredness. When Day becomes part of the bomber air crew he observes: 'being in the air crew obliterates past. [. . .] They were the crew and nothing other than the crew and that would be for ever. [. . .] The crew was extremely particular whenever it dealt with time – it woke and was live and moving in that moment only. It would not be concerned with its past and had no business thinking of its future' (Kennedy 2007: 68–9). Kennedy thus deploys World War II, the bomber-crew and its death-centred focus to re-imagine relationships with linear time.

Kennedy's novel shares with Atkinson's an exploration of war, and in particular the dynamics of the bombing raid, an interest in challenging the rationale of future-centred thinking while also finding a positive dimension to this death-inflected sphere. In *Day*, Alfie's attempts after the war to expose the SS background of fellow film-set worker Vasyl and prevent him from coming to Britian are met with

an official admonition: 'We must think of the future, not the past' (Kennedy 2007: 263). This political expediency of moving on from past destruction as a necessary step towards reconstruction serves as a mirror of the shaping ideology behind bombing raids – destruction now for a better tomorrow – which Alfie has to struggle with in his own consciousness. The novel overall rejects this kind of future-thinking – when the 'Good German' tells Alfie he 'should have kids. It would suit you.' It is 'Knowing that was probably untrue. Knowing that most hopes were misleading. And knowing that Day, Alfred F., would not be all right' (Kennedy 2007: 164). Likewise Alfie's fellow crew member, Molloy, when nearing the end of his tour of missions, is destroyed by 'the hope thing' which makes him unable to function in the moment (Kennedy 2007: 234). Alfie himself is shown singing 'Jerusalem', the epitome of hope, at the end of the novel simply as a means of letting British workers on the film escape into Europe: he is 'yelling the England that will never be' (Kennedy 2007: 268) while helping his fellows escape the pull of history.

Much of the theoretical work about queer temporality emerged out of the AIDS crisis, shaped by living in ways in which 'future' becomes something else. The centring of both *Day* and *A God in Ruins* on World War II suggests that it performs a similar function. Two out of the three novels have a particular emphasis on the bomber pilots, whose survival statistics were horrendous. In the first novel, one of Ursula's incarnations is as an air raid warden, another catalyser for awareness of death. Even the phrase echoing from the close of each narrative in *Life After Life*, 'darkness fell' connotes the falling of bombs. Bombing then, and in particular bombing raids over Germany, become oxymoronic emblems of repetition and finality. In the similarity and difference of each raid, in the heavy droning of the planes that accompanies each narrative account of 'life after life' which each time is a nearer death after death, culminating in the presentness of death and the completion of 'a life lived perfectly', the repetitiveness of a Derridean death drive is enacted. The bombing raid is both a repeated action and one of illuminating intensity in its specific nature. In *Day* Alfie moves from the repetitiveness of bombing in which 'you see the targets beside targets; nothing but targets [. . .] you don't talk about death. You only ever say you have knowledge of the workings of bombs' to the cognisance when flying over Hamburg that 'This is death. This is the edge of the real face of death, its size – we burned the sky open today and now death has come in' (Kennedy 2007: 235). Burning the sky open carries a deeper implication, echoing the blowing open of the continuum of history encouraged by Benjamin.

Yet it is from the naming of death that Alfie finds a measure of happiness and redemption in love – a love with Joyce that can only ever be in the moment and, in the context of her failed mariage, only enjoyed, as the complicated tenses of the novel's conclusion suggests, in the day. Edelman argues that

> If the fate of the queer is to figure the fate that cuts the thread of futurity, if the *jouissance*, the corrosive enjoyment intrinsic to queer (non) identity annihilates the fetishistic *jouissance* that works to *consolidate* identity by allowing reality to coagulate around its ritual reproduction, then the only oppositional status to which our queerness could ever lead would depend on our taking seriously the place of the death drive we're called on to figure. (Edelman 2004: 310–11)

The novels discussed here take seriously the place of the death drive, that which cannot be represented, but engage too with the possibilities of 'corrosive enjoyment' that its acknowledgement might bring. Queer time, suggests Halberstam, 'even as it emerges from the Aids crisis, is not only about compression and annihilation; it is also about the potentiality of a life unscripted by the concentrations of family, inheritance and child rearing' (Halberstam 2004: 2). In their experiments with different ways of scripting temporality both *Day* and *Life After Life* focus on death as a means of rebutting linearity and determinism and of reclaiming presentness.

Louise Welsh's 'Plague Times' trilogy can also be understood as a product of new thinking around temporality emerging from the AIDS crisis. Welsh is a writer consistently interested in generic experiments. In this trilogy she plays with her fondness for the thriller genre in fiction set in a dystopian future in which a fast-spreading lurgy, the 'Sweats', disrupts the patterns of conventional life and shakes up the possibilities of action and escape. A historian of the medieval period, Welsh collapses plague life and modern civilisation in enriching and destabilising ways. The apocalyptic thinking of these novels, as she notes in the acknowledgements of *A Lovely Way to Burn*, 'goes back to my early childhood, a mild obsession with "the bomb", the television dramas, *Threads* by Barry Hines and *Survivors* by Terry Nation. The idea that the collapse of civilization is imminent has been around since ancient times' (Welsh 2017: 357). For all their apparent generic conventionality, the concept of plague underpinning the texts raises questions around chance and determinism: the 'Sweats' appears to arrive at random so those who escape cannot claim agency but are nevertheless endowed with it. The social breakdown brought about

by the plague likewise poses political questions relevant to present-centred situations.

While Atkinson, Smith and Kennedy reshape relationships with the past, and in so doing challenge future-thinking narratives, Welsh's work takes a rather different direction. It might be understood in terms of a response to 'future-consciousness', associated with millennial thinking, with 9/11, with the temporalities of modernity in which the future is envisaged as empty yet constantly imagined and feared.[6] The dark preoccupations of her trilogy are less with past death worlds and more with a contemporary concern around what Kathleen Stewart defines as 'trauma time': 'We are in trauma time now. Where the here and now drifts between the future-making of awakened expectations and the dragging dread of lurking threats and half-remembered horrors' (Stewart 2005: 325). While working in a popular thriller genre, Welsh's 'Plague Times' trilogy embodies a climate in which 'violence and abjection are seen as a contagion, like a virus; self-control and social containment are the only known vaccine' (Stewart 2005: 325).[7]

Welsh literalises this world in which 'In the anxious stasis of the future, everyday practices [. . .] can guard against the moment of being "taken back"' (Stewart 2005: 333). In *A Lovely Way to Burn*, which follows Stevie Flint's attempts, in a plague-ridden London, to find out the truth about her boyfriend's murder, thriller and apocalyptic nightmare are combined in ways that emphasise the precarious balance of everyday and the monstrous: 'the London the tourists saw and the other London of rough sleepers and kettled demos, the cheap chicken fryers whose sleeping bags lay bundled in the back of the shop' (Welsh 2014: 59). Responses to the horror take the form of the mundane, as symbolised by supermarkets where it is hard to tell the difference between looters and hoarders (Welsh 2014: 166–7). The intersections of horror and the mundane are highlighted by Stevie's own banal job as a presenter on a shopping channel. *Death Is a Welcome Guest* continues this dystopian sequence with Magnus McFall, an Orcadian comedian trying to move out of London and return home in a novel which reworks Edwin Muir's own formulation of apocalyptic thinking in 'The Horses'. The final novel in the series, *No Dominion*, unites Stevie and Magnus in an adventure south, originating from their endeavour to save the new community they have created in Orkney. Again the novel references brands and cityscapes to acknowledge the power but also disintegration of everyday consumerism which had appeared to postpone the apocalypse:

The shopping centre had been designed to allow crowds to sweep through its halls. Magnus looked up at the mezzanine and saw they were exposed from every angle.[. . .] Stevie's voice was soft. 'Do you remember this? These shops?'

He saw what she meant. The Body Shop, Next, Boots, Clintons, Lush, H. Samuel . . . . (Welsh 2017: 284)

The characters forced into this world are caught within an imagined culture which, as Stewart suggests, 'marks a mode of attention at once deeply distracted and scanning for revelations and driven by the fury of its own traces' (Stewart 2005: 338).

Yet while these novels are shaped by death, resist future-thinking, challenge history, they do so in ways that can also be read as redemptive. Atkinson has described *A God In Ruins* as a novel about the Fall and it is certainly threaded with images of falling: but it is also full of images of flying. The moment of stop in the present – Teddy's death in the air – becomes the model of a life lived perfectly. Falling and flying, as seen in *Day* too, are not necessarily oppositional. And in Kennedy, Atkinson and Smith the movements between falling and flying are deployed in different ways, to convey notions of linear time's oppressiveness but also opportunities for liberation from it. As stated in *A God In Ruins*:

In the days before the war we are told, people lived in the knowledge of the dependable nature of time: that is now shattered. Before the war every day was much the same, wasn't it? Home, the office, home again. Routine dulls the senses so. And then suddenly it feels as if one's living on the forward edge of one's life, as if one never knows whether one is going to fall or fly. (Atkinson 2015: 190)

Smith's novel too, although shaped by both the death of George's mother and of the haunting artist, occupying a world in which George notes 'everything is so post death', is nevertheless full of images of pointing up, into the sky, away from the earth (Smith 2015: 97). As the artist asserts, 'things and beings shown to be moving upwards into the air have always about them the most and best vitality' (Smith 2015: 352). Both central characters in the novel resist the press of history: 'I don't want all my memories falling on me like an avalanche', muses the artist's ghost (Smith 2015: 330). George's narrative meanwhile moves towards the revelation that: 'What if history instead *was* that shout, that upward spring, that staircase-ladder thing, and everybody was just used to calling something quite different the word history. What

if received notions of history were deceptive?' (Smith 2015: 172). In Welsh's fiction too there is a redemptive theme brought about through love imagined differently. In the hint that a future community be more reliant upon young women warriors who will not be forced into marriage and childbearing, and its exploration of love in contexts removed from romance or birth allegiance, Welsh's fiction also confronts dominant and conservative models of future-thinking.

Annamarie Jagose warned, in a 2007 discussion about the 'reification of queer temporality, the credentialing of asynchrony, multitemporality and non-linearity as if they were automatically in the service of queer political projects and aspirations'.[8] It would be dangerous to assume that the novels discussed here are all in the service of that project. Nevertheless, their textual strategies and thematic obsessions work to 'queer' – in the sense of disrupting and refusing history as a linear narrative in which meaning is revealed by and through time.

In their engagement with history the novels are not casting it aside so much as challenging these 'deceived notions'. When George complains that World War I is irrelevant to her, her mother explodes with:

> What, the Great War? In which your great-grandfather, who happened to be my grandfather, was gassed in the trenches not once but twice. Which meant he and your great grandmother were very poor, because he was too ill to work and died young? And meant I inherited his weak lungs? [. . .] And then the break-up of the Balkans, and the start of the territorial trouble in the Middle East [. . .] and the civil unrest in Ireland, and the shifts of power in Russia, and the power shifts in the Ottoman Empire, and the bankruptcy, economic catastrophe and social unrest in Germany, all of which played a huge part in the rise of fascism, and the bringing about of another war [. . .] Not relevant? To us? (Smith 2015: 107)

This fiction is not against history. Rather, as Smith's novel suggests, 'Maybe anything that forced or pushed such a spring back down or blocked the upward shout of it was opposed to the making of what history really was' (Smith 2015: 173).

This literary desire to blow history open, informed by the urge to reshape categories of gender and sexuality, rethink agency and claim the newness of the present, comes at a moment in which Scotland itself was confronting and contesting its own various relationships to the past and future. Reflecting in 2012 on the Scottish independence debate, Mike Small wrote: 'Until the referendum we are in a liminal land, neither here nor there', continuing,

In Liminal Land one group of politicians is accused of spreading false hope while another spreads doubt and fear. Both campaigns have problems with this attempt to project forward to some imagined future, because while they can play safe to respective dreams and anxieties, it's in today's here and now that Britain is falling apart. (Small 2012: 179)

By fracturing time, by breaking history – linguistically, structurally, chronologically, emotionally – the novelists discussed in this chapter are, in their different ways, trying to escape from a history in which a mound of bodies from the past press down upon us and from notions of a future which demands sacrifice of the present. By narrating the ruins of time, they attempt to re-imagine a space in which 'one's living on the forward edge of one's life'.

## References

Arendt, Hannah [1968] (2007), 'Introduction', in *Illuminations*, trans. Harry Zohn, New York: Schocken Books.

Atkinson, Kate (2013), *Life After Life*, London: Doubleday.

Atkinson, Kate (2015), *A God In Ruins*, London: Doubleday.

Barnett, Laura (2015), *The Versions of Us*, London: Weidenfeld & Nicolson.

Benjamin, Walter [1968] (2007), 'Theses on the philosophy of history', in *Illuminations*, trans. Harry Zohn, New York: Schocken Books, pp. 253–64.

Berlant, Lauren (1997), *The Queen of America Goes to Washington*, Durham, NC and London: Duke University Press.

Dinshaw, Carolyn (2007), 'Theorizing queer temporalities: a roundtable discussion', in C. Dinshaw, L. Edelman, R. A. Ferguson, C. Freccero, E. Freeman and J. Halberstam (eds), *GLQ: A Journal of Lesbian and Gay Studies*, 13, http://dx.doi.org/10.1215/10642684-2006-030, pp. 177–95.

Edelman, Lee (2004), *No Future: Queer Theory and the Death Drive*, Durham, NC: Duke University Press.

Halberstam, Judith (2004), *In a Queer Time and Place: Transgender Bodies, Subcultural Lives (Sexual Cultures)*, 1st edn, New York: New York University Press.

Kennedy, A. L. (2007), *Day*, London: Jonathan Cape.

Kristeva, Julia (1981), 'Women's time', trans. Alice Jardine and Harry Blake, *Signs: Journal of Women in Culture and Society* 7: 13–35.

Rau, Petra (2016), 'Knowledge of the working of bombs: the strategic air offensive in rhetoric and fiction', in P. Rau (ed.), *Long Shadows: The Second World War in British Fiction and Film*, Evanston, IL: Northwestern University Press, pp. 197–220.

Rosenberg, Daniel and Susan Harding, 'Introduction', in Rosenberg and Harding, *Histories of the Future*, Durham, NC and London: Duke University Press, 2005.

Small, Mike (2012), [untitled], in Scott Hames (ed.), *Unstated: Writers on Scottish Independence*, Edinburgh: Word Press Books, pp. 179–85.

Smith, Ali [2012] (2013), *Artful*, London: Penguin.

Smith, Ali [2014] (2015), *How to be Both*, London: Penguin.

Stewart, Kathleen (2005), 'Trauma time: a still life', in Rosenberg and Harding, *Histories of the Future*, Durham, NC and London: Duke University Press, 2005, pp. 323–39.

Welsh, Louise (2014), *A Lovely Way to Burn*, London: John Murray.

Welsh, Louise (2015), *Death is a Welcome Guest*, London: John Murray.

Welsh, Louise (2017), *No Dominion*, London: John Murray.

## Notes

1. E. M. Forster, *Aspects of the Novel* (1927), cited in Smith 2013: 28.
2. *Sliding Doors*, film, directed by Peter Howitt. UK: Miramax, 1998; *About Time*, film, directed by Richard Curtis. UK: Translux; Working Title, 2013.
3. David Nicholls, *One Day* (London: Hodder & Stoughton, 2009); *One Day*, film, directed by Lone Scherfig, 2011; Audrey Niffenegger, *The Time Traveler's Wife* (New York: MacAdam Cage, 2003); *The Time Traveler's Wife*, film, directed by Robert Schwentke. USA: New Line Cinema, 2009.
4. For discussion of this see Edelman 2004: chapter 1.
5. 'Modern Fiction', in Virginia Woolf, *The Common Reader*, 1925 (rpt. London: Hogarth Press, 1951), pp. 184–95.
6. See Rosenberg and Harding 2005.
7. Stewart is referencing Mike Davis's *Ecology of Fear: Los Angeles and the Imagination of Disaster* (New York: Henry Holt, 1998).
8. Annamarie Jagose in Dinshaw 2007: 191.

# 'They peer at my dark land': The Ethics of Storytelling in Twenty-First-Century Scottish Women's Writing

## Marie-Odile Pittin-Hedon

In an article in *The National* dated 14 October 2016, Alan Riach stresses that the defining characteristic of the Scottish literary landscape is the use of the various languages of Scotland, which he links with Scotland's fundamental egalitarianism and its connection to the country's geographical diversity, as well as to freedom. One might detect the author's own leanings in his eliciting literature's 'freedom from oppressions and freedom to do certain things otherwise than under the constraints of a political zombie uniform mentality' (Riach 2016), but the fact remains that its versatility, diversity, its capacity to cross borders – geographic, generic, formal and political – particularly stand out in the twenty-first century. When Riach goes on to propose major themes in Scottish literature, a recurrent question appears – its participation in the ongoing debate on what constitutes national identity, what he calls 'the matter of the nation' (Riach 2016). This connection between national identity and Scottish literature, or more specifically the argument that literature provides a unique artistic space where the politics of national identity are played out is a long-standing idea. It has come under a certain amount of criticism for the ultimately limited scope it affords literature, which cannot be properly envisaged within such a unilateral criterion. The very influential critical works on women's literature that have been published since the mid-1990s, starting with Douglas Gifford and Dorothy McMillan's landmark volume in 1997, followed by Carol Anderson and Aileen Christianson in 2000, Christianson and Alison Lumsden in 2000, Glenda Norquay in 2002 and Norquay again in 2012, have thoroughly analysed the implications

of gender in the definition of Scottish literature, while noting, as for example Christianson and Lumsden or Eleanor Bell do, the difficulties attendant on the notion of writing as an extended meditation on the nation. For Bell:

> There has been a tendency in Scottish Studies to equate history with literature, so that literature tends to be regarded as the *effect* of cultural processes, rather than as an intervention in those processes, or indeed as a relatively autonomous act of aesthetic, ethical or political engagement. Subsequently, there is a certain factor of reducibility at work, where texts produced by Scottish authors must in the first instance be explained in terms of their Scottishness. (Bell 2004: 2)

We are all by now familiar with this shortcoming, which Janice Galloway expressed in fairly unambiguous terms in 1999, asking, 'Who wants to write about *nation* all the bloody time?' (Galloway 1999: 72). The post-devolution period has, however, seen a shift in this line of argument, a post-nationalist turn which, as Carla Sassi points out, allows for a type of criticism that challenges the cultural-nationalist paradigm (Sassi 2012: 8). But there still remains the question of the largely male, working-class identity that was conveyed in the fiction from the 1980s and much of the 1990s. It has led to much theorising on gendered positioning, in particular with the very influential images of 'debatable lands and passable boundaries' deployed by Aileen Christianson (Christianson 2002: 67), those 'inbetween spaces' that are the loci from which the female experience of gender and nation can be articulated. Running spectacularly against the theoretical positioning of women's writing as both marginal and not very visible is the prominence of women writers on both the national and international stage in the twenty-first century. This trend prompts us to re-examine the twin critical framework of gendered readings (an inheritance from the time when, as Simone de Beauvoir famously put it, women – and women writers – were confined to their parts as the accidental, not the principal) and the wider context of the way they help shape our concept of identity for the twenty-first century. Janice Galloway, in a Cristie Leigh March interview, acknowledges that desire to break free from the damaging, and actually plainly erroneous, limitations to women's creative potential:

> Simply for a woman to write as a woman, to be as honest about it as possible, is a statement; not falling into the conventions of assuming guy stuff is 'real' stuff and we're a frill, a fuck or a boring bit that does

housework or raises your kids round the edge. That stuff is not round the edge! It's the fucking middle of everything. Deliberately pointing up that otherness, where what passes for normal has no bearing on you or ignores you – that fascinates me. (March 1999: 86)

The whole 'round the edge/the middle of everything' question has certainly come to our attention in the last decade or so, when the new Scottish canon has increasingly come to be referred to as made up of women writers such as Galloway herself, Kathleen Jamie, Liz Lochhead, Jackie Kay, Louise Welsh and A. L. Kennedy, but also as including new names which are far too numerous all to be mentioned here – Jenni Fagan, Alice Thompson or Kirstin Innes to name but a few.[1] In her most recent book on the topic, Glenda Norquay defines what characterises contemporary women's writing in the twenty-first century as a 'resistance to fixity, combined with a detailed attention to the particular' (Norquay 2012: 10), emphasising its opposition to 'what passes for normal', therefore stressing its versatility and defiance of stereotyping, as well as the metonymic quality of its endeavour. The particular rather than 'the big bow wow strain', as Walter Scott said of his own writing, serves as a very effective place from which to configure the common experience. Norquay concludes by acknowledging the need for 'serious reconfigurations of the canon, informed by a recognition that literary genres carry with them their own traditions and assumptions around gender' (Norquay 2012: 115).

In order to reflect on the way that contemporary fiction shapes our sense of the real and of this multivalent concept that is Scottish identity in the twenty-first century, I would like to start from both Glenda Norquay and Aileen Christianson, while suggesting a slightly divergent approach to the perennial questions on the nature of Scottish literature – and Scottish women's literature. While women's literature is still concerned with issues connected with the implications of gender (this issue itself stretching to consider the lesbian or LGBT experience reflected in Fagan's *The Sunlight Pilgrims* (2016), the fiction of Louise Welsh or, famously, in Jackie Kay's *Trumpet* (1998) for example), they do so in ways that are not confined to themes, so that looking at their works raises the question of the politics of literature in various senses, an idea which I have captured by borrowing a line from Kate Clanchy's poem 'Men', which reads 'They peer at my dark land / as if through the sun on dazzling waves, and laugh' (Clanchy 1995: 1). In this line, the strong antagonism of pronouns, of light versus darkness, the suggestion of incommunicability and opacity in the 'dark land'

lend themselves to the fairly entrenched positions of gendered theorisations of literature. But the reversed metonymy – the land standing for the woman – also draws attention to the other aspects of the politics of literature, the representation of a female or/and Scottish identity. In addition, its poetic quality is to be linked to the notion of *poiesis*, the capacity to make, and therefore creates the link to the question of the meaning of literature as literature, as Jacques Rancière puts it in his book *Politique de la Littérature*. Rancière makes it clear that 'literature "does" politics as literature' that 'there is a specific link between politics and a definite way of doing literature as a definite practice of writing' (Rancière 2004: 10). This link is situated in what he identifies as literature's specific capacity to bring about the partition of the sensible, a phrase which, at least at first sight, seems clearer in French, '*le partage du sensible*', emphasising as it does literature's capacity to make the real available to all. Angus Calder equally asserts this capacity, claiming that, in Scotland, 'creative writing is an essential part of the political process', in the sense of 'helping to recreate Scotland', what he calls the polis (Calder 2002: xiv); but Rancière's partition of the sensible is even more proactive a concept than the recreation suggested by Calder:

> Writers grapple with significations. They use words as instruments of communication and thereby find themselves enrolled, whether they want it or not, in the task of building a shareable world. (Rancière 2007: 13, my translation)

Richard Kearney takes up the same argument in his essay on storytelling, when he argues that ever since Aristotle's *Poetics*, 'the art of storytelling [. . .] is what gives us a shareable world' (Kearney 2002: 3). In the current European context, the context of Brexit, the haggling throughout Europe over what to do with Syrian refugees, the uncertainties on how to tackle Islamic terrorism on a European scale, and the disastrous 2016 presidential election in the United States,[2] it seems even more crucial than ever to focus on what visions of a shareable world are still being conjured up by writers. This chapter will therefore look at contemporary women's fiction without adopting a specifically feminist or gender-oriented approach, but rather an approach based on Rancière and Kearney, centred on the story-making potential of a selection of writers, and examining what becomes of the shareable world idea in the contemporary context. Taking my cue from Glenda Norquay's recent depiction of contemporary women's fiction, I will go into the particular

rather than brushing a broad general portrait, focusing on some of the most recent novels or short story collections by Kirstin Innes, Leila Aboulela, Alice Thompson and Kirsty Logan. In so doing, I will start from the critical commonplace of the in-between space women writers have had to carve for themselves, in order to retrace the way that the marginal is liberated with the creative, renewed use of fantasy and Gothic to conjure up a 'dark land' to be peered at, a dark borderland which is also a re-grounding of the marginal and the liminal. This dark land also incorporates women's impressive contribution to Tartan Noir, which can only get a fleeting mention here in spite of its incredible vitality and significance in connection with women's literature, and its ability to create a liminal space that is a space of transaction, of crossing a divide that is both generic and political.

In *The Companion to Scottish Women's Literature*, Norquay quotes Liz Lochhead who, as early as 1991, confidently posits female literature in the following manner:

> OK. Three points about being a woman writer in Scotland. One: your gender is not a 'problem'. Two: you don't really need 'role models' [. . .] Three: you don't have to 'write positively about women' or create 'heroines'. (Norquay 2012: 6)

I propose to take things from there and see where that leads us.

## Peering at Dark Borderlands: Rewriting the Supernatural

Kirsty Logan and Alice Thompson both write fiction with a strong sense of the supernatural and create heroines who are not meant to conform to the heroic pattern. Thompson, in her Gothic novella *The Book Collector* (2015), recreates the Victorian type of the helpless hysterical victim, and has her come out of the story unscathed and victorious, but having had to take it upon herself to change the narrative, making a strong statement against female marginalisation and victimisation but also about the constraints of formulaic narratives. Logan's two collections of short stories *The Rental Heart* (2014) and *A Portable Shelter* (2015) and her novel *The Gracekeepers* (2015) take up the transformation of that most formulaic of genres, the fairy tale, as well as being inspired by the author's taste for the rich Scottish folklore of selkies, kelpies and fairies. Her works take magic away from the realm of the story to apply it to the narrative in order

to reconfigure the traditional magic place conjured up by the once-upon-a-time formula. *The Gracekeepers*, which the author calls 'the woman from the sea story',[3] depicts the tribulations of a circus boat in a flooded world, and involves two protagonists, North, the circus performer who dances with a bear for a living, and Callanish, the Gracekeeper whose job it is to perform death rituals. The novel also shares the fairy tale's characteristic of interrogating the linear logic of time and space. Time is only expressed in terms of the succession of shows the circus puts on, and of the death ritual applied by the graces, with mourning the only thing that is measured in days in this novel – death reintroducing regular time in extremis, or even when it is supposedly no longer needed. To the geographic logic of borders, maps and separation, space opposes the haphazard and the discontinuous, with place names such as 'The North-east Archipelago' or 'North-West 1 Archipelago' (Logan 2016: 103) thus mapping the land into a post-apocalyptic territory, a flat expanse of water that can no longer accommodate the idea of space:

> The land that her ancestor had mapped no longer existed. The contours of mountains and valleys, the lines denoting when one country became another, the shaded colours to show kingship: all of it was gone under the endless ocean. Back then it had shown the real world. Now it was only history, stories of a place that once was. (Logan 2016: 119)

The disconnect between the world that was, placed under erasure in this quotation, and the 'endless ocean' seems to have polarised not just the world depicted, but also the narrative; it makes for a renewed sense of existence for this borderline territory. Our conventional social distinctions have shifted to that between sea farers, or damplings, and landlockers, with hints that the 'border' separating the two groups of characters, who come across almost as species, is not a geographical line, but rather a line of danger, to the extent that both Callanish's and North's non-conformity to one or the other group – North is pregnant with the baby of a sea creature, while Callanish's hands and feet are ridged – is depicted as possibly lethal. The reader is given advance warning of the fact in the prologue, in which a young Callanish witnesses the killing of a circus performer by her bear. The motif of the creature from the sea, a *topos* of fairy tales – benign, magic, but also, if one remembers the fate of Andersen's little mermaid, ominous – is therefore taken up here by Logan to be re-examined in a fictional context that actualises the fairy tale's chilly potential. Both Callanish and North are isolated and endangered, while the novel echoes Logan's

poem 'said the sea-witch', in which she recasts the little mermaid story in a feminist framework:

> *then your tail will part and open into what men call pretty legs*
> the legs must be kept open. the mouth must be kept shut. the tongue is stolen.
> but grace is enough. beauty is enough, and legs for dancing. legs for opening.
> (Logan 2010: n.p.)

The question of gender – not as gender determinism and oppression as in the poem, but as gender divide – is the allegorical territory mapped out in the novel, when North performs her deadly dance with her bear only to slit her gown open with a razor blade and emerge as a boy, or when two girls turn out to be pink-haired men. In a way that is consistent with the dominant image of the shifting sea, in which topography, distance and borders are difficult to assess, the borderland that appears in the novel is the dark land of gender attribution and the prejudice associated with it, or more broadly the question of perceived difference, which can take many shapes and sizes. This point is illustrated in Logan's short stories, such as the magic realist story 'Una and Coll are not friends', in which a girl with antlers and a boy with a long tail are bundled together at school, by staff and children alike, merely because they are both strikingly different from the rest, regardless of the fact that they are also different from each other. But the allegory of confused gendering is only *one* of the suggested interpretations for *The Gracekeepers*, as the territory, the dark and oxymoronic liquid land, draws its meaning from the connection between two worlds. When North reflects on her baby's conception, she recalls 'tilt[ing] back her head and open[ing] up her body, letting words repeat inside her head, names she's only heard in stories: selkie, nereid, mermaid' (Logan 2016: 95). The world conjured up is a borderland because it is made up of disparate ontological worlds: existing folklore mixing with the world of the novel itself. It is therefore a mixed zone, necessarily a creative zone if it is to come up with the creative re-examining of such issues as life and death, human and non-human, the existence of a limitless universe and its implications for our notion of belonging, or the inversion of genders. In the world of *The Gracekeepers*, sex difference – or the human/animal difference – is subsumed in a superior entity: as Melia, another circus performer, cryptically puts it, 'they are all the sea' (Logan 2016: 65). Jacques Rancière identifies this kind of mixed zone, which he describes as supra-sensible and

fantasmagoric, as the very place from which one can see and describe the laws of our world:

> In order to understand the laws of a world, we should not just look for this world in mundane things; we should restore the supra-sensible, fantasmagoric quality of these mundane things in order for the encrypted transcription of our social organisation to emerge.[4]

In her short stories, Logan uses generic conventions and a distortion of the language of literature to forcefully bring the encrypted writing of the world to her readers' attention. To address the pitfalls and hardships of love, the unequal, potentially dangerous quality of relationships, she literalises metaphors, as in 'coin operated boys' in which mechanical lovers can be rented by the week (although you obviously have to go to Paris to find the perfect lover), or in the title story 'the rental heart', in which the characteristic stages and hazards of love, its stereotypical association with the heart, are transferred onto a mechanical device that can be clipped into people's chests and which reacts precisely in the ways that our most common metaphors – to have a heavy heart, or one's heart rising in one's throat – suggest, with the infamous 'breaking my heart' turning out to be a fairly uncomfortable experience:

> The more I loved him, the heavier my heart felt, until I was walking around with my back bent and my knees cracking from the weight of it. When Jacob left, I felt my heart shatter like a shotgun pellet, shards lodging in my guts. I had to drink every night to wash the shards out. I had to. (Logan 2014: 2)

This story, along with many others in the collection, makes use of fictional conventions to challenge well-established rules in our social organisation, to let us peer at the dark land underneath the conceits with which we describe it. Like *The Gracekeepers*, *The Rental Heart*, which was awarded the 2015 Polari First Book Prize for its exploration of the LGBT experience, suggests a territory in which gender distribution and the prejudices associated with it are reflected upon, as well as other, more general received wisdoms about our lives and our society. For example, 'Underskirts', a dark story in which an evil enchantress with a 'shipwreck-quick smile' (Logan 2014: 16) (or maybe just a *libertine*) lures young girls into her castle, makes much of its intertextual connection to both well-known fairy tales such as *Blue Beard* and nineteenth-century Gothic fiction along the lines of *The Castle of Otranto*. The very arresting connection with the intertexts, the sense

of entrapment conveyed not just by the events in the story, but also by the multiple viewpoints which enclose the victims even more certainly than the plot does, reflect on the enduring trappings of patriarchy in its division of the sexes, while the defamiliarisation provided by the fact that the Gothic villain is a woman forces the reader to adopt a fresh perspective on an age-old topic. Logan therefore achieves a warping of the conservative discourse of fairy tale, in keeping with Richard Poirier's identification of the goal of fictional language:

> Language is also [. . .] the place wherein we can most effectively register our dissent from our fate by means of troping, punning, parodistic echoing, and by letting vernacular idioms play against revered terminologies. [. . .] Language is the only means to avoid the trap of language. (Poirier 1987: 72)

'Underskirts' precisely hinges upon the need to 'register our dissent from fate'or to realise that, as another story, 'girl #18', indicates, 'there are always other places / there are always bridges' (Logan 2014: 60). Similarly, 'bibliophagy' goes back to the trope, favoured by Logan, of the literalisation of metaphors, to engage with the notion of the crucial importance of language, words even, as the basic component of all narrative, if we are to register our dissent. In this three-page story, an unnamed family man suffers from an eating disorder of a very peculiar type which makes him eat words, a shameful disease, an addiction that cannot be helped. When, at the end of the story, the inevitable occurs and he lifts the last 'sickly tangle of consonants' (Logan 2014: 37) into his mouth and swallows them, the comic postulate of the story, relying as it does on the absurd parallel between 'serious' addictions like alcoholism and drug abuse (my name is John and I eat words) is tinted with more sinister undertones, as the title, 'bibliophagy', suggestive of the consumption of *all* written words, indicates. This suggestion echoes Rancière's description of the function assigned to literature, realistic or otherwise, which consists in 'making the universe of our prosaic reality appear as a huge fabric of signs which weaves the written story of an era, a civilisation or a society' (Rancière 2004: 23–4). Only in the world depicted by Logan, the journey is made backwards from Rancière's suggestions of the goal of literature; the fabric is being destroyed, an act which, in the final analysis, does give the bibliophagist something to be ashamed of, especially in terms of the fateful last sentence of the story, 'this is the last, he says, and he swallows' (Logan 2014: 37), leaving the reader with a sense of unspecified doom.

Also starting from the generic conventions of the fairy tale and also twisting them by superimposing other genres and modes, such as the Gothic, the fantastic or crime, Alice Thompson provides her own reflection on the notion of Gothic entrapment in a way that ties in with the long line of Scottish women writers which includes Ali Smith and A. L. Kennedy.[5] In *The Book Collector*, Thompson turns gender entrapment and the imposition of such constrictions by formulaic narratives into a wider enquiry into the *nature* of formulaic narratives and their capacity to close up around us. The heroine, Violet, is a young Edwardian who leads a fairy tale existence[6] with her husband Archie and their baby son until her story turns into a darker tale which is a mixture of the Gothic and crime, when the prince is revealed to be a criminal. Thompson adds to the motif of entrapment provided by the Gothic turn a metafictional level which suggests that characters can be trapped not just in the labyrinthine environment of a Gothic castle, but also in the labyrinthine structure of the story itself. Violet believes she recognises the generic conventions which dictate her life and therefore is desperate to establish roles that can enable her to understand the mystery surrounding her in terms of an established pattern of readerly expectations, what literary criticism calls a pact of reading. Hence her insistence on keeping up the metaphor of her life as a fairy tale. In so doing, she does not see the complex webbing deployed around her by Thompson, so that when she wonders about the assumption that she has made about 'her whole life, the geography of the place, the permanence of her family', and when she adds that, 'She had never envisioned a different future, rather presumed it, the presumption of innocence' (Thompson 2015: 150), what she does not see is that rather than the presumption of innocence, she has made the presumption of narrative (and generic) continuity. This is confirmed by the fact that even when her own story veers towards the Gothic, with her imprisonment in the asylum followed by the discovery of her husband's kill-room, she still refuses to acknowledge the generic shift, trying to take stock of 'the new fairy story she had been plunged into against her will' (Thompson 2015: 132). But the correct assumption cannot be made easily, because it is the assumption of ontological discontinuity – she does not quite realise that she is not only giving her skin and her life to the book, but also her entire existence as a character. So that the central symbol of the asylum not only serves as a Gothic reminder, but also as a potent symbol of what alienating fate characters suffer once they have been chosen for integration into a narrative. Violet unknowingly describes this when she says of the young shop assistant, 'when he had been

reading, he had seemed so intact, as if he had given himself over to the interior world of the book' (Thompson 2015: 5). For there is a greater danger than that of being skinned to serve as book cover; it is that of the Gothic metafictional tale in which the point for the various characters is to avoid being caught in the 'interior world of the book'. That world is seductive and harmless at first, like Archie, like the genre of the fairy tale, but the Gothic overtones that take over the narrative from the beginning, reinforced by the murder mystery, give the measure of the very real danger. A danger that can in turn be seen to allegorically represent the trappings of gender roles, as is indicated by the use of three genres which, in their own ways, reflect a very conventional gender distribution within a patriarchal framework, and do not admit a great many variations.

So when Violet rebels at the end of the narrative, asserting that, 'I will not be put in a book of fairy tales' (Thompson 2015: 153), this rebellion reaches out to the shareable world that literature creates: it is a rebellion against a scripted fate. In order to escape the fairy-tale-turned-Gothic-turned-murder-mystery trap, it is necessary for Violet to turn the table on the narrative in a way similar to what happens in the plot, in which she gives her husband a fairy tale ending, by modelling his death on the ending of the Constant Tin Soldier tale. When 'a sense of ending came upon her', Violet 'felt impelled to bring the ending about' (Thompson 2015: 154), effectively shifting roles and becoming a figure of the narrator, taking the story into her own hands:

> So Archie wanted to put her in a fairy tale. Well, she would put him in one instead. She remembered the ending of 'The Tin Constant Soldier' [sic], the story where Archie and Clara belonged. But how to rewrite this fairy tale? (Thompson 2015: 154)

In an ultimate seizure of power, Violet constitutes herself as the narrator, the storyteller, in the very real sense of the 'maker' of stories, as she actually places Archie and Clara inside the bedroom then builds and lights the pyre that will destroy them. As a storyteller, she can 'put Archie in a story' – transform him into a character acted upon by stereotypically defined forces in a traditional tale, while granting herself the status of the manipulator of that force. Kearney links the storytelling potential with the value of human life:

> Storytelling invites us to become not just agents of our own lives, but narrators and readers as well. It shows us that the untold life is not worth living. (Kearney 2002: 156)

The final, downplayed image is of Violet who, after symbolically burning the trap down and giving the collector of books and therefore of characters a taste of his own medicine, emerges from the trap unscathed if a little sooty, a normal mother picking up her child from a friend's house. She turns the story into that of a life that is worth living, because it finally is a life that is told for its own sake. Thus the novel takes the question of women's fiction yet another step away from a discussion of themes, or at any rate it integrates them into a wider project for Scottish fiction, to insist on the ultimate power of narrative not just to register but to enact dissent against our fate. It is an act of rebellion against the untold life in the sense that formulaic narratives freeze events into stereotypes that do not account for our lives and therefore ultimately do not give us a shareable world. It is a projection of the ambiguity ultimately contained in Rancière's notion of *partage du sensible*, which means both sharing and separation or partition, as the English translation indicates,[7] emphasising as it does the paradox that giving us a shareable world means focusing on its partition, its union/disunion dialectics.

## Walking to the Edge: The Disconnect of the Present

Another way to promote a new partition of the sensible in order to make lives worth telling, and therefore worth living, can be found in Leila Aboulela's novel *The Kindness of Enemies* (2015) and in Kirstin Innes's first novel *Fishnet* (2015). Aboulela's novel has two timeframes and two settings. The first setting is Scotland in 2010, with Natasha Hussein (also Natasha Wilson), a lecturer in history, daughter of a Russian mother and a Sudanese Muslim father, who conducts research into a nineteenth-century warrior chief who fought to protect his people and their traditions against the invading forces of Tsarist Russia. Natasha meets Oz (Ossama), a student, and his mother Malak. They help her in her research, but when Oz is suspected of terrorism and arrested, she too becomes an object of scrutiny. The second narrative takes place in the Caucasus mountains during the Crimean War, seen from two sides: Princess Anna's, who is attacked and abducted with her family by Lezgin soldiers to be used as a bargaining chip by the other focaliser, Imam Shamil, the 'Lion of Dagestan', in exchange for his son Jamaleldin. Both plots present complex cases of dual, often conflicted, identity, and when Natasha reflects upon her own dual origin, the emphasis is placed on the coexistence of incommunicable elements:

I was seeing in these awkward composites my own liminal self. The two sides of me that were slammed together against their will, that refused to mix. I was a failed hybrid, made up of unalloyed selves. My Russian mother who regretted marrying my Sudanese father. My African father who came to hate his white wife. (Aboulela 2016: 40)

The negative wording ('awkward', 'slammed together', 'against their will', 'refused to mix', 'failed') presents Natasha as a rebuke to the postcolonial theory of hybridity through its fierce rejection of the idea of the successful blend, emphatically making the point of the violence done to the would-be hybrid, which the character captures with the fairly commonplace image of the half-human half-animal monster that she sees in her dreams, and the idea of the 'liminal self'. Indeed, this 'liminality' goes one step further than English novelist Meera Syal's statement of a more conventional sense of hybridity, as is expressed in a novel published two decades earlier, *Anita and Me*:

Papa's singing always unleashed these emotions which were unfamiliar and instinctive at the same time, in a language I could not recognise but felt I could speak in my sleep, in my dreams, evocative of a country I had never visited but which sounded like the only home I had ever known. The songs made me realise that there was a corner of me that would be forever not England. (Syal 1996: 111)

Syal couches her character's sense of her own uprootedness in geographical terms; Aboulela takes the organic metaphor further when Natasha claims, '[w]e should nourish one identity and starve the other so that it would atrophy and drop off' as the necessary condition for the 'half and halfs' to 'snuggle up to the majority and fit in' (Aboulela 2016: 104), clearly describing hybridity in terms of its monstrosity, reminiscent of Suhayl Saadi's monster attacking Zaf in *Psychoraag*, or Logan's own version of the monstrous, half-human, half-mechanical dolls in her stories. This monstrosity constitutes a dark land to be peered at, as it covers a territory that is more dubious, more elusive and dangerous than the marginality of the woman in a male-centred universe. It is also a reflection on the difficulty of projecting the past onto the present to make sense of ourselves, of where we're heading, of our future. Natasha explains why she chose to become a historian:

I preferred the distant past, centuries that were over and done with, ghosts that posed no direct threat. History could be milked for this cause or that. We observed it always with hindsight, projecting onto it our modern convictions and anxieties. (Aboulela 2016: 41)

With her dual timeframe, Aboulela weaves the conversation between the past and present into the very fabric of the novel. Like Natasha herself in her role as a historian, the novel attempts to understand not who we are, but rather how we project the madness of the present onto the future, in a world that comes across as riddled with antagonisms which can no longer be separated into neat Manichean oppositions, and with violence, terrorist or otherwise. Paul Ricœur is very clear on what the difference is between a meaningful future, and what he calls 'empty utopias' (or one might say, as it ultimately comes down to the same thing, empty dystopias):

> The narrative voice of a novel generally retells something that has taken place in a fictional past. One could almost say that fictional narration tends to suspend the eschatological in order to inscribe us in a meaningful past. And I believe that we must have a sense of the meaningfulness of the past if our projections into the future are to be more than empty utopias. [. . .] The structure of narrativity demonstrates that it is by trying to put order on our past, by retelling and recounting what has been, that we acquire an identity. (Ricœur 1995: 222)

For Ricœur, the stakes are high: a suspension of the eschatological – the world has to be narrated in fiction for its continuance, its survival, a statement that puts the concept of liminality into a political framework that reaches beyond the conventional feminist or postcolonial approaches. When Oz/Ossama is arrested on suspicion of terrorism, Natasha's description of the event registers a failure of language:

> One of them [the police] speaks and says the other name instead of Oz. His voice is loud, says they have a warrant for his arrest. Malak asks why and the answer starts with 't', ends with a suffix and she draws in her breath. (Aboulela 2016: 74)

When the narrative breaks up, unable to register the unfolding event, it bears the mark of what Jean-Jacques Lecercle calls 'the violence of language', 'the fact that all speakers are "violently" constrained in their use of language by quite particular social or psychological realities' (Lecercle 1990: iii) – one might add by political realities. Then fiction becomes the tool to construct what Kearney calls a new paradigm, one in which the fictional, as well as the historical, enacts the 'transformative plotting of scattered events' (Kearney 2002: 12), which is also a *responsibility* that cannot be taken lightly. Natasha makes this clear when giving the reader a glimpse of the report she could write about

her student Oz in order to extricate herself from possible accusations of aiding and abetting in a terrorist enterprise. As her attempt shows, it takes very little rewriting to change the nature of the real:

> So I would write that he made snowmen and ~~chopped~~ practised cutting their heads off with a sword.
> So I would write that he ~~joked~~ spoke about setting up a jihadist camp in the countryside.
> So I would write that he was researching weapons ~~used~~ to use for jihad. (Aboulela 2016: 143)

But what the novel provides us with instead is a thoughtful, articulate reflection on the question of historical differences, of Jihad, on the tricky nature of the concept of belonging. This appears, for example, in the diverging versions of Jamaledin's future according to Tsar Nicholas – 'you will rule Dagestan and Chechnya on my behalf' (Aboulela 2016: 58), '[y]ou will bring enlightenment to your own people. For this I have fashioned you' (Aboulela 2016: 59) – and according to his father Shamil, who deems him 'worse than dead' because 'not only is he a hostage but [. . .] the infidels have corrupted his soul and taken away his religion' (Aboulela 2016: 63).

In that context, we need to assess who we are as a society, as a community which is a far cry from Benedict Anderson's 'imagined community', and in order to implement the new paradigm, what is required is a fictional narrative which can perform what Ricœur calls a 'synthesis of the heterogeneous' (Ricœur 2000: 313), in order to re-instil meaning into our world, to counter the inarticulate – because it relies on the heterogeneous – narrative of terrorism or more generally of fragmentation so freely available on mainstream as well as social media. Because what this is, is an absence of narrative, not in Cairns Craig's sense of a gap in the common trajectory of the nation, but in almost the opposite sense of an excess of scattered and therefore unreadable, meaningless signs. The link between the absence of narrative and the eschatological is made very clear in another contemporary novel, Jenni Fagan's *The Sunlight Pilgrims* (2016), in the colourful words of a character called Crisp-Man:

> We're a race of zombies fucking the earth into oblivion. Fucked-up. Beheading people like it's Bingo! Look, Mum, see me on the internet with this bloke's head in my hand and a big-fucking-knife! Say cheese! Woo hoo. It's fucking trigger-happy time mate. That shit's a medieval bloodbath. (Fagan 2016: 18)

*The Sunlight Pilgrims* is not a novel about terrorism; it focuses on climate change – another issue that also points to the subsuming of the world into dystopia – but it nonetheless includes terrorism as one of the non-discourses of modernity, Crisp-Man concluding his rant with 'it's the end of times, that's what it fucking is' (Fagan 2016: 19). And the narrative follows suit, by depicting a world that is freezing over. At the same time, the novel as a whole, like *The Kindness of Enemies*, programmatic in its title despite not being a political text in the conventional sense of the term, is an attempt at supplying the synthesis of the heterogeneous, at sketching the new paradigm that only a return to narrative can achieve. The narrative of the future, literally, in Fagan's novel, and, in Aboulela's, the narrative of the past presented in the chapters devoted to Jamaleldin, Shamil and Anna. Those narratives supply the missing narrative that will avoid 'milking history for a cause' to be projected onto our present and determine our lack of future. They will prevent our entry into the realm of empty dystopia because they are a return to fully-fledged discourse, as opposed to the disconnectedness of slogans, or images, which are merely signs, thus foregrounding the connection between discourse and ethics. *That* is what literature can do as literature; *that* is what the politics of literature is. Kearney reminds us of this necessity, writing that, '[s]tories make possible the ethical sharing of a common world with others in that they are invariably a mode of *discourse*' (Kearney 2002: 150). What perhaps makes this particularly relevant to our world is the urgency of reintroducing ethics into it. Allow me to rely again on Crisp-Man's wisdom, as he explains the climate change that has hit the planet:

> The earth strikes back! [. . .] It's had enough of our bullshit, we're broken. All the way down to the bone. If human bones were rock, that's what it would say right through the middle – broke as-fuck-idiots-cunts-exterminate-exterminate. (Fagan 2016: 17)

With the mineral simile which conveys the finality, the irresistible, telluric force of what we are bringing upon ourselves, and the fragmentation of language at the end which cannot cohere into any meaningful discourse, the outcome as advocated by the character, if a little radical –'Only civilised thing to do is nuke ourselves' (Fagan 2016: 17) – seems inevitable, and is hovering dangerously close.

The discontinuous, the liminal and its power of destruction is also explored by Kirstin Innes in her remarkable debut novel *Fishnet* (2015), a narrative of the present which explores the nature of loneliness in twenty-first-century business parks, the claustrophobia of office space and the social invisibility of sex workers, compounded by their para-doxical ubiquity on the dematerialised sphere of existence that is the internet. Although it is a realistic tale, in keeping with what used to be called 'dirty realism' at the time of James Kelman's early novels,[8] the novel shares some of the features of what Monica Germanà calls postmodern fantasy, in the sense that the novel creates a zone, half way between Logan's or Thompson's dark borderlands and Aboulela's lim-inal spaces, which sits uneasily between the real world and a world that is not so much imaginary as virtual: the universe of chat rooms, blogs and websites.[9] The novel traces Rona's disappearance from the real into the virtual, a much more dangerous universe that, once entered, cannot be left easily. It conveys a sense that in wanting to 'retrieve' her sister, Fiona, like Rona, is in fact walking to the edge, to borrow the title of a novel by another contemporary writer, Kate Tough. Fiona tries to virtually follow in her sister's footsteps, to locate her in the labyrinth of the World Wide Web, which is then shown to be effectively boundless, lethal. It is a new version of the liminal zone, a new fantastic otherworld, for which words are the last surface trace left by characters who, having walked over the edge, have been swallowed up for good. When Fiona goes online to look for Rona, there is a sense that her sister is within reach:

> Rona on a computer somewhere. Working, doing something, typing her own name in, again and again until her own adverts bloomed. Want to be found? (Innes 2015: 38)

But the novel soon destroys that illusion by removing Rona from Fiona's narrative:

> Just a couple of clicks and I'm back in the right narrative again. I've found a forum where the girls and men both go, where the girls advertise themselves and the men critique them. (Innes 2015: 44)

Rona's inexplicable and therefore unexplained disappearance has left her in one of the multiple parallel pseudo 'narratives' of the World Wide Web, making her a stranger in a new, cyber-Gothic universe. A deft performance for Innes, who thus makes sure, in a context of prostitution and very real danger, that such notions as familiar/alien

territories cannot be neatly separated. Neither can right and wrong, so that the story cannot elicit pity, which according to the author prevents empathy.[10] The two places just coexist:

> There are days when I feel like I've stepped through the looking glass. That the days before that hen weekend – before that conversation in the ski slope cafeteria, before the smell of tea on Christina's breath – that we were part of some other life, other world. A world where I was aware of prostitution, course I was, but only in the same way that I was aware of, say, accountancy.
>
> Now it's everywhere. It's like being given goggles that allow you to see another dimension sitting on top of the one you live your normal life in. (Innes 2015: 94)

The different 'narrative' awaiting Fiona on the other side of the looking glass, or maybe above, or beneath her own narrative, relies on the principle of a multiplicity of narrative levels that depicts the world we live in as an intrinsically layered, metaleptic universe made up of jarring discourses, a sort of postmodernist narrative invading our own or, again, an invasion of discourse by signs. Twenty-first-century novelists such as Innes, but also Aboulela, Thompson, Fagan or many other writers are no longer writing from or about the margin (or the liminal) to place them on the map; they are describing how liminality has come to be part and parcel of the main narrative of ourselves, a notion that does not specifically apply to women's fiction. Fagan says that, '[a]ll writers writing from the periphery are pointing toward the center. [. . .] In a sense, the periphery is a mirror, showing the center what it is. That's why we're artists, we're responding to the center' (Evans 2016), displacing the centre-margin dialectics in a way that recalls Aboulela's and Innes's centring of the liminal. It is in that sense, I think, that the opening up of the Scottish literary canon can be understood. Salman Rushdie speaks of telling the human truth, which goes beyond other truths:

> The novel tells you flat out that it is untruthful. So what do we mean then by truth in literature? Clearly, what we mean is human truth. Not journalistic, photographic, recorded truth, but the truth we recognize as human beings . . . about how we are with each other, how we deal with each other, what are our strengths and weaknesses, how we interact and what is the meaning of our lives. (Rushdie 2014)

Rushdie goes on to explain that the goal for the work of fiction is 'arriving at the truth by the road of untruth', an idea also expressed in fairly similar terms by A. L. Kennedy, who claims that 'we try to deal with

something true by telling lies' (Szamosi 2015), thus providing the key to the narrative of the shareable world. 'We look for light in darkness' is how Fagan describes *The Sunlight Pilgrims* (Evans 2016). Telling the truth is therefore walking us to the edge, shedding light on the uneven, darkly complex surface of our world, shedding light on the liminal space which incorporates the dematerialised spheres that increasingly encroach upon our existences, our sense of who we are, because it is ultimately the stuff of experience, as we are reminded by Kearney:

> The imaginary liberates the prisoners of our live experience into possible worlds where they may roam and express themselves freely, articulating things that generally dare not say their names and giving to our inexperienced experience the chance to be experienced at last. (Kearney 2002: 25)

Because of the continuity between the world of fiction and the world of our experience, which the writers express in thematic, formal and technical ways, the vicariousness of this shared experience comes to be sidelined by the shareable territory that it delineates, and its ordering of fragments into a new paradigm. The margin is showing the centre what it is and the line from Kate Clanchy's poem, 'They peer at my dark land', can thus be seen as shifting from the defensive – which is the context of the poem itself – to the assertive: contemporary women's fiction gives 'them', the other, something to be peered at. It is mythical in the classical sense of the term of providing us with a *mythos* which, in Kearney's words 'convey[s] the common function of narrative as *poiesis*' or 'a way of *making* our lives into life-stories' (Kearney 2002: 129), and even making our lives into a territory where we can make sense of them in a collective, shared way. As Jackie Kay put it when interviewed by her friend Ali Smith, 'Art is always finding new answers, new questions. Having art in your life opens doors in rooms in your house you never knew existed and opens windows you didn't know were there' (Smith 2016). It is undoubtedly the very successful enterprise of contemporary Scottish women's literature, and more generally of literature, to open our windows on the unsuspected dark lands of our own world.

## Bibliography

Aboulela, Leila [2015] (2016), *The Kindness of Enemies*, London: Orion.
Anderson, Carol and Aileen Christianson (eds) (2000), *Scottish Women's Fiction, 1920s to 1960s: Journeys into Being*, East Linton, East Lothian: Tuckwell Press.

Bell, Eleanor (2004), *Questioning Scotland: Literature, Nationalism, Post-modernism*, Basingstoke: Palgrave Macmillan.

Calder, Angus (2002), *Scotlands of the Mind*, Edinburgh: Luath Press.

Christianson, Aileen (2002), 'Gender and nation: debatable lands and passable boundaries', in Gerry Smyth and Glenda Norquay (eds), *Across the Margins: Cultural Identity and change in the Atlantic Archipelago*, Manchester: Manchester University Press, pp. 67–82.

Christianson, Aileen and Alison Lumsden (2000), *Contemporary Scottish Women Writers*, Edinburgh: Edinburgh University Press.

Clanchy, Kate (1995), *Slattern*, London: Chato and Windus.

Craig, Cairns (1999), *The Modern Scottish Novel: Narrative and the National Imagination*, Edinburgh: Edinburgh University Press.

Evans, Kirsten (2016), 'Looking for light in darkness: a Q&A with Jenni Fagan', *Bookmag*, 12 October 2016. http://www.bkmag.com/2016/10/12/looking-light-darkness-qa-jenni-fagan-sunlight-pilgrims-the-panopticon/ (accessed 10 January 2017).

Fagan, Jenni (2016), *The Sunlight* Pilgrims, London: Heinemann.

Galloway, Janice (1999), *Edinburgh Review* 100: 71–2.

Germanà, Monica (2010), *Scottish Women's Gothic and Fantastic Writing: Fiction since 1978*, Edinburgh: Edinburgh University Press.

Gifford, Douglas and Dorothy McMillan (eds) (1997), *A History of Scottish Women Writers*, Edinburgh: Edinburgh University Press.

Innes, Kirstin (2015), *Fishnet*, Glasgow: Freightbooks.

Jamieson, Teddy (2015), 'Kirstin Innes: "If you're pitying somebody you can't really empathise with them"', *Glasgow Herald*, 30 March 2015. http://www.heraldscotland.com/arts_ents/13207847.Kirstin_Innes___If_you_re_pitying_somebody_you_can_t_really_empathise_with_them__/ (accessed 21 February 2016).

Kearney, Richard (2002), *On Stories*, London and New York: Routledge.

Lecercle, Jean-Jacques [1990] (1999), *The Violence of Language*, London: Routledge.

Logan, Kirsty (2010), 'said the sea-witch', *Goblin Fruit*, available at http://www.goblinfruit.net/2010/winter/poems/?poem=seawitch (accessed 26 June 2016).

Logan, Kirsty (2014), *The Rental Heart*, Cromer: Salt Publishing.

Logan, Kirsty (2015), *A Portable Shelter*, Glasgow: ASLS.

Logan, Kirsty [2015] (2016), *The Gracekeepers*, London: Vintage.

March, Cristie Leigh (1999), 'Interview with Janice Galloway', *Edinburgh Review* 101: 85–98.

Norquay, Glenda (ed.) (2012), *The Edinburgh Companion to Scottish Women's Writing*, Edinburgh: Edinburgh University Press.

Poirier, Richard (1987), *The Renewal of Literature*, New York: Random House.

Rancière, Jacques (2004), 'The politics of literature', *SubStance* 103, 33.1: 10–24.

Rancière, Jacques (2007), *Politique de la Littérature*, Paris: Galilée.

Riach, Alan (2016), 'Mapping the landscape of our literature', *The National*, 14 October 2016, available at http://www.thenational.scot/culture/alan-riach-mapping-the-landscape-of-our-literature.23522 (accessed 16 October 2016).

Ricœur, Paul (1995), 'The creation of language', in Richard Kearney, *States of Mind: Dialogues with Contemporary Thinkers on the European Mind*, Manchester: Manchester University Press, pp. 216–45.

Ricœur, Paul (2000), *La Mémoire, l'Histoire, l'Oubli*, Paris: Seuil.

Rushdie, Salman (2014), 'Magical realism is still realism', Big Think Interview, available at http://bigthink.com/videos/magical-realism-is-still-realism (accessed 16 October 2016).

Sassi, Carla (2012), 'Focus on Scottish studies: a new agenda for the field. Introduction', *Anglistik: International Journal of English Studies* 23:2: 7–16.

Smith, Ali (2016), 'Ali Smith interviews Jackie Kay', Thursday, 10 March 2016, available at http://www.picador.com/blog/march-2016/ali-smith-interviews-jackie-kay?utm_source=Twitter&utm_medium=Post&utm_content=Blog (accessed 16 October 2016).

Syal, Meera (1996), *Anita and Me*, London: Harper.

Szamosi, Gertrud (2015), 'A. L. Kennedy interview', *Faces and Places*, 20–24 February.

Thompson, Alice (2015), *The Book Collector*, Cromer: Salt Publishing.

## Notes

1. See for instance the *Herald* article of September 2013, 'Women begin to lead the way in Scottish literature', in which the confident assertion of a 'new "matrilineal" heritage' is made; *The Herald*, 21 September 2013, http://www.heraldscotland.com/arts_ents/13123901.Women_begin_to_lead_the_way_in_Scottish_literature/; or the Waterstones reading with Kirsty Logan and Kirstin Innes in October 2016, which was advertised as presenting the new Scottish literary canon (Waterstones Glasgow, Argyle Street, Thursday 27 October 2016).

2. Ali Smith, in her Goldsmiths Prize lecture, 'The novel in the age of Trump', says that there has been a change of paradigm since Trump's election. She speaks of 'President Trump's divisive barbaric yawp' and claims that 'The novel matters because Donald Trump', adding, 'Do I need to add another verb to that?' See *The New Satesman*, https://www.newstatesman.com/culture/books/2017/10/ali-smith-s-goldsmiths-prize-lecture-novel-age-trump

3. See https://www.penguinrandomhouse.com/blog/2015/07/30/three-from-the-sea-scottish-folktales-about-the-world-beneath-the-waves-by-kirsty-logan-author-of-the-gracekeepers

4. 'Pour comprendre les lois d'un monde, il ne faut pas seulement le chercher dans les choses banales: il faut rendre à ces choses banales leur aspect suprasensible, fantasmagorique, pour y voir apparaître l'écriture chiffrée du fonctionnement social' (*Politique* 31, my translation).

5. The fantastic and/or Gothic fiction they produce is identified by Monica Germanà as breaking with the tradition through their engagement with feminist and postmodernist discourses, as can be seen in Thompson's *Pandora's Box*, a rewrite of the Frankenstein story which is an indictment of the constrictive boundaries of male desire, or *Justine*, which also interrogates gender categories and the boundaries of the real/fictional world. See Monica Germanà, *Scottish Women's Gothic and Fantastic Writing*.

6. The story boasts the traditional figures of the genre, such as the witch and the stepmother.

7. This is also indicated in the phrase 'partage des eaux', which means 'watershed'.

8. The phrase 'dirty realism' originally referred to American fiction and is, therefore, an import.

9. This space is also explored in Ewan Morrison's *Swung* (2007) and *The Last Book You Read* (2005).

10. See Kirstin Innes's interview with Teddy Jamieson.

# 'Connected to time': Ali Smith's Anachronistic Scottish Cosmopolitanism

*Fiona McCulloch*

According to Zygmunt Bauman, globalisation generates 'a new socio-cultural hierarchy' of free market mobility and wealth that immobil-ises a growing number of 'others' who 'sink ever deeper into despair born of a prospectless existence' (Bauman 2000 [1998]: 70). Similarly, angled towards outsiders rendered uncomfortable with mainstream values and engulfed by contemporaneity, Ali Smith's fiction offers a response to the effects of neoliberal globalisation. She is interested precisely in those 'others' identified by Bauman who are casualties of global power, such as homeless, and thus economically immobilised, Else in *Hotel World* (2001). More recently, Smith's work is resonant of Bauman's identified precariat in her depiction of characters who suffer the uncertainty of zero hours and casual contracts, with the perpetual anxiety of becoming an outsider. In this exegesis of others in Smith's more recent works where demarcations of social stratifica-tion are disrupted, I consider the composite nexus evident between Scotland, cosmopolitanism and anachronism, which forges a queer resistance to global temporality.

Her main characters in *There But For The* (2011, hereafter abbre-viated to *TBFT*) occupy peripheral positions in British society and its hegemonic endorsement of globalisation: Anna Hardie is an exiled unemployed Scot in her mid-forties; Mark Palmer is a 59-year-old gay man who is five years bereaved of his partner, Jonathan, while still grieving the suicide of his artist mother, Faye, in his childhood; elderly May Young feels discarded by society; and precocious child Brooke Bayoude is bullied for being intelligent and black. *TBFT* is set in Green-wich in 2009, during London's global financial dominance, and Smith's

seasonal quartet-in-progress (*Autumn* (2016) and *Winter* (2017) pub-
lished at time of writing) directly engages with globalisation's impact
upon British and American national discontents. As Bauman berates
globalised accelerated capitalism's immobilisation of others, similarly,
*Autumn*'s Elisabeth Demand, a 'no fixed-hours casual contract junior
lecturer at a university in London' (Smith 2016: 15), exists in the pre-
carious freefall of neoliberal economic insecurity. While *TBFT* charts
globalisation's impact upon others, *Autumn* and *Winter* disclose its
blowback experienced during the increasingly neoconservative popu-
lism of 2016's EU referendum and the US election of President Trump.
As such, Elisabeth witnesses unfettered hostilities and tensions wrought
by Brexit, while her friendship with European Daniel Gluck serves as
the novel's cosmopolitan crux weighted against such national contrac-
tion. Her mother, Wendy, likewise signifies cosmopolitan hope against
rising hate crimes: her newfound lesbian relationship reinvigorates her
to protest against Britain's new regime.

Similarly, *Winter*'s lesbian immigrant, Lux Bain – '[s]hort for Velux'
(Smith 2017: 74), who 'can't get a good job because nobody knows if
I'll still be able to be here' (Smith 2017: 247) – provides a window to
view Brexit Britain's mistreatment of others. Her story unfolds while
spending Christmas with relative strangers – Art Cleves (an online
copyright monitor, his 'new' employment relies upon unstable inter-
net trends, so reflecting Bauman's precariat), his mother, Sophia, and
his activist aunt, Iris. Iris and Lux serve as viewing apertures into
a disparate family Christmas which, in turn, is a trope for national
divisions. Neither is invited by retired businesswoman Sophia to stay
at her home: both activist and immigrant are regarded as intruders
or foreigners within this uneasy homeland, though a gradual thaw
occurs during their stay. Despite several disused rooms, Sophia rec-
ommends, nativity-like, that Lux 'sleep in the barn', emphasising 'I
also wonder if you know how unwelcome you are' (Smith 2017: 85).
Sophia's house, 'Chei Bres . . . means House of the mind, of the head,
of the psyche' (Smith 2017: 270): a spatial metaphor for psychosocial
tensions, it also offers curative potential after Sophia experiences a
Scrooge-like temporal haunting.

In this essay I argue that *TBFT*, *Autumn* and *Winter* critique and
interrogate globalisation's rapidity through the motif of anachronis-
tic immobilisation, with each character temporally 'stuck', hindered
or discarded by neoliberalism and neoconservativism. To emphasise
globalisation's propensity to isolate as well as populist nationalism's
divisions, these texts step outside of time to negate that which capi-
talist society privileges and offer an alternative value system based on

cosmopolitan empathetic connections that privilege the human heart in all its connotations as a vital source of community. Smith's texts dismantle Greenwich time's temporal authority and reignite an inner rhythm that accommodates community over isolated individuals. To reach the heart of the matter, she privileges love as a cosmopolitical connection. For Jeremy Tambling, love 'is an anachronic force' that 'undermines questions of historical inscription, memory, and fashion, and love and homosexuality and [. . .] old age and being out of date' (Tambling 2010: 21). Love, then, or the heart, is an anachronistic empathetic cosmopolitan conjunction between self *and* other which dispels capitalist individualism. Tambling alludes to 'homosexuality', 'old age' or 'being out of date' as anachronisms, all of which are articulated by Smith. Characters correlate with Tambling's model – May's, Daniel's, Sophia's and Iris's old age, Anna feels out of date and, as a Scot, out of place, Mark's, Wendy's and Lux's homosexuality, Daniel's timelessness, or Elisabeth's intergenerational love for Daniel as well as her own spatiotemporal immobilisation, all illustrate 'love' as the ultimate 'anachronic force' that 'undermines questions' of social value. Smith disruptively queries and queers hegemonic values like heteronormativity and nation in favour of a communitarian cosmopolitan love for a wounded world. Her work discredits hierarchies of ubiquitous power and recasts those otherwise written off and disenfranchised within Bauman's 'prospectless existence'.

Though Bauman rightly targets globalisation's weakening of others, his critique of cosmopolitanism *as* global affluence (Bauman 2000: 99) conflates cosmopolitanism and globalisation and, as such, is a restrictive interpretation that limits its empathetic potential; on the contrary, cosmopolitanism frequently emerges from positions of disempowerment, and so is equated with those very 'others' that Bauman identifies as casualties of globalisation. Developed from postcolonialism, cosmopolitanism responds to globalisation's detrimental impact upon those marginalised with a solidarity that is 'both postcolonial and cosmopolitan' (Gilroy 2013: 127). This cosmopolitical perspective refutes Bauman's view of cosmopolitanism as an elitist beneficiary of globalisation and instead recognises its outsiderness, which is very much in keeping with my cosmopolitical perspective. Thus, 'Cosmopolitans today are often the victims of modernity, failed by capitalism's upward mobility' (Breckenridge et al. 2002: 6), like Smith's characters. Far from being comfortable world citizens, cosmopolitans in this light are displaced by rather than benefactors of Bauman's 'socio-cultural hierarchy' of globalisation. Instead of helplessly sinking into Bauman's 'despair',

Smith's cosmopolitan outlook offers a counter-voice of empathetic outrage against British hegemony's simultaneous validation of neoliberal globalisation and neoconservative national populism. Cosmopolitanism, then, comes from a marginal perspective, yet such 'victims' gain political traction in their ability to actively resist and intervene, empowering others in a cosmopolitical solidarity, like Rosi Braidotti's 'nonhierarchical model of cosmopolitanism' (Braidotti 2013: 12) based upon deterritorialised nomadic subjectivity or Patrick Hanafin's 'cosmopolitanism from below' (Hanafin 2013: 40). This is not the transcendental affluent model of cosmopolitanism Bauman berates, but an engaged grassroots struggle against globalisation's dehumanising impact and the illusory appeal of Brexit. *TBFT*, *Autumn* and *Winter* speak for the dispossessed and Smith writes from a Scottish cosmopolitan perspective which, though not immediately obvious upon first glance, resonates throughout her pages like an ethical palimpsest, much like those sidelined characters otherwise erased by mainstream society.

These counter-narratives privilege those rendered invisible, written out of history and dispossessed, echoing Cairns Craig's view that the modern Scottish novel exists not 'within the narrative of history, but between history and its other, between the mapmaker's map and an "otherworld"' (Craig [1999] 2002: 241). Smith's fiction likewise exists interstitially to chart that 'otherworld' where the cosmopolite emerges *from* this position of historical disempowerment. From a Scottish working-class background, of Northern Irish and English parentage, this queer woman writer residing in Cambridge herself embodies a marginalisation whose interstitial hybridity accentuates her cosmopolitanism. In relation to marginalised women's writing, Julia Kristeva considers how it can interrogate the 'social contract' and offer alternative temporalities based upon 'new ethics' (Kristeva 1981: 21, 35). Smith's 'new ethics' similarly enables an alternative trajectory that interrupts globalisation's temporality. I argue that, like Smith's characters, Scotland too is immobilised in its marginalised depiction as an anachronistic nation out of step with prevailing Anglocentric norms yet, since its post-devolutionary awakening, refuses Bauman's stagnation, instead favouring Kristeva's 'new ethics' of cosmopolitanism. According to Michael O'Neill, Scotland's devolutionary journey charts 'a more cosmopolitan or prismatic concept of citizenship indicat[ive of] a new political climate' (O'Neill 2004: 368), while Eleanor Bell notes that 'If national identity is becoming increasingly cosmopolitan [. . .] it is also apposite that this should now be more widely recognised in formulations of Scottish national identity' (Bell 2004: 140). Put another way, David McCrone believes,

'Scotland, like other societies, may be entering a post-nationalist age. The vehicle on that journey, ironically, seems to be nationalism itself' (McCrone 2001: 195). Such glocalised national plurality incorporating others rather than privileged citizenship is precisely the 'new ethics' of Smith's fictional oeuvre which, for me, correlates with an emergent Scottish cosmopolitanism.

Likewise, Michael Gardiner applies Deleuze's concept of 'minor literature' to post-devolution Scottish fiction; akin to 'postcolonial literature', he argues it is a 'literature of effect and becoming rather than one of static assumptions' (Gardiner 2007: 48). Contemporary Scottish fiction is not statically bound but dynamically resists global disempowerment, so that the 'minor is invariably more literary than the major' (Gardiner 2007: 48) in its potential for heterogeneous becoming and speaking *for* as well as from the margins. Smith reflects, 'literary Scotland is a collective, immensely versatile, often cosmopolitan consciousness, or a vital, wide-open book' (Smith 2009). Her 'minor literature' is borne out of and immersed in that Scottish cosmopolitan perspective: its political impetus becomes an anachronistic force that interrupts and reroutes literary history to accommodate alterity, just as postmodernism's micro narratives undermine grand narratives.

Kristeva's temporal disruption of the social order is closely aligned to her view of the foreigner within in *Strangers to Ourselves* (1991), for whom the 'present [is] in abeyance' (Kristeva 1991: 7), similar to Bauman's view of globalisation's temporal immobilisation of others. Yet, like cosmopolitanism's grassroots potential, Kristeva regards alterity's 'threat' as simultaneously curative in its reconfiguration of home. National anxiety caused by perceived 'intruder[s]' (Kristeva 1991: 14) dominates Smith's texts: Lux as immigrant, Elisabeth's cosmopolitan affinity and her under-paid intellectualism (notably, experts became populist targets during Brexit and Trump's campaign), and unemployed Scottish Anna's empathy with others. Similarly utilising Kristeva's foreigner within, Nicholas Royle argues that Scotland is synonymous with alterity: 'The "uncanny" comes from Scotland, from that "auld country" that has so often been represented as "beyond the borders", liminal, an English foreign body' (Royle 2003: 12). Like Smith's characters, foreign/uncanny Scotland too is peripherally housed.

Anachronistically 'auld', Scotland's Kristevan 'abeyance' resists British hegemony: post-devolution heterogeneity charts a cosmopolitical trajectory which, like Smith, speaks up for vulnerable citizens, including those transnationally displaced by global conflations like climate change and conflict. Such grassroots 'cosmopolitan solidarity' (Hanafin 2013: 40) emphasises the geopolitical impact of

minority citizenship and literature. In London, Anna, Elisabeth and Lux respectively experience their inner foreignness, out of step with their surroundings, just as Bell's consideration of Kristeva's *Strangers* notes that 'recent Scottish fiction [. . .] has often been concerned with these themes of exile and estrangement' (Bell 2004: 139). No longer useful as a compliant worker, Anna, like the temporal disjuncture of her 'auld country', epitomises Royle's 'English foreign body', accentuating her empathy with asylum seekers and signalling an interruptive Scottish Women's Time. Yet it must be recognised that not all Scots support a grassroots cosmopolitical momentum: 2014's failed independence referendum and a recent Conservative surge suggest a trend that mirrors Britain's neo-imperial Brexit anxieties and reveals a cohort supportive of hegemony's status quo. Smith's fiction, though, focuses on cosmopolitan otherness.

Anna, like Elisabeth and Lux, experiences insecurity, existing in-between jobs and 'broke' (Smith 2011: 52); a foreigner within, home becomes *unheimlich*: 'She was going home. Well, to what passed, for her, for home right now' (Smith 2011: 29). Continued unemployment could mean homelessness, 'or I may kill myself' (Smith 2011: 15). Home's fragility accentuates a fissure between London living and inner identity – 'A long time ago I was Scottish' (Smith 2011: 30). Anachronically remembering her identity, Anna recollects experiencing ostracism during a teenage trip, as 'one of the total outsiders. This is because she is the only Scot on the tour' amidst 'loudmouthed scary confident articulate English people' (Smith 2011: 33). Sensitive to her alterity, she feels silenced by her travel companions' bluster: 'She had not known she was this shy. She had not expected, out in the world, to find herself quite so much the wrong sort of person' (Smith 2011: 35). From youth, an internalised discursive binary relegates her to 'wrong' citizen, an 'outsider' defined by 'loudmouthed [. . .] articulate English people'; her Gramscian subaltern tongue is stilled. Anachronistically 'the wrong sort of person' (Smith 2011: 35), young Anna learns that the world is predicated upon hierarchical systems of belonging, identified earlier by Bauman.

Yet, crucially, 'Anna Key in the UK' (Smith 2011: 44), with her 'really funny accent' (Smith 2011: 29), sounds a dialogical note of anarchic discord. A UK foreign body, Anna is *key* to disrupting its status quo through her grassroots Scottish cosmopolitanism. Similarly, Monica Germanà argues that 'it is the Scottish "other" woman who disrupts dysfunctional middle-class English lives in Smith's *The Accidental*' (Germanà 2013 [2010]: 7); Anna's geogendered otherness, in turn, signals an Anglocentric foreign dissonance. Feeling a

long way from home, a lack of belonging anachronistically awakens her to social injustice, quitting a job in 'the Centre for Temporary Permanence', interchangeably, 'the Centre for Permanent Temporariness' (Smith 2011: 6), where asylum seekers' traumatic stories are bureaucratically belittled. Silenced by linguistic disenfranchisement, asylum seekers have 'trouble speaking, either because of translation problems, or because a rain of blows had made them distrust words ... In any language, it was almost always about what home was' (Smith 2011: 59). Conscious of her own ethnolinguistic *unheimlich*, Anna empathetically compares avian freedom – 'lucky birds, world-travellers' (Smith 2011: 56) – with immigrants' struggles to relocate home amidst hostile borders.

Similarly, *Winter*'s foreign queer woman is interlinked with Scotland and *Autumn*'s Elisabeth and Wendy reflect a post-Brexit English interest in Scottish relocation. Lux, whose Croatian family fled to Canada, is 'not Scottish' but her surname 'Bain' is a 'Scottish name' (Smith 2017: 112). Like Smith's fiction, Lux is a cosmopolitan synthesis who reflects Scotland's post-devolution plurality, even though she is not Scottish. Similarly, *Autumn* charts a groundswell of appeal in relocating to Scotland's alternative, more welcoming concept of home to salve Brexit's growing antagonisms. Elisabeth's financial limbo ensures 'no job security' while living 'in the same rented flat you had when you were a student over a decade ago' (Smith 2016: 15). Although 'failed by capitalism's upward mobility' aforementioned by Breckenridge et al., she embodies cosmopolitanism rather than the intolerant national mood. Her childhood neighbour, Daniel, explains that her French surname means 'Of the world, or in the world [. . .]. It might also mean of the people' (Smith 2016: 50). Able to harness the foreigner within, Elisabeth cosmopolitically connects with others, despite the backdrop of the 2016 EU referendum: 'a week since the vote' (Smith 2016: 53). Post-referendum, she witnesses Britain's polarised tensions between 'misery and rejoicing' (Smith 2016: 59), where 'people called each other cunts' and 'felt unsafe' (Smith 2016: 60). *Autumn* begins, 'It was the worst of times, it was the worst of times. Again. That's the thing about things. They fall apart, always have, always will' (Smith 2016: 3). It charts a tale of two countries, given Britain's 52:48 per cent referendum split. Intertextualising Chinua Achebe's *Things Fall Apart* emphasises Britain's intolerance of the foreigner, while 62 per cent of Scots vote to remain in the EU, sparking searches of 'Google: *move to Scotland*' (Smith 2016: 59). Brexit's rift emphasises British anti-immigration set against Scotland's progressive cosmopolitan nationhood. Smith intertextualises *The Tempest*, 'a play about civilization, colonization and imperialism' (Smith 2016: 207), a

stark reminder of neo-imperial ideology conjured during the campaign, with 'people getting hypnotized on an island' (Smith 2016: 208) swayed by jingoistic rhetoric. By comparison, Smith's characters exist outside of dominant culture; they are queer and anachronistically out of time insofar as they feel uneasy with heteronormative, hegemonic Britishness and global capitalism, each striving for an anarchic alternative.

Like *TBFT*'s central yet absent empathetic figure Miles Garth, an 'ethical consultant' (Smith 2011: 128), *Autumn*'s 'European' Daniel (Smith 2016: 77), who spends the novel's duration comatose, and ethereal immigrant Lux, who disappears towards *Winter*'s end, Smith's work ethically interrogates contemporary Britain. Miles, a connective figure, conceals himself in the spare room of his dinner party hosts, effectively stepping outside of time, which activates Anna's headspace to reconnect with others. Room is generated by interrupting the flow of events through Miles's anachronistic figure, arriving 'from the moment in the story when the narrative was interrupted to make *room* for the anachrony' (Genette 1983 [1972]: 48, my italics). Ancient yet timeless ('Can't believe he's still alive', Smith 2016: 55), Daniel also interrupts time 'in an increased sleep period [. . .] when people are close to death' (Smith 2016: 33). Like Miles's, Daniel's resultant anachronistic 'room' allows Elisabeth to 'stand just far enough away' (Smith 2016: 202) to reflect upon her personal and geopolitical circumstances. Lux's Christmas visitation likewise triggers Sophia's temporal haunting, reliving memories that help her to reconnect with her family. Likewise, Scotland's absent presence drives Smith's cosmopolitical trajectory towards a hopeful turn against immobilised despair. It spectrally appears in snatched glimpses and remarks, just beyond focus but the peripheral vision of which is pivotal to the ethical essence of these texts: Scotland serves as Smith's ethical metaphor, the beating heart of her narrative, out of which *key* character Anna's empathy for others emerges alongside feeling out of time and place in London.

Anna's empathetic awakening coincides with the return of her psychogeographically repressed alterity, mapping the revenant of a geopolitical trajectory that interrupts Anglocentric-driven neoliberal discourse with an alternative narrative that centralises caring over material success. Reasserting her Scottishness energises a rekindled camaraderie: rather than maintain complicity through employment that encourages detachment from human suffering, Anna's empathy for others 'worth less than a lightbulb' (Smith 2011: 61) precipitates her resignation. In turn, she experiences the economic vulnerability of becoming mired in a society that only rewards compliance to its

hegemonic values. To connect with the plight of others involves a traumatic loss; estranged from her hitherto familiar life she nevertheless experiences solidarity's hopeful community. Previously, Anna was promoted for providing 'exactly the right kind of absent presence' (Smith 2011: 61): in turn, the job suppresses her ability to feel, waking up 'from a dream in which she saw her own heart [. . .] having great trouble beating because it was heavily crusted over with a caul' (Smith 2011: 6). To excel in society's simulacra, one has to perfunctorily perform an efficient role, but its dehumanisation awakens Anna to her heart's atrophy.

Smith's identification with Scottish literature's 'cosmopolitan consciousness' produces an awakened fiction that ethically interrogates the communitarian cost of globalisation's flat-lined values and 'belong[s] with certain other contemporary works that trace the rhythm of what could be called a cardiogrammatology' (Royle 2003: 192). Cardiogrammatalogical literature is 'a love letter of sorts, about the strangeness of the heart but also about the heart as what dictates the love of thinking, the love of writing, the very possibility of literature or philosophy' (Royle 2003: 192). Smith's cardiogrammatalogical fiction concerns itself with love as a cosmopolitical act. Cardiogrammatalogically, Anna's resignation letter is a 'love letter of sorts' to herself and transnational asylum seekers, to stymie mistreatment of others and protect her heart's capacity for cosmopolitan empathy. Similarly, the palimpsestic omission 'There but for the grace of God go I' (Mark Currie too notices that 'the novel's title evokes blanks, or silences, through incompletion' (Currie 2013: 52)) urges empathy with others less fortunate. The remaining title *TBFT*, composed of seemingly random conjunctions, prepositions and definite articles lacks nouns to allow the reader to connect with something identifiable. Instead, it encourages temporal hesitation, corresponding to four anachronic sections/*rooms* whose characters form an interlinking chamber at the narrative's heart. For Smith, the heart's connective conjunction fuses self/other as a vital cosmopolitical component without which humanity becomes isolated from itself. *Autumn* too reflects Royle's 'strangeness of the heart': despite Daniel's 101 years, 32-year-old Elisabeth acknowledges, 'I love him' (Smith 2016: 216); she welcomes alterity, just as she herself is other. Likewise, in *Winter*, despite an initial frostiness, Sophia warms to Lux. For Smith, the heart's anachronic rhythms emanate an interruptive cosmopolitan intellect, creativity and love – a cardiogrammatological revolution – against global acceleration.

Similarly, discussing queer temporalities, Carolyn Dinshaw pon-
ders the 'possibility of touching across time, collapsing time through
affective contact between marginalized people now and then', since
'with such queer historical touches we could form communities across
time', so that 'This refusal of linear historicism' unleashes 'multiple
temporalities in the present' (Dinshaw et al. 2007: 178). In *TBFT*,
*Autumn* and *Winter*, temporal 'refusal' allows for geopolitical empa-
thy 'between marginalized people' to resist the diktats of Kristeva's
identified social contract. Intergenerational connections between, for
instance, Elisabeth and Daniel or Lux and Sophia are examples of
Dinshaw's communities touching across time and disrupting linearity,
breaking down divisions between self/other. Similarly, Daniel disrupts
linear history by remembering his epistolary communication with his
sister, Hannah, during the Holocaust: their Jewish surname Gluck
means luck, and Hannah escapes from the Nazis, as, presumably,
does Daniel since he lives in England. Hannah's letter offers resistance
amidst suffering: '*Hope is . . . a matter of how we deal with the nega-
tive acts towards human beings by other human beings in the world,
remembering that they and we are all human, that nothing human is
alien to us*' (Smith 2016: 190). Daniel and Hannah's cosmopolitical
'*human*' resistance serves as a warning from history: survivors of the
Holocaust, they are a reminder that 'In the collective symbolic system
of the Nazis, "cosmopolitan" was synonymous with a death sentence.
All victims of the planned mass murder were portrayed as "cosmopol-
itans"' (Beck 2006: 3). Cosmopolitans are spatiotemporal 'victims',
not Bauman's privileged citizens.

Queering timelines between Brexit and historical genocide, Smith
holds contemporary rhetoric to account through Hannah's historical
letter: '*we have [. . .] to be ready to be above and beyond the foul
even when we're up to our eyes in it*' (Smith 2016: 190). A few pages
later, when Elisabeth hears Brexiteers chant, 'Rule Britannia [. . .].
First we'll get the Poles. And then we'll get the Muslims. Then we'll
get the gyppos, then the gays' (Smith 2016: 197–8), it reverberates
with history's chilling echo. Smith reinforces the point in *Winter*: 'The
people in this country are in furious rages at each other [. . .] and the
government we've got has done nothing to assuage it and instead is
using people's rage for its own expediency. Which is a grand old fas-
cist trick [. . .]. And what's happening in the United States is directly
related, and probably financially related' (Smith 2017: 56). Smith's
imbrication of multiple temporalities demonstrates the impact upon
marginalised people: in times of cruelty, empathetic cosmopolitan-
ism is her urgent counter-narrative, equipping us to 'read the world'

(Smith 2016: 68) differently from dominant discourses, since '*nothing human is alien*'. In the temporal interstices of contemporary and historical hostilities, Daniel warns, 'When the state is not kind [. . .] the people are fodder' (Smith 2016: 171).

Like Dinshaw's queer temporality 'touching across time', Smith's temporal interruptions coupled with her awareness of Scottish fiction's cosmopolitan consciousness serves as a bridge: for instance, in *TBFT* Anna's personal suffering, albeit lesser, enables her affinity with asylum seekers to resonate with Scotland's palimpsestic past. Poignantly, 'right here in Greenwich' (Smith 2011: 87) is where 'Queen Elizabeth the First' hears news that 'her cousin, the Queen of Scotland, had given birth to a son' (Smith 2011: 88). Greenwich, symbol of England's temporal, maritime and royal (the Palace of Placentia was the birthplace of several Tudors) authority is shaken by Scotland's news. After abdicating in 1567, Mary Stuart seeks refuge in England from Elizabeth, but the latter, feeling threatened, detains her foreign relative and ultimately silences her in 1587. If one queers linear time, Scotland's history emerges including the Unions of Crowns and Parliament, the Clearances and resultant transnational diaspora (creating a 'cultural trauma of dispossession' (Devine 2006 [1999]: 182)), Thatcher's unwitting fuelling of devolution, and, in *Autumn* and *Winter*, neoconservative Brexit's imposition upon a nation that did not vote for it. Not only has Britishness '*been rhetorically and practically encouraging the opposite of integration for <u>immigrants</u>*, it has also been '*encouraging <u>ourselves</u> not to integrate. We've been doing this as a matter of self-policing since Thatcher taught us to be selfish and not just to think but to believe that there's no such thing as society*' (Smith 2016: 111). For Smith, Brexit is an inevitable culmination of Foucauldian surveillance against otherness, including Scotland. Its 'new kind of detachment' and 'loftiness' (Smith 2016: 54) exposes the apotheosis of Thatcherite selfish individualism.

To queer time involves a '*revisiting*'; like *Winter*, 'haunted by the ghosts of all these dead things' (Smith 2017: 39, 4), Smith's cosmopolitical connection mirrors Derrida's hauntological 'conversation' (Derrida 1994 [1993]: xviii). She rebukes systematic erasure of others by queering time to incorporate Scotland's own marginalisation as integral to Anna's geogenetic ethical code. Discontented and empathetic towards deracinated peoples, she anachronistically reaches back to a 'long time ago' when 'I was Scottish', revisiting and reconfiguring her self, remembering she too was silenced by 'loudmouthed English people'. As her name implies, she is *anachronistic* – out of step with her environment, against time, a cosmopolitan time traveller who refuses to accept hegemony's status quo.

Anna also means Grace (a heartfelt titular palimpsest), an ethical intervention against globalisation's flow, unlike the computerised acronym GRACE which outmoded her telephonist mother. Anna's cardiogrammatological turn away from her London employer's ostracism of others encourages a renegotiation of her Scottish cosmopolitanism.

To empathise involves feeling others' pain; like Anna's pre-awakened numbness, in *Winter* Sophia 'had been feeling nothing for some time now. Refugees in the sea. Children in ambulances [. . .]. Dust-covered dead people [. . .]. People beaten up and tortured in cells. Nothing [. . .]. But now she sat at her table on Christmas Eve and felt pain play through her' (Smith 2017: 29–30). Both experience cardiogrammatological shifts from zombification to empathy, while *Autumn*'s Daniel too sees 'The world's sadness' (Smith 2016: 13): dreaming about 2015's drowned refugees trying to reach Europe, 'He looks along the shore at the dark line of the tide-dumped dead' (Smith 2016: 12). Like Bauman's distinction between globalisation's affluent 'tourists' and impoverished 'vagabonds' (Bauman 2000: 92), Smith writes, 'These people are human, like the ones on the shore, but these are alive. They're under parasols. They are holidaying up the shore from the dead' (Smith 2016: 12). Liminal beaches serve sun-seekers and dead asylum seekers. Exiled Daniel embodies wounded cosmopolitanism: stooped with age, 'Like he carried the weight of the world on his back' (Smith 2016: 56), while Brexit Britain attacks communitarian principles as anachronistically outmoded – '*You're time's over*' (Smith 2016: 112). Smith's cosmopolitan empathy stems from a wider Scottish geopolitics whose direction of travel diverges from a Britishness itself forged upon obsolete imperial jingoism. Though empathy is painful, cosmopolitan solidarity is vital to challenge inhumane individualism. Otherwise, neoliberalism and neoconservativism produce 'political zombies', who are 'politically myopic and intellectually shallow', and thus devoid of the 'intrinsic acumen to question and to think critically outside the liberal, capitalist, ideological box' (Navarro 2012: 389). Concomitantly, Smith's work sees and dis-illusions.

Her coalescence of margins – Scotland, asylum seekers and characters like Anna, Brooke, Elisabeth, Daniel and Lux – epitomises cosmopolitanism, since 'Refugees, peoples of the diaspora, and migrants and exiles represent the spirit of the cosmopolitical community' (Breckenridge et al. 2002: 6). For Homi K. Bhabha, such brokenness in the face of capitalist hostility translates into an

empathetic community that 'emerges from the world of migrant boarding-houses and the habitations of national and diasporic minorities. Julia Kristeva [. . .] called it wounded cosmopolitanism', but 'it is better described as a vernacular cosmopolitanism which measures global progress from the minoritarian perspective' (Bhabha 2010 [1994]: xvi). Such 'wounded', 'vernacular', 'minoritarian' cosmopolitanism epitomises Smith's Scottish fiction, and also resonates with Gardiner's Deleuzian view of Scotland's 'minor literature' dynamically 'becoming' a resistant force against 'static assumptions'. Anna's Scottish vernacular 'funny accent' interjects heteroglossia's becoming; imagining better, Smith's work rebukes Britishness and evokes cosmopolitical Scotland's Kristevan new ethics.

Anna is 'broke' (Smith 2011: 52): quitting her job causes a financial fissure that aligns her cosmopolitically with Breckenridge et al.'s anachronistic 'victims of modernity' cited earlier. Brooke (sounding like broke) interprets this 'Like, broken?' (Smith 2016: 52), while 'Anna sat on a wall' (Smith 2016: 58). Anna's Humpty Dumpty-like fragile existence nevertheless signifies wounded cosmopolitanism: a shattered eggshell multiplies empathy's interstitial crevices. Her minoritarian solidarity equates with Smith's advocacy of cosmopolitan Scottishness: both align with the view of 'precisely someone who is able to live – ethically, culturally – *in both the global and the local at the same time*' and, as such, 'we may be able to think of cosmopolitanism as a sort of "ethical glocalism"' (Tomlinson 2008 [1999]: 195, 196), which accords with O'Neill's, Bell's and McCrone's aforementioned views. Cosmopolitanism/nationalism are not mutually exclusive, then, but an ethical fusion that encompasses nationhood alongside global citizenship. Ulrich Beck concurs, 'it would be a fatal error to conclude that cosmopolitan empathy is replacing national empathy. Instead, they permeate, enhance, transform and colour each other' (Beck 2006 [2004]: 6). Anna's empathetic fissure, like Miles's and Daniel's rooms, accommodates others.

Like Dinshaw's queer temporality interrogating linear dominance, Jago Morrison believes 'If time is thought of not as a tangibly existing "thing" but as a system of perception [. . .] then like any other such system it could be open to refutation' (Morrison 2003: 32). *TBFT*, *Autumn* and *Winter* repudiate globalised time: Smith refutes hegemonic 'perception' by repositioning her characters outside of spatiotemporal strictures. External clock time is reset to favour humanity's inner chronograph: '*Say that your own heart's keeping time for mine*' (Smith 2011: 183), amplifying connectivity and love

over capitalist individualism. Characters' streams of consciousness queerly navigate time: Anna 'looked at her watch' (Smith 2011: 50); 'Mark sat on the [clock-like] circular bench' (Smith 2011: 172) and 'looked at his watch' (Smith 2011: 174): almost 60, he embodies a timepiece. Relativity condenses space-time: his mother 'long dead', it is as though 'it was last Thursday that it happened' (Smith 2011: 185), just as 'Time travel *is* real, Daniel said. We do it all the time. Moment to moment, minute to minute' (Smith 2016: 175), while Sophia ponders 'Could you stop time playing itself through you?', or Iris observes, 'A long time in your life, a short time in mine . . . That's life, and time, for you' (Smith 2017: 136, 169). Smith's textual *memento mori* oscillate between past, present and future, urging us '*not to waste the time, our time, when we have it*' (Smith 2016: 190).

Morrison notes, 'it is possible to see how writers easily find themselves in a position of resistance to the dominant culture of time' (Morrison 2003: 29) regarding twentieth-century temporal standardisation. Similarly, contemporary writers acutely respond to globalisation's 'intense phase of time-space compression' (Harvey 2011 [1990]: 5). By 'Accelerating turnover time in production', David Harvey argues globalisation generates rapid workforce shifts regarding capital flow, de-skilling and re-skilling, since 'Firms sub-contract or resort to flexible hiring practices' (Harvey 2011: 6). Such reorganised labour and modes of production enable corporations to shift to 'flexible accumulation', so 'bypassing the rigidities of Fordism and accelerating turnover time' (Harvey 2011: 5), maximising profits and workforce insecurity. Smith charts that temporal immobilisation through her devalued but empathetic others; *Autumn*'s Elisabeth 'remembers that probably pretty soon she won't have any job to give any lecture in anyway' and simultaneously 'thinks about the students she taught who graduate this week to all that debt, and now to a future in the past' (Smith 2016: 132). Elisabeth, whose present mirrors Kristeva's abeyance, recognises the future generation's anachronic immobilisation. Such spatiotemporal anxieties are exposed from the marginalised position of characters like Anna, Elisabeth and Lux. Experiencing Harvey's workforce insecurity, these immobilised foreigners within – including their aforementioned associations as Scottish composites – nevertheless embody cosmopolitical resistance and grassroots solidarity with others.

Lux's foreign abeyance equips her with a cosmopolitical insight to Christmas's 'empty gestural' fleeting superficiality in a time beset with conflict, questioning 'Why would you not work all the time for peace on earth and goodwill' (Smith 2017: 195–6). Her 'intrusion'

into Art's family Christmas helps to heal its rifts: her discussion of Shakespeare's *Cymbeline*, where 'the people in the play are living in the same world but separately from each other, like their worlds have somehow become disjointed or broken off each other's worlds' (Smith 2017: 201) resonates with the Cleves's fragmented household and, in turn, comments upon Brexit Britain. As Sophia concedes, it is a 'play about a kingdom subsumed in chaos, lies, powermongering, division and a great deal of poisoning and self-poisoning' (Smith 2017: 200). By inviting the foreigner within their home, familial isolation is overcome, just as *Winter* textually mediates between current social hostilities. Intertextualising Dickens's *A Christmas Carol*, Scrooge's temporal haunting (past, present, future) equates with Sophia's anachronic flight when the 'village church bell rang midnight' (Smith 2017: 105) on several separate occasions. Queering temporality is vital in Smith's texts as a means of awakening her characters from globalised zombification; she refers to seventeenth-century scientist Johanne Kepler, who 'thought that truth and time are sort of related' (Smith 2017: 96). In Brexit's and Trump's post-truth societies, Smith's fiction interrupts global time and considers how truth is re-presented: in *Autumn* Wendy despairs 'how those liars have let this happen. [. . .] I'm tired of lying governments. I'm tired of people not caring whether they're being lied to anymore' (Smith 2016: 57). In the interstices of fiction and truth, Smith's texts challenge her reader, interrogating narratives that demonise the foreigner within and urging an accommodation of others.

Regarding Brexit, Smith ponders, 'what happens culturally when something is built on a lie' (Laing 2016), questioning the disingenuous targeting of voters who feel disenfranchised by globalisation: 'The power of the lie, Daniel said. Always seductive to the powerless' (Smith 2016: 114). Predictably, however, 'the haves and the have nots stayed the same' (Smith 2016: 61). Far from an anti-elitist redistribution of wealth, Brexit's and Trump's seductive populism resemble neoconservative ruses, combining 'elite class and business interests intent on restoring their class power, on the one hand, and an electoral base among the "moral majority" of the disaffected white working class on the other' (Harvey 2009 [2005]: 84). Rather than be deluded by narrative subterfuge, Smith advocates grassroots cosmopolitical resistance, since 'whoever makes up the story makes up the world [. . .]. So always try to welcome people into the home of your story' (Smith 2016: 119). To scrutinise Brexit's discursive verisimilitude, her fiction accommodates a counter-narrative of empathetic hospitality: just as Anna earlier empathises with refugees'

search for home, Daniel urges, 'always give your characters the same benefit of the doubt you'd welcome when it comes to yourself [. . .]. Always give them a home' (Smith 2016: 120). Smith's house of fiction urges cosmopolitan conviviality (Gilroy 2004) for those socio-politically dispossessed. Though Daniel advocates accommodating others, hegemonic narratives dispossess: our House of Commons has cut funding 'for the houses where the kids who arrive here as asylum seekers have been staying', alongside 'scrapping [. . .] the Minister for Refugees' (Smith 2016: 254–5), signalling Britain's rejection of refuge.

*TBFT*'s Miles seeks refuge in the Lee's spare room to escape the prejudice views expressed at their dinner party; he is as unwelcome as those seeking shelter in the nation's home, just as jobless Anna, precariously employed Elisabeth and immigrant Lux suffer the insecurities of an inhospitable London home. Yet the Lee's home is a performative veneer: 'This beautiful, perfectly done-out, perfectly dulled house' (Smith 2011: 4), like 'a theatre performance' (Smith 2011: 27) set. Its 'c18th door' (transmogrified, for media publicity, to a seventeenth-century door) and 'Scottish river pebbles' (Smith 2011: 18) affirms Harvey's 'irony [with globalisation] is that tradition is now often preserved by being commodified and marketed as such' (Harvey 2011: 15); historical and geographical heritage are relocated and cannibalised. This echoes 'the fabric of traditional working-class communities being taken over by an urban gentry' (Harvey 2011: 15), coalescing displaced Scottish pebbles with Anna's relocation 'a long time ago' (Smith 2011: 30). Arguably, she signifies Scottish economic migration during Thatcherite deindustrialisation, where its geopolitical 'fabric' is decimated. Both pebbles and populace are deracinated and relocated to an often-unwelcoming home, which is explored further in *Autumn*'s and *Winter*'s exposure of Brexit hostilities. Despite appearances, the Lee's home is a 'hateful place' (Smith 2011: 29), where 'It's lucky we can all sit in different rooms' (Smith 2011: 155) and Eric moves out. Lee infers shelter from the elements, yet their gentrified property, metaphorical of inhospitable Britain, implies an impermanent lease.

*TBFT* anticipates the divisions wrought by Brexit and Trump: neoliberalism's paradoxical 'free market' allows neoconservative dinner party guest, aptly named Rich, to celebrate 'a more, or less borderless world', while stringently policing the borders of intellectual thought, nation, sexuality, race and gender against alterity, believing 'everywhere needs some defence against people coming and overrunning the place with their terrorism or their deficiencies' in response to

Brooke's interjection, 'Except for the borders where they check your passport for hours' (Smith 2011: 146). Although British citizens, Brooke's family are unwelcome foreigners within, while *Autumn*'s Elisabeth witnesses a cottage vandalised with 'black paint and the words GO and HOME' (Smith 2016: 53), since 'This isn't Europe [. . .]. Go back to Europe' (Smith 2016: 130). By *Winter* Brexit's hostilities bite, exposing the 'terrible divisions in our country': echoing Trump's administration and an increasing appetite for fascism across parts of Europe, the 'world order was changing', fuelled by opportunistic 'people in power [who] were self-servers' (Smith 2017: 56). During *TBFT*'s dinner party Brooke whistles 'Somewhere Over the Rainbow' from Victor Fleming's *The Wizard of Oz*, and Anna puns, 'Somewhere over the rainblow' (Smith 2011: 4, 61), juxtaposing Fleming's metaphor for imaginative flight with tortured refugees. For Brooke's father, the song's 'octave leap [. . .] makes the word *somewhere* leap right into the sky, out of hopelessness to hope' (Smith 2011: 138): creative rainbows must overcome rainblows. Like *Oz*'s 'no place like home', Smith's texts locate home where the heart is, a vital organ to treasure against those Riches whose refusal of houseroom to others predicts Brexit – leaving them no place.

Blinded by Brexit's divisive rhetoric, 'Not to see what's happening right in front of our eyes' (Smith 2016: 175) is all too common. *TBFT*, *Autumn* and *Winter* anticipate Conservative rule again disenfranchising others, including Scotland, awakening a nation to resist such inevitability. *TBFT*'s intrinsic and barely suppressed antagonisms emerge fully articulated in *Autumn*'s post-Brexit dissonance which in *Winter* is attributed to Thatcher's legacy: 'the effect of forty years of political selfishness' (Smith 2017: 55). Theresa May's, 'If you believe you are a citizen of the world, you're a citizen of nowhere' (May 2016) ignores Jo Cox's assassination by a British neo-Nazi during the EU referendum: 'Someone killed an MP' but 'it's old news now' (Smith 2016: 38). May's speech becomes *Winter*'s epigraph and Iris, who has been in Greece helping refugees, rails, 'tell them what it's like to come back here, when you're a citizen of the world who's been working with all the other citizens of the world, to be told you're a citizen of nowhere, to hear that the world's been equated with nowhere by a British Prime Minister' (Smith 2017: 233). A Scottish cosmopolitan writer, Smith's indignity towards British jingoistic exiling of unpatriotic others foregrounds SNP politician Tasmina Ahmed-Sheikh (an embodiment of Scotland's post-devolution heterogeneity). Tory MP Nicholas Soames barks at Ahmed-Sheikh when she

'question[s] a British Prime Minister's show of friendly demeanour and repeated proclamation of *special relationship* with an American President, who also has a habit of likening women to dogs' (Smith 2017: 89–90), as Smith accentuates Britain and America's neoconservative alignment. Like the misogynistic suppression of Ahmed-Sheikh, during the Scottish independence referendum right-wing media vilified Scotland's First Minister as 'the most dangerous woman in Britain'. Her desire to build an outward-looking nation *within* Europe regarded as a foreign threat to British hegemony, Scotland's cosmopolitan voice is silenced.

With continued misogynistic hostility towards Scotland post-Brexit 'There were so many complaints from Scots about the headline "Nicola Sturgeon is a liar and a traitor – off with her head!" in yesterday's *Telegraph*, it later changed it to "Nicola Sturgeon – another treacherous queen of Scots – has miscalculated"' (Burns 2017). Apart from antagonistic references to Mary, Queen of Scots and Sturgeon's *treason*, inferring that Scotland's nationhood is a foreigner within, such rhetorical violence (beheading) against Sturgeon's triggering of another independence referendum is further reckless given Cox's aforesaid slaying. Almost anticipatory, Elisabeth fears 'Savagery's coming. Heads are going to roll' (Smith 2016: 213), in *Autumn*'s call to cosmopolitical awakening, and *Winter*'s Sophia converses with the 'disembodied head [. . .] of a child' (Smith 2017: 7), symbolising global brutality. While Scottish women writers like Smith are 'redrawing the literary map of Scotland', since 'their work *cuts across* patriarchal constructions' (Christianson and Lumsden 2000: 1, 2), Sturgeon remaps the nation's trajectory away from masculinist Caledonian paradigms and towards cosmopolitical heterogeneity, unlike the Conservative Prime Minister's apparent endorsement of Britain's phallogocentric status quo.

Smith's cosmopolitical consciousness against globalised callousness charts an ethical outlook that resonates with Scotland's post-devolutionary interstitial navigation towards 'nationalism and cosmopolitanism' (Bell 2004: 136). Incorporating marginalised citizens, 'Scottishness' comprises a 'forward-looking, heterogeneous identity' (Carruthers, Goldie and Renfrew 2004: 15). However, Berthold Schoene argues that 'Scotland's assumed moral superiority as a victim of historical circumstance must not be permitted to persist uninterrogated' (Schoene 2007: 2), citing its complicity in the British imperial project as evidence. Bell also considers this problematic relationship but believes that postcolonial readings of Scotland can apply (Bell 2004: 142–5). While one must be wary of negating Scotland's

active imperial role to passive colonised victimhood, it is more help-ful to link nationhood to economic and gendered others rather than homogenise Scotland. Like Gardiner's view of Scotland's postcolonial 'minor literature', those already marginalised are further disenfran-chised by Empire rather than benefactors.

Scotland ought to be considered in light of postcolonialisms, much like feminisms' plurality, which incorporates global diversities including race, ethnicity, sexuality and social class. It is too reductive to denounce Scotland's 'assumed moral superiority' since many of those multiply marginalised citizens *have* been victims of history and resonate with Gramsci's subaltern. It is not to perpetuate a Scotland/ England binary that Smith awakens Anna's Scottishness or empha-sises the nation's resistance to Brexit in *Autumn* or links *Winter*'s Lux (a foreigner within) with Scotland, but to remind her reader that Scotland *is* other and, in increasingly neoconservative times, its ethi-cal alterity offers a vital interrogative voice. Scottish literature and geopolitics encourages cosmopolitan '*inter*-dependence' (Carruthers, Goldie and Renfrew 2004: 14), signalling it is not parochial but, instead, looks outwards to its position within a global world, just as Craig advocates that Scotland's hybridity exemplifies 'that national-isms and national cultures are always multiple' (Craig 2004: 250). Anna's exile or Elisabeth's or Lux's surnames emphasise a hybrid outlook as well as a critical exegesis of Anglo-hegemonic dominance as *the* valid British culture, which is accentuated in Anna's affinity with Brooke as an English outsider, and English foreigner within, Elisabeth's, affinity with European Daniel. Anna does not maintain national division, but sees Brooke as a kindred spirit, symbolising cosmopolitical Scotland, further reinforced in *Autumn* and *Winter*'s recognition of its vote to remain within Europe.

However, Schoene berates the SNP for 'perpetuat[ing] the myth of the Scots being somehow a better people, definitely more trust-worthy than the English, their political decision-making informed by a moral fibre' (Schoene 2008: 72) and cites Scottish New Labour politicians as evidence of untrustworthy Scots. Establishing a moral Scots/immoral English binary that Scottish writers like Smith would contest, this rejects post-devolution's cosmopolitanism and reduces neoliberal New Labour to essentialist Scottish nativism, inferring that, therefore, all Scots are no better. Apparently, 'as long as Scots can occupy some of the highest offices in British politics, it is errone-ous to suggest that within the United Kingdom they have no voice and are deprived of power' (Schoene 2008: 74). As the aforemen-tioned Tory surge indicates, neoliberals and neoconservatives *do*

exist, but are not representative of *all* Scots: androcentric elites cannot provide a voice for subaltern others. Far from feeling empowered, Smith's *Hotel World* attacks 'Blair's Britain' as 'MASSIVELY MORE UNEQUAL THAN 20 YEARS AGO' (Smith 2001: 45, 177). Her Scottish cosmopolitical consciousness rejects neoliberalism.

Similarly, the Yes campaign is not an exercise in national fervour but, rather, strives to dismantle a top-down geopolitical status quo – much like Hanafin's aforementioned grassroots cosmopolitical solidarity – both within and without Scotland's borders. The loss of all but one Scottish Labour MP in 2015's general election is surely a resounding response to any misguided view that neoliberals provide a voice for Scotland's populace, while their slight recovery in 2017's general election is attributed to Corbynite Labour's socialist rebranding. In Smith's imaginative commentary upon British society, Anna Key's vernacular cosmopolitanism dialogically articulates Scotland's voice: she calls time on feeling dispossessed and displaced in London by reconnecting with her roots and empathising with asylum seekers. Like McCrone's, Tomlinson's and Beck's glocal views of cosmopolitanism, Kok-Chor Tan considers that a 'cosmopolitan can as well defend national self-determination if she believes that the ideal of equal and impartial concern for individuals is best realized by respecting their claims to national sovereignty', so that 'there is no necessary conflict between moral cosmopolitanism and the idea of national self-determination' (Tan 2006 [2004]: 94). Like Tan's 'moral cosmopolitanism', Anna's embodiment of Scottish cosmopolitanism evidences an awakening national consciousness alongside an ethical global empathy, just as Scotland's desire for 'self-determination' does not mirror British neo-imperial nationalism but, rather, seeks to challenge globalisation's immobilisation of others and offer cosmopolitical connection.

A queer Scottish woman writer, Smith exposes globalisation's hyper-reality and emphasises the political impetus of intellectual creativity as a remedy for zombification. Alert to Scottish fiction's dialogical cosmopolitan consciousness earlier as a 'wide-open book', it is her vehicle for solidarity: Daniel informs Elisabeth, 'Always be reading something [. . .]. How else will we read the world?' (Smith 2016: 68), or *TBFT* alludes to Sophie and Hans Scholl's resistance to the Hitler Youth sparked by reading a banned book. Though 'the Nazis cut their heads off' (Smith 2011: 153) for accessing alternative discourses, Smith insists that reading, creativity and critical thinking are vital defences against post-truth silencing: 'The fact is, imagine' and 'Imagine if all the civilizations in the past had not known to have

the imagination to look up at the sun and the moon and the stars and work out that things were connected [. . .] to time' (Smith 2011: 355). To avoid Bauman's immobilised despair, imaginative capacity encourages dynamic mobility, equipped with the anachronic ability to see beyond hegemonic society's simulacra. Against Nazi ideology, the Scholl's act of resistant reading is vital 'stellar work, to try to change things, make it possible for people to think, I mean differently' (Smith 2011: 153), so interrogating the self-serving narratives of power. Brooke asks 'what is the point of a book, I mean the kinds that tell stories?' and Miles responds 'Think how quiet a book is on a shelf [. . .]. Then think what happens when you open it' (Smith 2011: 345). Initially 'quiet', when read, literature articulates a heteroglossic intervention against 'the end of dialogue' (Smith 2016: 112).

Smith's Scottish cosmopolitan literature offers an alternative vision of ethical hope: though all too 'Easy to go to the bad [. . .] I'm always much more interested in things going to the good' (Smith 2011: 142). It is the foreigner within who emanates curative empathetic cosmopolitanism: when visiting comatose Daniel, Elisabeth worries about the post-Brexit citizenship rights of carers, realising that 'she hasn't so far encountered a single care assistant who isn't from somewhere else in the world' (Smith 2016: 111). Threatened with deportation, these *carers* fulfil vital employment needs, as well as symbolising an empathetic capacity to heal.

*TBFT*, *Autumn* and *Winter*, like Tambling's anachronic love and Royle's cardiogrammatology, intellectually awaken: 'throwing [. . .] words' like 'little rocks wrapped as presents' (Smith 2011: 353), Smith's 'little'/minor Scottish literature debunks 'lying governments' (Smith 2016: 56). 'Singing revolution' (Smith 2011: 39), she interrupts global rotation. Queer spatiotemporal interrogation of contemporaneity is, like winter's stasis, 'an exercise in remembering how to still yourself then how to come pliantly back to life again' (Smith 2017: 66): taking time to critically reflect, her texts defy Bauman's immobilisation by offering a cosmopolitical response to a hostile climate.

## References

Bauman, Zygmunt [1998] (2000), *Globalization: The Human Consequences*, Cambridge: Polity Press.
Beck, Ulrich [2004] (2006), *The Cosmopolitan Vision*, Cambridge: Polity Press.

Bell, Eleanor (2004), *Questioning Scotland: Literature, Nationalism, Post-modernism*, Hampshire and New York: Palgrave.

Bhabha, Homi K. [1994] (2010), *The Location of Culture*, London and New York: Routledge.

Braidotti, Rosi (2013), 'Becoming-world', in Rosi Braidotti, Patrick Hanafin and Bolette Blaagaard (eds), *After Cosmopolitanism*, London and New York: Routledge.

Braidotti, Rosi, Patrick Hanafin and Bolette Blaagaard (eds) (2013), *After Cosmopolitanism*, London and New York: Routledge.

Breckenridge, Carol A, Sheldon Pollock, Homi K. Bhabha and Dipesh Chakrabarty (2002), *Cosmopolitanism*, Durham, NC and London: Duke University Press.

Burns, Janice (2017), 'English Newspaper's Call for Nicola Sturgeon's Beheading Sparks Anger', *The National*, March 2017. http://www.thenational.scot/news/15158795.English_newspaper_s_call_for_Nicola_Sturgeon_s_beheading_sparks_anger/ (accessed 6 April 2017).

Carruthers, Gerard, David Goldie and Alastair Renfrew (eds) (2004), *Beyond Scotland: New Contexts for Twentieth-century Scottish Literature*, Amsterdam and New York: Rodopi.

Christianson, Aileen and Alison Lumsden (2000), *Contemporary Scottish Women Writers*, Edinburgh: Edinburgh University Press.

Craig, Cairns, [1999] (2002), *The Modern Scottish Novel: Narrative and the National Imagination*, Edinburgh: Edinburgh University Press.

Craig, Cairns (2004), 'Scotland and hybridity', in Gerard Carruthers, David Goldie and Alastair Renfrew (eds), *Beyond Scotland: New Contexts for Twentieth-century Scottish Literature*, Amsterdam and New York: Rodopi.

Currie, Mark (2013), 'Ali Smith and the philosophy of grammar', in Monica Germanà and Emily Horton (eds), *Ali Smith*, London and New York: Bloomsbury.

Derrida, Jacques [1993] (1994), *Specters of Marx: The State of the Debt, the Work of Mourning and the New International*, New York and London: Routledge.

Devine, T. M. [1999] (2006), *The Scottish Nation, 1700–2007*, London and New York: Penguin.

Dinshaw, Carolyn, Lee Edelman, Roderick A. Ferguson and Carla Freccero (2007), 'Theorizing queer temporalities: a roundtable discussion', *GLQ: A Journal of Lesbian and Gay Studies*, 13.2–3: 177–95.

Gardiner, Michael (2007), 'Literature, theory, politics: devolution as iteration', in Berthold Schoene (ed.), *The Edinburgh Companion to Contemporary Scottish Literature*, Edinburgh: Edinburgh University Press.

Genette, Gerard [1972] (1983), *Narrative Discourse: An Essay in Method*, New York: Cornell University Press.

Germanà, Monica [2010] (2013), *Scottish Women's Gothic and Fantastic Writing: Fiction Since 1978*, Edinburgh: Edinburgh University Press.

Germanà, Monica and Emily Horton (eds) (2013), *Ali Smith*, London and New York: Bloomsbury.

Gilroy, Paul (2004), *After Empire: Melancholia or Convivial Culture?* London and New York: Routledge.

Gilroy, Paul (2013), 'Postcolonialism and cosmopolitanism: towards a worldly understanding of fascism and Europe's colonial crimes', in Rosi Braidotti, Patrick Hanafin and Bolette Blaagaard (eds), *After Cosmopolitanism*, London and New York: Routledge.

Hanafin, Patrick (2013), 'A cosmopolitics of singularities: rights and the thinking of other worlds', in Rosi Braidotti, Patrick Hanafin and Bolette Blaagaard (eds), *After Cosmopolitanism*, London and New York: Routledge.

Harvey, David [2005] (2009), *A Brief History of Neoliberalism*, Oxford and New York: Oxford University Press.

Harvey, David (2011), 'Time-space compression and the postmodern condition', in Liam Connell and Nicky Marsh (eds), *Literature and Globalization: A Reader*, London and New York: Routledge.

Kristeva, Julia (1981), 'Women's time', *Signs* 7:1, Autumn.

Kristeva, Julia (1991), *Strangers to Ourselves*, trans. Leon S. Roudiez, New York: Columbia University Press.

Laing, Olivia (2016), 'Ali Smith: "It's a pivotal moment . . . a question of what happens culturally when something is built on a lie"', *The Observer*, October 2016. https://www.theguardian.com/books/2016/oct/16/ali-smith-autumn-interview-how-can-we-live-ina-world-and-not-put-a-hand-across-a-divide-brexit-profu (accessed 6 April 2017).

McCrone, David [1992] (2001), *Understanding Scotland: The Sociology of a Nation*, London and New York: Routledge.

May, Theresa (2017), 'Theresa May's conference speech in full', *The Telegraph*, October 2016. http://www.telegraph.co.uk/news/2016/10/05/theresa-mays-conference-speech-in-full/ (accessed 6 April 2017).

Morrison, Jago (2003), *Contemporary Fiction*, London and New York: Routledge.

Navarro, Armando (2012), *Global Capitalist Crisis and the Second Great Depression: Egalitarian Systematic Models for Change*, Plymouth: Lexington Books.

O'Neill, Michael (2004), *Devolution and British Politics*, Harlow: Pearson Longman.

Royle, Nicholas (2003), *The Uncanny*, Manchester: Manchester University Press.

Schoene, Berthold (ed.) (2007), *The Edinburgh Companion to Contemporary Scottish Literature*, Edinburgh: Edinburgh University Press.

Schoene, Berthold (2008), 'Cosmopolitan Scots', *Scottish Studies Review* 9:2, Autumn.

Smith, Ali [2001] (2002), *Hotel World*, London: Penguin Group.

Smith, Ali (2009), 'Why interview writers', *Scottish Review of Books* 5:2. https://www.scottishreviewofbooks.org/2009/09/why-interview-writers/ (accessed 6 April 2017).

Smith, Ali (2011), *There But For The*, London: Hamish Hamilton.

Smith, Ali (2016), *Autumn*, London: Hamish Hamilton.

Smith, Ali (2017), *Winter*, London: Hamish Hamilton.

Tambling, Jeremy (2010), *On Anachronism*, Manchester and New York: Manchester University Press.

Tan, Kok-Chor [2004] (2006), *Justice without Borders: Cosmopolitanism, Nationalism, Patriotism*, Cambridge: Cambridge University Press.

Tomlinson, John [1999] (2008), *Globalization and Culture*, Cambridge: Polity.

# Democracy and the Indyref Novel

*Scott Hames*

Like Scotland, slightly
synthetic and in a state
of indecision.
Stewart Sanderson, 'Aiblins'
(Ailes and Paterson 2016: 19)

Whether viewed as an exciting pilot episode or a gripping series finale, the independence referendum of 2014 is the dominant showpiece of contemporary Scotland. Not quite 'over', its endings, beginnings and deferrals colour every aspect of cultural and political life and dominate the horizon of recent national history (and projected futurity). This chapter explores how the key political event of the past decade has been novelised, and how the rhetorical and experiential qualities of 'indyref' have been registered in Scottish fiction.[1] The novels I will discuss are (in order of publication) Craig A. Smith's *The Mile* (2013), Effie Deans's *An Indyref Romance: Harmony and Dissonance* (2015), Allan Cameron's *Cinico; Travels with a Good Professor at the Time of the Scottish Referendum* (2017), Mary McCabe's *Two Closes and a Referendum* (2017) and Kirstin Innes's *Scabby Queen* (2020). The first and last of these books have a degree of distance from September 2014. *The Mile* was written during indyref's long phony war (2011–13), just prior to the events it imagines, while *Scabby Queen* employs a clear narrative remove from the fervours of indyref, whose central character moves through a broader world of British and European radical politics. (Indyref is only one political drama among several in the life and myth of Clio Campbell.)

Partly in the spirit of aggregation a referendum involves – and, as I will argue, the vision of political community it tends to enforce and reproduce – I have clumped these novels into two rough groups. I deal first with 'Indyref Novels' that feel immersed in the passions and

slogans of 2014 (*The Mile, An Indyref Romance, Two Closes and a Referendum*), and second with more distanced and ironical 'Fictions of Indyref' that treat the 'festival of democracy' more as a play of narrative, propaganda and self-performance (*Cinico, Scabby Queen*). Novels in these two camps manifest distinct cultures of argument and rationalisation and, through them, disparate models of democratic community and participation. While this approach might imply a certain hierarchy – 'Fictions of Indyref' enjoying a degree of aesthetic autonomy from the arguments of 2014 – I will conclude by suggesting that the less knowing and 'literary' treatments of indyref may in fact be truer to its legacies to date. In a sense, being able to detach yourself from the ceaseless discursive profusion of indyref suggests you were never truly enmeshed in it, and therefore not a full 'participant' in the textual event, at once closed and open, highly tribal and highly diffuse. This underscores the shallow modes of political agency and imagination furnished by the plebiscite itself, and its in-built tendencies towards massifying, alienated speech. I view indyref as a social-discursive phenomenon busy with chatter, groupness and defensive rationalisation, with few opportunities (or incentives) to foster consensus, recognition or deliberation. These features of indyref erode the traditional liberal rubrics through which the novel has been valorised as a democratic form, but also reveal the emerging contours (and limits) of online politics and participation, and their centrality to Scotland's constitutional debate.

## Indyref as Discourse and Topos

In *Mrs Dalloway*, Virginia Woolf has a middle-aged character muse on 'the power which adds the supreme flavour to existence – the power of taking hold of experience, of turning it round, slowly, in the light' (Woolf 2000: 86). This controlled and illuminating gaze is not possible in making sense of indyref. It is not only that indyref-as-experience is too recent, contested and unsettled to withstand sober and distanced contemplation: it is also too slippery, copious and various considered as a discursive phenomenon. Vectored by mass media and social media, indyref-as-event was highly dispersed and difficult to localise, more a word-cloud smeared across 2012–14 (and beyond) than a single collective decision fixed to a date on the calendar. In what follows, I will treat indyref less as a discrete historical moment or policy choice and more of a nebulous societal 'process' and topical milieu, manifested (and becoming socially real) through

torrents of public argument, writing, chatter, retweeting, mediation. In this sense 'indyref' names a primarily discursive and rhetorical phenomenon – a Great Debate – around whose central matrix various subcultures, experiences, identities and meanings took shape; but all determined in the last instance by the aggregative and discursive frame of the referendum itself.

It is undoubtedly the case that people had intense and meaningful experiences of indyref separable from 'the campaigns', but those experiences were yoked tightly to a shifting rhetorical nexus, constantly updated and revised via cascades of media, reportage and commentary, so that reconstructing that experience comes perilously close to simply citing and replaying stock arguments. This is a key problem in fiction responding to (and usually reproducing) the weekly tit for tat of the main campaigns: it seems impossible to extract any 'supreme flavour' from this material without laboriously re-chewing trite slogans. At one level, this difficulty stems from the historical urgency of most indyref writing, poised to take an active role in the event (or the shaping of its memory), rather than holding it up to the light of contemplation. Despite the still-bleeding rawness of these events and debates, they feel curiously stale in nearly all these novels. We encounter the familiar claims and counter-arguments as a closed system at some remove from the reading moment, as though peering through the glass of a 2014 terrarium separated from our living concerns. Whereas indyref was often experienced as an intense (sometimes joyous, sometimes tense) politicisation of real life, these novels tend to affirm 'the autonomy of the political': the sense that these debates and figures belong to a realm, industry and profession only loosely tethered to the world of ordinary citizens, whose role is close to that of spectators or cheerleaders.[2] Invited to re-enter the conscious historicity of 2014, the reader of indyref fiction often finds themself scrabbling against the terrarium glass, struggling to gain purchase on something 'beneath' the polished surfaces and slogans, and to inhabit the Great Debate on terms separable from its own didacticism. This is just one novelistic challenge presented by the topic.

## I. The Great Debate: indyref novels

To briefly introduce the novels, Craig A. Smith's *The Mile* is structured around a pub crawl and search narrative the week before the vote, as a cast of strongly typified characters pinball around Edinburgh in a sprawling boozy conversation occasioned by a stag party. The jacket blurb promises 'three friends: a nationalist, a unionist

and a couldnae-care-lesser', establishing Ian, Euan and Stuart as a kind of focus group of representative political types. The more memorable characters are clear national symbols, especially a 'mysterious ninety-five-year-old man in red tartan trousers' (says the jacket blurb) named Jock, who is a kind of walking storehouse of Scottishness and patriotic memory. Jock has wandered away from his care home, trailing war stories and empty whisky glasses, and is pursued by young Rosie, a selfless NHS nurse determined to protect him from his own romantic appetites. Jock joins the pub crawl, and the novel becomes a series of bantering vignettes exploring Scottish cultural identity, moving through a series of Edinburgh howffs, subcultures and touristic historical tableaux.

Effie Deans's *An Indyref Romance*, subtitled 'harmony and dissonance', is a courtship novel between Yes-supporting Paul and No-minded Jenny; the latter's mentor is a pro-Union blogger who shares a pseudonym with the book's author. The only No-aligned indyref novel I am aware of, it often feels somewhat dislocated from the adventure and excitement of the other texts. This is historically suggestive in itself: to a large degree, 'indyref' as scene and social phenomena was owned by the Yes side of the argument, and one of the most effective Better Together tactics was simply to discourage interest and involvement (the 'eat your cereal' trope, treating the debate as a nerdy distraction from real life (Better Together 2014)). Of all the novels considered here, Deans's comes closest to naked propaganda, using characters to dramatise arguments from her popular unionist blog.

By contrast, Mary McCabe's *Two Closes and a Referendum* (2017) is a warm social novel exploring the debate as it weaves through the lives of a dozen households based in two Glasgow tenements, a handsome sandstone in Dennistoun and a humbler corporation pebbledash in Barmulloch. This is the most 'democratic' indyref novel to date, grounding the Great Debate in a real and complex sense of community (there is kindness and frost between neighbours, some of whom cook for each other, while others intimidate and racially abuse each other). The novel leans Yes but shows respect for No both at the level of character and temperament.

## Chess pieces and blue skies

Before proceeding with these novels, we need to specify a few special features of the 'actual' indyref they depict. Viewed as an experience we can reconstruct through its artefacts, indyref was largely discourse – claims, citations, narratives, slogans, counter-claims – sluicing back

and forth between two determinate 'sides'. There were clear patterns to be observed in this outpouring: a tidal rhythm of attacks and rebuttals, expert evidence and counter-factuals, dogmatic affirmations and cagy concessions, all typified by repetition, remediation and re-inscription. After a while, the stock arguments took on a life of their own, acquiring a sort of schematic autonomy within the adversarial logic of the debate. Before your interlocutor had finished their sentence – about Nato, about the McCrone Report, about the Barnett formula – you often had a clear sense not of 'what they were saying', but rather 'which of the standard chess pieces they were deploying'. In *Two Closes and a Referendum*, the Yes activist Ewan describes his rhetorical armoury in just these terms: 'A4 sheets go in the Poly-pockets. By this stage of the game I have a leaflet for every major question which has arisen at the door. [. . .] Labour for Indy, Green for Indy, Britain is for the Rich: Scotland Can Be Ours (*Radical Indy*) [. . .] I don't want change (*focused on the fearful*), Polish leaflet, How to Disarm a Nuclear Bomb (*anti-Trident*), Reassuring Pensions letter from the DWP' (McCabe 2017: 63–4). Arguments for restored nationhood are pre-packaged and micro-targeted at defined subgroups, and Ewan quickly learns to see his fellow Glaswegians through this grid.

As in a game of chess, the indyref pieces were separate from the players, and it was usually the powers and limits of the pieces – the stock arguments of the grid – that determined what moves were possible in a given situation. At the level of mass public debate, we can tell the political story of indyref largely through those chess pieces, without concentrating very much on the people wielding and playing them. In *The Mile*, Euan bitterly observes that 'Jock's vote should count for ten, a hundred even [. . .] His wisdom was worth more than some arsehole voting no based on their football team's colours, or some biased news report they'd seen on the telly' (Smith 2013: 158). But in a referendum we tabulate ballots and not voters, their reasons or their wisdom. In this sense the topic is stacked against conventional novelistic treatment of character and motivation, of which more below.

This facet of indyref might be contrasted with the blue-skies image of the vote itself, as an open-ended instance of popular sovereignty and empowerment. Former SNP leader Jim Sillars argued that 'on 18 September, 2014, between the hours of 7 am and 10 pm, absolute sovereign power will lie in the hands of the Scottish people. They have to decide whether to keep it, or give it away to where their minority status makes them permanently powerless and vulnerable' (2014: 3). On the fateful day, the cover of the *Scottish Sun* was an acre of white

space under the headline 'Yes or No. Today Scotland Starts With A Blank Page'. But this empty expanse, and the notion of a sovereign self-writing, was profoundly conditioned by the saturation of discourse that preceded and enabled it. Politically speaking, the decision was much less open-ended than Sillars and the *Sun* image suggest, being a determinate choice between set alternatives the individual voter had little say over (any more than a chess player can innovate a new piece, or change the rules for what pawns can do).[3] The more immediate and interpersonal dimensions of the campaign were certainly extraordinary – the revival of town-hall meetings, strangers speaking to each other in playparks and bus stops, campaigners of all ages making new friends and finding a new sense of purpose and identity through activism – but much of that 'real-world' activity, and the relationships it fostered, clung tightly to the discursive matrix described above. How can this dynamic, and the relationship between pre-ordained rhetorical limits (the grid) and spontaneous social connections (the festival), be rendered novelistic?

These are not new problems, of course. Amanda Anderson's 2016 study *Bleak Liberalism* highlights how the political novel of the nineteenth century registers the limits of democratic politics and liberal culture, awareness of which 'haunts' its most vaunted exemplar texts. Anderson focuses especially on the treatment of argument, as the central 'formal mode in the political novel (typically enacted through political or ideological discussions between characters)', viewed in the context of Victorian novelists' common interest 'in depicting a lived relation to political commitment or belief' (2016: 79). In Anderson's context, the represented dialogue of characters enacting their values in speech – including respect for the values and speech of their interlocutors – is the key means of representing argument as a 'lived relation' between liberal political subjects. Typically, this is not what we find in novels representing indyref (at least thus far). The political debates retailed in these fictions depart from the classic liberal mode in which sincere belief and passionate critique strengthen the basis of political community, even despite surface clashes. What we find instead is a structural detachment of 'politics' from life, and the reproduction of a closed and sovereign galaxy of positions in which characters (and implied readers) are invited to dwell as partisan adherents. In these novels we seldom encounter argument as a dialogic social form which strengthens the democratic culture in which it is conducted and embedded. Instead, we find a style of zero-sum conflict modelled on self-affirming 'bubbles' of affiliation, where the faithful gather to reassert their fixed commitments and mobilise their unifying emotions.

Needless to say, this pattern reflects the rhetorical dynamics of social media, which is where a good deal of indyref 'really happened' and was spectated and re-mediated (a subject for another essay).

### Cultures of rationalisation

Though shadowed by the online #indyref, the set-piece debates of indyref fiction more often reproduce the formats of TV discussion programmes, with their memorised trump cards and crafted applause lines. In place of a culture of *argument*, affirming social bonds even through the experience of contradiction and disagreement, we find more closed and alienating cultures of *rationalisation*, where two characters seem to 'talk past each other', lobbing defensive justifications and iron-clad factoids as clinching moves in the chess game. The repartee may be swift or dazzling, and entertaining in its own way, but both 'sides' invariably cleave to their prior positions, rendered psychologically unassailable to prevent the opponent from scoring a victory. Even in the best of these indyref novels, the labours of rationalisation prove difficult to integrate into satisfactory novelistic experience, tending towards leaflet-speak dialogue and a deadening flatness of true-believing political subjectivity.

In the first group, Indyref Novels, the discursive chatter of 2014 is typically imported wholesale, often at the expense of believable social texture. Take this scene between Paul and Mark in *An Indyref Romance*:

'I think we need a bit more optimism about the future: an alternative to austerity.'

'I'm afraid, you're not going to get rid of poverty by putting a tick in a box.'

'But our oil?'

'It's volatile: the price goes up wildly and falls wildly, and, anyway, Scotland gets the revenue from it already. You can't very well spend it twice.' (Deans 2015: 66–7)

Comment is perhaps unnecessary. A more demotic treatment of this churn is a recurring feature of *The Mile*:

'I don't see the point in breaking up the country. We've got enough to deal with without worrying about the logistics of it all. I mean, what money do we use?'

'It really doesn't matter what the fuck we choose to name our beans Euan' Ian said, 'and anyway, we're keeping the pound. It's in everyone's interests.'

'And what about all the other changes. The Health Service? Defence? Do we get an army?'

'Of course we will, but we'll get rid of Trident first. And we'd save enough to build 20 fucking schools in the process.' (Smith 2013:129)

These and countless similar passages in these novels underscore the alienation of argument as 'lived relation', with characters deploying rhetorical ammunition in which they have very little ownership, palpably regurgitating the reasons of others. (In a sense these talking points 'use' the voices of the characters as a delivery system, quite as much as the characters rely on them as convenient rhetorical firepower.) There is no meaningful working-through of opposed principles and almost no sense of characters meeting on shared ground to grapple with a shared problem. By contrast, Anderson examines a lengthy back-and-forth in Elizabeth Gaskell's *North and South* (1854), concluding:

> In a character-character debate such as this, we find ourselves serially within different argumentative positions, each with a kind of integrity, and each taking on its own authority via what we might call a mode of narrative argument that functions as mediated telling. [. . . This] creates in the reader the experience of hearing contrasting beliefs that are sincerely held and strongly argued, both of them meant to compel a certain acknowledgement and respect, insofar as they resonate with moral values the novel endorses. (Anderson 2016: 13)

These Victorian effects of 'narrative argument [. . .] as mediated telling' operate by establishing a continuity between the political rationality of the characters, that of the narratorial consciousness, and that of the implied reader. Accordingly, characters gain a degree of dignified authority over the shaping and construction of the novel's rhetorical problems, rather than merely exhibiting pre-defined positions within them. By contrast, in indyref novels character-to-character argument usually feels like cut and pasted *journalism* rather than artful 'telling', authenticating indyref-as-discourse at the expense of indyref-as-experience; or perhaps affirming the impossibility of separating the two. Often, characters seem like puppets of an external journalistic-narratorial consciousness: pawns in a Great Debate in which they are the chess pieces rather than the chess players. Of the novels considered here, only *Two Closes* earnestly achieves the more traditional effect Anderson is describing; *Cinico* and *Scabby Queen* engage sceptically with self-righteous certitudes, in ways that undermine (sometimes subtly) the authority of outspoken characters.

It is of course hardly surprising that novels published in 1854 and 2015 should differ in their treatment of dialogue, character and the conduct of political debate. My point is not to measure these indyref fictions against a Victorian benchmark, but to ask what norms of political discourse we can infer from the way argument *is* handled and experienced in these texts. The reification of political debate into canned talking points defines not only the 'content' of indyref arguments in these texts, but the whole texture of public life and democratic engagement they depict, partly reflecting how the referendum constitutes and reproduces political community.

With the exception of *Two Closes and a Referendum*, these novels do not figure the political process as a battle of ideas (still less ideals), premised on a shared commitment to deliberation and coexistence. McCabe's novel is different, and it takes seriously a wide range of characters and viewpoints, from cat-lady pensioners to bullied teenagers, Afghan refugees to a (slightly cartoonish) bigoted Orangewoman. The panorama includes industrious Czech migrants, semi-criminal 'neds', a mixed Scots-Pakistani marriage, and a white, lower-middle-class Glasgow every-family struggling under austerity. These are types but lightly drawn, and with human interest in excess of what they signify. All are unheroic, 'world-maintaining' characters of the kind Lukács admired in Scott's novels, where historical forces are carried by 'the decent and average, rather than the eminent and all-embracing' (1962: 39). Local architecture and social history are prominent in the interstitial world between indyref debates, and the main subplot sees a young couple (Malky and Kirsty, one from each tenement) run away to a derelict Red Road high-rise, where their teenage hopes and fears mingle with the towering ghosts of regeneration past. Many of McCabe's characters bond, change and quarrel over the intensifying debate, but most are wary, mildly sceptical, and don't go on any particular 'journey'. A few are passionate campaign volunteers, some are dutiful water-carriers, other are totally alienated – this novel both 'includes' the so-called 'Missing Scotland' and unsentimentally notices what non-voters occupy their lives with (see Introna 2016).

The key political narrative concerns Ewan and Donald, a gay couple with opposing views on independence. Ewan is younger, more attractive, and a dedicated Yes organiser; Donald is a prosperous gourmand who wishes the debate would go away, and fears that it could destroy their relationship (an unofficial civil partnership he would prefer to formalise, for security's sake). Donald half-heartedly involves himself in the drab Better Together campaign, but mainly walks on indyref

eggshells, and the characters grow gradually apart. There is allegory here, but deftly handled – the more cautious, fearful, No-voting man accepts his role as the 'provider' in an economically unequal relationship, while the more romantic Ewan gets carried away by freedom and possibility and has a heterosexual fling after a National Collective event. The resulting child (and break-up with Donald) puts his own place and identity into question as the novel closes; he has accepted the risks of his passionate choices. It is the only text discussed here that registers real anguish on different sides of the indyref question, as the political becomes personal, with real relationships on the line.

## II. The Big Story: fictions of indyref

The direct overspill of propaganda into dialogue isn't just a problem of 'character' or realism. Although people really did talk in a robotic point-scoring way at times (especially online), a re-description of these stock talking points doesn't offer us a usable *story* of indyref, capable of making a cohesive and meaningful narrative out of innumerable chess-like conversations. The inescapable climax of the process – the outcome of the vote – promises resolution at the level of a result, but that is not sufficient. The journalist-narrator of *Cinico* comments directly on this problem as he warms to his task, following a professorial guide through various corners of Scottish constitutional debate:

> This could become an entertaining little romp. The professor could do the work, and I could do what I do best – chatter away, entertain and seduce the odd woman *en passant*. [. . .] The professional challenge was more concerning. What was the big story? Was I supposed to root around until I came across it by chance, or was I supposed to manufacture it and fit the facts around it? The latter seemed the more likely, but the intellectual effort was not enticing. (Cameron 2017: 29)

The quest or mystery plot of the vote itself – that is, anticipation of the result – cannot adequately organise the broader social-discursive experience of indyref, and so the question of how to 'manufacture' such a resolution arises in each of these books. *Cinico* ironically admits and partly refuses this duty, honouring the narrator's opening pledge of passivity (with a hint of sloth) – 'I came into this world to observe and not to understand, to record and not to persuade' (7). But this stance proves impossible to maintain: the sprawling 'bigness' of the phenomenon and its textual outpourings quickly overwhelms the mimetic impulse, and so 'story' must be imposed – but somewhat

cynically, as a formal and professional necessity, akin to the difference between rationalisation and belief.

*Cinico* (Cameron 2017) is a wry, picaresque study of indyref intended (says the Editor's Preface) to 'examine the whole phenomenon through the eyes of a foreign journalist – from the outside, as it were – [and] give an alternative perspective to the well-rehearsed arguments we remember from these times' (3). This preface (and the notion that Cameron translated the novel from a found text, and then died) is one of several features clearly drawn from eighteenth-century writing closer to polemical fable than the novel (most obviously Voltaire's *Candide*, whose wide-eyed naivety is reversed in the outlook of Cameron's Italian journalist Cinico de Oblivii, cynical and oblivious). Guided by a 'Good Professor' around Scotland, Cameron's novel is a highly discursive romp through various questions and ruminations adjacent to the mainstream debates of indyref (notably, European echoes and forebodings of Scotland's choice). A running theme is the role of writing in constructing and despoiling political debate. Interviewing a tetchy Professor of Scottish Literature, from whom he wishes to understand the place of 'culture' in the debates of indyref, Cinico is rudely informed that journalists 'feed on your words, fail to understand them and then regurgitate them in abysmal prose'. Cinico is unoffended: 'I sympathised with her point of view. I never thought that my profession was a worthy or even useful one, as so many journalists do. We deal in lies and subterfuge at the bidding of our masters. We are hacks' (23). His own outright hackery furnishes a key plot twist (of which more below), and the general feeling in *Cinico* is that politics, like journalism, like literature, is no more than a dismal game of words.

Kirstin Innes's *Scabby Queen* (2020) is a sprawling semi-historical novel centred on the one-hit popstar Clio Campbell, a fiery radical and sometime activist whose bohemian life roams between small-town Ayrshire, Brixton squats, Highland church halls and Genoa protests between the early 1990s and 2018. Clio's many-voiced narrative explores the intimate politics of friendship, aging, sex, motherhood and betrayal, allowing public events and controversies (the Poll Tax, the Iraq War, the 'Spycops' scandal, indyref) to emerge in the more personal story of an outspoken minor celebrity: someone who is publicly 'political', though never entirely on her own terms. Anchored in a highly recognisable Scotland, elements of Clio's legend resonate with the real public lives of various cultural and political figures, but the novel keeps an important gap between the actual Scotland and the world of Clio, just as the narrative enforces a certain distance

from her seductive narrative of self. For Clio the personal is political, and the political is performative; the fight for justice is never entirely distinct from a publicity campaign.

Her big indyref moment comes on a live televised debate. Clio is voicing passionate Yes arguments on *Question Time*, and a school-friend (Adele) recognises her, 'that voice, talking about how Scotland had always voted differently from England, how there was a democratic deficit. Saying that this was a fresh chance, a new start' (315). A Scottish Labour MP, Gordon Duke, replies with his own 'monologue' for No. Duke's radical disgrace sees him fall from grassroots community organiser and Poll Tax protester to supporting New Labour, the Iraq War and now Better Together. He is also Clio's former lover and comrade. The content of his speech is not relayed, but that he now symbolises corrupt male entitlement is clear enough ('the man on the telly swept a palm through thick silvery hear, spread his arms and legs wide in his chair, leaned forward to the camera' (316)). Clio soon explodes in indignation, leaping up to denounce Duke as a 'Judas', 'talking over a woman with your practised lines', and appears on Adele's TV screen as both hysterical and magnificent, 'tall and angry and commanding' (316).

Melodrama noted, the reader is invited to identify with the essential justice of Clio's fury, not the patronising smirk it elicits from Gordon Duke, and to grasp that her outburst is a legitimate reaction to empty, patriarchal and anti-democratic debate. Before she loses control, Clio 'was trying to talk, turn it back into conversation, but the man allowed her no space, using practised tricks to keep ploughing on' (316). The emphasis on cynical, inauthentic speech is key. Clio is reaching for a culture of 'real' dialogic argument, akin to the standard described by Anderson, in a process (and TV format) that thrives on conflict and theatrical speechifying. But no sooner have we grasped the principled essence of Clio's interruption, her dramatic rant against 'practised lines' has itself gone viral and been reified into indyref talking points. Enjoying renewed fame at a women's Yes event, Clio is introduced as the inspiration 'who faced down the mansplainers on *Question Time*'. Speaking at the meeting, her TV 'meltdown' is quickly enfolded into Clio's preferred Yes narrative of empowerment and doing-things-differently:

> She talked about the ways that men in power had tried to squash the politics out of her, all her life; she talked about the ways that women could do politics differently, by sitting down and talking to each other. She talked about the things a country with women's interests at its heart would prioritise. (317)

Clio soon becomes a celebrity 'cybernat', throwing herself into a frenzy of Twitter clicktivism which quickly engulfs her public image and sense of self. Her friend Ruth is a worried spectator via social media, noting that Clio's 'profile was high enough to attract [her attackers]; her public statements sufficiently unmodest to keep them fuelled and ready' (344). But the intensities of #indyref also offer Clio a genuine sense of purpose, drama and identity: 'Clio had moved back to Scotland needing friends and a place in the world; she had found it as an outspoken advocate for Scottish self-determination' (344). To my knowledge, Clio is the first character in fiction to truthfully represent the non-trivial number of people who gained a new *joie de vivre* through indyref, but who also became slightly unhinged, arguing with strangers 'relentlessly, into the night, sometimes five or six at a time, lost in long trails of oblique replies and misunderstanding, refusing to let any of her anonymous sparring partners have the last word' (344).

*Scabby Queen* pays shrewd attention to various media formats (from the pop-magazine interview to the Sunday feature to the self-promotional grief-tweet) and their role in constituting public narrative. Her cybernat phase brings these forces to a new intensity, as Clio is effectively absorbed into a torrent of furious online textuality, becoming one of the pieces on the indyref chess board and losing control of her own voice. When she dies a few years later, she appears to outwit the media by sending a delayed suicide note, timed to reach the public a few days after she has been swiftly rediscovered, memorialised and filed away (per the rhythms of modern celebrity mourning). This public document effectively overwrites the newspaper obituaries and Instagram tributes which have just appeared, ensuring Clio has the last word on her life, on her own terms; and yet this defiant act becomes another facet of her legend, swiftly commodified in a cash-in biography authored by a sleazy journalist. Her internet martyrdom is intended as a break for freedom and a way round 'men in power' with their practised lines controlling and exploiting her story, but her melodramatic parting message – 'I am killing myself to draw attention to the fact that you are all sleepwalking into fascism and chaos' (333) – seems to fail by its own logic, unable to stop or interrupt the process in which this very outburst will be incorporated into a media-Clio owned and operated by her tormentors. This side of the novel is a commentary on female celebrity and ownership of the public self, but it strongly resonates with the slogans of self-determination which prompt Clio's indyref renaissance.

## Matrimonial allegory and closure

Innes explores the postmodern and reflexive qualities of Clio's self-performance, while the other novelists invoke highly traditional templates in managing the formidable narrative problems that come with directly representing indyref: a mass exercise in highly mediated self-representation. It is striking that all four of the novels attempting this feat employ courtship and marriage plots drawn from the early history of the modern novel, largely to impose closure and 'connection' on characters and events defined by Yes/No division.

With *An Indyref Romance*, the whole conceit of the book is the 'harmony and dissonance' of a chaste affair between two students at the University of Aberdeen: a passionate Yes campaigner Paul, and the more reserved and cosmopolitan Jenny, who is minded to vote No. Together they form a very earnest couple grounded in spiritual growth and uplifting conversation, as Jenny educates Paul about classical music and arthouse cinema, and explains her conservative Christian lifestyle. Over time they form a close bond unsullied by earthly appetites or political differences, developing a tolerant, durable love in which 'everyone can stick to their beliefs, but find fulfillment and contentment in each other's arms' (Deans 2015: 120). At the height of their passion Jenny asks only that 'we continue together. That's all I want' (105). This is the conservative mode of 'harmony' alluded to in the novel's subtitle, and it directly indexes the Better Together conception of the UK as a dependable and transcendent marital bond, a 'best of both worlds' in which difference can be tolerated without rancour. But the world of these characters departs so clearly from the recognisable Scotland of 2014 (particularly the views and behaviour of younger people), the book takes on qualities of political fantasy and wish-fulfillment.

In the novel's only real twist, Jenny angers Paul by exposing his pro-independence views to ridicule through her friend Effie Deans, the pro-Union blogger. In his presence, Jenny has been quietly tolerant of Paul's political views, only to savage his arguments behind his back in essays to her tutor and mentor, who draws directly on these writings in her (real-life) blog. Here is the scene where Paul's local Yes group confront him with the evidence of Jenny's embarrassing betrayal (which doubles as a canny plug for the website):

> He presented some printouts of some of the recent articles that had appeared on the Effie Deans site *Lily of St Leonards*.
> Paul read through the articles and began seeing phrases that he had mentioned, examples that he had cited. He saw the arguments he had been making for the past few months taken apart piece by piece. He saw

the assumptions that he had made contradicted with care, and with reason. He heard Jenny's voice as he read through the articles. He found his anger rising. She'd deceived him. She'd used their relationship to attack what he held most dear. (Deans 2015: 132–3)

What is most fanciful here is the notion that Paul can detect the odour of his personal Yes-chatter from anyone else's.[4] After this revelation the affair is swiftly ended – Paul finds comfort with the free-living republican Yes activist Roisin – but the controlling Jenny is unapologetic. At first she blames the SNP for the loss of her true love – after all, they called this destructive referendum in the first place (148) – but she explains her actions with a clinching defiance clearly intended to speak for the No side in general: 'What I wrote was what I believed. It was things I had kept hidden from him because I didn't want us to fall out. He'd been allowed to put his arguments, but I'd been scared to put mine. [. . .] He couldn't handle my honesty' (Deans 2015: 132–3). After the result, *An Indyref Romance* stages a tentative thaw as the representative No voter (Jenny) graciously offers the Yes voter (Paul) a chance to rebuild their trusting relationship, and to leave 2014 behind. But this is a heavily one-sided armistice – a strongly 'closed' form of openness – in which capitulation to the No talking points is the price of peace.

Imagery of marital discord has a deep history in Scottish constitutional politics. As *The Mile* repeatedly points out, one traditional motif of post-Union unease is the legend that the 1707 Act was marked with the bells of St Giles Cathedral ringing 'Why should I be so sad on my wedding day?' Divorce imagery was a mainstay of the debate, on both sides. David Cameron framed his 'final plea to Scots to save the United Kingdom from a permanent "painful divorce"', imploring voters 'please don't break this family apart' (Dearden 2014). On the pro-independence side, too, it was common to hear that 'irreconcilable differences' meant that the Union – sometimes figured as a dead or even abusive marriage – had reached the end of the line (see essays by Janice Galloway and Magi Gibson in Hames 2012). When Union-supporting Euan learns that his wife is divorcing him in *The Mile*, he is positively elated, and the novel swiftly aligns his impending liberation with Scotland's own opportunity to start over:

It'd been ending for years, their marriage, but once she'd moved out he could start afresh. He'd paint the walls white. Chuck out all the crap he didn't need. Get back to basics. [. . .] The years ahead were suddenly filled with promise, excitement, potential. He could be anything he wanted to be! [. . .] It was time for a change. A new beginning! (Smith 2013: 111)

Within a few pages, the romantic is crudely assimilated to the constitutional. Jock suggests '"it sounds like ye've got rid of one problem in yer life, so have a wee think [. . .] Maybe it's time tae ditch another marriage that ye seem so keen on? What dae ye think?" Euan shrugged. "Maybe Jock, maybe"' (Smith 2013: 122).

Sure enough, Euan quickly becomes open to new experience and the attractions of Scottish independence. In the final scenes of the book he is presented with a new romantic possibility with Rosie, the selfless care worker who has been searching for Jock, the folk superhero of Scottishness at the centre of the story, who helps all the other characters rekindle some element of pride or passion. The final scenes bear a passing resemblance to the end of a Walter Scott novel: Rosie (who happens to be English) might easily be a cipher for Rose Bradwardine, who makes a new dynastic match with Edward Waverley, with their nuptials sealing the symbolic resolution of Jacobite conflict. Hastening to tie things up, Scott's narrator in *Waverley* has the arrangements 'briefly told in narrative, like a newspaper report of a chancery suit' (Scott 2015: 366). In *The Mile*, we need a team of accountants and tax experts. Stretching the romance convention to an extreme, a cascade of surprise windfalls make Jock's death on the eve of indyref the start of new life for all the surviving characters, with whom he argued and bonded on his final night of freedom. His Victoria Cross medal, a valuable box made by the infamous Deacon Brodie, a diamond wedding ring and a rare first edition of Adam Smith's *Wealth of Nations* become the inherited fortune on which new plots, unions and alliances are founded. In return, Euan casts Jock's postal ballot in favour of independence.

Amanda Anderson notes that the romantically charged political dialogue of the classic courtship novel seldom applies a fixed stamp of approval on contending personalities brought to a standstill. Instead, the novel in this tradition shows a 'formal and thematic insistence on continuing collective deliberation [. . .] a primary component of liberal-democratic practice [which] crucially counters the sense of closure wrought by the romantic plot' (2016: 93). 'If everything will be decided by ongoing deliberation', she continues, 'then one cannot freeze the ideological content of the storyworld' (2016: 93). *Two Closes and a Referendum* comes closest to this open-ended quality, by throwing all sorts of unions and disunions together on voting day, with varying degrees of fixity: Ewan and Donald have split, married couples cast their ballots together (sometimes the same way, sometimes with one partner secretly 'cheating' on the agreed

marital vote), parents and grandparents use their vote to bond with the young, neighbours vote together to 'Save the Union', though it is clear their own affinities are meagre and temporary. These bondings and ruptures function mainly as a device drawing the Great Debate to a definite close, allowing indyref as passionate experience to conclude. But they also offer a telling image of aggregation: a profusion of indyref stories 'ending' and intersecting on abstract, incommensurate terms, where the stacking up of all these plots and acts cannot possibly resolve into any Big Story, nor settle any of the practised grooves of political reason invested (but also foreclosed) by the tallying of ballots. Resorting to a spectral frame narrator – we begin the novel viewing Scotland from outer space – tends to confirm that this social-discursive phenomenon cannot be rendered intelligible on its own ground-level narrative terms. In the novel's closing pages, even this otherworldly voice (that of Ewan's late mother, Jinty) reverts to sheer journalism, heavy on politics as 'process', in summarising indyref's upshot and unfinished meaning.

*Cinico* is the only Indyref Novel that is open and self-conscious about its templates and artifice. The novel is constructed as a modern *Candide*, but in reverse, so that the sardonic Italian journalist becomes gradually more open and optimistic as he spends the summer of 2014 in the company of various Yes campaigners and representative types. The novel abounds in picaresque, eighteenth-century atmospheres, following a verbose traveller who bounces around Scotland bumping into paper people who launch into lengthy, essayistic speeches reflecting on identity, nationhood, migration and spirituality. There is no sense of realistic experience or time, and the novel is really a digressive treatise told through entertaining puppets. This is indyref fiction as higher journalism: where there is no real attempt to ground the ephemeral discursive tides of indyref in some 'underlying' social reality, but which reports on those surface flows – in all their stilted or polished verbosity – *as* the dramatic locus of the story: a series of witty vignettes, pious speeches and statistical scrums. In this model, the meaning of nationhood constituted by indyref is at one with the reifying mechanics of abstraction and aggregation required by the vote itself. The modes of social description and representation we encounter in all these novels mirror the plebiscite which inspired them: in which a whole nation of thronging disagreements was boiled down to a determinate binary choice, and where everyone's views and aspirations (and spite and passion) were emplotted as allegiance to one of two national metanarratives.

## Conclusion: A Better Tale to Tell?

If we consider the local historical conditions of 2014, it is striking that none of these novels interrogate the referendum's tacit logic of majoritarian direct democracy. This logic clearly runs counter to the pragmatic consensualism (and finessing of 'usual suspect' stakeholders) which characterises Scotland's post-devolution governance (Bonney 2003; Keating 2010). The Scottish Government's White Paper pledged that 'an independent Scotland will build on existing, robust and well-established foundations to develop our governance and a modern participative democracy' (Scottish Government 2013), but there is a clear risk and potential irony in seeking to establish an inclusive, deliberative democracy via direct plebiscite.[5] As Brian Barry observes, 'the institution of collective decision-making by a simple majority of the popular vote is in itself the antithesis of "amicable agreement"' (cited in Vatter 2000: 174), echoing James Madison's wariness, at the birth of the American Republic, about enshrining 'the superior force of an interested and overbearing majority' (Federalist No. 10, 1787; in Genovese 2009: 49). This critique found very little purchase in the official campaigns, or in novels representing those campaigns, despite their frequent attention to the rights and voices of cultural minorities (notably *Cinico* and *Two Closes*). Instead, minorities are usually woven into an All-Scotland tapestry aligned with the totalising visions of Yes/No.

Having naturalised this majoritarian 'frame' – or faithfully recording its naturalisation in Scottish (and British) society – all these texts are bound by the massifying, aggregative binary logic of the referendum itself: Yes v. No, 1.6 m < 2 m votes. In this sense, there is a jarring mismatch between referendum mechanics and the explosion of *individuated* indyref discourse (e.g. countless social media posts explaining the individual voter's leanings and reasonings, personal #JourneytoYes testimonies etc), and *subcultural* modes of political interest and identity (in groups such as National Collective ('Artists and Creatives for Independence'), Rural Better Together, English Scots for Yes, and so on). This tension between *mass*, *self* and *group* poses a range of novelistic difficulties, none of them 'new' or specific to modern Scotland, but each acquiring new force and interest in the age of online politics and mobilisation.

Perhaps this shift from the lived experience of socialised persons to the discursive positionality of abstract citizens – in literature, in politics – will foster a move from romantic-particularist literary ethics in Scotland (the school of Kelman, Leonard and Galloway) towards

a more republican conception of national space and representation. In the outstanding Scottish political novel of the past decade, James Robertson's *And the Land Lay Still*, the drama is centred not on the inner flux of the reflective individual but his objective disposition within the public national story. Here the empirical 'givens' of Scottish history, nationhood and identity only require to be portrayed with due fairness and sociological acuity, from an externalised narrative stance grounded in journalistic recall (see Hames 2019). A more sceptical attitude to national representation is voiced in Cameron's *Cinico*:

> The nation works at the level of the crowd, the mass, and usually the instinct to conform in the absence of genuine dialogue. Where is the sane individual who would opt for war? But nations do this all the time. Individuals shudder and quite rationally fear for themselves and their loved ones, whilst the nation is titillated, energized, emboldened by an ill-defined glory that could touch everyone – a mirage they are drawn to like senseless automata. (Cameron 2017: 119)

How shall individual and nation coincide? In thought, agency, imagination, feeling? And can such an alignment really be argued for, dialogically, or only rationalised in ways that evoke *Cinico*'s automata? These remain open questions as demands for a second indyref return to the centre of Scottish politics.

I conclude with Alec Finlay's *A Better Tale to Tell*, the only indyref art-writing to engage directly with the prosaic, procedural qualities of Scottish constitutional 'participation' while preserving the individual voice (and its 'bleakness', viewed in Anderson's terms: its awareness of its own constrained agency). Finlay has assembled found poems from anonymous consultation responses on 'more powers' devolution, as explored by the Smith Commission in 2014–15 (fulfilling 'the Vow' made by Unionist political leaders a few days before the referendum; see BBC News 2014). One refashioned citation comments:

> I am concerned
> at suggestions
>
>> the Commission
>> should take account
>>
>> of the views
>> of civic society

we do not elect
the 'chattering classes'

> the self-serving
>     rational maximisers
>         of personal hedonic
>         utility

(Finlay 2015: 27)

Here we find living critical speech – but confined within the grey and nebulous limits of British constitutional reform (the tactful vagueness of 'more powers'). There is no sense of liberated voice or agency, and in a sense it is that higher process that speaks here, deploying the speech of sceptical citizens it has already digested into its own representative purposes – namely, rationalising the current constitutional order (and its existing mechanisms of reform and consultation) rather than any break with these structures of incorporation.

For all its many-voiced directness and disruptive potential, the referendum itself is one such structure. As James Foley and Pete Ramand observe (drawing on Vernon Bogdanor) British referendums are a 'conservative device', 'designed to be *pro-systemic*, to build up consensus and to shore up necessary myths of consent and popular sovereignty' (Foley and Ramand 2018: 78). In this respect they are continuous with the broader mystifications of liberal democracy understood since Marx, who saw the '"parliamentarization" of political life as analogous to the theatre' (Bourdieu 2014: 355). 'Elected every four or five years as the sovereign expression of popular will', Perry Anderson noted several decades ago, parliament 'reflect[s] the fictive unity of the nation back to the masses as if it were their own self-government' (Anderson 1976: 28). A winner-takes-all referendum held to secure a new 'sovereign' Scottish Parliament is trading in several layers of mirage, though none of these novels really pursues the point, operating mainly on the journalistic surface of the leaflet war. In this first wave of fictional response, it seems that indyref's attendant myths of nation, democracy and representation have been placed beyond novelistic critique. Instead, dramatic interest centres on the instrumental chessboard and its word-games, a Great Debate elevated to its own discursive 'sovereignty', unmarked by human dialogue or ethical doubt. Straining for narrative and emotional resolution, these texts mirror the echo-chambers of contemporary social media even as they resort to weak allegory and didactic archetypes drawn from the prehistory of the modern novel. Viewed in aggregate, they suggest the

richly furnished deliberations and 'mediated telling' of Anderson's bleak Victorians has lost all purchase on the textual culture of 2014. Though indyref was made possible through the success of Scotland's admirably inclusive strain of liberal nationalism, the culture of argument that defined the political novel in English – argument as a 'lived relation' between liberal political subjects, compromising and compromised, open-ended and delimited in advance – is seldom to be found in this fiction. This is not to fault the writers, but the special challenges of their source material, and the political conditions it faithfully reflects.

## References

Ailes, K. and S. Paterson (eds) (2016), *Aiblins: New Scottish Political Poetry*, Edinburgh: Luath.

Anderson, A. (2016), *Bleak Liberalism*, Chicago: Chicago University Press.

Anderson, P. (1976), 'The antinomies of Antonio Gramsci', *New Left Review* I.100: 5–78.

Barr, A. (2016), *Summer of Independence*, Edinburgh: Word Power.

BBC News (2014), 'Smith Commission receives more than 14,000 submissions', 31 October. https://www.bbc.co.uk/news/uk-scotland-scotland-politics-29857267

Better Together (2014), 'The woman who made up her mind', 26 August. https://www.youtube.com/watch?v=OLAewTVmkAU

Bonney, N. (2003), 'The Scottish Parliament and participatory democracy: vision and reality', *Political Quarterly* 74.4: 459–67.

Bourdieu, P. (2014), *On the State: Lectures at the Collège de France, 1989–1992*, ed. Patrick Champagne et al., trans. David Fernbach, Cambridge: Polity.

Cameron, A. (2017), *Cinico; Travels with a Good Professor at the Time of the Scottish Referendum*, Glasgow: Vagabond Voices.

Clegg, D. (2014), 'David Cameron, Ed Miliband and Nick Clegg sign joint historic promise which guarantees more devolved powers for Scotland', *Daily Record*, 16 September. https://www.dailyrecord.co.uk/news/politics/david-cameron-ed-miliband-nick-4265992

Cochrane, A. (2014), *Alex Salmond: My Part in His Downfall*, London: Biteback.

Deans, E. (2015), *An Indyref Romance: Harmony and Dissonance*, Aberdeen: Eo Ipso Publishing.

Dearden, L. (2014), 'Scottish independence: full text of David Cameron's "no going back" speech', *Independent*, 16 September. https://www.independent.co.uk/news/uk/scottish-independence/scottish-independence-full-text-david-cameron-s-no-going-back-speech-9735902.html

Finlay, A. (2015), *A Better Tale to Tell: Composed Entirely from Submissions to The Smith Commission*, Glasgow: Centre for Contemporary Arts.

Foley, J. and P. Ramand (2018), 'In fear of populism: referendums and neo-liberal democracy', *Socialist Register* 54: 74–98.

Genovese, M. A. (ed.) (2009), *The Federalist Papers*, New York: Palgrave Macmillan.

Geoghegan, P. (2014), *The People's Referendum: Why Scotland Will Never Be the Same*, Edinburgh: Luath.

Hames, S. (ed.) (2012), *Unstated: Writers on Scottish Independence*, Edinburgh: Word Power.

Hames, S. (2019), *The Literary Politics of Scottish Devolution: Voice, Class, Nation*, Edinburgh: Edinburgh University Press.

Hames, S. and A. Hunter (eds) (2016), *If Scotland . . . Conjecturing 2014* [special issue of the *Journal of Scottish Thought*, vol 8]. https://www.abdn.ac.uk/riiss/content-images/JST_vol8.pdf

Innes, K. (2020), *Scabby Queen*, London: Fourth Estate.

Introna, A. (2016), 'Reveries of a progressive past: the missing Scotland as indyref heritage', *Journal of Scottish Thought* 8: 117–29 [special issue on *If Scotland . . . Conjecturing 2014*, guest eds S. Hames and A. Hunter].

Keating, M. (2010), *The Government of Scotland: Public Policy Making After Devolution*, 2nd edn, Edinburgh: Edinburgh University Press.

Lukács, G. (1962), *The Historical Novel*, trans. Hannah and Stanley Mitchell, London: Merlin.

McCabe, M. (2017), *Two Closes and a Referendum*, Glasgow: Ringwood.

Pike, J. (2016), *Project Fear: How an Unlikely Alliance Left a Kingdom United but a Country Divided*, London: Biteback.

Robertson, J. (2010), *And the Land Lay Still*, London: Penguin.

Scott, W. (2015), *Waverley; or 'Tis Sixty Years Since*, ed. Claire Lamont, Oxford: Oxford University Press.

Scottish Government (2013), *Scotland's Future*. White Paper on Independence. https://www.gov.scot/publications/scotlands-future/

Sillars, J. (2014), *In Place of Fear II: A Socialist Programme for an Independent Scotland*, Glasgow: Vagabond Voices.

Smith, C. A. (2013), *The Mile*, Edinburgh: Pilrig Press.

Torrance, D. (2013), *The Battle for Britain: Scotland and the Independence Referendum*, London: Biteback.

Vatter, A. (2000), 'Consensus and direct democracy: conceptual and empirical linkages', *European Journal of Political Research* 38: 171–92.

Woolf, V. (2000), *Mrs Dalloway*, London: Penguin.

## Notes

1. I have confined this chapter to novels about the 'actual' indyref, and have not touched on the growing number of speculative indyref fictions

(typically exploring fantasies and nightmares coming after a Yes or No result). It is interesting to note that conjectural, what-if? responses to indyref currently outnumber the broadly realist texts on which I have focused here: interested readers should see Peter Curran's *The Scottish Referendum Murders* (2015), Tom Gallagher's *Flight of Evil: A North British Intrigue* (2018), Bill Austin's *Free Scotland* (2018) and Andrew Scott's *Scotched Nation* (2019). Alan Clements anticipated indyref and its possible aftermath (even guessing the right year) in his 2009 speculative thriller *Rogue Nation*.

2. There are interesting parallels here with indyref diaries and memoirs, especially their dual quality of revealing behind-the-curtain detail and making the larger public narratives of indyref clearer and more legible. Interested readers might compare these novels with Torrance (2013), Cochrane (2014), Geoghegan (2014), Barr (2016) and Pike (2016). This last is cited by McCabe as a source for *Two Closes*.

3. Indeed, the leadership of the No campaign swapped its whole prospectus two days before the vote, from 'No Thanks' to 'The Vow' pledging extensive new powers (Clegg 2014).

4. Almost the same plot appears in *Cinico*: an indyref romance is destroyed when the visiting Italian journalist gives in to pressure and rewrites a pro-independence editorial so that it argues the opposite of what he and his Yes-supporting girlfriend believe. In Cameron's novel, the rhetorical back-and-forth directly actuates the love plot.

5. It should be added that referendums are not the Scottish Government's chosen means of legitimating independence, but the only recognised method of securing UK constitutional change.

# Shifting Grounds: Writers of Colour in Twenty-First-Century Scottish Literature

*Silke Stroh*

This chapter explores the role played by writers of colour on the Scottish literary scene during the first two decades of the twenty-first century, as well as their potential for changing conceptions of Scottish literature in the decades to come. As has also been pointed out by an important new organisation, the Scottish BAME Writers Network (SBWN, founded 2018), so far only a limited range of Scottish or Scottish-based writers of colour has been known to a wider audience (Guyan 2020: 2f., 15f., 18f., 28, 2021: 3, 17, 21, 28). The much smaller academic segment of the audience presents a similar picture. Most secondary sources that address Scottish(-based) writers of colour at all remain firmly focused on three well-known figures: Jackie Kay, Leila Aboulela and Suhayl Saadi. While this attention is undoubtedly well-deserved, it sometimes reduces them to token figures that affirm a progressively inclusive image of Scottish culture while, at the same time, the rest of the canon is kept 'reassuringly' white. The present contribution aims to go beyond these three big names by providing a more general overview that also pays attention to other writers. It also discusses important elements of the literary infrastructure that help to shape the field, focus attention and facilitate the emergence of new writers. These elements include theatre companies, writers' groups, bursaries, events and dedicated anthologies. This overview will be supplemented by short case studies of four individual authors – Bashabi Fraser, Tendai Huchu, Raman Mundair and Chin Li – who have so far not received as much attention as the three authors mentioned above. This different sample is intended to encourage further exploration

of the full diversity of Scottish literature today. The issues pertaining to this context can also be linked to wider debates on categories of Scottishness, inclusivity and canon (re)formation, burdens of representation, and the problems of ethnic, racial and national ascriptions.

## Conceptual and Terminological Issues

For readers who are relatively new to this field, it might be useful to start with a brief review of assumptions and labels that often shape the ways in which writers of colour are discussed (or dismissed). These also reflect wider social dynamics of inclusion and exclusion. The questions 'Who counts as a Scottish writer?' and 'What counts as Scottish literature?' can, of course, be answered in different ways. Potential criteria include an author's ancestry, birthplace, place(s) of upbringing and/or later residence, the length of their residence in Scotland, a writer's (at least partial) self-identification with Scotland or Scottishness (not necessarily the same), their works' thematic engagement with this country, as well as their engagement with traditional Scottish literary forms and Scottish vernacular language(s). Some might also include literature that is not 'about' Scotland in any way, but 'merely' *produced* in Scotland – perhaps even by authors whose stay does not extend beyond a short visit. Many people might assume that at least some of these factors must come together if the label 'Scottish literature' is to apply. But the combinations might vary from work to work, from author to author, and between different phases in an author's lifetime. It is also important to remember that various writers have dual or multiple national, cultural and ethnic affiliations, or reject such labels altogether as limiting, essentialist categorisations that cannot adequately capture transcultural, transnational and translocal life-worlds and have wrought much social damage. Thus, such labels are always subject to negotiation; they are always provisional and can at best be a rough orientation. Of course, this applies not only to the writers and works featured in this chapter, but to *any* national, regional, cultural or ethnic categorisation. Any account of 'national' literature (Scottish or otherwise) will also come up against writers and phenomena that look to other places and constituencies.

Further problems of ascription pertain to categories of 'race'. Of course, these are based on colonial constructs that posit whiteness as

the 'superior' norm while various people who are categorised as non-white (such as Black Africans and the Black African diaspora, South Asians, East Asians, and at different times in history also Irish, Arab or Latinx people) are relegated to the rank of inferior Others. So, should we actually continue to use such categories and cordon off 'non-white' Scottish literature in a separate chapter? Should writers of colour not be discussed across a wide range of inclusive chapters based on other criteria, such as genre or theme? Partly this is already being done, but it still makes sense to complement this approach by also providing accounts that specifically foreground writers of colour. Although 'race' is a mere social construct, it continues to do grave harm. Many studies and anthologies which are, on the surface, 'race'-blind still exclude writers of colour altogether or allow them only a very marginal presence. Prematurely demanding that all discussions should be 'race'-blind can be a white strategy of evasion that makes ongoing racism invisible and reassures white people that they have already transcended historical guilt and no longer need to question their own behaviour and privilege (for a similar argument, see e.g. Mundair 2020a). Separate accounts foregrounding writers of colour can help to redress the balance as long as blind spots and under-representation in literary histories and criticism still exist.

This entails another conceptual compromise: although a range of different groups are marginalised on racist grounds, is this enough to lump them all together within the same category? The precise ways in which racism is experienced vary from group to group, and there can also be racism *between* People of Colour (e.g. anti-Black racism among Asians). Different national, regional, cultural and ethnic backgrounds must also be taken account of. This is further complicated by intersections with other categories of social differentiation, such as class, gender or sexual orientation. The inclusiveness of this chapter does not mean to erase those complexities but should be seen as a strategic compromise that enables us to highlight some shared problems, and at times also the political alliances that authors and activists have attempted to forge between groups.

But which terminology should be employed for this broad framework? Labels commonly used at present include 'non-white', 'Black British' (as a political category encompassing a wide range of racialised groups, e.g. also including those of Asian descent), 'Black and Asian British', 'People of Colour (PoC)',[1] 'Black and minority ethnic (BME)' and 'Black, Asian and minority ethnic (BAME)'. All these are accepted by some members of the communities in question as (however limited, provisional and strategic) self-designations – while being rejected by

other members. At times, those who employ such labels use (some of) them synonymously, but there are also important nuances of meaning that distinguish them and can lead users to prefer certain terms over others. Terminologies remain contested and should be treated with caution; and, when talking about specific authors or organisations, one should always take their own preferences into account.

A tentative summary of the debates might say that all those terms are at times considered as convenient shorthand for different groups faced with racist marginalisation, and to express solidarity in resistance. Counter-arguments object that blanket terms obscure the substantial differences mentioned above. 'Non-white' has also been seen to perpetuate assumptions of whiteness as the norm. The emphasis of 'BME' and 'BAME' on minority status can obscure the fact that those who are minorities in Britain may not be minorities elsewhere, and that People of Colour are in fact a global majority. 'BME' and 'BAME' have also been criticised for mentioning categories of ethnicity (primarily a cultural concept) and 'race' (a biologistic concept) in the same breath, thus inviting conflations. And indeed, some people understand 'PoC' and 'BME'/'BAME' as synonymous, although 'minority ethnic' can include white ethnic minorities. While some of the latter have also, at certain times in history, been constructed as racially Other (for instance where Britain's mainstream defined itself as an Anglo-Saxon master race destined to rule or displace the 'inferior Celtic race' on its margins), the dominant reading of 'race' today considers all white groups as racially the same. This again reminds us that experiences of marginalisation vary between groups, and that blanket terms can obfuscate this (for details on the various arguments, see e.g. Newland et al. 2016; Nasta and Stein 2020b: 9f.; British Sociological Association 2020; Joseph 2020; Mundair 2020a: 66f.). As a compromise, some attempt a reflected usage of such terms by openly acknowledging their different implications and limitations before making explicit in which way *they* employ the label(s), and for which purposes. This can also combine awareness of potential commonalities and alliances with a much-needed acknowledgement of heterogeneity and contextuality (e.g. see the usage in SBWN 2020c). The present chapter uses 'People of Colour' as a preferred compromise where an inclusive term is needed, but this should not be taken to imply lack of awareness of the limitations of such labelling.

Another important issue is the tendency (now perhaps especially among white audiences) to view writers of colour in terms of a 'burden of representation'. Artists are not sufficiently treated as individual creative practitioners, but mainly as representatives of their ethnic

or 'racial' group and its social realities. And the latter are deemed so homogenous that they can be completely represented through a single artist or work. A classic text about this problem which is frequently cited in pan-British contexts is Kobena Mercer's essay 'Black art and the burden of representation' ([1990] 1994). In a Scottish literary framework, the burden of representation has, for instance, been problematised by Jackie Kay and fellow writer Jay G. Ying (Kay et al. 2019/2020: 82). This issue can also mean that a writer of colour's aesthetic excellence in terms of narrative strategies, poetic form or stylistic experiment is sidelined by readers who are merely in search of 'typical minority themes', mildly 'exotic' touches of Other life-worlds, liberal ticking of 'diversity boxes', etc. Such sidelining not only concerns individual talent and aesthetic form, but also a wider range of themes that writers engage with. As literary critic Sara Upstone (2020: 660f.) puts it: '[W]e are not yet at the point to indulge the utopian fantasy that ethnicity is no longer an issue. So it is important that black and Asian British texts are [. . .] received in the context of ethnic awareness. [. . . .] At the same time, [. . .] it is vital that [. . . they] be recognised for their crucial contributions in other respects too.' A similar compromise is attempted in the present chapter.

Critical reflection on conceptual frameworks should be complemented by an awareness of the infrastructures that play an important role in shaping perceptions of Scottish literature and drama, in excluding or promoting writers of colour, and in (re)defining canons. These are the focus of the next section.

## Literary Infrastructures

When we look at the Scottish literary sector as a whole, the playing field seems to be far from level. This is also suggested by the aforementioned surveys commissioned by the Scottish BAME Writers Network in 2020 and 2021. Although they only yielded a small dataset that is not statistically representative, they may still be seen as an important indicator. In 2021 for instance, 79 per cent of the respondents – 94.7 per cent of whom were writers – strongly disagreed with the idea that Scotland's literary sector offered equal opportunities for white people and People of Colour. In addition, nearly 30 per cent reported that their own literary careers had recently been impacted by barriers based on ethnicity or racism (Guyan 2021: 2f., 19).

This highlights the need for dedicated organisations and projects that aim to increase opportunities and audiences for writers and

other artists of colour in Scotland. One area where such activities were already evident at the very start of the century is theatre. The year 2004 saw the foundation of Theatre Insaan,[2] based in Glasgow, under the direction of Faroque Khan, which lasted until 2009 (see Khan 2008; BBA Shakespeare 2020). In 2006, Edinburgh followed suit with the establishment of Wave Theatre under the leadership of Annie George, who also soon began to write her own plays. Wave continued to set important impulses until its closure in 2013 (see Ley and Dadswell 2011; George 2017, 2020). Another initiative from the performing arts is Bijli[3] Productions, a theatre company based in Glasgow which focuses on diversity. Co-founded in 2017 by Mariem Omari and Umar Ahmad, both of whom are also playwrights, Bijli already received mainstream recognition as one of two Companies in Residence at National Theatre Scotland in 2017/18 (Bijli Productions 2020a, 2020b; Omari 2020).

Another important element of the literary infrastructure is provided by bursaries. In 2016, the Saltire Society and the Scottish Book Trust collaborated on a bursary for 'an emerging minority ethnic voice in fiction, poetry or spoken word', which was eventually won by Annie George (Saltire Society 2016). The following year saw the launch of Megaphone, a residency/bursary organised by The Workers Theatre[4] to support writers, theatre makers and filmmakers of colour based in Scotland.[5] The recipients in 2017 were playwright, performer and poet Hannah Lavery, spoken word artists/performers Bibi June Schwithal and Mara Menzies, and filmmaker Lucas Kao (Dibdin 2017). As of 2021, a second round of Megaphone residencies is being planned for the near future (Bell 2021).

In 2018, as already noted, the Scottish BAME Writers Network was established. Its co-founders were Jay G. Ying and Alycia Pirmo-hamed. While acknowledging both white and non-white minorities, the network focuses on those experiencing racialisation, which in current terms suggests a focus on People of Colour – and, in fact, the SBWN sometimes uses the terms 'BAME' and 'PoC' synonymously (SBWN 2020a, 2020b, 2021c; Guyan 2020: 5–7). The organisation aims to provide 'advocacy, literary events and professional develop-ment opportunities for BAME writers based in or from Scotland' and 'to connect [. . .] these] writers with the wider literary sector' (SBWN 2021a, also see 2021b). It has also proposed to showcase a wider *range* of Scottish(-based) BAME authors (Guyan 2020: 16). Another important foundation from 2018 is Fringe of Colour, a multi-award-winning Black arts initiative linked to the Edinburgh festivals. First started by Jessica Brough as a database of artists of

colour in the Fringe Festival program, it was extended in 2019 by the addition of a free ticket scheme for young People of Colour and a Fringe of Colour Living Room in the basement of an Edinburgh bookstore where performers and audience members of colour could discuss the festival and relax. In 2020, Fringe of Colour set up its own online festival, with a second season in August 2021 (Chu 2019; Fringe of Colour 2021). Last but not least, it is worth mentioning the Writers of Colour Group with its regular meetings at the Scottish Poetry Library (Kay et al. 2019/2020: 79; Pearl 2020; Scottish Poetry Library 2020). These various initiatives have laid, and continue to lay, important groundwork for promoting Scottish and Scottish-based writers and artists of colour and provide excellent starting points for further explorations of the diversity of the Scottish literary scene in the twenty-first century.

A similar function can be fulfilled by literary anthologies. There are various collections of Black and Asian British writing that include authors with Scottish connections (e.g. Chatterjee 2000; Dawes 2010), although these are not always discussed as such, instead being submerged in wider, pan-British perspectives (on the need to devolve concepts of Black Britishness, also see the powerful argument in Jackson 2020). At the same time, several modern anthologies of Scottish literature (e.g. O'Rourke 2002; Gifford and Riach 2004) include a few writers of colour, though not as many as might be hoped for. While a complete overview would exceed the scope of this chapter, this section presents a small number of anthologies that focus more specifically on Scottish writers of colour, either exclusively or at least as a central *part* of their remit. At the very start of the century, the first important collection of this kind was *Wish I Was Here: A Scottish Multicultural Anthology* (2000), edited by Kevin MacNeil and Alec Finlay. It contains poems and prose by white writers from older Scottish minority cultures (Shetland and the Gaelic world), writers from more recent minorities like the Black or South Asian Scottish communities, and white Scottish mainstream writers writing *about* minorities.

The next major compilation, *Out of Bounds: British Black & Asian Poets* (2012), edited by Jackie Kay, James Procter and Gemma Robinson, had a dedicated section for Scotland, alongside other sections on Wales, Northern England, the Midlands and Southern England. The regional allocations are based on the thematic content of individual poems rather than the biographical background of their authors. Thus, some poets feature in more than one regional section, and the Scottish section also contains writers who would not normally be regarded as Scottish in any sense, whether by birth, residence, self-identification or long-term

thematic engagement, and whose presence on the Scottish scene may have been only short-term and not going far beyond the individual poem/s included here. Nonetheless, the collection also includes a considerable range of writers who can be regarded as Scottish in one or several of the senses given above, and whose oeuvre engages with Scotland in a more sustained manner. It thus serves as a useful point of entry for readers who seek an introduction to Black and Asian Scottish poetry up to the time of the anthology's publication, and a springboard for further exploration.

*Thali Katori: An Anthology of Scottish & South Asian Poetry* (2017a), edited by Bashabi Fraser and Alan Riach, also includes a good selection of Scottish Asian writers, among others. The aim of the collection as a whole is to 'look into the complexity of identities and relationships that not only characterise these territories in themselves but also the relationships between them' (Fraser and Riach 2017b: 17). Part of the selection consists of Scottish- and South-Asian-themed work by South Asian and South Asian diasporic writers. These are complemented by Scottish or part-Scottish writers' poems about South Asia, or about South Asian people and cultures in Scotland.

Another relevant collection is *Ceremony* (2019), a pamphlet-sized anthology of poetry and prose produced by the Scottish BAME Writers Network in partnership with the Scottish Poetry Library, edited by Alycia Pirmohamed. Even more recently, two major Scottish literary magazines published special issues that placed a particular (albeit not exclusive) focus on BAME writers. One of these was *Gutter*, no. 21 (February 2020), guest-edited by Alycia Pirmohamed and Jay G. Ying. Many of the authors featured are based in, or otherwise connected to, Scotland, and the compilation includes poetry, short stories, excerpts from novels, essays and an interview. The other magazine was *Dark Horse*, no. 43 (summer 2021), whose BAME content was guest-edited by Sean Wai Keung and Shehzar Doja. All these valuable interventions will hopefully point the way towards a greater diversification of Scottish literary canons in the years to come. I would like to follow up this selective overview by zooming in on a small selection of individual writers as further illustrations of the vibrancy of the contemporary scene.

## Individual Writers: Four Short Case Studies

The four sample authors presented here have been chosen with a view to achieving a balance between different backgrounds, generations,

genders and genres. While part of this section addresses varying takes on the diasporic condition and Scottish connections as a guiding motif, it will also take account of other important themes in these authors' works, as well as selected formal and stylistic issues, to suggest the plethora of other lenses through which their writing can be viewed.

Tendai Huchu was born and raised in Zimbabwe, moved to Britain as an adult and has been based in Edinburgh for many years. That he is hitherto mainly discussed as a Zimbabwean writer is presumably not only due to the geographies of his early life (other writers who immigrated in their twenties are sometimes more readily claimed as part of British literature), but also due to the fact that he often returns to Zimbabwean settings for his fiction, as in his first novel, *The Hairdresser of Harare* ([2010] 2011), or short stories like the Orwellian sci-fi dystopia 'The sale' (2012; with a good analysis in Moonsamy 2016: 336–40) and the experimental intertextual pastiche 'The second coming of Dambudzo Marechera' (2014b). Those of Huchu's works that are set in the UK also tend to focus on Zimbabwean or Zimbabwean diasporic characters, as in his later novels, *The Maestro, the Magistrate & the Mathematician* ([2014] 2015) and *The Library of the Dead* (2021), or the short stories 'Brian' (2014a) and 'Dead white guy' (2016). In addition to his Zimbabwean thematic links, another reason for the apparent reluctance to see Huchu (or other writers of colour) as (also) a part of Scottish literature might be an ongoing mainstream misconception of Scottish culture as an essentially white space, perhaps much more so than pan-British culture (where, say, the London or Manchester areas are widely acknowledged as diversity hubs). White Scottish writers engaging with non-Scottish spaces do not seem to get expunged from the image of Scottish literature quite so easily. And, in fact, it does make eminent sense to acknowledge Huchu as an important voice in Scottish literature as well. This is perhaps most evident in *The Maestro, the Magistrate & the Mathematician*, a novel very firmly rooted in contemporary Edinburgh, creating an intense sense of place while we follow its diasporic characters as they negotiate the city's geography and its multi- (or rather trans-)cultural social spaces. As critic F. Fiona Moolla ([2018] 2021: 235) has aptly put it, Huchu 'may well be the writer who [. . .] has written [. . .] Edinburgh into the twenty-first century global novel', doing for the Scottish capital 'what Charles Dickens did for London, and James Joyce did for Dublin'. His fantasy novel *The Library of the Dead* is also set in Edinburgh. With well-constructed plots and a compelling style, Huchu's works combine evocative descriptions of his characters' daily routines and emotional lives, a spirit of warmth and humour, and keen political and social criticism.

Huchu's diasporic characters tend to be relatively recent migrants negotiating dislocation, mainstream hostility and economic struggles, while their building of new lives in Britain is still very much a work in progress, precarious and open-ended. Bashabi Fraser, by contrast, often presents a vision of diasporic life that looks back on a longer history, where many initial struggles have already given way to a firmer sense of arrival, achievement, fusion and relative harmony. Fraser was born in West Bengal in 1954 and, ever since childhood, has moved repeatedly between India and Britain. She first came to Edinburgh in 1985 and has lived there permanently since 1994. Since the 1990s, she has published seven volumes of poetry (six of which appeared in the new millennium), as well as some children's stories (2004a, 2004d) and a puppet play (2004b). Her work spans Scotland and South Asia, often placing particular emphasis on their *interconnections* from nineteenth-century colonialism to the present day. The South Asian diaspora in Scotland occupies a central place in this panorama. While she also acknowledges moments where the white mainstream remains reluctant to embrace diversity, she nonetheless projects an emphatically inclusive, transcultural image of Scotland. In three of her books this is already reflected in the titles, each of which programmatically combines an iconic cultural or geographic feature from India with an equally iconic Scottish feature: *Tartan & Turban* (2004c), *From the Ganga to the Tay* (2009) and *Ragas and Reels* (2012). This last is a collaboration with photographer Hermann Rodrigues where each poem is paired with an image to create an intermedial kaleidoscope of South Asian Scottish lives and their successful contributions to the country. Expressing community pride and empowerment, this also aims to transform mainstream images of Scottishness, creating a more diverse image of this nation for the twenty-first century. Further reflections on Scottish/South Asian connections appear in *The Homing Bird* (2017). Two other collections give more space to other topics: in *Letters to my Mother and Other Mothers* (2015) these include family life, women's rights, Chinese and Arab democracy movements, and ecological concerns; whereas *Patient Dignity* (2021) is themed around the COVID-19 pandemic. All in all, Fraser's work can be said to combine a cosmopolitan rewriting of traditional images of nation and locality with a sense of transnational humanism (for a more detailed analysis of her work, see Stroh 2019).

Another important South Asian diasporic voice on the Scottish literary scene is Raman Mundair. Born in India, she moved to England as a young child in the 1970s, grew up in Manchester and Leicestershire, spent most of her adult life in England and Scotland, and is currently

based in Shetland and Glasgow. Identifying as a 'Queer, British Asian intersectional feminist and activist' (e.g. biographical information published with Mundair 2020b), she is not only a writer but also a visual artist and filmmaker. Her literary activities encompass poetry – most notably the collections *Lovers, Liars, Conjurers and Thieves* (2003) and *A Choreographer's Cartography* (2007b) – short stories (e.g. 2007c, 2015) and drama. Here, I would like to pay special attention to the last, in the interests of generic variety. Mundair's public debut as a playwright was with the one-act show *Side Effects* (2006), produced in cooperation with National Theatre Scotland and the 'A Play, a Pie, and a Pint' series of the Glasgow venue Òran Mòr before touring to Edinburgh and Dublin. Thematically, Mundair (2020c) describes it as 'a juxtaposition of a [. . .] Glasgow night out wit[h] date rape and Abu Ghraib'.[6] In a different form, Western aggression towards a demonised 'Muslim world' also features in Mundair's second play, *The Algebra of Freedom* (2007a), which was produced by 7:84 Theatre Company, premiered at The Arches in Glasgow in 2007, then toured to different parts of Scotland, and was published in the same year. Its fictional storyline was inspired by a real event from 2005, namely the police killing of Brazilian immigrant Jean Charles de Menezes on the London Underground because he was mistaken for a fugitive terrorist. The police officers were never prosecuted for this deed. In the play, after a similar shooting, policeman Tony is plagued by guilt and reluctant to sign a false account exculpating himself and his unrepentant colleague. The second protagonist, Parvez, is an Asian British Muslim mourning his wife, apparently killed while doing aid work in Palestine. Keen to avenge injustices against Muslims, Parvez is tempted to join a terrorist cell. Haunted by the dead, both men are torn between simplistic ideologies of antagonism, the struggle to accept a shared humanity and the concept of forgiveness.

This is a much more troubled world than is projected in many of Fraser's poems. Nonetheless, even Mundair's work has moments where Britain, or more specifically Scotland, is assertively claimed as home. What is especially interesting is the precise *part* of Scotland where this home is located: while Black and Asian British experiences are conventionally associated with big-city spaces like London, Manchester, Edinburgh or Glasgow, Mundair's most intense engagement with Scottish space can arguably by found in her poems about Shetland. For instance, her second collection contains a whole section about this archipelago, named after its coordinates, '60° north', which lovingly reflects on the local landscape and language (Mundair 2007b: 9–24). Sometimes, she even writes in Shetlandic herself. The

right of People of Colour to move beyond British urban spaces and also claim a home in rural environments that are conventionally seen as bastions of whiteness is also discussed in Mundair's essay 'Your land is my land: perspectives from an immigrant' (2018) where, in a postscript, she defiantly calls herself a Shetlander. Elsewhere, we move from the local to the global: her poem 'A choreographer's cartography' ([2004] 2007), which gave its name to her second collection, invokes a variety of dance forms from around the world and combines them to symbolise a joyful cosmopolitanism that rejects national boundaries, crosses cultures with ease, and insists on a common human right to equality and belonging.

The work of Chin Li presents yet another set of literary facets. Born in Hong Kong, Li has been living in Scotland for many years and has published poetry, short stories and experimental essay writing. For instance, 'Cooking for one' (2014) is a piece of flash fiction about loneliness and the missing of a lost partner. 'Beyond the garden: a love story' (2015) actually expands beyond the theme of love and loss to develop a surreal, dream-like vision of recurrent human violence, from Jesus's crucifixion via the crusades, witch burnings and World War I to urban adolescent knife crime, contemporary drone-using warfare in the Middle East and the Apocalypse. Two stories from 2019, 'The sea is wild' and 'The last chant', respectively present the perspective of a refugee on a perilous boat journey and a reflection on democracy movements in Hong Kong and elsewhere (2019b, 2019c). Some of Li's poems return to the motif of love and loss: 'A long-distance voice' (2019a) meditates on the separation from an aging loved one, perhaps a father. Last but definitely not least, 'A few of everything' (2020) is an intensely poignant poem about a speaker who knows that his wife has only a limited time left to live, while both try to anticipate his life afterwards, between the keenness of loss, an eagerness to remember, the fear of forgetting, and the need of acceptance.

## Conclusion

One criterion in the selection of these four case studies was a relatively strong connection to Scotland in terms of long-term residence and/ or thematic engagement. Nonetheless, even those authors of course also engage with other locations, as is to be expected in (not only) diasporic writing. Moreover, it is important to note that other writers of colour who have been active on, and claimed for, the Scottish scene have a more transient connection with Scotland: some were

born and/or brought up in Scotland but have since moved away both physically and thematically. Others have been sojourners from the outset who only arrived as adults (e.g. for a short-term post as writer in residence) and moved away again after a few months or years. This creates further problems of categorisation, and of claiming these writers as part of Scottish literature. While such authors also deserve consideration in discussions of the Scottish scene (as indeed is also reflected in the inclusive approach taken by several of the anthologies and organisations cited), these conceptual problems should be taken into account. They are yet another reminder of a wider issue that goes far beyond the confines of this particular chapter: the problem that national classifications (especially when employed in an unreflecting, essentialist and exclusivist manner) can be intensely limiting. This ties into more general debates on whether it is possible to speak of a post-national, post-ethnic and/or cosmopolitan turn in recent Scottish society, writing and criticism (see e.g. Schoene 2007). Nonetheless, we should not assume a simplistic teleology from the national to the global – as contemporary politics (as well as some of the primary texts discussed here) remind us, the nation-state as a framework for political action remains very much with us, for better or worse. Moreover, nation-states – and nations as imagined communities – sometimes prove to be relatively *flexible* frameworks that can be filled with different contents, the precise nature of which is open to (re)negotiation by the various social agents. This is also reflected in several of the texts and debates discussed here, as the Scottish literary scene is being constantly redefined in the light of a complex dialectic between shifting local, national and transnational affiliations.

## References

BBA Shakespeare (British Black and Asian Shakespeare Performance Database, University of Warwick) (2020), 'Faroque Khan', BBA website. https://bbashakespeare.warwick.ac.uk/people/faroque-khan (accessed 10 September 2020).

Bell, Henry (2020a), personal website. https://henryjimbell.com/Projects (accessed 20 July 2020).

Bell, Henry (2020b), email to S. Stroh, 10 September 2020.[7]

Bell, Henry (2021), email to S. Stroh, 14 September 2021.

Bijli Productions (2020a), homepage. http://bijliproductions.com/ (accessed 10 September 2020).

Bijli Productions (2020b), 'About us', Bijli website. http://bijliproductions.com/about/ (accessed 10 September 2020).

British Sociological Association (BSA) (2020), 'Language and the BSA: ethnicity & race', BSA website. https://www.britsoc.co.uk/ (accessed 5 September 2020).

Chatterjee, Debjani (ed.) (2000), *The Redbeck Anthology of British South Asian Poetry*, Bradford: Redbeck.

Chu, Deborah (2019), "The hot 100 2019: #2 Jess Brough (Fringe of Colour)', *The List*, 1 November. https://www.list.co.uk/article/112305-the-hot-100-2019-2-jess-brough-fringe-of-colour/ (accessed 25 August 2020).

Dawes, Kwame (ed.) (2010), *Red: An Anthology of Contemporary Black British Poetry*, Leeds: Inscribe.

Dibdin, Thom (2017), 'Residencies announced for Scottish diversity project', *The Stage*, 9 May. https://www.thestage.co.uk/news/residencies-announced-forscottish-diversity-project (accessed 19 September 2020).

Fraser, Bashabi (2004a), *Just One Diwali Night*, Kolkata: Dasgupta.

Fraser, Bashabi (2004b), *Ramayana*, Edinburgh: Edinburgh Puppet Workshop.

Fraser, Bashabi (2004c), *Tartan & Turban*, Edinburgh: Luath.

Fraser, Bashabi (2004d), *Topsy Turvy*, Kolkata: Dasgupta.

Fraser, Bashabi (2009), *From the Ganga to the Tay: A Poetic Conversation between the Ganges and the Tay*, illustrated with photographs made by the author and Kenny Munro, Edinburgh: Luath.

Fraser, Bashabi (2012), *Ragas and Reels: Visual and Poetic Stories of Migration and Diaspora*, Edinburgh: Luath.

Fraser, Bashabi (2015), *Letters to my Mother and Other Mothers*, Edinburgh: Luath.

Fraser, Bashabi (2017), *The Homing Bird*, Beaworthy: Indigo Scotland.

Fraser, Bashabi (2021), *Patient Dignity*, Edinburgh: Scotland Street Press.

Fraser, Bashabi and Alan Riach (eds) (2017a), *Thali Katori: An Anthology of Scottish & South Asian Poetry*, Edinburgh: Luath.

Fraser, Bashabi and Alan Riach (2017b), 'Introduction', in Fraser and Riach 2017a: 17–25.

Fringe of Colour (2021), homepage. https://www.fringeofcolour.co.uk/ (accessed 11 September 2021).

George, Annie (2017), 'Breaking barriers, moving forwards'. Excerpt from a paper given at the Project X Symposium 'Let's Move to More *Visibility*', Tramway Arts Venue, Glasgow, September, on George's website, https://anniegeorge.net/traces/ (accessed 10 September 2020).

George, Annie (2020), Professional profile on LinkedIn. https://www.linkedin.com/in/annie-george-5aaa81a/?originalSubdomain=uk (accessed 10 September 2020).

Gifford, Douglas and Alan Riach (eds) (2004), *Scotlands: Poets and the Nation*, Manchester: Carcanet, and Edinburgh: Scottish Poetry Library.

Guyan, Kevin (2020), 'BAME perceptions and experiences of Scotland's literary sector'. Report commissioned by the Scottish BAME Writers

Network, based on a data survey conducted in February and March 2020, released on Scottish BAME Writers Network homepage, 7 July. https://scottishbamewritersnetwork.org/wp-content/uploads/2020/07/EDI-Scotland-Final-Report-20200701.pdf (accessed 25 October 2020).

Guyan, Kevin (2021), 'Perceptions and experiences of writers of colour in Scotland's literary sector'. Report commissioned by the Scottish BAME Writers Network, based on a data survey conducted in March 2021, released on Scottish BAME Writers Network homepage, 26 May 2021. https://scottishbamewritersnetwork.org/2021-survey-report/ (accessed 11 September 2021).

Huchu, Tendai [2010] (2011), *The Hairdresser of Harare*, Harare: Weaver. (2nd edn, Athens: Ohio University Press.)

Huchu, Tendai (2012), 'The sale', in Ivor W. Hartmann (ed.), *AfroSF: Science Fiction by African Writers*, n.p.: Storytime, e-book version: n.p.

Huchu, Tendai (2014a), 'Brian', *The Manchester Review*, 12 July. https://www.themanchesterreview.co.uk/?p=3649 (accessed 9 September 2020).

Huchu, Tendai (2014b), 'The second coming of Dambudzo Marechera', *One Throne Magazine* 4 (Winter). https://www.onethrone.com/issue-4-winter-2014 (accessed 9 September 2020).

Huchu, Tendai [2014] (2015), *The Maestro, the Magistrate & the Mathematician*, Bulawayo: amaBooks. (Repr. Cardigan: Parthian.)

Huchu, Tendai (2016), 'Dead white guy', *Enkare Review*, 21 September. https://enkare.org/2016/09/21/dead-white-guy-tendai-huchu/ (accessed 9 September 2020).

Huchu, Tendai (as T. L. Huchu) (2021), *The Library of the Dead*, Edinburgh Nights series, Vol. 1, New York: Tor.

Jackson, Joseph H. (2020), *Writing Black Scotland: Race, Nation and the Devolution of Black Britain*, Edinburgh: Edinburgh University Press 2020.

Joseph, Chanté (2020), 'Bookmark this: are acronyms like BAME a nonsense?', *Gal-dem*, 25 June. https://gal-dem.com/bookmark-this-are-acronyms-like-bame-a-nonsense/ (accessed 9 September 2020).

Kay, Jackie, James Procter and Gemma Robinson (eds) (2012), *Out of Bounds: British Black & Asian Poets*, Newcastle: Department of English Literary & Linguistic Studies, Newcastle University, and Tarset: Bloodaxe.

Kay, Jackie, Jessica Brough, Alycia Pirmohamed and J. G. Ying (2019/2020), 'The conversation', *Gutter* 21 (February): 76–84. (Transcript of a discussion conducted in October 2019.)

Kennedy, Patrick (2006), review of the performance of Raman Mundair's play *Side Effects* at Dublin Fringe Festival, published by *RTE: Ireland's National Public Service Media*, 13 September. https://www.rte.ie/entertainment/2006/0913/450256-sideeffects/ (accessed 10 September 2020).

Khan, Faroque (2008), abstract of his paper 'Insaan: the challenges of cultural diversity', book of abstracts for the conference 'British Asian

Theatre: From Past to Present', University of Exeter, 10–13 April: n.p. [p. 12]. https://www.exeter.ac.uk/ (accessed 28 June 2020).

Ley, Graham and Sarah Dadswell (2011), account of Wave Theatre, in Graham Ley and Sarah Dadswell (eds), *British South Asian Theatres: A Documented History* (book with DVD), Exeter Performance Studies, Exeter: University of Exeter Press, p. 252.

Li, Chin (2014), 'Cooking for one', *Glasgow Review of Books*, 24 October. https://glasgowreviewofbooks.com/2014/10/24/cooking-for-one-a-short-story-by-chin-li (accessed 10 September 2020).

Li, Chin (2015), 'Beyond the garden: a love story', *Glasgow Review of Books*, 6 November. https://glasgowreviewofbooks.com/2015/11/06/beyond-the-garden-a-love-story-a-short-story-by-chin-li// (accessed 10 September 2020).

Li, Chin (2019a), 'A long-distance voice', *Ink, Sweat & Tears* (literary online magazine), 4 March. https://inksweatandtears.co.uk/ (accessed 10 September 2020).

Li, Chin (2019b), 'The sea is wild', *Litro*, August. https://www.litromagazine.com/2019/08/the-sea-is-wild/ (accessed 10 September 2020).

Li, Chin (2019c), 'The last chant', *Glasgow Review of Books*, 30 September. https://glasgowreviewofbooks.com/2019/09/30/7017/ (accessed 10 September 2020).

Li, Chin (2020), 'A few of everything', *Gutter* 21 (February): 119–21.

MacNeil, Kevin and Alec Finlay (eds) (2000), *Wish I Was Here: A Scottish Multicultural Anthology*, Edinburgh: Pocketbooks.

Megaphone (English development scheme for BAME writers in children's literature) (2020a), homepage. https://megaphonewrite.com/ (accessed 10 September 2020).

Megaphone (2020b), 'Background', Megaphone website. https://megaphonewrite.com/background/ (accessed 15 July).

Mercer, Kobena [1990] 1994, 'Black art and the burden of representation'. (Rev. repr. in Mercer, *Welcome to the Jungle: New Positions in Black Cultural Studies*, London: Routledge, pp. 233–58 and 321f.)

Moolla, F. Fiona [2018] (2021), 'Travelling home: diasporic dis-locations of space and place in Tendai Huchu's *The Maestro, the Magistrate and the Mathematician*', *Journal of Commonwealth Literature* 56.2: 234–51. (Pre-published online 2018 https://journals.sagepub.com/doi/abs/10.1177/0021989418802609)

Moonsamy, Nedine (2016), 'Life is a biological risk: contagion, contamination, and utopia in African science fiction', *Cambridge Journal of Postcolonial Literary Inquiry* 3.3 (September), special issue: *African Science Fiction*: 329–43.

Mundair, Raman (2003), *Lovers, Liars, Conjurers and Thieves*, Leeds: Peepal Tree.

Mundair, Raman [2004] (2007), 'A choreographer's cartography', *Kavya Bharati* 16, special issue: *Poetry of the Indian Diaspora – I*: 55f. (Strongly rev. repr. in Mundair 2007b: 57f.)

Mundair, Raman (2007a), *The Algebra of Freedom*, n.p. [London]: Aurora Metro Press.

Mundair, Raman (2007b), *A Choreographer's Cartography*, Leeds: Peepal Tree.

Mundair, Raman (2007c), 'Lamb', *Star Weekend Magazine* 6.17 (4 May). https://www.thedailystar.net/magazine/2007/05/01/fiction.htm (accessed 10 September 2020).

Mundair, Raman (2015), 'Day trippers', in Jacob Ross (ed.), *Closure: Contemporary Black British Short Stories*, Leeds: Peepal Tree, pp. 136–42.

Mundair, Raman (2018), 'Your land is my land: perspectives from an immigrant', *Bella Caledonia*, 5 January. https://bellacaledonia.org.uk/2018/01/05/your-land-is-my-land-perspectives-from-an-immigrant/ (accessed 9 September 2020).

Mundair, Raman (2020a), 'The fragile white body, censorship and resistance', *Gutter* 21 (February), themed issue focusing on BAME writers, guest-edited by Alycia Pirmohamed and Jay G. Ying: 65–9.

Mundair, Raman (2020b), 'Loneliness and connections in the midst of COVID', Fringe of Colour, 13 July. https://www.fringeofcolour.co.uk/responses/ loneliness-and-connections-in-the-midst-of-covid (accessed 10 September 2020).

Mundair, Raman (2020c), 'Decolonising theatre: a playwright's perspective', *Bella Caledonia*, 1 September. https://bellacaledonia.org.uk/2020/09/01/decolonising-theatre-a-playwrights-perspective/ (accessed 9 September 2020).

Nasta, Susheila and Mark U. Stein (eds) (2020a), *The Cambridge History of Black and Asian British Writing*, Cambridge: Cambridge University Press.

Nasta, Susheila and Mark U. Stein (2020b), 'Introduction', in Nasta and Stein 2020a: 1–21.

Newland, Courttia, Adam Elliott-Cooper et al. (2016), 'Beyond "PoC" and "BAME": the terminology we use to define ourselves', Media Diversified, Part I (16 July): https://mediadiversified.org/2016/07/16/past-poc-and-bame-the-terminology-we-use-to-define-ourselves/; Part II (17 July): https://mediadiversified.org/2016/07/17/182118/ (accessed 9 September 2020).

Omari, Mariem (2020), email to S. Stroh, 10 September 2020.[8]

O'Rourke, Donny (ed.) (2002), *Dream State: The New Scottish Poets*, 2nd rev. edn, Edinburgh: Polygon.

Pearl, Jeda (2020), personal website. http://www.jedapearl.com/ (accessed 1 July 2020).

Pirmohamed, Alycia (ed.) (2019), *Ceremony*, Tarland: Tapsalteerie.

Saltire Society (2016), 'Discovering a new voice', Saltire Society website. https://www.saltiresociety.org.uk/awards/literature/previous-years/literary awards/2016/emerging-minority-ethnic-voice/ (accessed 10 September 2020).

Schoene, Berthold (2007), 'Going cosmopolitan: reconstituting "Scottishness" in post-devolution criticism', in Berthold Schoene (ed.), *The Edinburgh*

*Companion to Contemporary Scottish Literature*, Edinburgh: Edinburgh University Press, pp. 7–16.

Scottish BAME Writers Network (SBWN) (2020a), 'Call to action: Scottish literary sector', blog entry, 6 June, SBWN website. https://scottishbame-writersnetwork.org/call-to-action/ (accessed 2 July 2020).

Scottish BAME Writers Network (SBWN) (2020b), 'Mission and values', SBWN website. https://scottishbamewritersnetwork.org/mission-statement-values/ (accessed 2 July 2020).

Scottish BAME Writers Network (SBWN) (2020c), 'Safer Spaces', SBWN website. https://scottishbamewritersnetwork.org/safer-spaces-policy/ (accessed 2 July 2020).

Scottish BAME Writers Network (SBWN) (2021a), homepage. https://scottishbamewritersnetwork.org/ (accessed 11 September 2021).

Scottish BAME Writers Network (SBWN) (2021b), 'About', SBWN website. http://scottishbamewritersnetwork.org/about/ (accessed 11 September 2021).

Scottish BAME Writers Network (SBWN) (2021c), 'News release: Creative Scotland award 2021 announcement + "staying connected"', blog entry, 22 January 2021, SBWN website. https://scottishbamewritersnetwork.org/news-release-creative-scotland-2021-award-announcement/ (accessed 11 September 2021).

Scottish Poetry Library (SPL) (2020), website. https://www.scottishpoetry-library.org.uk/2019/04/poetry-groups-at-the-spl/ (accessed 1 July 2020).

Stroh, Silke (2019), 'Scottish–Indian connections and (trans)national identity: Bashabi Fraser's engagement with the literary and visual archive', *Literatur in Wissenschaft und Unterricht (LWU)* 49.4 (officially dated 2016, but actually published in 2019): 249–64.

Taylor, Amy (2017), 'Sara Shaarawi introduces Megaphone' (combination of a news report and an interview with Shaarawi), *The Skinny*, 16 May. https://www.theskinny.co.uk/theatre/shows/previews/sara-shaarawi-workerstheatre-megaphone (accessed 20 July 2020).

Upstone, Sara (2020), 'Post-ethnicity and the politics of positionality', in Nasta and Stein 2020a: 650–62.

The Workers Theatre (2017), 'Megaphone: a new theatre residency for artists of colour. Open call for submissions'. https://workerstheatre.word-press.com/megaphone/ (accessed 20 July 2020).

The Workers Theatre (2021), homepage. http://workerstheatre.co.uk/ (accessed 11 September 2021).

## Notes

1. This should not be confused with the term 'coloured', whose connotations vary in different countries but which in many places (including the UK and the USA) is now widely rejected as a racist slur.

2. *Insaan* means 'human' in Urdu and Hindi.
3. Bijli is an Urdu and Hindi word for electricity or lightning.
4. This Scottish-based but internationalist project in itself was newly set up in 2015 by Sara Shaarawi, Henry Bell, Harry Josephine Giles and Linden McMahon. It aimed to offer residencies, cooperations and events, as well as (in the medium term, initially by 2020) establishing its own studio theatre, although (judging from research conducted at the time of writing between summer 2020 and September 2021) developments seem to have progressed more slowly than initially anticipated (information based on Taylor 2017; The Workers Theatre 2017, 2021; Bell 2020a, 2020b).
5. This Scottish Megaphone bursary should not be confused with an English initiative of the same name, i.e. the Megaphone development scheme for BAME writers in children's literature, which was established in 2015 and has, for instance, been funded by Arts Council England (Megaphone 2020a, 2020b).
6. *Side Effects* has not yet been published in book form. However, a relatively detailed account of the contents is provided in Kennedy (2006).
7. I would like to express my gratitude to Henry Bell for sharing this information and allowing me to cite it.
8. Again, I would like to express my thanks to the author for providing me with information, and for permission to cite it here.

# Mapping Escape: Geography and Genre

*Timothy C. Baker*

At the close of Willa Muir's *Imagined Corners* (1931) the novel's two protagonists, both named Elizabeth Shand, escape the confines of the small northeast town of Calderwick for Europe. If Calderwick is where Lizzie Shand has been able to discover 'her central, dispassionate, impregnable self' (Muir 1987: 280), it is also a place that is hostile to the individual; only in Europe, Muir suggests, can one overcome the natural hostility to free thinking found in Scottish towns. The tension between European and Scottish life appears in many other texts by Scottish women writers over the twentieth century, from Catherine Carswell's *The Camomile* (1922) to Janice Galloway's *Foreign Parts* (1994). More recent texts, however, have stressed regional as well as national divisions, and suggest a new perspective can be found simply by shifting setting. In thematically diverse twenty-first-century novels ranging from Laura Marney's comic *No Wonder I Take a Drink* (2004) to Jenni Fagan's dystopian *The Sunlight Pilgrims* (2016), characters turn to remote highland and island communities as places of remove and renewal. In both novels, as well as those discussed below, remote communities not only prove to be more complex than the characters sometimes imagine, but also are used to illustrate the failure of dominant epistemological and geographical categories.

Linda Cracknell's *Call of the Undertow* (2013) and Sarah Moss's *Night Waking* (2011), for instance, feature a cartographer and historian, respectively, who leave the structured environment of Oxford for remote Scottish communities. The two novels share a geographic focus on isolated, rural landscapes, a thematic focus on motherhood and loss, and a generic combination of conventional realism and the fantastic, making use of Gothic tropes. They also interrogate ideas of disciplinary expertise: the protagonists come to understand the land and people

around them through their academic specialisms, but also discover the limits of such discourses. Likewise, in crime novels such as Karen Campbell's *Rise* (2015) and Denise Mina's *Blood Salt Water* (2015), the apparent idyll of remote communities is shown to be ultimately unstable as larger political and social forces intervene in characters' lives. Shona MacLean's *The Redemption of Alexander Seaton* (2008), meanwhile, not only challenges the divide between rural and urban environments, but casts doubt on the entire project of geographic knowledge. Each of these novels challenges traditional understandings of genre fiction by focusing on the complex relationship between gender, landscape and knowledge. In particular, focus on maps and other cartographic forms of writing draws attention to the complicated relation between place, self and story in contemporary Scottish women's fiction.

Questions of spatial identity are perhaps intrinsic to any discussion of Scottish literature. In a recent argument for the utility of contemporary digital geographic technology in understanding Scottish culture, for instance, Eric Gidal and Michael Gavin argue that all Scottish studies might be considered an example of 'spatial humanities', revealing Scotland as 'an internally divided site of mobility and interconnection' (Gidal and Gavin 2016: 144–5). In his influential argument for Scotland as peripheral, likewise, Cairns Craig claims that the 'fundamental trajectory of the modern Scottish novel . . . [is] between the mapmaker's map and an "otherworld" where space has different dimensions' (Craig 1999: 241). Such a trajectory is well-represented in two key modernist-era texts. In John Buchan's *The Thirty-Nine Steps* (1915) Richard Hannay's flight to Scotland begins when he peruses an atlas, selecting Galloway simply because it 'was the nearest wild part . . . . [and] not over thick with population' (Buchan 1999: 21). The characteristics of the landscape are fixed by the atlas but are also in some sense arbitrary: Scotland is simply a convenient hideaway. In Nan Shepherd's *The Quarry Wood* (1928), the protagonist's father, Geordie, locates Scotland in both more abstract and local terms, as he tries to explain the aurora borealis to his daughter: '"On the sooth o' Scotland there's England, on the north the Arory-bory – Burnett's lassie, the reid-heided ane – Alice; on the east – fat's east o't"' (Shepherd 1987: 19). Although Geordie cannot remember the rhyme and can 'get no further with the boundaries of Scotland' (Shepherd 1987: 20), his combination of immediate referents and poeticisms replicates the tension between the desire for worldly knowledge and local wisdom that occupies the rest of the novel. In both novels Scotland is neither simply a place on a map nor defined by individual experiences but is defined by the tension between the two.

Both Shepherd's and Muir's novels can also be seen in relation to Jane Garrity's claim that 'British women's metaphorical mapping of space can be read as an attempt to recast their actual marginality and displacement by constructing an alternative women's sphere that conjoins female agency, mobility, and national expansion' (Garrity 2003: 26). For Garrity, the interest in both literal and conceptual mapping found in mid-century women's writing is a way to reassert the links between national, gendered and territorial identity. Yet while the novels below certainly share a concern with the figure of the map, their focus is more strongly on regional, rather than national, identity; they also suggest the limitations of any geographic discourse. The map, as a socially constructed and inherently selective representation of reality, demonstrates the limits of any given system of knowledge. As such, questions of geographical knowledge are often juxtaposed in the following novels with larger epistemological concerns. The novels also share an interest in destabilising generic conventions. Moss and Cracknell, for instance, make use of Gothic tropes, while Mina and MacLean similarly explore and challenge the form of the crime novel. As such, each of the novels below can be read in terms of Marie-Odile Pittin-Hedon's recent claim that the Scottish novel 'problematises the notions of space, identity, and writing' (Pittin-Hedon 2015: xiii); reading these novels in relation to contemporary phenomenological and geographic discourse illustrates how contemporary Scottish women's fiction can be seen in relation to contemporary discourses of space.

## Gothic Landscapes: Sarah Moss and Linda Cracknell

As Monica Germanà has recently noted, contemporary Scottish female Gothic, although difficult to define, combines a focus on authorial and patriarchal control with a ghostly Scottish scenery in which 'the fluid lines of the Scottish landscape form an illegible text' (Germanà 2017: 234). The connection between spatial and narrative identities is central to many discussions of the female Gothic more generally. Reflecting on Ellen Moers's notion of the 'female landscape', for instance, Nancy K. Miller argues that

> the 'female landscape' is not only . . . a scene within which to read metaphors of sexuality, it is also an iconography of a desire for a revision of story, and in particular a revision of closure. This desire for another logic of plot which by definition cannot be narrated, looks elsewhere for expression. (Miller 1986: 278)

Moers's original work, in 1976, was one of the first concerted attempts to define the 'female Gothic', a term that continues to be subject to much debate, but arguably remains important for its ability to challenge questions of national identity, sexuality, language, race and history. As Lauren Fitzgerald notes, while the very concept may seem to have 'outlived its usefulness', its importance remains in the way that it incorporated feminist thought into literary study in a period less given to specialisations than our own (Fitzgerald 2009: 13). Thinking of the female Gothic was, and perhaps remains, a way of taking women's genre writing seriously. While Moss's and Cracknell's novels might not fit a rigid definition of Gothic, their use of Gothic motifs suggests Miller's ideas of 'revision of closure' and the look elsewhere for expression; likewise, both novels explore the links between text and landscape as a way of deconstructing traditional forms of authority and identity. Most importantly, both novels challenge the idea of disciplinary or intellectual expertise and forms of knowledge: their focus on images of archives and maps is used to reinforce ideas about the limitations of traditional and patriarchally-driven forms of knowledge.

*Call of the Undertow* and *Night Waking* tell remarkably similar stories. In both, a young woman leaves Oxford for a remote Scottish environment; in Cracknell's novel the cartographer Maggie Thame moves to Caithness to work on an atlas of West Africa, while in Moss's the historian Anna Bennett moves to an uninhabited island off the west coast of Scotland, modelled on St Kilda, to write a monograph on Romantic conceptions of childhood. In both, children are placed at the forefront: Thame is fleeing not only a failed relationship but, it is revealed late in the novel, her inadvertent killing of a small child in an auto accident, while Bennett is struggling to raise two small children in a difficult situation. Both, similarly, meet a strange child: in Bennett's case simply a temperamental teenager, the daughter of her first guests at the island retreat she is opening, while Thame encounters an otherworldly boy who may be a selkie. In both, too, the narrative arc follows a similar pattern: the protagonist, through dealings with these various unhappy children, learns to confront her own weaknesses as a parent or carer, and returns to some sort of academic life at the end. In both, crucially, hostile or remote landscapes are used as a crucible, of sorts, in which the protagonist readies herself for a return to England or the Central Belt. Rather than echoing the claustrophobic Scottish landscapes in novels by Elspeth Barker, Alice Thompson or Iain Banks, the novels emphasise domestic and familial concerns, and include an apparently conservative resolution, where a status quo is reasserted.

In their focus on academic discourses of space and history, however, the novels suggest alternative ways not only of thinking of such disciplines, but of the way Scotland is figured within them. In *Night Waking* Bennett finds traditional practices of writing history frustrating, in part because of their separation from her everyday life. Midway through the novel she explains to Zoe, the visiting teenager, the importance of social history and of the context in which legal decisions are made, in a scene interspliced with her toddler singing about Old MacDonald's farm, home to a dragon and a leopard, and the wolf on the bus, who goes munch munch munch:

> 'Leopards say roar! Leopards on a farm!'
> 'With a roar, roar here, and a roar, roar there. Ee-i, ee-i, o.' Killing babies is wrong but if it is your own baby you may be mad, which is not a criminal offence. Zoe passed me the bowl and I pulled the dough apart into three more or less equal pieces. 'Yes,' I said. 'I see the appeal of that. History is also about narrative in the end. Whether the gaps and silences might mean anything. Though the consequences of the stories you tell are much more general. Cultural memory and national identity rather than who goes to prison. And you don't get to think about individuals in quite the same way.'
> 'Wolf on a bus.' (Moss 2011: 263)

The point about history is undoubtedly familiar. As Carolyn Steedman writes, discussing the same period on which Bennett's work focuses:

> Our understanding of all sorts of plot – fictional plots and social plots – our understanding of *how things happened* indeed, is bound up with this understanding: that there is sequence, event, movement; things fall away, are abandoned, get lost. Something emerges, which is a story. (Steedman 2001: 166)

Understanding history as story means acknowledging a principle of waste. To speak of cultures or nations means not speaking about individuals, or not speaking about them in the same way. As is clear from the passage above, *Night Waking* foregrounds elements that are, it seems, inessential to its apparent narrative: the specificity of children's interruptions, the domestic chores done or undone, and so on. The internal and external, the academic and the domestic, are inseparable.

Perhaps inevitably, Bennett's realisation that these details matter is what permits her return to academia, when she finds a series of

letters detailing nineteenth-century neonatal care on the island and makes it the basis of her future research. Bennett's task – and Moss's – becomes the incorporation of women's voices into historic narratives, and a focus on lower-class lives. The novel integrates letters from a visiting midwife May Moberley – who, with her family, is the subject of two sequels – with the contemporary-set narrative, indicating the extent to which no account of 'society' as such can be complete without a concomitant focus on the individual. Even as May herself vanishes from the text, to the point where her final letters are often unsigned, the inclusion of her letters indicates the extent to which the space of the text itself must be multiform in order to include the diversity of experiences of a particular place.

The trajectory of Cracknell's novel is not dissimilar. Thame approaches her atlas from a position of remove, where Western Africa is almost an imagined land. As she struggles with her project, she finds quotidian life intervening:

> Despite a place as illusory to her as Narnia or The Shire, she was starting to draw outlines of the land, filling statistics into pie charts, and translating river systems into diagrams . . . She stared on at the map of Lagos. Her thoughts became dangerously unfocussed, scattering to where she would walk, whether she could be bothered to make lasagne later, a vague sense she should phone Carol. Solutions to the Lagos problem dodged her. She stared for too long. (Cracknell 2013: 27–8)

Rather than reflecting her own experience with a particular place, Thame uses mapmaking as a distraction. For the protagonists of both novels, systems of knowledge are initially arbitrary and untied to the world they inhabit. As Peter Turchi argues, maps simultaneously 'suggest explanations' and resist them, insofar as they 'are often more revealing in what they exclude' (Turchi 2004: 11, 29). At a basic level, Thame's maps exclude the places she knows, and in turn present non-Scottish places as implicitly fictional. Yet like Bennett, Thame is ultimately able to use this discordance between experience and knowledge as a new foundation to her work: both protagonists make interruption the theme of their work, and the key to their success. Although this process might seem familiar, however, it ends up requiring a redefinition of space.

In both novels, Scotland is initially positioned as a peripheral space, in the sense made famous by Cairns Craig. It is a position from which one can reflect on the outside world and chart its comings and goings. Yet both protagonists are shocked, in a sense, to

discover that the world they inhabit actually matters. In *Call of the Undertow*, for instance, Thame forges a friendship with the young selkie-boy Trothan, presented from the first as someone alien and outside the community, and teaches him mapmaking. At a public gathering he reveals his non-traditional map of the town:

> Each time she looked back, she became aware of more she hadn't seen in his drawings before and words she had no time to read. She would look properly later. The map simply looked a gorgeous thing. Highly detailed, figurative, but also conveying a real sense of geography, not only of the land, but the seabed, and the connections between them. She'd never seen anything quite like it. It seemed to take the artistic merit of early maps and the later passion for accurate geography, but then to add a further layer of story and subjective interpretation of the landscape. The seals and guillemots had been depicted in their own abstracted square of sea, which was seen from a sort of Picasso-esque perspective. (Cracknell 2013: 151)

The space of the town can only be truly presented when it is made into an inclusive story, when it is interpreted. As Denis Wood argues, maps at their best transcend individual experience to present 'a reality that exceeds our vision, our reach, the span of our days, a reality we achieve no other way. We are always mapping the invisible or the unattainable or the erasable' (Wood 1993: 4–5). Maps both draw from and surpass direct experience in order to create a new, transformational reality. Trothan's map, for instance, includes non-human as well as human realms, but also tells a human story: it includes details of an illegal fishing venture, down to boat registration numbers, causing much consternation in the town. In Trothan's map, unlike the maps Thame has previously made, everything can be included, but that principle of inclusion causes discord by creating a new reality. Yet both maps, of Dunnet and West Africa, change both characters' and readers' perceptions of space into something that is both knowable and multiple.

The multiplicity of space has been established by Doreen Massey, who writes: 'we understand space as the sphere of the possibility of the existence of multiplicity in the sense of contemporaneous plurality; as the sphere in which distinct trajectories coexist; as the sphere therefore of coexisting heterogeneity' (Massey 2014: 9). Space, that is, is not only multiple, but is co-continuous with multiplicity itself: space is what allows difference. In this sense, a map or a history that hopes to reflect a particular space accurately must privilege interrelation, as

Trothan's does. Certainly ideas of multiple, heterogeneous space can be seen in authors such as Ali Smith and A. L. Kennedy, among others. In *Hotel World* (2001), for instance, the distinct trajectories of the various protagonists – and of various narrative styles – are able to coexist because the setting is, in Marc Augé's terms, a 'non-place' (Augé 2008: 63). In Cracknell's text, on the other hand, the real physical space of Dunnet is combined with the fictional and fantastic characters yet maintains some of the generic and narrative play we find in Smith's work. This combination of the real and fantastic is in part, of course, a feature of contemporary Gothic more generally. Cracknell's focus on cartography, however, also draws attention to the fabricated, material realisation of this feature: a sense of space that privileges multiplicity is only possible in the act of writing or drawing, which creates, as Wood argues, a new reality. Space, here, is revealed most truly in its material, textual form.

In Moss's novel, too, spatial history is textually constituted. The letters detailing the island's history are interspersed throughout the text but are only found by the protagonist at its end; the discovery of these texts leads her to look at contemporary interviews and other primary sources. These sources are, crucially, inconclusive. As she says in her interview at the University of Glasgow, the ambiguous conclusions of her research offer '"a sharp illustration of the impossibility of untangling history and ideology"' (Moss 2011: 370). This sense of the impossibility of any single narrative explanation is crucial to both novels. In each, history and space are formed through writing. Those documents are available to other people and change how a given space is perceived. Yet the wealth of detail does not provide definitive answers. As befits their use of Gothic tropes, the texts in these novels are definitive and open, inclusive and exclusive, comprehensive and partial. As such, both novels ultimately present a view of ordinary life as, in Lauren Berlant's words, 'a zone of convergence of many histories' (Berlant 2011: 10). They privilege the subjective, multiple and liminal. Both novels finish with an apparent happy ending, where the protagonist is able to rejoin the world. Bennett becomes an academic and plans to write a monograph on her discovery. Thame uses Trothan's techniques to solve her own problems with mapmaking. Yet neither conclusion is definitive: Bennett has not solved her children's problems, while in Cracknell's novel Trothan's fate is never resolved.

Both novels thus present, in Miller's terms, a revision of closure that privileges the non-narratable. There is, in both novels, more to the story than can be set down on its pages – the happy ending

belongs to the novel, but there is another ending, less complete and less happy, which lingers underneath. This ambiguity raises challenges to ideas of a straightforward depiction or representation of space. Thinking of space as multiple challenges the idea of a space as intrinsically pure, or representable – as, indeed, maps or even histories might make it appear. Massey writes:

> Space is as much a challenge as is time. Neither space nor place can provide a haven from the world. If time presents us with the opportunities of change and (as some would see it) the terror of death, then space presents us with the social in the widest sense: the challenge of our constitutive interrelatedness – and thus our collective implication in the outcomes of that interrelatedness; the radical contemporaneity of an ongoing multiplicity of others, human and non-human; and the ongoing and ever-specific project of the practices through which that sociability is to be configured. (Massey 2014: 195)

Both Moss's and Cracknell's novels present a similar idea: there is no haven, and interrelatedness is always a challenge. The novels highlight the fragility of experience, and of any discourse that attempts to document it. Both novels, in moving towards a more open and inclusive conception of knowledge and representation, also highlight the challenges that such a conception may involve. As such, the discourses of both history and space, predicated on interruption and fragmentation, are envisioned as simultaneously liberating and irresolvable.

## Mapping Crime: Shona MacLean, Denise Mina and Karen Campbell

While contemporary Gothic often focuses on liminal spaces or deconstructs established notions of space, contemporary crime fiction is often more committed to a traditionally realistic portrayal. As multiple critics have noted, crime fiction often has a 'strong emphasis on contemporary social and political realities' (Horsley 2005: 159), and indeed 'makes a place in the social world for the discussion of the impact of events on others' (Evans 2009: 166). Central to this idea of the social is the presentation of a familiar, inhabited space: Mina's and Campbell's Glasgow, and MacLean's Aberdeen, are intimately observed and finely drawn. Mina's only historical text, *The Long Drop* (2017), for instance, places a map of 1957 Glasgow on its

frontispiece, with key locations highlighted in red, and combines historical and geographical information in straightforward descriptions:

> A different policeman from Hamilton Police Station sets off to visit the family home in Sheepburn Road, Uddingston. Uddingston is a nice town, far enough away from Glasgow to stay nice. The poor people, mostly Catholics, are corralled into an estate nearby called Birkenshaw. (Mina 2017: 77)

The narrative voice appears wholly reliable, and the focus of the passage is what the place reveals about social realities, rather than the place itself. While regional and local identities are central to the narrative, they are presented in terms of individual and collective experience, rather than as abstractions. Yet each of these authors also challenges established notions of space and cartography, especially in their focus on peripheral spaces, and the combination of real and fictional places.

Campbell's *Rise* opens with a Buchan-like appeal to abstract geography: 'Pin in a map, pin in a map. Anywhere at all. Don't care, as long as it's not here' (Campbell 2015: 1). The novel's central characters escape to the small Highland town of Kilmacarra as a place that offers possibilities for a new life. For Justine, fleeing an abusive life in the city, it is simply a place that is not Glasgow, while for Michael, a former minister, it is a place of hope for a new, independent Scotland. Yet as Justine reflects, a town such as Kilmacarra cannot offer a pure haven:

> Why had Justine assumed a small country village would be a place of refuge and anonymity? Didn't everyone migrate to these places for the same thing? The retirees seeking the quiet life in a not-so-foreign land. The slow and failing businessman who knew a nice country pub was the answer. The suburban family wishing for only a muddy plot and organic carrots and then *JOCASTA WOULD SLEEP*. (Campbell 2015: 42–3)

As in Laura Marney's *For Faughie's Sake* (2014), also set in the lead-up to the referendum, a small town which is held to be Scotland in miniature ultimately becomes defined by the multitudes of new arrivals. Kilmacarra is dominated by its ancient landscape, with mountains and stone circles, and yet it is resolutely more modern, and less resistant to urban infiltration, than any of the characters wish. While both Michael and Justine initially approach their sojourn in the Highlands, as in earlier crime novels by Josephine Tey, as 'a

retreat into the past' (Walton 2015: 81), both come to realise that even the most remote parts of Scotland are defined by contemporary concerns, both social and political. Unlike the sometimes-hostile communities in Moss's and Cracknell's novels, however, Kilmacarra is not inherently unwelcoming; Justine finishes the novel taking comfort in being 'pinned into the map' (Campbell 2015: 419), defined by the community that surrounds her. This moment of acceptance is, perhaps, only made possible by the fictional setting: if in general terms '[s]pace oscillates between reality and fiction' (Westphal 2011: 90), Kilmacarra replicates such movement by bearing many real-world components, but ultimately being a wholly imagined space. It is only as the characters take control of a space that is simultaneously real and fictional that it can be fully inclusive. Kilmacarra, that is, is a community whose map exists only in the constellation of different characters, rather than on any printed document.

The narrative of Mina's *Blood Salt Water* bears many similarities to Campbell's novel, but centres on the real village of Helensburgh. Like Kilmacarra, Helensburgh is figured as a place of escape for several characters, a town of '[l]ovely, gentle people' where one might seek solace from grief (Mina 2015: 13). At the same time, however, it is also entirely alien, not least to Alex Morrow, Mina's long-running protagonist investigator. Helensburgh, she discovers, is a place where nothing is real: as one character says, 'There's too much money out here for any of it to be left real' (Mina 2015: 135). Instead of a place of new beginnings, it is instead a place fundamentally of deceit, where both individual and collective identities are altered for profit. While both *The Long Drop* and earlier Morrow novels highlight the hidden realities of particular Glasgow neighbourhoods, here the focus is on the essential unreality of a certain conception of small-town life: no place is remote, no character unimplicated. The novel as a whole charts the 'arbitrary status' of 'existing boundaries' and ways of approaching space (King 1996: 172).

As in the previous Morrow novel, *The End of the Wasp Season* (2011), architecture is posited as a key to identity. Morrow stumbles over other characters' 'obsession with houses' (Mina 2015: 287) and their privileging of architecture over human lives. Francis Delahunt's insistence that Helensburgh is an idyllic location, for instance, not only is contrary to what the novel has revealed, but also demonstrates his disconnection from the world. For Delahunt, Helensburgh, and the houses in it, are locked in a past that is removed from the globalised nature of contemporary criminal activities. Privileging space, and houses, over people leads to a misunderstanding of both.

While Campbell's novel suggests that a place is ultimately known through its people, in Mina's the relation between people and place is far more tenuous and difficult to define.

Both Mina's and Campbell's novels utilise small-town settings that are familiar from earlier generations of crime novelists, not least Agatha Christie. Central to their portrayal of both real and imagined communities, however, is the fundamental idea that no place in Scotland remains peripheral. If the protagonists of Moss's and Cracknell's novels must learn to incorporate multiple perspectives into their view of a particular place, in the latter two the emphasis is shifted slightly to suggest that no place can be known individually but must always be seen in relation to larger political and social realities. While the tone of each novel is different, they are united in suggesting that place is fundamentally unstable and is always informed by multiple experiences. In this, perhaps surprisingly, they can be read as aligned with Sara Ahmed's account of a queer phenomenology that takes account of both the familiar and unfamiliar:

> 'getting lost' still takes us somewhere; and being lost is a way of inhabiting space by registering what is not familiar: being lost can in its turn become a familiar feeling . . . The work of inhabiting space involves a dynamic negotiation between what is familiar and unfamiliar, such that it is still possible for the world to create new impressions, depending on which way we turn. (Ahmed 2006: 7–8)

This orientation is found in all four novels. The generic constraints produce a familiarity that is juxtaposed with the unfamiliar, to the end that explanatory discourses, especially those that provide explanation or resolution, are revealed to be partial. These novels show the necessity of incorporating wastage, misdirection and failure into any conception of the world, and the limits of traditional discourses of knowledge. While Campbell's novel is more optimistic than the other three, suggesting the possibility of individual reincorporation into a community, each of the novels attests that paying attention to the unfamiliar can transform an individual's relation to a particular place.

This mixed orientation, blending the familiar and unfamiliar, is perhaps most evident in the cartographic strategies of MacLean's novel. Alexander Seaton, a Banff schoolteacher in the early seventeenth century, is entrusted to transport a map that, it is revealed, may carry clues to a Catholic invasion. The maps he sees are initially remarkable for their specificity:

The Collie Rocks were there, Meavie Point, the Maiden Craig, the Bow Fiddle Rock, and many more besides . . . But there too were the man-made features – the new harbour works at Banff, the harbour at San-dend, the fastness of Findlater above the bay at Darkwater. At the edge of each sketch an arrow, next to what could only be a roadway, anno-tated 'to Elgin', 'to Turriff', 'to Strathbogie'. It was this last that began to give me the clue, if I had needed it, to the possible significance of the discovery of these documents, and the unrest they caused to those in the room. (MacLean 2008: 76)

Here MacLean makes visible what James Corner calls the 'collec-tive enabling enterprise' of mapping, 'a project that both reveals and realizes hidden potential' (Corner 1999: 213). For Corner, mapping is not simply a way of recording what is already present but is a process of exploration that precedes landscape. This is precisely the sort of map with which Seaton is charged: its depiction not only of known areas, but the previously unrecorded Banff coastline, makes it effective as a weapon. Maps, the novel suggests, are transformative, and often dangerous. The map is not simply 'a means of interaction between the real and the imaginary' (Westphal 2011: 162), but a way of making the imagined real. The world these maps reveal, in MacLean's novel, is worth killing for.

The central irony of MacLean's novel is that although the loca-tions are detailed and familiar, the historical setting defamiliarises them: Banff is no longer a multi-day horseride from Aberdeen, for instance, but within commuting distance. As such, the real locations become imagined. The significance of detailed maps of the Scottish coastline is difficult for the modern reader, who has easy access to such maps, to understand fully. This tension allows for Seaton's belated realisation that 'this was not a matter of spies and maps and papist plots. This was a matter of a husband, his wife, a young man and some flowers' (MacLean 2008: 378–9). By the end of the novel the maps that have occupied much of its plot are simply dismissed as irrelevant to the characters' lives, and ultimately insignificant. In this sense, MacLean's novel echoes Peta Mitchell's claim that, inso-far as maps reflect dominant structures of thought, 'every map that claims to be objective must in fact be inherently biased and political, deployed in order to shore up the stability and continued power of a totalizing authority or culture' (Mitchell 2008: 20). If maps have historically often been used as a tool of domination, creating borders and territories, MacLean's novel suggests that the true alternative lies not in using maps as a form of resistance, or secret knowledge, but

rather disregarding them altogether. The realisation that maps are ultimately a tool for the powerful, and are fundamentally political in themselves, leads our characters to turn from broad political engagement to more local concerns.

## Conclusion

Each of these novels explores the tension between rural and urban environments; in each, an apparent peripheral or remote setting is revealed to be more integrated in broader regional or national discourses than the characters initially imagine. Likewise, in each novel broader discourses of geography, history and cartography are often challenged: the claims of universal knowledge that these fields make are ultimately shown as false or partial. Just as importantly, though, each of these novels challenges the extent to which generic classifications are sufficient or explanatory. Although each makes use of the trappings of Gothic or crime conventions, none is limited to a single genre. Rather, they are united in demonstrating the extent to which all spaces are ultimately imagined. As Eric Prieto argues, literature has a fundamental role in the construction of space: 'The "fictive imagination" . . . seems to be more sensitive to those qualities of spatial and geographical formations that are most difficult to detect from within the established, formalized explanatory frameworks of the physical and social sciences' (Prieto 2011: 14). This suggests not only that a novel may reveal more about a particular place, real or imagined, than a map, but also that a novel's focus on a particular place can transcend the logic of maps altogether. For Wood, the utility of maps lies in the disappearance of the author:

> As long as the author . . . is in plain view . . . [the map] is seen as no more than a *version* of the world, as a *story* about it, as a *fiction* . . . Soon enough we have forgotten this is a picture someone has arranged for us (chopped and manipulated, selected and coded). Soon enough . . . it is the world, it is real, it is . . . *reality*. (Wood 1993: 70)

Maps begin as fiction, and only gradually are accepted as reality. The way to combat this, then, is through fiction, which can illustrate the extent to which a dominant representation of knowledge is always intrinsically partial. Fiction, that is, is able to be 'more sensitive' to spatial concerns precisely because it illustrates the fragmentary, partial, multiple foundations of knowledge. The same is true of the knowledge

that pertains to literature itself: by combining tropes from multiple genres, or resisting particular generic conventions, each of these novels points to the instability of broader categorisations.

The relation between text and geography is well-illustrated in a more conventionally realistic novel, Eleanor Thom's *The Tin-Kin* (2009). The novel combines the narration of the present-day protagonist, Dawn, as she returns to Elgin following her aunt's death, with three first-person perspectives from the 1950s, as a way of recuperating the lost voices of the traveller community. On finding an old photograph with an inscription on the back, 'Dawn's eyes filled with tears she couldn't explain. The slope of the handwriting pulled at her like a road in an atlas, the lie of the land and the lives connected to it. These small faces were not ghosts. They were not make-believe' (Thom 2009: 65). The combination of voices in the text makes the place alive, while the text's rootedness in a particular place makes the convergence of multiple voices possible. Text and place, writing and maps, are ultimately fundamentally related. This is what Mitchell calls 'a self-conscious "cartographic" writing, a writing in which traditional borders have been blurred or even obliterated' (Mitchell 2008: 1). The figure of the atlas in Thom's novel does not illustrate authority, but rather the converse: it demonstrates the lack of fixed borders and the fundamental role of individual affective experience in understanding place. A given space can only be known through a constellation of multiple voices that reject authoritative forms of knowledge. As Massey writes, 'If space is the sphere of multiplicity . . . then space can never be closed, there will always be loose ends' (Massey 2014: 95). In both geographic and generic terms, each of these novels foregrounds those loose ends, whether in the incorporation of unheard historical voices, peripheral places, and alternative forms of mapmaking.

As Gilles Deleuze has influentially argued, incorporating these 'loose ends' into a conception of maps allows for a focus not on stable identities, but transformative trajectories and becomings:

> Maps should not be understood only in extension, in relation to a space constituted by trajectories. There are also maps of intensity, of density, that are concerned with what fills space, what subtends the trajectory . . . A list or constellation of affects, an intensive map, is a becoming. (Deleuze 1998: 64)

Maps must be seen not in terms of a representation of the real, or the already-there, but instead as a path of movement focusing on the in-between. Maps can be thought of not as a source of knowledge,

or what Deleuze calls 'tracing', but as a metaphor of nomadism and affect. Rosi Braidotti refines Deleuze's work to focus on the idea of becoming, which she defines as 'opening [the self] out to possible encounters with the "outside"' (Braidotti 2011: 52). In this sense, the map ceases to be a record of an external world as such, but instead, as a form of becoming, opens the self to a new 'outside'. Each of these novels, in this way, demonstrates a fundamental openness to the world, a sense in which space – either physical space or the space of a particular discourse – is revealed through its limitations, as well as through principles of inclusion.

Like many of the works of their contemporaries discussed elsewhere in this volume, these novels resist easy categorisation, and do not suggest easy conclusions. Instead, each documents the way in which space is both transformative and always transformed: relationships with space are multiple and affective, rather than imposed by national ideologies. Likewise, each novel recognises the need for a multiplicity of narrative voices and styles to create a new way of seeing the world. Rather than imposing forms of knowledge or understanding on the reader, contemporary Scottish women's fiction creates a space of open enquiry, where the novel is presented as fundamentally democratic and inclusive. As such, these novels carry an implicit suggestion to move beyond the confines of categorisation, by nation or genre or gender, to a more fragile discourse of criticism that looks to the fragmentary, the multiple, the resistant and the non-narratable as a way of reconfiguring the space of literature.

## References

Ahmed, Sara (2006), *Queer Phenomenology: Orientations, Objects, Others*, Durham, NC and London: Duke University Press.

Augé, Marc (2008), *Non-Places: An Introduction to Supermodernity*, trans. John Howe, 2nd edn, London: Verso.

Berlant, Lauren (2011), *Cruel Optimism*, Durham, NC and London: Duke University Press.

Braidotti, Rosi (2011), *Nomadic Theory: The Portable Rosi Braidotti*, New York: Columbia University Press.

Buchan, John (1999), *The Thirty-Nine Steps*, ed. Christopher Harvie, Oxford: World's Classics.

Campbell, Karen (2015), *Rise*, London: Bloomsbury.

Corner, James (1999), 'The agency of mapping: speculation, critique and invention', in D. Cosgrove (ed.), *Mappings*, London: Reaktion, pp. 213–52.

Cracknell, Linda (2013), *Call of the Undertow*, Glasgow: Freight.

Craig, Cairns (1999), *The Modern Scottish Novel: Narrative and the National Imagination*, Edinburgh: Edinburgh University Press.

Deleuze, Gilles (1998), *Essays Critical and Clinical*, trans. D. W. Smith and M. A. Greco, London: Verso.

Evans, Mary (2009), *The Imagination of Evil: Detective Fiction and the Modern World*, London: Continuum.

Fitzgerald, Lauren (2009), 'Female Gothic and the institutionalisation of Gothic Studies', in D. Wallace and A. Smith (eds), *The Female Gothic: New Directions*, Basingstoke: Palgrave Macmillan, pp. 13–25.

Garrity, Jane (2003), *Step-Daughters of England: British Women Modernists and the National Imaginary*, Manchester: Manchester University Press.

Germanà, Monica (2017), 'Authorship, "ghost-filled" islands and the haunting feminine: contemporary Scottish female Gothic', in C. M. Davison and Germanà (eds), *Scottish Gothic: An Edinburgh Companion*, Edinburgh: Edinburgh University Press, pp. 222–35.

Gidal, Eric and Michael Gavin (2016), 'Introduction: spatial humanities and Scottish Studies', *Studies in Scottish Literature* 42.2: 143–50.

Horsley, Lee (2005), *Twentieth-Century Crime Fiction*, Oxford: Oxford University Press.

King, Geoff (1996), *Mapping Reality: An Exploration of Cultural Cartographies*, Basingstoke: Macmillan.

MacLean, Shona (2008), *The Redemption of Alexander Seaton*, London: Quercus.

Massey, Doreen (2014), *For Space*, London: Sage.

Miller, Nancy K. (1986), 'Arachnologies: the woman, the text, and the critic', in Nancy K. Miller (ed.), *The Poetics of Gender*, New York: Columbia University Press, pp. 270–95.

Mina, Denise (2015), *Blood Salt Water*, London: Orion.

Mina, Denise (2017), *The Long Drop*, London: Harvill Secker.

Mitchell, Peta (2008), *Cartographic Strategies of Postmodernity: The Figure of the Map in Contemporary Theory and Fiction*, New York and London: Routledge.

Moss, Sarah (2011), *Night Waking*, London: Granta.

Muir, Willa (1987), *Imagined Corners*, Edinburgh: Canongate Classics.

Pittin-Hedon, Marie-Odile (2015), *The Space of Fiction: Voices from Scotland in a Post-Devolution Age*, Glasgow: Association for Scottish Literary Studies.

Prieto, Eric (2011), 'Geocriticism, geopoetics, geophilosophy, and beyond', in R. T. Tally, Jr (ed.), *Geocritical Explorations: Space, Place, and Mapping in Literary and Cultural Studies*, Basingstoke: Palgrave Macmillan, pp. 13–27.

Shepherd, Nan (1987), *The Quarry Wood*, Edinburgh: Canongate Classics.

Steedman, Carolyn (2001), *Dust*, Manchester: Manchester University Press.

Thom, Eleanor (2009), *The Tin-Kin*, London: Duckworth Overlook.

Turchi, Peter (2004), *Maps of the Imagination: The Writer as Cartographer*, San Antonio, TX: Trinity University Press.

Walton, Samantha (2015), 'Detection, modernity and Romanticism: the Scottish landscape in the crime novels of Josephine Tey', in F. Reitemeier and K. Sanrock (eds), *Crimelights: Scottish Crime Writing – Then and Now*, Trier: Wissenschaftlicher Verlag Trier, pp. 79–96.

Westphal, Bertrand (2011), *Geocriticism: Real and Fictional Spaces*, trans. R. T. Tally, Jr, New York: Palgrave Macmillan.

Wood, Denis (1993), *The Power of Maps*, London: Routledge.

# 'Whom do you belong to, loch?' Ownership, Belonging and Transience in the Writings of Kathleen Jamie

*Amy Player*

Kathleen Jamie's most recent work explores her responses to the environment in the twenty-first century and reflects her ever-increasing preoccupation with the natural world. Like much of the writing falling under the contested label of 'new nature writing', Jamie's texts resist easy categorisation and cross the borders of multiple genres. She conceded of her 2005 prose collection *Findings* that 'It's not nature writing, but it is; it's not autobiography, but it is; it's not travel writing, but it is' (Jamie in Scott 2005), and this tension animates much of her recent work. Jamie is certainly not the first writer to resist the labels attached to her writing, or to readily accept the suggestions of what her writing subsequently 'is', or should be, 'about', and her frustration at continually being further classified as either a female writer or a Scottish writer indicates that even though she may have moved beyond these labels, they continue to be applied to her work. She is further reluctant to be categorised as a 'nature writer'[1] and in fact keenly resists such pigeonholing, arguing that 'It seems to be part of the job to keep redefining and refreshing what these categories mean. [. . .] [M]y job is to keep pushing it and pushing it' (Jamie in Scott 2005). To this end, this chapter will explore how Jamie's writing resists the limitations of these labels and works to address wider questions concerning our own transience and broader relationship with the non-human world in an increasingly critical, contemporary context, all the while considering how Jamie's work points to possible new paths for writing emerging from Scotland today.

Following the Scottish devolution referendum in 1997, Jamie pointed out that 'we must start to think beyond that, and to make connections beyond that, be they with England or Europe or North America or Afghanistan, or be they with realms which are non-human' (Jamie in Dósa 2009: 141). The direction Jamie's writing has taken in the past few decades has reflected this broadened approach, as she increasingly seeks connections between locations both within and outwith Scotland, and has sharpened her focus on the non-human world. The essays in *Findings*, for example, see Jamie covering a wide range of subjects which include her reflecting on illness and disease, visiting neolithic sites in Orkney, and surveying the dwindling corncrake populations of the Inner Hebrides. Though seemingly disparate in theme, the essays are united by Jamie's keen attentiveness to her surroundings, her ability to explode myopic notions of what constitutes 'nature', and they are framed in her measured and lyrical prose (she is, first and foremost, a poet). The essays largely take place in Scotland, often not far from Jamie's home in Fife, though she has nevertheless expressed frustration at *Findings* being classed as such, noting: 'I have a horror of it being filed under Scottish', and adding emphatically that although the essays 'are all set in Scotland [. . .] it is not a book about Scotland' (Jamie in Scott 2005). Such a position not only suggests too restrictive a focus for a work which crosses the boundaries of multiple genres, but also implies that the writing itself shouldn't be limited by the location in which it takes place. Jamie's resistance to the text being categorised as 'Scottish' here reflects Jos Smith's position that new nature writing can be increasingly characterised by its push 'against the historical focus on national traditions' (Smith in Stenning and Gifford 2013: 3), and so reflects the broader tendency for such writing to no longer be defined by or restricted to national borders. However, despite Jamie's aversion towards the labelling of *Findings* as 'Scottish' here, she nevertheless noted that 'I do think part of the reason for *Findings*' success, for example, was that the land and landscapes were described by an indigene. Not by someone arriving as a tourist – or crucially, as an owner' (Jamie in Crown 2012). Though Jamie positions herself as an 'indigene' here, I would argue that the significance of this comment comes less from whether the authorship of the text, or the text itself, could be categorised as Scottish, but instead stems from the fact that her connection to the places she describes is crucially *not* one which is prefaced by ownership, an issue which has increasingly come to the fore in her work in recent years.

It is nevertheless difficult to dissociate Jamie's preoccupation with questions of land access and ownership from the fact that she is

writing out of a country with one of the most unequal distributions
of land ownership in Europe. Jamie has referred to 'the scandalous
business of land and land ownership, especially in Scotland, where
80% of the land is owned by 10% of the people' (Jamie in Crown
2012), and issues related to these imbalances often surface in her
work. In a recent interview, Jamie remarked: 'I feel I might be strik-
ing a tiny blow: by getting out into these places, and developing a
language and a way of seeing which is not theirs but ours. [. . .] It's
the simplest act of resistance and renewal' (Jamie in Crown 2012).
Whilst Jamie's distinction between 'theirs and ours' here could itself
be critiqued for raising tensions by further couching the argument
in terms of ownership, I consider it as a way of attempting to rein-
state a more community-based ownership which counters the pre-
dominant Scottish model. Indeed, whilst Scotland's relatively recent
Land Reform Acts are considered in many ways to constitute com-
paratively more progressive models for land ownership and may
well have granted more universal access rights to the land, the huge
imbalances in land ownership which remain in Scotland provide a
discordant counterpoint to this. Addressing such issues in an article
for the *London Review of Books* in 2015, Jamie described a small
community buyout of a loch, called Lochmill, close to her home in
Fife. Following the 2003 Land Reform Act, Jamie noted that 'th[e]
scheme has been chipping away at the private ownership of Scot-
tish land' (Jamie 2015a). Though Jamie remarked that such buy-
outs were 'more usually associated with the huge holdings of private
landlords in the Western Highlands and islands, not tiny lochs in
Fife' (Jamie 2015a), the sale of the loch to the local community
could *itself* be viewed as a form of small-scale 'resistance', and so
reflect a progressive shift away from such imbalances in ownership.

In celebration of the buyout, Jamie collaborated with Scottish
artist Kyra Clegg to produce a film-poem entitled 'Lochmill in two
weathers', which first appeared on the *Bella Caledonia* website. The
intermedial work layers Jamie's spoken-word poetry over Clegg's
visuals, with the visuals featuring two films juxtaposed against one
another. One film shows a close-focus view of the loch, honing in on
the reeds and rippling water, with a series of superimposed images of
the loch and its wildlife layered over it; the other shows the loch in
a seeming state of permanence, with the lens fixed on the same view,
and with only the subtly perceptible ripples on the loch's surface
betraying a sense of fixity, or an absence of movement, in the frame.
Jamie's description of the loch encapsulates a sense of stillness; she
describes 'haar on the hillsides, the trees low over the water', and

notes how the 'alders / by the nameless burn that feeds the loch / stand with their roots in water / their tips in cloud' (Clegg and Jamie 2015).[2] By outlining both visually and in words the intricate details and small-scale, overlooked beauty of the loch in this way, the film-poem celebrates the place itself and its integral interest, thus serving as a way of *reclaiming* a place which until relatively recently had been closed off to (and, by extension, comparatively unnoticed by) the wider community. Whilst the two films unfold in parallel to one another, towards the end, the two separate visual perspectives merge into a single, wider view of the loch. As this broader perspective comes into view, the concluding lines to the poem address the loch directly: 'whom do you belong to, loch? / The sky, and the sky to me' (Clegg and Jamie 2015), with this apostrophe evoking a sense of reciprocity whilst again undermining the notion of singular ownership. Indeed, the closing lines in particular demonstrate how the loch itself, though central to the debate, remained conspicuously voiceless as to this question of ownership. That the place itself has no 'say', whilst self-evident, nevertheless emphasises the strangeness and indeed the anthropocentrism of the very concept of land ownership. In this context, too, it seems particularly apt that the creative response to the buyout notably balances multiple perspectives, being both collaborative and deeply community oriented, given that both Clegg and Jamie live nearby. What's more, as an intermedial, hybrid work, 'Lochmill in two weathers' opens up possibilities for an alternative 'way of seeing' through pushing the boundaries of form and can thus be situated as part of a new direction for Jamie's work.[3]

In the concluding paragraphs to her article on Lochmill, and following the successful buyout, Jamie added that 'Our loch is, so to speak, a drop in the bucket. But it's our drop, and maybe it will someday be our bucket' (Jamie 2015a). Such a shift could be viewed as moving towards Jamie's 'striking a tiny blow' (Jamie in Crown 2012) against (and indeed as a redress to) such imbalances of ownership. In the way that ownership often reflects the imposition of borders which are man-made in origin, contesting singular ownership here challenges the fixity of these borders and destabilises the sorts of boundaries that may have previously prevented access to the land. Furthermore, that Lochmill's future now lays in the hands of the local community opens up new possibilities for broader ownership and (re)connection to the landscape in both a local Scottish context, and also in a more global context, too.

Jamie's frustration with such imbalances of ownership and their frequent association with questions of class and privilege also surfaced

in her review of Robert Macfarlane's *The Wild Places*. In the review, which appeared in the *London Review of Books* and was entitled 'A lone enraptured male', Jamie expressed frustration with Macfarlane's initial definition of a 'wild place' as being 'outside human history' (Jamie 2008: 26), along with his apparent discovery of 'wild places', and particularly those within Scottish borders. She argued that 'There's nothing wild in this country: every square inch of it is "owned", much has seen centuries of bitter dispute; the whole landscape is man-made, deforested, drained, burned for grouse moor, long cleared of its peasants or abandoned by them' (Jamie 2008: 25). For Jamie it is important to show that beyond their frequent depiction as places of leisure or 'escape', these 'wild places' have been places of work and indeed hardship in both the recent and more distant past, arguing that

> For a long time, the wild land was a working place, whether you were a hunter-gatherer, a crofter, a miner. But now it seems it is being claimed by the educated middle classes on spiritual quests. The land is empty and the saints come marching in. (Jamie 2008: 27)

Jamie's assertion that such places are being 'claimed' implies another form of ownership and appropriation which again overlooks possible alternative narratives of them. As Alan Riach has echoed, such 'wild places' can also be sites

> where land-ownership might be a matter of violence, where the language of place names offers a history far from serene, where the 'preservation' of 'Nature' might come at the cost of neglecting or obscuring threatened or tortured realities, from which or through which people might – or sometimes, must – go fearfully. (Riach 2015: 21)

By folding such aspects of place into her own narratives, Jamie crucially acknowledges that these layers of the place's history constitute part of the wider picture of the place too, however problematic they may be.

For Jamie, it was Macfarlane's distance from 'home' in *his* travels which likely made it easier for him to label the places he visited as 'wild'. And yet, though Macfarlane may well return to his Cambridge home at the end of his travels in *The Wild Places*, he has *also* expressed a deep connection to Scotland, having previously discussed his 'own biographical and family connections to Scotland and to the islands and the highlands' (Macfarlane in Smith 2015), which Jamie was presumably unaware of at the time of writing. Jamie's critique certainly

raises some tensions, notably about who apparently 'qualifies' to write about Scotland, for if Macfarlane were somehow deemed less 'eligible' because he is not Scottish by birth, and his visits are *comparatively* fleeting, then Jamie herself would fall foul of such categoric distinctions when writing about locations beyond Scottish shores, as she increasingly does in her later work. Furthermore, as Jamie's review progresses she crucially admits that some of Macfarlane's developing perspectives about wilderness in *The Wild Places* align with her own (Jamie 2008: 27). In this vein, Jamie's position is better framed as reflecting her wider frustrations with Scotland historically being owned or 'spoken for' by individuals who have often had a disproportionate say in how the land has either been used or indeed represented in writing.

Anna Stenning and Terry Gifford argued that Jamie's critique in 'A lone enraptured male' could nevertheless be framed as a position 'which suggest[s] that nature writing should operate along national lines' (Stenning and Gifford 2013: 3). There is undoubtedly an element of this division which emerges in her review: she labels *The Wild Places* 'a deeply conservative book, and very English, in the long tradition of English settledness' (Jamie 2008: 27) and admits that her critique reveals 'the admission of a huge and unpleasant prejudice' along with a 'mix of class, gender and ethnic tension' (Jamie 2008: 26). Indeed, as has been shown, such tensions are difficult to overlook when engaging with the non-human world in a contemporary context, and particularly so in Scotland, where questions of ownership and land access can still be influenced by these unequal factors. Jamie's critique emphasises the difficulty of writing about nature without also entering into a complex web of issues embedded within the landscape, such as its often-contested history, and draws attention to the inherent responsibilities that come with a writer's decisions about how to represent it. In an interview, Jamie stated that she viewed writing as 'the scene of our constant negotiation' (Jamie in Dósa 2009: 144), and her shift to a more reconciliatory and accommodating perspective in the review reflects how writers *themselves* should be open to reconsidering their definitions, and to recasting the subsequent boundaries in their work, too.

In Jamie's view, narratives such as Macfarlane's privilege the writer's perspective and run the risk of overlooking contentious questions of land ownership. She argued:

> The danger of this writing style is that there will be an awful lot of 'I'. If there is a lot of 'I' (and there is, in *The Wild Places*) then it won't be the wild places we behold, but the author. [. . .] [B]ecause almost no one

else speaks, this begins to feel like an appropriation, as if the land has been taken from us and offered back, in a different language and tone and attitude. Because it's land we're talking about, this leads to an unfortunate sense that we're in the company, however engaging, of another 'owner', or if not an owner, certainly a single mediator. (Jamie 2008: 27)

That Jamie views such perspectives as constituting a form of 'appropriation' once again raises questions of the writer's responsibility in terms of how they frame and represent these places in their own work. Indeed, Jamie has herself expressed the importance of this in her own writing by seeking to omit the I-centric perspective whenever possible. She has remarked: 'I look at a page I've written, see that I've used the word "I" 17 times and go back and reduce it by two thirds', whilst adding: 'I am the perceiving centre of the experience and I can't help that [. . .] But it does get wearying. I want to try to enable other people to see, rather than say, "look at me doing this!"' (Jamie in Ramaswamy 2012). Such ideas reflect Jamie's own attempts to move towards perspectives of place which are not centred on singular perspectives, and which position Jamie as a sort of mediator by endeavouring to 'enable other people to see' through her writing. In this regard, it could also be considered as another way of going beyond the centrality of a writer's perspective, and of testing the limits of that centrality, where an individual's experience is just one layer of a much wider narrative taking place over a much broader temporal spectrum. Jamie argues that with such singular perspectives,

> What's being reduced is not the health and variety of the landscape, but the variety of our engagement, our way of seeing, our languages. There are lots of people, many of them women, who live in, or spend long seasons in places like Cape Wrath, St Kilda, Mingulay, thinking about the wild, studying its ways. Interesting people, with new ideas. It's a pity we meet none of them. (Jamie 2008: 27)

Jamie's resistance to such 'reductive' narratives which reinforce ideas of ownership and privilege[4] here, along with her desire to expand the possible voices which come to represent Scotland in writing, reflects a broadening, rather than a narrowing of the possible perspectives of place. She adds: 'it pays to wonder, who's telling me this, who's manipulating my responses, who's doing the mediating?' (Jamie 2008: 27). Jamie's assertion here by extension encourages the readers to themselves be more discerning and questioning of how places

have been 'mediated' to them, thus engendering a more critical and alert engagement with place.

Questions of ownership also emerge from Jamie's writing beyond Scotland. In a recent visit to a village on the Alaskan west coast as part of an archaeological dig overseen by the University of Aberdeen, Jamie commented that the dig had helped the locals in a 're-learning [of] their own culture' (Jamie 2014). In the essay, entitled 'Postcard from Quinhagak', Jamie notes that the indigenous Alaskan people 'have been here thousands of years', before adding: 'Of course, they own their own land now – I envy them that, everything derives from that fact' (Jamie 2014). Jamie points out how historical imbalances in land ownership in the Alaskan community have been challenged by what she calls 'cultural resilience', which can be developed through a 'rediscovering [of] shared values' (Jamie 2014). This engagement with 'shared values' emerges in much of Jamie's recent writing: her aforementioned film-poem 'Lochmill in two weathers' can be viewed as a community-based example of such 'cultural resilience' to imbalances in ownership, and Jamie's observations of this Alaskan community similarly echo with ideas of shared values of community ownership and land access in Scotland and beyond. Indeed, Jamie frequently makes connections between disparate communities, and even when no longer writing 'about' Scotland, it nevertheless still frames her perception of 'elsewhere'. In her description of Alaska, for example, she comments:

> I've been here two weeks and it's starting to feel familiar. There's something almost Hebridean about it, with the fishing boats drawn up and the fish-drying sheds – though the inland landscape is vast and the Bering Sea surprisingly shallow and calm. (Jamie 2014)

Jamie often makes connections between her home and that of others, showing that one's 'away', or periphery, can *also* be perceived as another's 'centre', or *home*. Jamie's mediations between the near and far enable her to find points of convergence between disparate cultures and distant locations. In this way, she could be viewed as providing an example of what Jürgen Neubauer has argued is the sort of writing which which 'do[es] not map a fixed national community', but which instead 'imagine[s] flexible communities of difference' (Neubauer 1999: 12), and so, through crossing the borders between the seemingly familiar and unfamiliar in her own work, Jamie suggests possibilities for broadened connections to landscape, and possibilities for (re)connection to it, too.

The idea of mediating between and beyond the local and the global is reflected yet more acutely in Jamie's second prose collection, *Sightlines*, where her focus shifts beyond Scottish shores. She notes in the opening essay: 'for thirty years I've been sitting on clifftops, looking at horizons. From Orkney, Shetland, St Kilda ... [...] Suddenly I wanted to change my map. Something had played itself out. Something was changing' (Jamie 2012: 16). Jamie's broadened horizons in *Sightlines* lead her to question her own sense of centrality in both a personal and a geographic sense. When on an expedition to Greenland, she recalls: 'I've long loved the word "tundra", with its suggestion of far-off northern emptiness, and I guess these must be tundra plants, under my feet' (Jamie 2012: 2). When looking at feathers left behind by migrating geese, she adds: 'To my mind, geese only travel north, to some place beyond the horizon. But this is that place. From here, they go south' (Jamie 2012: 3). Jamie's sense of centre here shifts so that a place she had once labelled as distant has become close, and what was unfamiliar again begins to overlap with the familiar. Jamie's realisations here destabilise the apparently fixed notions of centre and periphery, thus questioning the notion of near and far, of local and global, a position which points towards what Ursula K. Heise argues is an 'imagining [of] forms of belonging *beyond* the local and the national' (Heise 2008: 6, my emphasis). In Jamie's travels, both those closer to home and those farther from it, she finds connections which serve as a bridge between diverse locations, rather than reflecting points of difference, suggesting that the distinction of nation, and the borders which separate them, may be becoming less of a central issue in this writing, to recall Jos Smith's earlier assertion. In this respect I would argue that Jamie's subsequent engagement with diverse locations, along with her desire to not be restricted to the 'Scottish writer' label, is equally reflected in Neubauer's argument that 'Scottish writers are beginning to imagine life in postnational constellations in which interactions and relationships are both more local and more global than the nation' (Neubauer 1999: 12), particularly given that her attention is increasingly drawn to making connections between multiple locations both within and outwith Scotland.

In contrast to Jamie's increasingly expansive approach, Timothy Clark has pointed out that

> In Europe a sustained concern with protecting the environment has often been associated with a simplistically conservative or sometimes nationalist politics, defending some place or way of life as an icon of a cultural identity or as an image of once traditional ways of life. (Clark 2011: 96)

Similarly, Stenning and Gifford have argued that 'a national culture based on ancestry and rootedness has a dangerous historical precedent by way of the Nazi appropriation of regional *Heimat*' (Stenning and Gifford 2015: 3), and some nature writers have admittedly veered into this territory. Richard Smyth cites T. H. White and Henry Williamson as 'nature writers' who might be accused of such narrow-minded nationalism (Smyth 2019), and this problematic legacy has undoubtedly played a role in some contemporary nature writers' resistance to the label. Philip Hoare has argued that

> Given where we stand today, in the age of the [A]nthropocene, contemporary nature writing cannot help but exist on a precipice. Invariably, it speaks to a wish for better days. [. . .] Yet there is a troubling aspect to this utopian impulse. You see it in the extirpation of "non-native species" (what William Morris called "vile weeds") and in the longing for the purity of the past. (Hoare 2015)

Writers such as Jamie demonstrate an acute alertness to the dangers of slipping into such positions in their writing, and this alertness is arguably heightened given the contemporary political climate in Europe, where nationalism appears to be on the rise.

Although Steven Poole has implied there is a nostalgic or escapist thread to some new nature writing (Poole 2013), Jamie's writing certainly challenges such a position. When assisting with a surveying project on the island archipelago of St Kilda in an essay in *Sightlines*, a place she calls one of the 'fabled outliers' along with 'North Rona [and] Sula Sgeir' (Jamie 2012: 143), Jamie notes that these are all 'Places with such long human histories', whilst adding 'I soon came to distrust any starry-eyed notions of "wild" or "remote". Remote from what? London?' (Jamie 2012: 143). This seemingly fixed notion of a place being 'remote' in relation to a dominant centre is a tension which Jamie often contests in her writing, but she also challenges the notion of how this 'remoteness' is often used as a means to idealistically frame such places. As she argues of the structures which remain on the island: 'They didn't sing of a lost idyll, those cold empty doors. If the cottages spoke at all, it was to say – Look, they made their decision. They quit. They moved on' (Jamie 2012: 161–2). Here Jamie crucially resists a more 'utopian' perspective of these 'fabled outliers' by acknowledging that such places are *also* subject to change. In this, she also avoids slipping into the sort of nostalgic, or even nationalist, perspective which might have reinforced problematic ideas of rootedness, or, to recall Hoare, perspectives which could have been used

to bolster a 'longing for the purity of the past' (Hoare 2015), or an idealisation of the 'once traditional ways of life' Clark has referred to (Clark 2011: 96).

In her own visit to the island archipelago, Jamie too 'moves on' when the forecast cuts short her stay, adding that 'To linger on St Kilda just for the sake of it would merely have been romance' (Jamie 2012: 163). By demonstrating an acute awareness of the dangers of romanticising the past, Jamie often emphasises the importance of acknowledging the wider context of such places in her writing, too. Jamie's more flexible approach to place here helps us envisage a way forward and therefore counters the aforementioned charges of nostalgia or escapism. Indeed, she has herself argued that contemporary nature writing can in fact be situated on the proverbial front lines of environmental engagement, arguing that 'Nowadays in "nature" or "the environment" we are far from consoled. It's in nature we find the most frightening changes. The more alert nature-writers [. . .] are energised by that truth' (Jamie 2013c). In this way, Jamie's environmental engagement can be clearly situated in opposition to the strand of 'simplistically conservative or sometimes nationalist politics' associated with protecting the environment Clark referred to through her challenges to the insularity of such escapist or nostalgic perspectives, as she critically demonstrates her willingness to face up to the future by confronting such 'frightening changes' in her own writing.

Jamie's poem 'Here lies our land' was commissioned to commemorate the 700th anniversary of the Battle of Bannockburn, and like her engagement with St Kilda it too avoids the dangers of romanticising the past by celebrating Scotland and its history in a stance which I would describe as consciously inclusive. Indeed, although the poem's titular affirmation of 'our land' could be viewed as reinforcing a sense of ownership, the poem challenges this. It opens: 'Here lies our land: every airt / Beneath swift clouds, glad glints of sun, / Belonging to none but itself' (Jamie 2013a). The initial pronoun can be seen to challenge *singular* ownership and thus emphasises a more collective relationship to place. Indeed, a further challenge to ownership is made with the assertion that the land 'Belong[s] to none but itself' (Jamie 2013a), along with the qualification in the next stanza that 'we are mere transients' (Jamie 2013a). That the poem goes on to underline the comparatively fleeting nature of this collective identification and sense of ownership in the broader scheme is also a reminder that ownership, even if in a more collective sense, is *itself* temporary. In Jamie's commentary on the poem, she underlines this perspective, noting: 'the Scots may have "won" Bannockburn, but

not the land itself. We may exploit the land but everything changes and we pass away and the land endures' (Jamie 2013a), returning us once again to the fleeting nature of human ownership, and indeed of belonging, too.

When discussing ownership of the poem, Jamie noted: 'I don't think of this work as "mine" any longer [. . .] like the land it describes, it belongs to everyone that appreciates it' (Jamie 2013a). Jamie's position here can be read against the singular model of land ownership she contests, and as looking beyond human concerns of ownership more broadly. For Val Plumwood, 'land ownership can be based on far more communal and narrative criteria that yield relationships that are two-way and two-place, in which you belong to the land as much as the land belongs to you' (Plumwood 2002: 229–30), and it is this privileging of modes of ownership which encourage more reciprocal relationships to the land which I view Jamie's writing as working towards. 'Here lies our land' echoes Riach's assertion that 'Jamie's poems continue to emphasise the liminal space that even something as seemingly secure as nationality is always in the process of moving *through*' (2015: 30), as it helps construct a notion of nationality whilst also demonstrating its very mutability. Jamie adds: 'If the land could speak, I'd wondered, what would it say? Something welcoming, hopefully. Something that opened out our vision and sense of ourselves. Something about belonging not to those who "own" it, but to those who love it' (Jamie 2013c). Whilst 'love' for a country can easily slip into nationalism, for Jamie, this 'love' is instead the foundation for a broader vision which encompasses the wider sense of collectivity which is interwoven through the poem, and which suggests an alternative model for a relationship to place which is critically centred on appreciation and care of the land, rather than possession of it.

Jamie stated emphatically that she wanted to ensure the poem was not 'triumphalist', and that she 'sought a tone which suggested shared experience and quietude', particularly as those who visit the site of Bannockburn today 'would have been subjected to a lot of medieval battle-clamour; [and] their minds would surely be loud with nationhood and self-determination' (Jamie 2013c). By framing her poem as a salve to the divisions which conflict and nationhood tend to incur here, Jamie looks instead to provide a sense of connection. John Berger's assertion that 'Poetry can repair no loss, but it defies the space which separates' (Berger 2001: 450) is of relevance here, as Jamie's poem similarly demonstrates this capacity to resist divisions. Indeed, whilst the poem itself is now inscribed onto the monument at Bannockburn and thus occupies a more fixed 'place'

in the Scottish landscape, Jamie's position, looking as it does to our 'place' in a much wider temporal scheme, enables it to look beyond present concerns and shift towards a more collective and expansive understanding of our relationship with the non-human world, both in Scotland and further afield. In this way, the poem's broader focus on Bannockburn can be thus read as a form of defiance to this 'space which separates'.

Jamie's own broadening horizons have also increasingly come to accommodate a greater, more expansive sense of 'nature' in her writing. Given that environmental issues take place on both a local and a global scale, and coupled with the fact that we are now coming to recognise the truly global scale of our human impact on the planet through our increasing awareness of the Anthropocene era,[5] embracing this more expansive understanding of nature takes on an even greater sense of urgency. In her *Sightlines* essay 'Pathologies', Jamie reconsiders the ways we frame nature and the language we use to discuss it. Though it largely takes place within the confines of a pathology laboratory in Dundee, in many respects this essay is one of the most boundary-pushing examples of 'new nature writing' to have been published in recent years, as critics such as Stenning and Gifford have similarly attested (Stenning and Gifford 2013: 1), containing some of Jamie's most strident challenges to conventional conceptions of nature. Jamie argues that both death and illness are part of nature (even if they are the 'Nature we'd rather do without' (Jamie 2012: 36)), and that our tendency to selectively frame what we consider to be 'natural' is problematic, arguing that 'It's not all primroses and otters' (Jamie 2012: 24). Visiting a pathologist and observing slides of a diseased colon, she notes:

> I was looking down from a great height upon a pink countryside, a landscape. There was an estuary, with a north bank and a south. In the estuary were wing-shaped river islands or sandbanks, as if it was low tide. It was astonishing, a map of the familiar; it was our local river, as seen by a hawk. (Jamie 2012: 30)

Looking at nature on a far smaller scale than usual here prompts Jamie to connect the landscape she sees 'outside' with the 'inside' landscape she observes through a microscopic lens, and the boundaries between them become blurred. What we consider to be familiar, our very selves, is in fact rendered unfamiliar. Jamie is both 'home' and far from it here, and the notion of familiarity is both reinforced *and* unsettled: Jamie calls it 'a collusion of landscape and language',

where she discovers 'the unseen landscapes within' (Jamie 2012: 34). Jamie's ability to destabilise common assumptions of the natural in this essay challenges the idea of 'local', thus encouraging us to see things differently, and most notably in relation to the notion that nature is somehow 'separate' from us. The recognition that nature exists inside of us challenges the boundaries between the human and non-human worlds and serves to help undo the damaging Cartesian dualisms which have traditionally situated the human as apart from, and indeed often superior to, the non-human world. Jamie's ability to push the boundaries of our conventional understanding of nature *itself* constitutes a form of resistance to such divisions, whilst also providing an alternative lens through which we can engage and interact with the world around us. In this way, both the internal human 'landscapes' and the parallel external Scottish ones Jamie observes become the site for a wider, more expansive conception of our understanding of nature, which in turn provides a hybrid understanding of our broader 'place' in the non-human world today, both in a Scottish context and more widely too.

Whilst the idea of an 'embodied' nature was also present in some of Jamie's earlier writing, such as the essays 'Fever' and 'Surgeons' Hall' in *Findings* (2005b) or the poems in *This Weird Estate* (2007), her prose-poems in *Frissure* (2013b) also signalled an intriguing shift in direction for her work. Following Jamie's recovery from illness, the scar left behind after her own surgery evoked for her not just a line of poetry but also the drawn line of an artist (Jamie 2013b: vi), which encouraged her to collaborate with Scottish artist Brigid Collins to respond to the changing 'landscape' on her own body (Jamie 2013b: vi). The resulting text combined what Jamie tentatively called 'fragments? prose-poems?' (Jamie 2013b: xiii) with Collins's mixed media art to provide an affecting reflection on the possibilities for recovery and change. David Wheatley pinpointed *The Overhaul* (2012) as the work where 'Jamie's forms begin to look beyond their borders' (Wheatley 2015: 58), adding that in her work, 'the borders of nation and body alike are subject to unforeseen redrawing, sometimes with traumatic consequences' and that 'the landscapes that drive Jamie's art lend themselves to drawing, redrawing and transplantation, giving the slip to the restrictive imperatives of territory and territoriality' (Wheatley 2015: 60). This 'redrawing' continues to be apparent in her most recent work too, as it is increasingly drawn to exploring the possibilities of form and challenging the 'territories' of genre yet further, such as with *Frissure* or 'Lochmill in two weathers'. It is telling that one of the definitions of her writing Jamie *has* expressed

preference for, namely that it was 'Somewhere between the Presbyterian and the Tao' (Jamie 2018), notably acknowledges multiple influences and directions and does not confine her writing to fixed genre categories, thus allowing Jamie to 'redraw' the 'territories' in which it can be located, and so to accommodate a more fluid and flexible approach in her work.[6]

As previously discussed, Jamie's spatial horizons frequently broaden in *Findings* to *Sightlines*, but so too do her temporal horizons. Whilst she often reflects on the comparatively recent human histories of places, her horizons also extend yet further back through her engagement with deep time. On her visit to Greenland in the opening essay of *Sightlines*, 'Aurora', she reflects on colossal icebergs and the deep past which is present in the ice core samples taken from them, and comments: 'we are tourists, on this trip, anyhow. Maybe also in the larger sense [. . .] here today [. . .] and silence tomorrow' (Jamie 2012: 16). Here Jamie expands the notion of tourist not merely as a fleeting visitor of a place in a human time frame, but also in a far wider sense too, thus acknowledging that our passage on earth is comparatively transitory. Such thoughts not only help to contextualise our understanding of the Anthropocene era, but also suggest a way of thinking beyond the comparatively narrow anthropocentric frame of reference and question the mutability of nationhood when placed in this far broader temporal spectrum. In the concluding *Sightlines* essay 'Wind', when departing from the uninhabited island of Hirta on a helicopter, Jamie writes:

> There are myths and fragments which suggest that the sea that we were flying over was once land. Once upon a time, not so long ago, it was a forest with trees, but the sea rose and covered it over. The wind and the sea. Everything else is provisional. A wing's beat and it's gone. (Jamie 2012: 242)

That this observation comes from the concluding paragraph of the final essay of the collection is significant, especially given the opening essay also deals with this sense of transience. This engagement with the deep past builds yet further on previous notions of belonging, and so can be read subsequently as one of Jamie's most contemporary challenges to the anthropocentric notions of belonging and ownership.

Provisionality can be viewed as a mode for helping us better understand our 'place' in the world: but it *also* helps provide us with

a way of considering the problematic question of belonging. As Jamie pointed out in an essay in *Findings*,

> Once-common species, like the corncrake, are becoming more localised, more specialised. But, as they do, it seems that people are learning a new identification with the birds of their patch. Mull makes much of its sea eagle, a species that was hunted to extinction, then reintroduced. (Jamie 2005b: 96)

For Jamie, this question of our own belonging in the non-human world seems also to be connected to *how* the way we define nature can limit the way we perceive and categorise our own surroundings. As she argues: 'And what's natural? We're having to replant the forests we cleared, there's even talk of reintroducing that natural predator, the wolf' (Jamie 2005b: 126). Drawing our attention to the fact that nature exists in a state of flux could serve as a corrective to ideas of belonging which *can* impose rigid and seemingly fixed borders. Ecosystems change, nature responds to change, and so too should our understanding and definition of them, as the question of what belongs is often more fluid than our conventional definitions allow for. In this way, perhaps for us, adapting to such changing circumstances could be viewed as a way of acknowledging this state of flux which is reflected in both the human *and* the non-human world. As Riach has argued, for Jamie, 'Scotland is contextualised with co-ordinate points that arise from the foundations of her understanding of socially gendered, power-structured identities, in which nationality is only one component and redefinable part. The nation is a wild place of contesting forces' (Riach 2015: 21). It is this notion of Scotland as a site for 'contesting forces' which I think is crucial to the understanding of Jamie's engagement with it, as her engagements with the human and non-human worlds in her recent writing acknowledge Scotland as a nation under change. Indeed, Jamie's most recent poetry collection, *The Bonniest Companie*, can be viewed as a response to this change, particularly given that it was Jamie's means of responding to the momentum of the independence referendum in 2014. She remarked: '2014 was a year of tremendous energy in my native Scotland, and knowing I wanted to embrace that energy and participate in my own way, I resolved to write a poem a week, and follow the cycle of the year' (Jamie 2015c), so the form *itself* is responsive to the changes in the nation. Jamie's response to political change in Scotland also echoes Ian Brown and Colin Nicholson's assertion that 'As the "United" Kingdom's nature is questioned, so writers who cross

genre, language and art-form boundaries reflect that enquiry. Interrogating artistic borders, they interrogate the national idea' (Brown and Nicholson 2007: 263). For Jamie, the nation is not fixed but subject to constant change and flux, like the human body, and like the non-human world more broadly, too.

We can be profoundly shaped by the places we live in, but we can *also* be shaped by and have strong connections to the places we travel to, and as we are increasingly living in more than one place over our lifetimes the sense of rootedness associated with staying in one place is becoming less common. Indeed, Macfarlane has pointed out how 'the root (delving downwards) and the step (moving onwards)' can be viewed as the 'contrasting metaphors for our relations with the world' (Macfarlane 2012: 323).[7] This is a tension which I consider to similarly animate Jamie's writing about Scotland and beyond, and it also points towards a position which Heise argues is 'sceptical vis-à-vis local rootedness and instead validate[s] individual and collective forms of identity that define themselves in relation to a multiplicity of places and place experiences' (Heise 2008: 5). Jamie frequently questions what, more precisely, constitutes our human 'place' in the world, often by undermining the notion of belonging, thus reflecting Heise's sense of scepticism towards this singular idea of 'local rootedness'. Tracing her family history in an essay for *Granta Magazine* entitled 'Airds Moss', Jamie noted that her great-great-grandparents were Irish, 'brought over as children when their parents joined the droves of Irish workers piling into Scotland', whilst also adding 'we were all migrants once' (Jamie 2005a: 89). Here Jamie again demonstrates that the notion of belonging can be a more fluid and shifting one, by recalling that belonging, in a broader temporal scheme, is fleeting too.

When discussing Scotland's independence referendum in 2012, Jamie commented: 'We find the prospect of being a small, independent nation on the fringe of Europe exciting, and look forward to making our own decisions, even if that means having to fix our own problems. We'll take the risk' (Jamie in Riach 2015: 30). As Riach has argued, Jamie's position here demonstrates 'a safeguard against the ossification of identity which nationalism sometimes inclines towards' (Riach 2015: 30). It is this resistance to such 'ossification' which I think is crucial to understanding Jamie's work, as by demonstrating that identity should be open to adapting to change, Jamie is able to diverge from approaches to questions of nation which 'ossify' and maintain a more fluid approach to identity, which in turn enables it to be more open to connections. Whilst the question of borders is

once again coming to the fore in the wake of the Brexit vote of 2016 and with the possibility of a second Scottish independence referendum, Jamie's writing helps with a (re)envisaging of Scotland as a nation and as part of Europe. In this, Jamie can be viewed as aligning herself more with a more *modern* Scottish identity by looking out to Europe (and beyond) at a time when British identity appears to be turning increasingly inwards.

Stenning and Gifford have argued that 'a consideration of national and regional identity is [nevertheless] relevant given the operation of political and cultural environmentalisms at this scale', adding that, 'Many discussions of the environment are inextricably linked to politically fraught issues of national identity, economic health and belonging' (Stenning and Gifford 2015: 2). As has been shown, for Jamie, such 'politically fraught issues' cannot be dissociated from place (either in Scotland or elsewhere), so questions of nationhood and borders cannot be *entirely* overlooked. Indeed, whilst Jamie may be considered to frequently look beyond borders in her writing, questions of borders have again come to the fore in the current European political climate. However, the environmental issues we face are of course bigger than questions of any one nation, an idea which Jamie was already working towards in 2009, where she argued that the world

> needs a sensibility that overcomes nation-states and understands something other than political boundaries – a sensibility that understands cultural or ecological areas. It is time to realise that what is at stake is bigger than ourselves and our own states, and we've got to deal with that. (Jamie in Dósa 2009: 141)

and this sensibility is exemplified in Jamie's writing. Indeed, that much of the new nature writing is in many respects broader in scope than adhesion to national labels reflects what Stenning and Gifford point out is in fact 'nature's [*own*] disregard for man-made borders' (Stenning and Gifford 2015: 2) – borders which Jamie increasingly looks beyond in her own writing. When walking in the Central Highlands, Jamie comes across abandoned shielings which nature is in the process of 'reclaiming'. Describing the gradual process of lichen and moss growing over the structures, she notes that 'Two centuries on, the shieling huts were ruins but the grass still remembered to be green' (Jamie 2005b: 124). By reflecting on what remains beyond a normal human lifetime here, Jamie encourages us to think beyond our own anthropocentric scales of time. Furthermore, through blurring the

distinction between the natural and the man-made here, Jamie again highlights the temporality of human-imposed borders within a far broader time frame.

Many new nature writers engage with questions of our relationship with the non-human world on both a smaller and a larger scale, in locations both familiar and unfamiliar, and also through various reconfigurations of these categories. Jamie's writing looks both further afield, but *also* probes deeper into our understanding of the nearby: both perspectives bring something to her development of alternative 'way[s] of seeing' and can encourage us to see the local differently, but they can *equally* encourage us to reconsider our conception of the global, along with the perceived boundaries (and the connections that can be made) between them. Jamie demonstrates what Stenning and Gifford have argued is writing which has 'moved beyond the binary of local and global, challenging and illuminating diverse understandings of place' (Stenning and Gifford 2015: 2), as she engages with and reconfigures both of them in surprising ways in her work. As Lucy Collins has pointed out, 'in questioning the necessity of reading her work within a Scottish nationalist framework, [Jamie] is not disavowing the significance of community, but rather finding ways to connect to a global context' (Collins 2011: 158), and this sense of connectivity which frequently seeks connections *beyond* is an ever-increasing characteristic of Jamie's work. In both her poetry and prose, Jamie opens up the possibility for a broader, more reciprocal relationship with the non-human world, both within and outwith Scotland. She does this not just by considering alternative models of ownership, but also through her increasing engagement with more hybrid forms of writing, which itself reflects a more expansive approach to borders and enables further connections to be made between disparate entities and locations. Jamie's openness to form, and to broader definitions and understandings of nature and our place in it, thus helps open out to a broader understanding of Scotland in a contemporary context.

Jamie's writing helps emphasise how our own local environments are both a part of and a window into the more global sense of nature, and the diversity of landscapes considered in her work helps us to reconsider our relationship with the non-human environment on both a narrower *and* a wider scale. Indeed, the broader understanding of our surroundings which Jamie's writing encourages can help us to think beyond existing labels and borders, with her testing of borders reminding us of our own transience, and challenging fixed notions of nationhood and belonging. In this way, Jamie's

writing helps prompt alternative relationships with the non-human world whilst also suggesting a way forward for thinking about these issues in the twenty-first century, which can be applied to the places she writes about within Scotland, but also to those beyond Scottish shores.

## References

Berger, John (2001), 'The hour of poetry', in *John Berger Selected Essays*, London: Bloomsbury.

Bracke, Astrid (2018), *Climate Crisis and the 21st Century British Novel*, London: Bloomsbury.

Brown, Ian and Colin Nicholson (2007), 'The border crossers and reconfiguration of the possible: poet-playwright-novelists from the mid-twentieth century on', in Ian Brown (ed.), *The Edinburgh History of Scottish Literature: Modern Transformations: New Identities (from 1918)*, Edinburgh: Edinburgh University Press.

Clark, Timothy (2011), *The Cambridge Introduction to Literature and the Environment*, Cambridge: Cambridge University Press.

Clegg, Kyra and Jamie, Kathleen (2015) 'Lochmill in two weathers'. https://bellacaledonia.org.uk/2015/02/22/filmpoem-lochmill-in-two-weathers-by-kyra-clegg-kathleen-jamie/ (accessed 1 October 2018).

Collins, Lucy (2011), "The poetry of Kathleen Jamie and environmental crisis', in Anne Karhio, Seán Crosson and Charles I. Armstrong (eds), *Crisis and Contemporary Poetry*, Basingstoke: Palgrave Macmillan.

Crown, Sarah (2012), 'Kathleen Jamie: a life in writing', *The Guardian*, 6 April 2012. https://www.theguardian.com/culture/2012/apr/06/kathleen-jamie-life-in-writing (accessed 1 June 2018).

Dósa, Atila (2009), *Beyond Identity: New Horizons in Contemporary Scottish Poetry*, Amsterdam: Editions Rodopi.

Falconer, Rachel (ed.) (2015), *Kathleen Jamie: Essays and Poems on her Work*, Edinburgh: Edinburgh University Press.

Heise, Ursula K. (2008), *Sense of Place and Sense of Planet: The Environmental Imagination of the Global*, New York: Oxford University Press.

Hoare, Philip (2015), 'The naming of the shrew: language, landscape and the new nature writing', *The New Statesman*, 19 March 2015. https://www.newstatesman.com/culture/2015/03/naming-shrew-language-landscape-and-new-nature-writing (accessed 19 June 2019).

Jamie, Kathleen (2005a), 'Airds Moss', in *Country Life*, London: Granta.

Jamie, Kathleen (2005b), *Findings*, London: Sort of Books.

Jamie, Kathleen (2007), *This Weird Estate*, Edinburgh: Scotland and Medicine.

Jamie, Kathleen (2008), 'A lone enraptured male', *London Review of Books* 30.5: 25–7.

Jamie, Kathleen (2012), *Sightlines*, London: Sort of Books.

Jamie, Kathleen (2013a), 'Here lies our land', *Scottish Poetry Library*. http://www.scottishpoetrylibrary.org.uk/poem/here-lies-our-land/ (accessed 20 October 2018).

Jamie, Kathleen (2013b), *Frissure*, Edinburgh: Polygon.

Jamie, Kathleen (2013c), 'Four Fields by Tim Dee – Review', *The Guardian*, 24 August. https://www.theguardian.com/books/2013/aug/24/four-fields-tim-dee-review (accessed 19 June 2019).

Jamie, Kathleen (2014), 'Postcard from Quinhagak', *Bella Caledonia*, 30 August. https://bellacaledonia.org.uk/2014/08/30/postcard-from-quinhagak/ (accessed 10 May 2018).

Jamie, Kathleen (2015a), 'In Fife', *London Review of Books* 37.8: 26.

Jamie, Kathleen (2015b), 'Lochmill in two weathers – a filmpoem'. http://www.kathleenjamie.com/lochmill-in-two-weathers-a-filmpoem/ (accessed 8 May 2018).

Jamie, Kathleen (2015c), *The Bonniest Companie*, London: Picador.

Jamie, Kathleen (2018), 'Kathleen Jamie: author statement', *British Council Literature*. https://literature.britishcouncil.org/writer/kathleen-jamie (accessed 8 May 2018).

Macfarlane, Robert (2012), *The Old Ways*, London: Hamish Hamilton.

Macfarlane, Robert (2015), *Landmarks*, London: Penguin.

Neubauer, Jürgen (1999), *Literature as Intervention*, Marburg: Tectum Verlag.

Nixon, Rob (2018), 'The Anthropocene: the promise and pitfalls of an epochal idea', in Gregg Mitman, Marco Armiero and Robert S. Emmett (eds), *Future Remains: A Cabinet of Curiosities for the Anthropocene*, Chicago: University of Chicago Press.

Plumwood, Val (2002), *Environmental Culture: The Ecological Crisis of Reason*, London: Routledge.

Poole, Steve (2013), 'Is our love of nature writing bourgeois escapism?', *The Guardian*, 6 July. https://www.theguardian.com/books/2013/jul/06/nature-writing-revival (accessed 20 June 2019).

Ramaswamy, Chitra (2012), 'Interview: Kathleen Jamie, author or Sightlines', *The Scotsman*, 14 April. https://www.scotsman.com/lifestyle/culture/books/interview-kathleen-jamie-author-of-sightlines-1-2233424 (accessed 22 May 2018).

Riach, Alan (2015), 'Mr and Mrs Scotland are taking a vacation in the autonomous region', in Rachel Falconer (ed.), *Kathleen Jamie: Essays and Poems on Her Work*, Edinburgh: Edinburgh University Press.

Scott, Kirsty (2005), 'In the nature of things', *The Guardian*, 18 June. https://www.theguardian.com/books/2005/jun/18/featuresreviews.guardianreview15 (accessed 3 May 2018).

Smith, Phoebe (2015), 'Robert Macfarlane interview: "When I'm writing a book, I have no idea where I'll end up"', Wanderlust, 23 April. https://www.wanderlust.co.uk/content/robert-macfarlane-interview-when-im-writing-a-book-i-have-no-idea-where-ill-end-up/ (accessed 1 October 2018).

Smyth, Richard (2019), 'Nature writing's fascist roots', *The New States-man*, 3 April. https://www.newstatesman.com/culture/books/2019/04/eco-facism-nature-writing-nazi-far-right-nostalgia-england (accessed 19 June 2019).

Stenning, Anna and Terry Gifford (2013), 'Twentieth-century nature writing in Britain and Ireland', *Green Letters: Studies in Ecocriticism* 17.1: 1–4.

Stenning, Anna and Terry Gifford (2015), 'Introduction: European new nature writing', *Ecozon@* 5.1: 1–6 (Spring).

Wheatley, David (2015), 'Proceeding without a map: Kathleen Jamie and the lie of the land', in Rachel Falconer (ed.), *Kathleen Jamie: Essays and Poems on Her Work*, Edinburgh: Edinburgh University Press.

## Notes

1. This is an issue she has addressed in no uncertain terms, noting that the question 'Do you consider yourself a woman writer or a Scottish writer?' is one which she 'can no longer answer politely' (Jamie 2018).

2. At present, 'Lochmill in two weathers' only appears in the spoken word format on the *Bella Caledonia* website. As such, the suggested line breaks here are my own.

3. Jamie herself called the work 'a new departure' (Jamie 2015b).

4. Nevertheless, Macfarlane wrote the introduction to the 2011 re-edition of Nan Shepherd's *The Living Mountain*, and Shepherd was also the focus of a chapter in his *Landmarks* (2015). In this respect, he is arguably using his popularity as a writer (which is another, albeit different, form of 'privilege' to the sort Jamie refers to) in order to champion writers he considers to have been overlooked and underappreciated, so here he is using his 'privilege' for the benefit of others.

5. The term 'Anthropocene' is not universally accepted, however: see Rob Nixon's "The Anthropocene: the promise and pitfalls of an epochal idea" (2018: 1–18) or Astrid Bracke's *Climate Crisis and the 21st Century British Novel* (2018: 15–18) for a more in-depth discussion of the term's usages and limitations.

6. Brown and Nicholson pinpoint this 'border crossing' of the boundaries of genre as a shift which is occurring in Scottish writing more generally too (2007: 262–72).

7. In *The Old Ways*, Macfarlane discusses this as a particular characteristic of Edward Thomas's work (2012: 323).

# Misty Islands and Hidden Bridges
*Kevin MacNeil*

What is an island? A body of land surrounded by water? What about islands that are not surrounded by water at low tide? What about the Isle of Skye, which is attached to the mainland (or the mainland is attached to it!) by a bridge? A fixed definition of the word 'fiction' is similarly elusive. 'Literature in the form of prose, especially novels, that describes imaginary events and people'? What implications are there if the novel is set in a real place? I believe the word 'fiction' has a counter-intuitive aspect – a truth – that must be part of today's investigation.

At any rate, in Scotland there are about 800 offshore islands, 94 of which are inhabited and 14 of which have a population of over 1,000. And while there are relatively few novels set on these islands, there is nonetheless a significant and varied bookshelf of such books. Authors would include those from islands, such as Malachy Tallack, Robert Alan Jamieson, Laureen Johnson, Amy Liptrot, and those not from, but writing about, the islands, such as Ann Cleeves, Peter May, Anne Macleod, Lillian Beckwith, Sheenagh Pugh. I think we need to be wary of suggesting there are any inherent qualitative distinctions between works written by those who have, say, a lifelong knowledge of a place and those who may have simply visited. That would be absurd; the reality, naturally, is much more nuanced. One of the best-known island narratives of all time, *The Tempest*, was written by someone who was not an islander and I have spoken elsewhere about successful ways in which Shakespeare brings an understanding of elements of small island culture to that play.

Now – full disclosure – in the passing I might point out that I was born and raised on the Isle of Lewis to a mother from Lewis and a father who is an *Uidhisteach*, a Uist-man, with Barra blood (the surname 'MacNeil' is very common on Barra), and I have also lived on Skye and in Shetland, so I have considerable experiential – as

well as vicarious, literary – knowledge of island culture. In 2011 I edited a book called *These Islands, We Sing: An Anthology of Scottish Islands Poetry*. I thought it would be the latest such anthology; I was astonished to learn that it was, in fact, the *first* and to date *only* anthology to collect work from any Scottish island, as opposed to a book whose jurisdiction was limited to a specific island group or expanded to include the Highland region on the mainland. As I mentioned in my introduction to that anthology, 'even dedicated readers sometimes overlook the disproportionate excellence of 20th- and 21st-century poetry from the Scottish isles' (MacNeil 2011: xvii). That kind of neglect is what I want to address in this chapter. While this Caledonian archipelago has produced an inordinate number of talented poets, *relatively* few writers of prose fiction have emerged from the Scottish islands. They *do* exist, and a number of them began their writing lives as poets. But they are a minority within a minority. How do we account for this?

There are a number of contributing factors: firstly, poetry was a part of everyday life in the islands – sung, as it was, to aid chores, especially rhythmical ones such as rowing or waulking tweed, not to mention its entertainment value at *cèilidhs*; secondly, and relatedly, oral storytelling was a tradition unto itself, necessitating a more 'live', malleable and even somewhat spontaneous use of words than novel-writing does; thirdly, one might be tempted to say that in contrast to the more performance-based activity that was storytelling, novel-writing derived from a place that was perceived as being more individual, more solitary and, crucially, more middle class (I say 'perceived as' since the argument could be made that novels, like traditional tales, can transcend class or, for that matter, can support, tacitly or otherwise, one class over another). But from an island perspective, that perception, perhaps even *suspicion*, of novels was there. Finally for the moment, there is the undeniable truth that a sort of Tall Thistle Syndrome exists on the islands, very similar to the Nordic Law of Jante, the first rule of which states 'You're not to think *you* are anything special'; Scottish island cultures tend to be small-c conservative and it takes a certain strength of character to go against expectation or to do something outwith the norm, such as becoming a novelist, or an artist of any kind.

And so, in the real world we must acknowledge that such cultural imperatives exist and have a real-life bearing on individuals. On the Presbyterian island of Lewis, for example, there are some who would consider writing, and artistic endeavour generally, to be an indulgence, a folly. I might add that, because I come from a working-class, island

background, it took unnatural and uncharacteristic self-belief on my part to become a writer. What this helped foster in me from a positive side, though, was what has increasingly proved a deep compulsion to write for purposes that do not relate to ego. Compare that occasional insular distrust of prose fiction with Hugh MacDiarmid's assertion made in the 1930s (quoted in Madeleine Bunting's essay 'Island mythologies') that 'it is impossible to write about the Scottish islands today without recognising civilization's urgent need to refresh and replenish itself at its original sources' (MacDiarmid in Bunting 2017: 3) – a quotation that has a non-political, but very personal, resonance in contemporary works of non-fiction such as Orcadian Amy Liptrot's excellent and hugely successful memoir *The Outrun*. MacDiarmid also stated: 'All that is still greatest in literature and art and philosophy was created not in the great cities . . . but under conditions destitute of those modern blessings and, for the most part, in places as lonely and bare as these islands are.' Since MacDiarmid's time, though, the relationship between writers and their chosen environment has changed. The well-known Scottish writers were once much more widespread geographically than they are now. There are some valid logistical reasons for this – population growth patterns and internal migration, for example – but still; in an age of easy, instantaneous communication over long distances it is worth noting that a major shift has seemingly taken place. The best-known writers from Scotland – the likes of Neil Gunn, Lewis Grassic Gibbon, Nan Shepherd, George Mackay Brown, etc – were rural writers. Nowadays, the names most commonly associated with Scottish literature – for example, Irvine Welsh, James Kelman, Ian Rankin, even J. K. Rowling – belong to urban-based authors.

The islands, meanwhile, so often peripheralised, do nonetheless still exist! And novels relating to the islands continue to appear. The ethnologist in me recognises the need to acknowledge that, however we define them, 'insider' and 'outsider' writer perspectives on islands are important if we are to gain any kind of balanced view. Now, this quietly implies that there is a relationship between fiction and reality, and I do intend to come back to that. The academic terms for insider and outsider perspectives are 'emic' and 'etic' respectively. (Emic perspectives being those taken by a researcher who is a member of the community being studied, etic perspectives being those taken by a researcher who is an outsider to that community.) While that applies to academic research I think we can accept that similar issues apply to writers when writing about a specific, real-life place and culture. It is important to appreciate that the emic/etic bifurcation is by no means

clear-cut. It is, rather, an intricate one. Can an outsider become an insider? How long does that take? Is identity itself fluid to the point where no two people in any case experience the same culture the same way even if their biographies are superficially very similar? The story is told of two friends who part by a riverside, one following the river north, the other following the river south. Walking north, one friend sees the moon reflected in the river to their left and thinks, 'Nice! The moon is coming with me.' The friend walking south sees the river to their right reflecting the moon and thinks, 'Nice! The moon is coming with me.'

I firmly believe that emic and etic approaches to literature are *both* vital. But I wish to suggest that for a small island community, routinely overlooked, marginalised, 'othered' or misunderstood, these factors are subject to a particular relevance. It is interesting to note that the same intellectual and ethical pressures that apply to ethnologists also apply to writers who decide to set a novel on a real-life, contemporary, small island. Questions inevitably arise. 'How do I negotiate the following, and to what extent do they each relate to my remit as an author: trust and responsibility, accuracy, authenticity and plausibility, matching or subverting the images islanders and non-islanders have of the culture being evoked?' Meanwhile, the indigenous islander might pick up a novel and think. 'Ah. Previously we didn't really exist. Now we do, but in a *version* of us I might not recognise.'[1] Like an island mist, a nebulous grey area hovers here wherein cultural appreciation can shade into cultural appropriation. I am going to take an unusual perspective on this and quote from Zadie Smith's recent book of essays, *Feel Free*. In a marvellous piece entitled 'Dance lessons for writers', Smith contemplates the dance moves of two Davids, Byrne and Bowie:

> It's interesting to me that both these artists did their 'worst' dancing to their blackest cuts. 'Take me to the river,' sings David Byrne, in square trousers twenty times too large, looking down at his jerking hips as if they belong to someone else. This music is not mine, his trousers say, and his movements go further: Maybe this body isn't mine, either. At the end of this seam of logic lies a liberating thought: maybe nobody truly owns anything. [. . .]
>
> People can be too precious about their 'heritage', about their 'tradition' – writers, especially. Preservation and protection have their place but they shouldn't block either freedom or theft. (Smith 2018: 145)

Well! I confess that I probably have been guilty in the past of being that writer who is 'precious' about their culture – partly because I

didn't know I had a culture until I went to university, partly because my culture was edged off the map or, when it was deigned to exist, was usually 'othered', partly because I came to feel that Hebridean culture, like the Gaelic language itself, was in a precarious position. Through time I have come closer to an attitude that is like Zadie Smith's and is, I hope, practical, mature and liberating.

What motivates writers from elsewhere to choose to set a novel on a Scottish island? Perhaps a sincere love of the culture? Or a fascination with what seems very different to their own original culture? Or because a Scottish island seems a place, whether bleak or picturesque or both, on which they can project 'otherness'? An island has all the stuff of drama – issues such as power conflicts including issues of control and submission, identity, change, the nature of Nature, relationships, escapism. These themes are fairly universal. But an insular environment magnifies them – which is also, of course, what drama usually seeks to do. An island is, in the literary sense, a crucible. A crucible can be defined as 'a container in which metals or other substances can be heated to very high temperatures' and in literary terms usually refers to a place in which people are trapped – contained – as in a lift, or a lifeboat. On a small island the sense of routine can be debilitatingly heightened, gossip is commonplace, a claustrophobia can arise, intensified by the scrutiny or manipulation of the perhaps well-intentioned, perhaps over-protective, perhaps judgemental guardians of the community, Prospero-style. Author-style. An island upbringing in Scotland often bestows on a person a sense of preternatural self-consciousness. The sense of being surreptitiously observed and discussed, common in the literature of the Scottish isles (especially that written by indigenous islanders) can leave the person who is the focus of such (often unwanted) attention feeling wary, judged, *trapped*. Again, that crucible. The result is usually an escape in the sense of a physical journey (such as going to the University of X or the University of Life or both), or an escape in the sense of an imaginative kind, or it can take the form of self-destruction. Murder is thankfully a rare, rare occurrence on any Scottish island . . .

And indeed now, I want to turn to crime. Or, rather, I want to turn to crime *fiction*. After all, one can hardly discuss present-day novels that pertain to the Scottish islands without considering the highly popular works of, for example, Ann Cleeves and Peter May. Shetland writer Malachy Tallack recently sent me an excellent (currently unpublished) essay in which he reflects upon the *Shetland*-set books by Ann Cleeves and the subsequent TV series.

'It is a strange experience,' he writes, 'to watch Shetland in Shetland, like looking in a mirror and seeing your own face bloodied and distorted . . . [The tv series] has found a working balance between scenery and slaughter . . . The role these islands play is a dual and essentially contradictory one. They are required to be, at once, both beautiful and threatening, like a postcard with a sinister note on the back.' (Tallack: 1)

Writer Jen Hadfield has lived on Shetland for a number of years now and it is impossible to think of Shetland poetry without considering her distinctive, deservedly award-winning work. 'I first visited Shetland in 2002', writes Hadfield, 'very keen for it to be a blank canvas on which I could superimpose a personal mythology of the far north. I got over it.' Of Shetland she writes:

This gorgeous, complex, commodity-rich place . . . settled for millennia by typical humans (ie open-minded, ignorant, compassionate, greedy, worldly, creative, perverse, generous, curious . . .) is surely fit material for an addictive, honest, fiction. (Hadfield 2013)

An honest fiction – we'll come back to that.
   Hadfield's take on Shetland the crime fiction locale, is different:

Shetland's crime fiction boom is just the latest in centuries of commodification. Its islanders are familiar with the benefits and costs of exploitation of its fish, soapstone, human labour, china clay . . . its wind and these days also of its 'liminality': that fashionable (and Orientalist) theory of the 'edge'. (Hadfield 2013)

What messages about island life do such novels send out? On the islands, crime, with some appalling notable exceptions such as domestic abuse, otherwise tends to be low level and often drink- or drug-related. Can an island-based novel centred round murder be 'authentic'? Should we expect it to be? Perhaps too much reality renders a novel inessential (after all, we have reality for that)? In an unpublished dissertation, 'Bodies on the beach: on-screen crime and detection drama in island settings', Shetland resident Kathy Hubbard discusses the fact that a location regularly used in the Jersey-based TV detective show *Bergerac*, former children's home Haut de la Garenne, was later revealed to have been a place of horrific sexual and physical abuse during the 1970s. A case of crime being that bit *too* real. Borges once wrote: 'Reality may be too complex for oral transmission; legends recreate it in a way that

is only accidentally false and which permits it to travel through the world from mouth to mouth' (Borges 1999: 373). The writerly ambition, surely, is to edit and shape reality, or some derivation thereof, into a narrative that offers meaning or entertainment or both. In his novel *The Black House*, set on Lewis, Peter May makes a brave and risky decision to load his narrative with exposition about the culture of the island. I find myself, then, in the strange, yet familiar, position of having my island home explained to me. It is fascinating to see ourselves as others see us. I do, however, harbour concerns about how definitive these aspects can become in the popular consciousness.

Literature constitutes a broad and deep human endeavour. I make no great distinction here between 'literary fiction' and 'crime writing'. Fine writing is fine writing. But I feel that the main marker of inauthenticity in the recent and current crop of island-based fiction by non-islander authors lies in the dialogue. This is not simply because of cliché ('I'd rather hear it from the horse's mouth' (May 2011: 110)), not because of flat, information-dump speechifying that is motivated by the author's need rather than the characters' – '*No, [a good cop is] what you were. Until a month ago. And what happened, well that was a tragedy.*') and it is not even simply because of awful stereotyping though that is an issue ('*Fin snorted. "What was he doing here? Protecting sheep from being molested after closing time on a Friday night?"*' (May 2011: 71) – an islander would not call to mind this stereotype about another islander). The great danger of providing a readership with information about a place or people that conforms to stereotypical rather than realistic images is that it can engender or sustain confirmation bias, the tendency for people to accept information in a way that supports their preconceptions.

People read with their eyes, but they also read with their ears. This is an area where I feel authenticity does matter. What is missing in May's work, and that of others who attempt to recreate islands and island characters in their novels, is an ability to evoke the distinctive speech patterns of those islands. And yet what a rich verbal resource these are to any writer. One of the strengths of Malachy Tallack's recent novel *The Valley at the Centre of the World* is his principled, characterful and credible use of Shetland dialect throughout the dialogue. Since the book was published, Tallack has wryly commented, 'Reviews of my novel so far have pointed out that there is too much Shetland dialect in the book, and the right amount of Shetland dialect, and not enough Shetland dialect.'[2] By contrast, there are those whose manipulation of the way islanders speak departs from any

form of reality and lands the reader, perhaps unwittingly, in a place of patronising parody. In the 1980s Iain Crichton Smith wrote: 'Gaelic is the language of the islands, and not the broken English . . . as heard, for instance, in the books of Lillian Beckwith' (Smith 1986: 20). Here are some examples of Beckwith's ill-judged (and, in fact, offensive) representations of Hebridean speech patterns (and the punctuation here is also, one presumes, knowingly erroneous):

> Surely its that quiet here even the sheeps themselves on the hills is lonely and as to the sea its that near I use it myself every day for the refusals. (Beckwith 1959: 1)

There's worse:

> On the dresser was a bowl of peanuts still in their shells which had been sent to me from England. Taking a good handful I put them into a bag and offered them to Johnny.
> 'Take these home to Kirsty,' I said.
> Johnny turned them over suspiciously. 'Which is these?' he asked me.
> 'They're peanuts' I told him. 'Very good to eat.' He still continued to turn them between his large fingers. (Beckwith 1964: 1)

These things matter. They matter because novels offer more than fiction. Discussing Louise Welsh's *Naming the Bones*, partly set on the isle of Lismore, Dr Maggie Scott writes:

> *Naming the Bones* took a place I know and love and turned it into a place of horror. I can't fully decide what to make of that – it seems casually exploitative of an exceptional place, a hidden treasure being tarnished. When a place has next to no identity in the mainstream public narrative it seems oddly glib to make use of it in such an excessively negative depiction.[3]

'Casually exploitative of an exceptional place' is a powerful phrase and brings to mind the sense of 'otherness' often foisted upon us as islanders. An imposed 'otherness' can surround islanders, and indeed frequently does, and it thereby runs the risk of becoming inescapable, overwhelming – becoming, through a form of osmosis, a generalised perception, which becomes 'our' perception, like an illusion we buy into and eventually buy into so unthinkingly that we accept it as reality. The same can be said of the self. Thus, otherness becomes us.

An acritical or oblivious mindset can lead to the absorption of false cognitions. If we, like the centres of power themselves, place undue emphasis on the value of their etic perceptions simply be*cause* they derive from centres of power and influence, those exterior conceptualisations become our norm, too, in a manner more insidious than willed. This is not to invalidate the work of those writers who use the islands as atmospheric or otherwise convenient storyteller wallpaper in any way, but it is to seek a fair balance. Culturally ingrained insecurities have real-life impacts on the identity, meaning and even the welfare of individuals. Turning a place into an unlikely, unreal or unfair stereotype is no more acceptable than turning a person into a stereotype. It demonstrates a paucity of effort and an attitude of carelessness, indifference, perhaps even disrespect.

As a side point I might suggest that this need not be a wholly oppressive or repressive circumstance – after all, it gives island authors something to write against. But this can potentially be constricting, too, because we first need to remove the lifeless tropes before we allow the living truths to grow. *Leòdhasach* Iain Crichton Smith wrote:

> It is true that more than most the islander is caught in a net of contradictions, imposed on him by history, and that to live from the centre of where he is, is far harder than for those who have been luckier with their geography and their history. (Smith 1986: 20)

In manifold ways, our marginalised voices are suppressed, our opportunities limited. Iain Crichton Smith again:

> The choices for the gifted islander are more poignant and frequent than they would be in a more settled land, for each choice appears to involve allegiance or disloyalty . . . To begin freely from home and colonise experience is a luxury that the modern islander does not have. (1986: 21, 32)

In contrast, the non-islander author therefore is in a relatively privileged position. They *can* begin freely. And if they are of a certain class or background and are writing for a readership of a certain class or background that wants a specific depiction of an island that confirms *their image* of that island, then the non-islander novelist has a commercial potential that can be enticing to publishers in the way that the televised *Shetland* is enticing to a broadcaster. Authenticity is unimportant. What some writers seem to choose to ignore is Iain Crichton Smith's assertion, which ought to be self-evident

but apparently isn't, that 'To be an islander is to inhabit a real space on a real earth.' My contention is that the best fiction inhabits a real space in a real mind in a manner that is insightful, emotionally engaging, meaningful and honest. Indeed, I have long been of the belief that those narratives which last – plays, novels, stories, films – are the ones that are built on a meaningful foundation. Books, too, inhabit a real space on a real earth.

One way – and, I have increasingly come to believe, the most important way – by which to assess a story is through consideration of its consequences, its real-life impacts. I think of this as a natural evolution of the essential centrality of narrative in our lives, a process that involves sharing information, offering vicarious experience, catalysing empathy, teaching life skills, and so forth. Stories without meaning do not last. All we are, and have, is narrative. I don't say this merely because I am a writer and a devoted reader. To understand anything in life, we give it story, meaning (our sense of selves, again, being a good example of that). But what happens when others impinge on our sense of self? In a way, nothing unusual – this, after all, is the stuff of human interaction, verbally, physically, emotionally, and so on. But if we absorb other people's perception of who we are, especially if that perception comes from a place of power and repeated cultural reinforcement, then we can begin, unconsciously or otherwise, to absorb that narrative. The effects of this are worth observing at a personal and a cultural, public level. An example of the latter is the ways in which the literary and tourist worlds collide.

One of the most profound statements concerning art is Pablo Picasso's 'Art is the lie that enables us to realise the truth.' In my own reading and my own writing practice I take this further and say, 'Fiction is a lie that reveals a bigger truth.' This, I believe, is true of the novels that last. So, for example, it does not really matter that Iain Crichton Smith's novel of the Clearances *Consider the Lilies* has anachronisms. The novel's core truth is powerful, convincing and honest. Does it therefore matter that some authors create scenarios that would be implausible or impossible in their supposed island setting, and thereby offer solutions that satisfy on a notional level only? Not, I suggest, if the insights transcend their abstractions and have emotional and/or intellectual truth. The best novels, therefore, have something to tell us. 'Storytelling', as Hannah Arendt said in *Men in Dark times* (1968), 'reveals meaning without committing the error of defining it'; stories share insights and understandings that we are then left to interpret. The best narratives offer truths by which we

might better find our way through life. This is one reason I baulk at the narrow-mindedness of those who consider creative writing to be mere indulgence. The greatest tales, those that last, do so precisely because of their truths. I do not believe that island-grown writers must yield to any expectation to 'represent their culture' (it is interesting that the Lewis-born-and-raised crime writer Malcolm Mackay often sets his books in Glasgow). Nor do I feel that writers from elsewhere who choose to set books on the islands ought to strive for any prescribed version of an island. But the novels that represent island life offer a chance – not an obligation, but a chance – for writers to shape fictions that share meaningful truths. The best novels move beyond fiction into truth. This is true of island-based novels just as it is for novels set in other countries, on other continents or other planets. I understand reality more truthfully, more coherently, more completely, through the novels I read than through the newspapers I read. In Scotland, and especially in the islands, we are traditionally very poor at celebrating our artistic endeavours. This is partly why I would love to see more island-based novels published by islander and non-islander alike.

To be is to mean something to someone. To write is to create or reveal meaning for someone. In a universe defined by change – undeniably *everything* is in constant flux – there must be something other than meaning, something outside of it, something not bound by it, to offer the space and means *for* change. We therefore engage with life through the making and sharing of stories. The English mathematician-philosopher Alfred North Whitehead said, 'What men believe to be true is true in its consequences.' Might the same not be said for the best works of fiction? What we read is the quality of our reading. What we experience is the quality of our experiencing. And so the quality of island-related writing matters. Pertinent here, also, is the concept of 'double-consciousness', a term invented by W. E. B. Du Bois to describe the form of internal conflict that arises in oppressed, colonised, disempowered or otherwise subordinated groups in an unequal society. A marginalised, minority society might thereby look at itself and the world not with a clear, unobstructed view but with a troubling, simultaneous sense of seeing self and world through the eyes of more powerful external agencies, whether oppressors or interpreters.

A novel set on an island that does not evoke the essence of that island – everything from material culture to linguistic quirks – in other words, a novel that could be set *anywhere* might as well *be* set somewhere else. Place is character. Truths can manifest in fiction in a

way that is accidentally honest. But the best fictions reveal truth with insight and integrity. As scholar Michael Newton recently wrote:

> When a society is invaded and dominated by another, it can easily lose its sense of self, especially if the dominating group imposes a different language, culture, worldview and cosmology upon the conquered, stigmatizing their former ways of knowing and being in the world. The conquered become dislocated from their rootedness in the world, ontologically speaking . . . When a culture is severely compromised, it tends to lose control over its own institutions, especially those that help it to understand itself.[4]

Literature is not an institution, but novels, as I have endeavoured to demonstrate, do help us understand ourselves. We might negotiate our way through a post-truth world (some claim we already are) but we could not survive a post-fiction world. Fictions relating to small island communities matter greatly.

## References

Beckwith, Lillian (1959), *The Hills is Lonely*. http://www.electricscotland.com/books/hills_lonely.htm (accessed 5 June 2018).

Beckwith, Lillian (1964), *The Loud Halo*. http://www.electricscotland.com/books/loud_halo.htm (accessed 5 June 2018).

Borges, Jorge Luis (1999), *The Total Library: Non-Fiction 1922–1986*, London: Penguin Books.

Bunting, Madeleine (2017), 'Island mythologies', *The Bottle Imp* (Association for Scottish Literary Studies). https://www.thebottleimp.org.uk/2017/06/island-mythologies/?print=print (accessed 20 May 2018).

Finlay, Alec and Kevin MacNeil (eds) (2000), *Wish I Was Here. A Scottish Multicultural Anthology*, Edinburgh: Pocketbooks.

Hadfield, Jen (2013), '"Shetland" and the intriguing disappearance of the North-Boat', *The Bottle Imp* (Association for Scottish Literary Studies). https://www.thebottleimp.org.uk/2013/05/shetland-and-the-intriguing-disappearance-of-the-north-boat/ (accessed 20 May 2018).

Hubbard, Kathryn (2017), 'Bodies on the beach: on-screen crime and detection drama in island settings'. Unpublished dissertation submitted as part of the final, examination for the degree of MLitt in Island Studies, University of the Highlands and Islands, copy sent to the present author in May 2018.

Liptrot, Amy (2016), *The Outrun*. Edinburgh: Canongate.

MacNeil, Kevin (ed.) (2011), *These Islands, We Sing: An Anthology of Scottish Islands Poetry*. Edinburgh: Polygon Books.

May, Peter (2011), *The Black House*. London: Quercus Books.

Smith, Iain Crichton (1986), *Towards the Human*. Edinburgh: Saltire Society.

Smith, Zadie (2018), *Feel Free*. London: Hamish Hamilton.

Tallack, Malachy, 'The heart of beyond'. Unpublished (at time of writing) essay, sent to the present author in May 2018.

## Notes

1. A thought that puts me in mind of Irfan Merchant's formidable poem 'I'm a racist' (Finlay and MacNeil 2000: 153).
2. Tallack's Twitter feed, accessed 3 June 2018.
3. Scott, communication to my Facebook page, May 2018 (permission to quote granted).
4. Michael Newton: https://virtualgael.wordpress.com/ (accessed 10 June 2018, since deleted).

# The Scots Language is a Science Fiction Project

## Harry Josephine Giles

Scots has a living vernacular, a well-established and historically con-
tinuous poetry tradition, and next to no modern prose. The absence
of a significant prose tradition, either fiction or non-fiction, means
that Scots is a national language without a well-established narrative
or formal prose register.[1] If a specific register of a language requires
common usage and understanding in order to exist, then this absence
of a historically continuous prose register goes some way to explain-
ing why attempts at journalism in Scots, such as in the recent pages
of *The National* and *The Herald*, have, as noted by Scott Hames
(Hames 2018), been met by opposition and derision: the understand-
ing is not there, so the register does not exist, so the understanding
is prevented. Nonetheless, novelists continue to attempt the work of
Scots prose – so what happens when you attempt to write in a lan-
guage that doesn't exist? My argument is that, if you want to write
in a language without the appropriate register, you have no option
but to continuously invent it, and that this continuous invention is a
science fiction project.

I begin by briefly outlining contrasting approaches to Scots prose,
and then examine the temporalities of Scots and Scottish science
fiction, at both the technical and narrative levels. Throughout, my
approach to Scots literature is informed by postcolonial studies and
in particular the postcolonial turn in science fiction studies, and so I
conclude with reflections on Scotland's double role anent postcolo-
nialism and the double bind in which it places the Scots science fic-
tion novel. If the Scots language is a science fiction project, then this
project is both what enables Scots to be written now and what limits
the possibilities for Scots in the future.

## Imagining Scots Prose

There are two major approaches to Scots language narrative prose.[2] The first is the vernacular, represented, for example, by James Kelman's *How Late It Was, How Late* (1994), Irvine Welsh's *Trainspotting* (1993), Alison Miller's *Demo* (2005) and Jenni Fagan's *The Panopticon* (2014). These novels, with greater or lesser fidelity and naturalism, and with greater or lesser proximity to the acrolect, seek to put on the page the Scots language as it is spoken in their author's time and locale. *Demo* opens thus:

> It was deadead good they let me go. I've never went abroad before except Majorca or Tenerife. And only in the summer to lie about on the beach and that. This was November and I'm like, will I take my big coat or will it still be warmer than Glasgow? My ma didny know. (Miller 2005: 3)

Linguistic features here include: first person narration; lexical items belonging to particular local vernacular ('deadead'); a spoken grammar marked by its difference from Standard English written grammar ('I've never went'); filler and phatic speech ('and that', 'I'm like'); and eye-dialectical phonetic spelling ('didny'). The result is to summon not a generalised Scots language but a specific Scots speaker, whose speech contains personal, local and national features. This approach to the problem of prose piggybacks on the continuous Scots vernacular register: rather than attempting to create a standardised literary register of Scots, it engages with the modernist and postmodernist experimental traditions of rendering voice in text.

The contrasting second approach is the literary and formal, represented, for example, by Iain W. D. Forde's *The Paix Machine* (1996), Matthew Fitt's *But n Ben A-Go-Go* (2005) and Wulf Kurtoglu's *Braken Fences* (2011).[3] Here is a representative sample from Fitt's novel:

> Glowerin numbly throu the keek panel o Omega Kist 624 up on Gallery 1083 on the fifth anniversary fae the day his life pairtner Nadia wis Kisted, Paolo had nae choice but tae acknowledge his thrawn pedigree. The langer he gowked at the recumbent figure ahint the reekit gless panel, the mair he felt the Klog cauldness tichten roon his hert. As he watched fae the view gate in the Rigo Imbeki Medical Center high up on Montrose Parish, the threid-thin voice o his grandfaither kittled in his mind. (Fitt 2005: 4)

178 Harry Josephine Giles

Linguistic features here include: third person narration; a lexis that mixes archaic ('kittled'), contemporary ('thrawn') and science fictional neologistic ('Kisted'); a written grammar consonant with that of Standard English and without filler speech or other markings of spoken language; consistent spelling as of a standardised language, including choices which mark difference from English even where there is not specific phonetic difference ('throu').

Thus, where the vernacular Scots writers are attempting to record Scots as it is spoken, the formal Scots writers are attempting to adhere to and/or create the standardised formal register of a European national language. Examining Scots, Breton and Occitan, William Calin says:

> Intellectuals in all three regions called for the creation of a high-culture tongue that would be capable of functioning in all ways that English and French are wont to do. It would be more learned and, at the same time, more all-embracing. On the agenda were the following: lexical enrichment of the vernacular [. . .]; a bridging of the dialects and the attainment of a form of linguistic unity by adopting a uniform, unified, 'rational' orthography[. . .]; the creation of scholarly, standardized dictionaries and grammars [. . .]; and use of language as an arm in the struggle for cultural and, if possible, political autonomy. (Calin 2000: 7–8)

Given the status distinction inherent in the vernacular vs. literary binary, even when the orature appears as literature, it is not surprising that each of the four novels in the former style are social realist narratives of working-class characters. More surprising, however, at least initially, is that each of the three novels in the latter style – the only existing adult novel-length works in standardised Scots that I can source – are science fiction. But I would argue that the situation of a language without a prose literature, a language that thus both does and does not exist, requires a science fictional imagination, and thus that the project of a national Scots language as a whole should be understood first as a science fiction project.

Bill Ashcroft argues that minority language literature, especially with vocabulary and orthography proximate to a colonial language, 'constructs a reader for whom its variations pose no serious obstacle' (Ashcroft 2008: 163). The unstated shadow of this claim is that such a reader does not yet exist; as John Corbett admits, a 'disincentive to writing science fiction in Scots is the perceived or actual incomprehensibility of the written language. [. . .] Extended prose in dense broad Scots represents a risk that few commercial publishers are prepared to

take' (Corbett 2012: 120). On Forde's novel, Corbett states that 'Not surprisingly, given that the imagined reader needs to be conversant with science fiction, classical mythology, a touch of history, and unremittingly dense Scots, Forde's novel has never achieved wide distribution' (Corbett 2012: 10).

Leaving aside the fascinating question of why vernacular Scots novels featuring working-class protagonists, also sometimes with 'unremittingly dense' language, are able to achieve such a distribution and, in Kelman's case, a Booker Prize win, the question for my subject is why science fiction is the chosen genre of the Scots language novelist. Forde claims in the précis of his book, published the year after Kelman's Booker victory, that 'There are no contemporary novels in Scots' and thus that his is the first such book 'to provide enjoyable thoughtful Scots prose' (Forde 2018: n.p.). Forde's claim implies that Kelman's work is not Scots; a more modest claim is that Kelman's is simply not the kind or register of Scots that Forde wants. Given that a language does not have to have a full complement of registers to be a language (and what would that complement be?), and that indeed many don't, this implied incompleteness of Scots speaks to the national as well as the artistic ambitions of its authors: a European nation-state must have a language in the European mould. I would argue that, because the reader of Forde, Fitt and Kurtoglu does not exist in their time, these authors write science fiction in order to imagine ('construct', in Ashcroft's terms) the world in which that reader already exists. It is not that they are creating a register so as to tell the story of a future world in which Scots exists; it is that they are creating a future world in which Scots is unhindered so that Scots can exist in the present.[4]

This science fictional leap also frees Scots novelists from the cultural baggage of a language that 'signifies the old, traditional language of childhood and past generations' and the resultant 'sentimental, nostalgic stance' (Corbett 2012: 118). Given that nostalgia implies loss, decline and absence, the nostalgic connotations of Scots create a Scots that is always already dying; the science fictional leap, therefore, creates a decisive break from that death so that Scots can live again.

## Techniques of Scots Temporality

The complex temporalities of these science fictional leaps are legible at the technical level, in the decisions made about how to render Scots on the page. Here, Fitt and Kurtoglu part ways: while Fitt's written register also has a spoken register in his character's

dialogue (that is, his Scottish characters speak in a register of the language in which the novel is written), Kurtoglu's Scots narration is extradiegetic, in that her Scottish characters' dialogue is rendered in English, while her non-Scottish characters' dialogue is rendered in Scots. These distinctions are made clearer in extract:

> 'Dinna move, Lars,' Paolo began cantily. 'Right nou, ten snipers are checkin your loser's coupon for plooks, their fingirs juist yeukin tae pit you intae a six-month sleep.'
>     Lars Fergussen boued his heid tae the gless an keeked up at the balconies o the hooses opposite. He chapped a metallic object aff the unnerside o the table an Paolo kent he had a pistol pointed atween his hurdies. 'I could kill you, Scotman, afore their vee tranquiliser guns get me.' (Fitt 2005: 59)

> 'Ye ken, Beatrice,' he sayed in Chinese, 'Ye sud chuse yer friens wi care.' She scanced ower his shoother at the wild-leukin fowk wha had arrived earlier. [. . .] As she rubbit awa the bruises in private later, she thocht o the auld Black-and-White film o *Devdas*, wi Dilip Kumar [. . .] She gied a guff. 'Sweet little Paro I am *not*.' (Kurtoglu 2011: 37)

In both cases, the diegetic status of Scots is made clear by contrast to other speakers. In both cases, Scots is the language of narration. But in Fitt's novel, set in a future Scotland, both Scottish and non-Scottish characters speak Scots: Paolo, the Scot, fluently, while Lars, the Danish immigrant, in broken grammar ('get me') and with a stereotypical accent ('vee'). It is implied by this that this future-Scots is the language characters speak in the imagined world. In Kurtoglu's China-set novel, in contrast, the Chinese character, Hsien, speaks in a Chinese which is rendered by the author in Scots, while the Scottish character, Beatrice, thinks in English, and speaks with the other Scottish character, Bill, in English as well. Most of the dialogue in the book takes place diegetically in Chinese, rendered extradiegetically in Scots, meaning that English is here the marked language, showing the characters' difference from the Chinese cultural norm of the setting.

Another linguistic distinction also takes place in Kurtoglu's novel: Neanderthal characters speak the 'Auld Language', which is marked in its difference from the Chinese dialogue by using an older form of Scots, as in 'Quhit wey fer thee?' (Kurtoglu 2011: 40) and 'Cud thoo no jüst cover thine een?' (Kurtoglu 2011: 41) Here, the 'auldness' of the language is marked by the use of a strong voiceless labiovelar fricative with the spelling of medieval Scots ('Quh), the close-mid front

rounded vowel with the spelling sometimes found in contemporary Orcadian and Shetlandic ('ü'), and the thee/thine distinction – again contemporary in Orcadian and Shetlandic – not present in the 'ye' of the Chinese-rendered-as-Scots. This linguistic dexterity (Kurtoglu as Caroline MacAfee is an editor of Scots language dictionaries and thesauruses) portrays cultural and linguistic distinctions between the characters, and also, as in Fitt's novel, serves to normalise Scots as the language of narration.[5]

A second technical distinction between the novels is in the use of neologism. While Kurtoglu by and large avoids creating new words for her narrative prose, and is also not engaged in the project of creating a Scottish cultural future in her novel, Fitt is prolific in the creation of words and ideas: 'cyberjanny', 'plastipoke', 'incendicowp'. As Corbett notes, this 'compounding of disparate elements has long been recognized as a staple of science fiction' (Corbett 2012: 122), while it is also at once the 'flamboyant adoption of linguistic strategies favored by the modernist makars' (Corbett 2012: 124). Indeed, by fusing Scots with science fiction, Fitt is taking the modernist syncretic project to its logical conclusion, linguistic futures.

The novels thus suggest two different futures for Scotland and for the Scots language. In Fitt's novel, England has been literally submerged by global warming-related flooding, and Scotland exists, independently, as a place of island cities; the tempting suggestion is that it is the very submersion of England that has allowed the Scots language to flourish. In Fitt's world, Scots exists as a language: as the neologisms indicate, Scots is not merely the language of our present but the language of the novel's future. In Kurtoglu's novel, where the Scottish characters speak English, the suggestion is that Scotland's ongoing participation in the British project, which becomes in the novel the globalising project of the 'Rational World', means the extinction of Scots in favour of a global English. But this pessimism as to Scots' future is contrasted with the optimistic execution of the novel itself: it is written in Kurtoglu's Scots of now, not Fitt's Scots of the future, implying that there is a suitable Scots that already exists, or rather doing the work of constructing that Scots and its readers, and thus arguing by its execution that, here and now, Scots is up to the task of literature and a global setting.

## Language as Temporal Ligature

If the technical deployment of language itself implies a temporality, a political orientation towards the future and the past, then these

dynamics also appear in the narratives of time travel, a figure which has recurred multiple moments in Scottish science fiction.[6] One earlier instance is in the work of James Leslie Mitchell. Intriguingly, as a counter-example to my argument, Mitchell is better known for his social realist fiction under the pseudonym Lewis Grassic Gibbon,[7] and it is this fiction which uses Scots grammar and phrasing in the narrative and Scots language in the dialogue, whereas the science fiction is written in English. However, Mitchell's science fiction does engage directly with language and Scottishness, and so despite the lack of Scots is useful to consider here, especially as a background to Kurtoglu's work on the same themes.

In both *Three Go Back* (1932) and *Gay Hunter* (1934), a trio of 1930s Europeans and Americans are transported through time to a primitivist culture. In the former book, they travel to the past, to an Atlantis inhabited by Cro-Magnons and Neanderthals; in the latter, they travel to a future Britain, where a military cataclysm has wiped out most of human culture and the island is inhabited by low-technology tribes. In both past and future, the low-technology tribes are idealised, in particular through their peaceableness, connection to nature and sexual freedom. This is a conception of pre- and post-historic humanity that is fully independent of paleoanthropological study and rather entirely shaped by Western ideas about Indigenous peoples developed during the eras of colonial expansion.[8]

Indeed, the dialectic between the two novels exactly follows that classically set up by Jean-Jacques Rousseau's foundational *Discourse on Inequality*. In *Three Go Back*, the antagonists are Neanderthal 'Beast-Men', far more violent and animal-like than the Cro-Magnons (and a genetic line which became extinct, unlike the *Homo sapiens sapiens* Cro-Magnons); in *Gay Hunter*, they are contemporary self-identified Fascists who seek to civilise the post-historic humans. Thus, just as in Rousseau's assessment of North American Indigenous peoples, 'man's good lay in departing from his "natural" state – but not too much; "perfectability" up to a certain point was desirable, though beyond that point an evil. Not its infancy but its *jeunesse* was the best age of the human race' (Lovejoy 1923: 165–86), Mitchell's (and Rousseau's) utopian primitivists are thus not 'noble savages' (a term which Rousseau never used), but rather peoples who have just enough 'civilisation' to improve them from animal nature, as represented by the Neanderthals, but not so much that they become Fascists. In Mitchell, the major signifier of this dialectic is language.

In *Three Go Back*, the time-travellers first identify the Cro-Magnons as such, and thus also identify the time period in which

they find themselves, by identifying their language. Although none of the three consciously recognises their language at first, one finds himself able to speak it, and comes to a realisation:

> It's Basque—an elementary and elemental form of Basque. My mother was Basque. I haven't spoken the language since childhood, but last evening found myself speaking and thinking in it half unconsciously . . . It's the loneliest language in twentieth-century Europe, as I suppose you know. No affinities to any other, just as the Basques have no apparent racial affinity to any existing group. It's been speculated that they're the pure descendants of the Cro-Magnards. (Mitchell 2009: 40)

Thus pre-historic humans are connected to 'pure' European minorities, themselves colonised by the French state in the early period of state- and language-formation, through their language. Basque is figured as connected to childhood and the unconscious, and, as a 'lonely' language, it is also figured as fully intertwined with a 'pure' race, the implication being that an uncontaminated genetic line has somehow transmitted an uncontaminated language. It is this connection through language that allows the travellers to enjoy their time with the Cro-Magnons and appreciate them as 'not savages; they're clean and kindly children' (Mitchell 2009: 42). Despite this assessment, they are also deemed human and adult enough for the travellers to enjoy their sexual freedom. One character puts the philosophical thesis clearly, idealising them as 'absolutely without culture and apparently absolutely without superstitious fears, cruelties, or class-divisions. It means that Rousseau was right' (Mitchell 2009: 43).

It is again language that distinguishes the Cro-Magnons from the Neanderthals: where the former have speech and can be communicated with, the latter never give more than 'a strange moaning cry' (Mitchell 2009: 61). Without communication, the encounter soon becomes armed conflict. There is also a notable distinction made through physicality, fully imbued with racist binaries: whereas a Neanderthal is described as having 'the bigness of a gorilla and something of its form' and as 'a strange, strayed, hungry, pitiful beast' (Mitchell 2009: 61) with 'an odd *black* resentment against life' (Mitchell 2009: 63, my emphasis), the Cro-Magnons first appear 'tall and naked, the sunshine glistening on *golden* bodies, their hair flying like the horses' manes. *Golden* and wonderful' (Mitchell 2009: 33, my emphasis). This goldenness is the adjective often used for the people, and the characters repeatedly describe their time as the Golden Age of Mankind. Through Basque, this Paradise is identified with European minority

language, and the Fall is identified with the rise of civilisation and the construction of the genocidal-imperial European nation-state. One character makes a prediction:

> the descendants of those people—the descendants of your children—will have drifted across to the fringes of Europe. [. . .] In Tyre they'll burn alive those children of yours inside the iron belly of Baal. Rome will crucify them in scores along the Appian Way. They'll chop off their hands in hundreds when Vercingetorix surrenders to Caesar. (Mitchell 2009: 51)

But through Mitchell's time travel the Golden Age is given a second chance, when civilisation authors its own collapse. In *Gay Hunter*, the eponymous and euonymous American heroine travels through time with two English others, Ledyard Houghton and Lady Jane Easterling, both self-identified Fascists. Whereas Gay is portrayed as quickly able to adapt to her technology-free surroundings, shedding her clothes and foraging for food, the Fascists, highly attached to their symbols of civilisation, are incapable and must be taught how to survive. Lady Jane's first act on arriving is to weave herself a skirt; Gay, meanwhile, tames a wolf. Thus when Gay meets the posthistoric Folk she immediately fits in, while the Fascists seek to civilise them. As with the Cro-Magnards, the Folk are, in Gay's eyes, 'naked, rosy-brown children' (Mitchell 1989: 73), while Lady Jane sees them as 'Filthy savages!' (Mitchell 1989: 74) As with the Cro-Magnards, the Folk speak a 'Tongue' which has a 'vague, far trace of familiarity here and there' and which is in its syntax similar to pre-imperial languages as Mitchell imagines them: 'a simple agglutinative tongue, without tense or time, such a tongue as the Europe of her day had long abandoned' (Mitchell 1989: 80). This adds to the description of *Three Go Back*'s pre-historic Basque by imagining the post-historic Folk as being outside of imperial temporality, and again connected to European language prior to the imperial nation-state.

In this novel, the Tongue is contrasted with imperial English, which certain Singers of the Folk can still understand and speak. Rem, a Singer, explains that 'Only the dying Voices speak this speech. And they go fainter every hunting season as we come back to the Place of Voices. The Old Singer says that when he was young the Voices were still very loud. None care to listen to them now. But I' (Mitchell 1989: 91). The Old Singer later adds that 'Rem and I are the last of the Folk to learn the tongue of the Voices. When we pass, that will also pass' (Mitchell 1989: 81). Gay travels to the Place of Voices, where she finds a dusty machine, pulls a lever, and listens to

the English-language recording of a 'tale of the culmination of the world's civilisations and their last downfall in war and riot' (Mitchell 1989: 85). Horrified by this narrative and driven to rescue the Folk from any cycling of history, any rebeginning of the imperial thrust through time, Gay destroys first the Place of Voices and second the Fascists' attempt to torture the Folk into a new city, the two civilisational threats to the idyll of the Folk. Shortly after this a mystical experience removes the final threat: in a song, Gay herself is transported back to her own time.

Here, language links times through carrying information and story, as well as by carrying Gay across as a traveller. Language creates alternative life-worlds or is what constitutes such a life-world. The Voice, however, is not merely an antagonist, but also what has enabled the Folk's idyll. Following Rousseau's argument, remembering the language and story of civilisation is what has enabled the Folk to be civilised *enough* to raise them above an animal state, and only when that idyll is safely established can the imperial Voice be destroyed and the Tongue be safe to flourish outside of time. The two acts of time travel in the book are also related to language, though not so directly: it is a joint attempt by the three travellers at a kind of lucid dreaming that transports them forward through time, and a similarly intense dream under the influence of Rem's singing that transports Gay back. Here it is imagination, in one case guided by song, that makes time travel happen. Language is thus a temporal ligature, conjoining temporalities just as the pair of books link past and future together to make Mitchell's argument about the present. In Mitchell this ligature is a threat, a contamination of utopia that must be erased. For Mitchell, while we may learn from the past (or the future), we cannot be there, and we civilised and historical humans cannot get outside of the dialectic of history, outside of time.

This, in Mitchell's other work, is taken up as a major Scottish theme, particularly in the more well-known trilogy *A Scots Quair*, published exactly contemporaneously with the science fiction in 1932, 1933 and 1934. Here, a related dialectic is set up: Chris and the Scottish land as outside of time on the one hand, and Ewan and the Scottish people as subjects of history on the other. As Christopher Silver puts it, 'Chris' view of history is cyclical, in contrast to her husband and son who become, through war and political agitation, lost in external historic events' (Silver 2015: 116). Whereas 'Chris Caledonia', as one of her husbands calls her, becomes one with the land in death, her son Ewan is 'condemned to a struggle he cannot see as ever being finished, a dilemma offering no adequate resolution of the novel's central question

about the possibility of living fully within historical time' (Shiach 2015: 14). The rupture which brings about this dilemma, in which neither escape from time nor fully living in time is possible, is described early in the first novel as a dilemma of language, as a learned break from

> Scots words to tell to your heart how they wrung it and held it, the toil of their days and unendingly their fight. And the next minute that passed from you, you were English, back to the English words so sharp and clean and true – for a while, for a while, till they slid so smooth from your throat you knew they could never say anything that was worth the saying at all. (Gibbon 1995: 32)

That is, it is the learning of civilised English which breaks the signifier of Scotland from her land and language, from her being. For Mitchell as a believer in the genetic reality of race, this rupture is historically repeated: not just English/Scottish but also Celtic/Pictish. As with Chris Caledonia in *A Scots Quair*, Gibbons's writing 'asserts that his own Mearns "peasant stock" is significant in being the remnant of what he took to be, in line with the historiography of the time, a pre-Celtic Pictish people' (Silver 2015: 111–12). Writing elsewhere, Mitchell puts this (false) history bluntly: 'the Kelts are a strain quite alien to the indubitable and original Scots. They were, and remain, one of the greatest curses of the Scottish scene, quick, avaricious, unintelligent, quarrelsome, cultureless, and uncivilisable' (Gibbon 2001: 7–8). It is easy here to see the identification between Mitchell's self-identified Pictishness and the Cro-Magnards' proto-Basqueness: Mitchell's lost Golden Age is also a vision of a lost Scotland and a losing Scots.

A related dialectic on similar ground is found in the Scots *Braken Fences*. Here, the opposition is between the 'Rational World' (RW), a globe-spanning culture of liberal scientism, and the 'Fundamentalist Zone' (FZ), confined by a militarised border to Central Asia. Wandering in this distinctly post-9/11 opposition are a group of lost Neanderthals, who have literally wandered out of their own time, our past, into the time of the novel, our future. The choice of Neanderthals as pre-historical ideal may be a deliberate response to Mitchell: it is notable in this regard that Beatrice and Bill first land among the Neanderthals due to a crashing flying machine, which is the inciting incident of *Three Go Back*, and that Beatrice later travels back in time through an act of singing, as with Gay Hunter. If this is a riposte, it is deepened by Kurtoglu giving the Neanderthals far greater character differentiation, narrative agency and cultural

depth than anything in Mitchell: her primitivism is a great deal less idealised and more believable. In any case, the choice of Neanderthal also enables a conclusion to the novel that places the protagonists once more outside of historical time: because Neanderthals are an evolutionarily extinct line, the choice to travel back with the Neanderthals removes Beatrice and her partner Hsien from the human story of civilisation.

Kurtoglu's RW is the culmination of twenty-first-century late capitalism, here represented not by the West but by an ascendant coalition of India and China. There are, on the one hand, measures of gender equality (female and male characters share the same economic roles and privileges) and racial equality (the Scottish protagonist, Beatrice Varshini, is of mixed descent, and again white characters and characters of colour share the same economic roles and privileges); on the other hand, these equalities are maintained and enabled through a militarised border wall which separates the patriarchal and racially divided FZ, across which migration is entirely forbidden, resulting in serious racialised cross-border inequalities, such as the subjugated Tibetan population. Similarly, while the RW exhibits technological superiority and economic abundance, this is regulated and maintained by the omnipresence of Welfare Officers, including Beatrice, who have unmitigated access to characters' lives and are able to wield coercive power against them, which Kutoglu calls 'soft totalitarianism' (Kurtoglu 2012: n.p.). Its peace is called the 'Pax Scientifica', a reference to the 'Pax Romana' which was brought about by the aforementioned genocides of the Roman Empire. Its freedoms are distinctly bound:

> Eugenics wis aye a gey sair pynt – the richt tae chuse yer ain mairraige pairtner, especially the wumman's richt, wis yin o thair vauntit freedoms, in contrast tae the FZ. Nanetheless, the Eugenics Law wis designt tae discourage fowk, nae twa weys aboot it, fae haein bairns wi expensive medical problems. Parents that deleeberately incurrt costs for an avoidable genetic ill or disabeelity got nae benefits, nae maternity leave, nae schuill place for the bairn, naethin. (Kurtoglu 2011: 198)

Trapped between these two options, Beatrice – who spends most of the novel wandering, with and without direction, along the border – is attracted to the communalism and nature-connection of the Neanderthals. This is not presented as a resolution of the dialectic, however, but an option which is threatened by it: the Neanderthals are enslaved and persecuted by the powers in the FZ, and would

be killed, or experimented on, if they attempted to cross its border. What they want, and what Beatrice chooses, is:

> the warld that human beins will ne'er see again [. . . W]haur there are hirds that muckle that fill the view tae the horizon, thair hoofs shak the erd, the beasts taks days tae gang by. [. . .] We wint forests fu o game an wild berries an hinny, forests that . . . yer bairns growes up an haes bairns o thair ain afore ye can reach the ither side o thaim. We juist want tae gang hame. (Kurtoglu 2011: 216)

Again the vision is of an abundant life outside of time, unpolluted by civilisation: hame. It is language that gives Beatrice access to this vision, and which denies such access to Bill: unlike her, he does not learn the Auld Language and so 'can't get into this nostalgia for the primal ooze' (Kurtoglu 2011: 183). The language also brings with it distinct life-worlds: the Neanderthals are in regular contact with the voices of their ancestors, which Beatrice interprets as their interpretation of inner thought and debate as experienced in the Auld Language. She is similarly sceptical of their own understanding of their history: they believe that their ancestors crossed over a river from a land of mammoths into what is now the FZ; Beatrice thinks they were created by a Chinese genetic experiment, a theory (though false within the narrative of the novel) that gives the Neanderthal the same doubled past-and-future signification as Mitchell's tribes. Most significantly, language is what enables transition between times. Bill and Beatrice find a rupture in space-time which can be opened by particular kinds of tone, such as the Neanderthals' drone singing. This tone is connected not just to them, though, but also to traditional Scottish culture and its own otherworlds. As Bill says:

> 'Ah've heard the Auld People [the Neanderthals] nicht efter nicht ettlin for tae reproduce that soon. Ah didna recognise it richt aff, bit Ah've been thinkin on it aa day an it finally came tae me. [A]n ancestor o mines, a Shetlan man, made a tune – it's aye a popular fiddle tune – bit *he* sayed that he heard it, comin fae unner the grun.' He leukit at Beatrice.
> 'Fae a Faerie Hill?' she speirt. [. . .]
> 'Exackly.' (Kurtoglu 2011: 169)

Beatrice then compares this to 'Ossian – or Thomas the Rhymer hissel. They thocht days had passed an it wis years back on Earth' (Kurtoglu 2011: 169). But in order for time travel to happen, this tone must be made only in specific places where borders can be open: place and time

are interwoven. Thus the narrative brings together rationalist science, Indigenous knowledge and Scottish folk tradition into one linguistic temporal ligature.

But to fully embrace the language and its time comes at a cost, both immediate and more deeply temporal. Beatrice's partner, Hsien, himself a genetic hybrid 'chimera' created through experimentation, has a condition which could be treated in the RW but not in the Neanderthals' time. Thus, in choosing to cross over together, they choose Hsien's early death. More deeply, Beatrice discovers a quirk of Neanderthal genetics which limits their reproduction and is used by Kurtoglu to explain their eventual outbreeding or extinction by *Homo sapiens*. The Neanderthals have no future. '"History doesn't have to repeat itself," [Beatrice] said, but she knew she was lying' (Kurtoglu 2011: 180). The Neanderthals do not have a future and so are outside of human history; because they have no historical temporality, they are, like Mitchell's post-historic Folk, outside of time. It is possible for a historic human to hybridise and to cross that border, but it is difficult and costly. For the highly rational Bill, for example, 'Only yae species can be human. It's a monotheism thing. There can only be yae planet that the sin an muin revolves aroon, only yae fowk chosen by God tae receive his revelations. Bit it's a species barrier aa richt. An it's a Border that canna be sealt' (Kurtoglu 2011: 198). This Border that for some cannot be crossed and that for all cannot be fully sealed is the border between languages: always divided, always permeable.

Jessica Langer dissects these colonial approaches to time in science fiction, equally applicable to Mitchell's time travel narratives, thus:

> Cultural difference, therefore, is predicated not only across space but also across time. The colonial ideology of progress includes the drive for technological process, and figures time as linear, with technologically progressive societies pushing forward and leaving others behind. [. . .] The dynamic of past and future is therefore complicated and folded over on itself: the colonized are seen almost literally as not only figures from history but as figures from the colonizer's own past, objects of simultaneous reverence as ancestors and scorn as primitives. (Langer 2011: 130)

That is, the colonial construction of the Indigenous in science fiction, through both the pre-historic and the post-apocalyptic, the Neanderthal and the genetically modified chimera, folds colonial time over on itself. But in Scottish science fiction this is complicated by Scotland's double vision, the seeing of Scotland as simultaneously colonised and

colonising, space alien and space explorer, Cro-Magnon and time traveller. Trapped within colonial temporality and the colonial construction of the primitive, these Scottish writers long to escape back into that primitive space outside of time, which is also a space of pure Scottishness and Scots, a Scots free of English, and free of the imperial-genocidal British nation-state. Indigenous in these novels is figured as pre-historic and post-historic, a racist colonial construction which erases the ongoing survivance of Indigenous peoples in the present[9] and, in so doing, prevents Scots from accessing its/their own imminent present. The contrast with the more successful vernacular novels is crucial here: whereas the vernacular social realism is attendant to an existing register of Scots and Scottish people's existence in the present, the construction of a literary prose register post-interruption in these novels relies on the construction of a pure, pre-colonial Scots (and Scottishness) which never became the language of a nation-state in the past and so does not exist as one in the present. The temporal ligature thus enables the writing of Scots and traps it within colonial limits.

Langer describes this double bind, replicated exactly in Beatrice's 'haurd choices' of whether to stay in a time where Hsien can be treated or travel back to the Golden Age, whether to use her genetic knowledge to save the Neanderthals or let history happen:

> This conflict, between the colonizer's desire to keep indigenous culture's 'pure' for the colonizer's own consumption and observation, and the desire of those colonial subjects to partake of the usually technological benefits brought by the coloniser, is familiar to historical colonialism and makes up part of a complicated problem of conflict. The opposite but corresponding conflict is between the colonizers' desire to 'civilize' and bring their colonial subjects into what it perceives as the temporal present – and the resulting indigenous drive towards 'nativism', the desire to keep one's own culture pure and to go back to an idealized precolonial cultural state. (Langer 2011: 133)

With a history and a present of colonising and being colonised, this conflict is the impossible choice Scotland and Scots has set up for itself.

## (Post)Colonial Scots Futures

To talk about the relationship between Scots and science fiction is thus to talk about colonialism, because a double perspective on colonisation

produces both Scots as a language and science fiction as a literature. As Patricia Kerslake has it, 'The theme of empire [. . .] is so ingrained in SF that to discuss empire in SF is also to investigate the fundamental purposes and attributes of the genre itself' (Kerslake 2007: 191). This preoccupation is in the historical roots of science fiction: John Rieder argues that science fiction as a recognisable genre emerges precisely at the moment of 'most fervid imperialist expansion' in the late nineteenth century (Rieder 2008: 3). Eric Smith glosses this genealogy thus: 'SF [. . .] must be contextualised as a product of imperialist culture, finding its original expression in late-nineteenth-century British and French fantasies of global conquest before emerging in the 'new' imperialist cultures of Germany, Russia, the Unites States, and Japan in the twentieth century' (Smith 2012: 1–2). The result is that the dominant tropes of science fiction are those of empire: first contact with aliens, with the colonial fiction of race reified in literature as the alien species; heroic exploration, such as translation of James Cook's *Endeavour* to James T. Kirk's *Enterprise* in *Star Trek*; and a host of technological, epidemiological, philosophical, martial, economic and other such plots that remap and replay the historical process of imperialism onto interstellar space and time.

Given this firm imperial foundation, science fiction has also now experienced a postcolonial turn, because

> SF need not mechanically replicate imperialist ideological structures. The genre may also, in its deployment of globalizing modes of Empire, provide the means for us to detect and decipher the ideological mystifications of global capital, the unique manifestations of globalization in particular national cultures, the emergence of technology as a cognitive mode of awareness, and the processes whereby individual national cultures exist alongside and engage the polymorphous bad infinity of the new global habitus. (Smith 2012: 1–2)

The result is a recent profusion of books recentring the Others of science fiction's empires: *So Long Been Dreaming: Postcolonial Science Fiction and Fantasy* (Hopkinson and Mehan 2004); *Walking the Clouds: An Anthology of Indigenous Science Fiction* (Dillon 2012); *Mothership: Tales from Afrofuturism and Beyond* (Campbell and Hall 2013); and *Octavia's Brood: Science Fiction Stories from Social Justice Movements* (Brown and Imarisha 2015) constitute a sampling of the approaches.[10]

Nalo Hopkinson positions this postcolonial turn as an appropriation of science fiction, stealing an imperial form to 'take the meme of colonizing the natives and, from the experience of the

colonizee, critique it, pevert it, fuck with it, with irony, with anger, with humour, and also, with love and respect for the genre of science fiction that makes it possible to think of new ways to do things' (Hopkinson, in Hopkinson and Mehan 2004: 9). Using the terminology of Audre Lorde's question of revolutionary strategy, Hopkinson suggests that 'massa's tools don't dismantle massa's house – and in fact, I don't want to destroy it so much as I want to undertake massive renovations – they build me a house of my own' (Hopkinson, in Hopkinson and Mehan 2004: 8). Here Hopkinson's utopian temporality runs similarly to that of Ytasha Womack, who in writing on Afrofuturism imagines the life of an African American schoolchild she met:

> Maybe, as she's mapping out her Mars trip, she'll write a story about her future, her interstellar travels, and the life force she brings to this red planet neighbour. Perhaps, with a desire to improve the world's conditions, she'll link into a larger group of people in a shared vision of sustainability and equality. Starting with her imagination and implementing ideas through her actions, she'll live the future. (Womack 2013: 193)

Here, African and African American-centred postcolonial science fiction restores future to a population disenfranchised by empire, beginning with acts of imagination and proceeding into a utopian future.

Afrofuturism and other postcolonial science fiction also offer contesting temporalities, however. One of the founding approaches of Afrofuturism, as modelled by, for example, the musician Sun Ra, is to mingle the imagery of precolonial African societies with that of science fiction. In 1974's *Space is the Place*, 'Sun Ra sits in a multi-hued harden in his new colony wearing Egyptian sphinx head garb and states that time is officially over. He "works on the other side of time"' (Womack 2013: 61–2). Sun Ra thus collapses past and future together, defying teleological history and science fiction utopianism as if they are part of the imperial ontology in themselves. As Jessica Langer puts it, we can 'identify the cyclical concept of time as in direct opposition to the Western colonial paradigm of linear time', examining 'non-Western conceptions of time, which centre on the past, or a cycle or spiral metaphor rather than on a linear progression from past to future' (Langer 2011: 141). In this reading, Afrofuturism does not appropriate empire's temporal fictional forms for its own ends but rather recovers its own long history: 'Afrofuturism has always been part of our culture' states Wanuri Kahiu, discussing science fiction from the African continent (Kahiu 2012). Similarly,

Grace Dillon argues that a Native approach to time travel fiction restores Indigenous scientific temporality to science fiction: 'Native slipstream views time as pasts, presents and futures that flow together like currents in a navigable stream. It thus replicates nonlinear thinking about space-time' (Dillon 2012: 3). This thinking, 'which has been around for millennia, anticipated recent cutting-edge physics' (Dillon 2012: 4), says Dillon, suggesting here that decolonising writers are not reappropriating science fiction but rather recovering the science and science fiction of their own history and disrupting imperial, utopian temporality in the process.

It is into this contested field, then, that Scottish science fiction is written.[11] But what positions can Scots science fiction take, and how does it appear? Are the strategies of postcolonial science fiction available to Scots literature? Introducing the only current survey of the literature, Caroline McCracken-Flesher accounts for Scottish science fiction through Scotland's own double perspective on coloniality:

> Superficially, this nationally marked literature is subsumed by the terms of both the universal and the global. Considered part of anglophone science fiction because British, Scottish science fiction is thus 'universal,' but as 'not English,' it perversely cannot rise to the level of the 'global'. (McCracken-Flesher 2012: 1)

This political problematic has its roots in the same colonised-and-colonising doubleness. Whereas McCracken-Flesher asks whether wee Scotland might be 'merely indulged' by 'global power', I would argue that Scotland's participation in global power should not be underplayed: that, far from being merely subaltern, Scotland's willing participation in colonisation, indeed its shaping role in colonisation, is part of what constitutes contemporary Scotland. As I have noted elsewhere, Scotland's political decisions maintain 'its position of colonial grievance while continuing to benefit from colonialism' (Giles 2018: n.p.). The predicament of Scottish literature in general and Scottish science fiction in particular is not just that it has been colonised to some extent or made subordinate to the Anglophone mainstream, whether English or American, but that liberal or radical desire within Scotland is trapped by the colonising history of the Scottish nation and its present status as a willing participant if not fellow leader in neoliberal white supremacist 'global power'. That is, it is hard to have a radical imagination about the future of a nation when that nation's historical constitution is that of a coloniser – or, as not-quite-colonised, Scotland and its like can never quite be postcolonial.

Similarly, the ambitions for the Scots language are themselves constituted by the boundaries of the European colonial nation-state, whose languages and their literary registers were constructed through specific historical processes of centralisation, homogenisation, resource extraction internally and globally, hierarchical racialisation, cultural extermination and genocide.[12] Is imperial science fiction the limit of Scottish writing, and is the standardised register as a technology of the nation-state the limit of Scots? Or is a postcolonial science fiction available to Scots, perhaps with the polymorphic possibilities of postcolonial language? Or, as a junior partner in empire, are both possibilities permanently foreclosed for Scots? McCracken-Flesher argues that 'this oddly imperial yet strangely subaltern literature, positioned both inside and outside the grand literary and critical narratives of the genre, operates as a form of criticism at once geographic and political' (McCracken-Flesher 2012: 2): the optimistic spin here is that Scots provides an unusual and fruitfully problematic site for criticism, language and literature. Perhaps the imaginative tools of science fiction deployed to crack open Scots' particular paradox of subjectivation are both precisely the tools required to break it and at once the same tools that perpetuate it.

## Bibliography

Ashcroft, Bill (2008), *Caliban's Voice: The Transformation of English in Post-Colonial Literatures*, London: Routledge.

Bold, Valentina (ed.) (2001), Lewis Grassic Gibbon, *Smeddum: A Lewis Grassic Gibbon Anthology*, Edinburgh: Canongate.

Brown, Adrienne Maree and Walidah Imarisha (eds) (2015), *Octavia's Brood: Science Fiction Stories from Social Justice Movements*, 1st edn, Chico, CA: AK Press.

Butler, Judith (1997), *Excitable Speech: A Politics of the Performative*, London: Routledge.

Calin, William (2000), *Minority Literatures and Modernism: Scots, Breton, and Occitan, 1920–1990*, Toronto: University of Toronto Press.

Campbell, Bill and Edward A. Hall (eds) (2013), *Mothership: Tales from Afrofuturism & Beyond*, UK edn, Greenbelt, MD: Rosarium Publishing.

Corbett, John (2012), 'Past and future language: Matthew Fitt and Iain M. Banks', in Caroline McCracken-Flesher (ed.), *Scotland as Science Fiction*, Lewisburg, PA: Bucknell University Press, pp. 117–32.

Deloria, Philip J. (1999), *Playing Indian*, New Haven, CT: Yale University Press.

Dillon, Grace (ed.) (2012), *Walking the Clouds: An Anthology of Indigenous Science Fiction*, 2nd edn, Tucson: University of Arizona Press.

Elgin, Suzette (2001), *Native Tongue*, Spinifex; BRAD.

Fagan, Jenni (2014), *The Panopticon*, London: Windmill.

Fagan, Jenni (2016), *The Sunlight Pilgrims*, London: Windmill.

Fitt, Matthew (2005), *But n Ben A-Go-Go*, Edinburgh: Luath Press.

Forde, Iain W. D. (1996), *The Paix Machine*. Fons Scotiae.

Forde, Iain W. D. (2018), 'Precis of "The Paix Machine"', The Scottish Corpus of Texts & Speech, Glasgow: University of Glasgow. http://www.scottishcorpus.ac.uk/document/?documentid=209 (accessed November 2018).

Gibbon, Lewis (1995), *A Scots Quair: Sunset Song, Cloud Howe and Grey Granite*, Edinburgh: Canongate Books Ltd.

Gibbon, Lewis (2001), *Smeddum: A Lewis Grassic Gibbon Anthology*, Edinburgh: Canongate Books Ltd.

Giles, Harry (2018), 'Scotland's fantasies of postcolonialism', *The Bottle Imp* 23. https://www.thebottleimp.org.uk/2018/07/scotlands-fantasies-of-postcolonialism/ (accessed November 2018).

Hames, Scott (2018), 'On Snottery Weans Forever: Against Dreichism', *Irish Pages* 10.1: 72–82.

Hopkinson, Nalo (2000), *Midnight Robber*, New York: Aspect/Warner Books.

Hopkinson, Nalo and Uppinder Mehan (eds) (2004), *So Long Been Dreaming: Postcolonial Science Fiction & Fantasy*, Vancouver, BC: Arsenal Pulp Press.

Kahiu, Wanuri (2012), 'Afrofuturism in popular culture'. https://www.youtube.com/watch?v=PvxOLVaV2YY (accessed 6 February 2018).

Kelman, James (1994), *How Late It Was How Late*, London: Vintage Classics.

Kennedy, A. L. (2016), *Doctor Who: The Drosten's Curse*, London: BBC Books.

Kerslake, Patricia (2007), *Science Fiction and Empire*, 1st edn, Liverpool: Liverpool University Press.

Kurtoglu, Wulf (2011), *Braken Fences*. Published by Caroline Macafee at www.lulu.com

Kurtoglu, Wulf (2012), *It's No Aboot Palestine*. http://wulfkurtoglu.blogspot.com/2012/08/its-no-aboot-palestine_31.html (accessed 18 January 2018).

Langer, Jessica (2011), *Postcolonialism and Science Fiction*, Basingstoke: Palgrave Macmillan.

Le Guin, Ursula K. (1988), *Always Coming Home*, London: Grafton Books.

Lovejoy, Arthur O. (1923, 1943), 'The supposed primitivism of Rousseau's Discourse on Inequality', *Modern Philology* 21.2 (November 1923): 165–86. (Repr. in *Essays in the History of Ideas*, Baltimore, MD: Johns Hopkins University Press, 1948 and 1960.)

Lyall, Scott (ed.) (2015), *The International Companion to Lewis Grassic Gibbon*, Glasgow: Scottish Literature International.

McCracken-Flesher, Caroline (ed.) (2012), *Scotland as Science Fiction*, Lewisburg, PA: Bucknell University Press/Co-published with the Rowman & Littlefield Publishing Group.

MacLeod, Ken (2012), *Intrusion*, London: Orbit.

Miller, Alison (2005), *Demo*, 1st paperback edn, London: Hamish Hamilton.

Milojevic, I. and S. Inayatullah (2003), 'Futures dreaming outside and on the margins of the Western world', *Futures* 35.5 (June): 493–507. https://doi.org/10.1016/S0016-3287(02)00095-2.

Mitchell, J. Leslie (1989), *Gay Hunter*, new edition, Edinburgh: Polygon/Birlinn Limited.

Mitchell, J. Leslie (2009), *Three Go Back*, Cabin John, MD: Wildside Press.

Mitchison, Naomi (1983), *Not by Bread Alone: A Novel*, London: Marion Boyars.

Mitchison, Naomi (2011), *Memoirs of a Spacewoman*, Glasgow: Kennedy & Boyd.

Mitchison, Naomi (2011), *Solution Three*, Glasgow: Kennedy & Boyd.

Rieder, John (2008), *Colonialism and the Emergence of Science Fiction*, Middletown, CT: Wesleyan University Press.

Rousseau, Jean-Jacques (1984), *A Discourse on Inequality*, ed. Maurice Cranston, London: Penguin Classics.

Shiach, Morag (2015), 'Lewis Grassic Gibbon and modernism', in Scott Lyall (ed.), *The International Companion to Lewis Grassic Gibbon*, Glasgow: Scottish Literature International, pp. 9–21.

Silver, Christopher (2015), 'Lewis Grassic Gibbon and Scottish nationalism', in Scott Lyall (ed.), *The International Companion to Lewis Grassic Gibbon*, Glasgow: Scottish Literature International, pp. 105–18.

Smith, Eric D. (2012), *Globalization, Utopia, and Postcolonial Science Fiction: New Maps of Hope*, Basingstoke: Palgrave Macmillan.

Sun Ra and Joshua Smith (1974), *Space is the Place*, dir. John Coney. Plexifilm 2003. DVD.

Tulloch, Graham (1985), 'The search for a Scots narrative voice', in Manfred Gorlach (ed.), *Focus on Scotland. Varieties of English around the World*, vol 5, Philadelphia, PA: Benjamins, pp. 159–80.

Vizenor, Gerald (ed.) (2008), *Survivance: Narratives of Native Presence*, Lincoln: University of Nebraska Press.

Welsh, Irvine (1993), *Trainspotting*, London: Jonathan Cape.

Womack, Ytasha L. (2013), *Afrofuturism: The World of Black Sci-Fi and Fantasy Culture*, Chicago: Chicago Review Press.

Zobel Marshall, Emily (2016), 'Resistance through "robber-talk": storytelling strategies and the carnival trickster', *Caribbean Quarterly* 62.2 (April): 210–26. https://doi.org/10.1080/00086495.2016.1203178.

## Notes

1. See e.g. J. Derrick McClure (1993), 'Varieties of Scots in recent and contemporary narrative prose', *English World-Wide* 14.1: 1–22.
2. My approach here builds on Tulloch (1985).
3. Each features a bright blue colour: the colour of the sky, blue sky thinking, and the Scottish national flag.
4. As an interesting counterpoint, Jenni Fagan's second novel, *The Sunlight Pilgrims* (London: Windmill, 2016), is shorn of the vernacular Scots of her first novel, and is set in an apocalyptic cooling Scotland which thus has no future.
5. Interestingly, the English-language edition of the novel erases all linguistic distinctions between characters, meaning that they are a reward for the Scots language reader, an extra element for that edition of the book.
6. Another notable example not discussed here, as it is less immediately relevant to the question of language, is Ken MacLeod's *Intrusion* (London: Orbit, 2012), which also features the post-historical quasi-Indigenous figures discussed below. Naomi Mitchison's science fiction, similarly, features a colonial figure of the Indigenous and transformation through language, but not time travel.
7. It will not escape the antisyzygist's notice that both Mitchell and Iain Banks separated their 'literary' and 'genre' fiction work by pseudonym, as MacAfee does with her linguistic and literary work. Naomi Mitchison and Margaret Elphinstone, meanwhile, are better known for their extensive historical fiction than their small science fiction output, but kept the same name, as did A. L. Kennedy for her *Dr Who* novel.
8. See Philip J. Deloria, *Playing Indian* (New Haven, CT: Yale University Press, 1999).
9. See e.g. Gerald Vizenor (ed.), *Survivance: Narratives of Native Presence* (Lincoln, NE: University of Nebraska Press, 2008).
10. Contrasting with the Scots science fiction novels, each of these features a red-brown cover, the colour of earth, sunset, sky and skin.
11. And not only Scottish science fiction. Language figures prominently too in postcolonial science fiction, as in Nalo Hopkinson's own work, and also of note is the construction of worlds through new language in feminist science fiction, including Suzette Hayden Elgin's *Native Tongue* (2001) and Ursula Le Guin's *Always Coming Home* (1988).
12. See e.g. Alexandre Duchêne and Monica Heller (eds.), *Language in Late Capitalism: Pride and Profit* (New York: Routledge, 2011).

# Convivial Correctives to Metrovincial Prejudice: Kevin MacNeil's *The Stornoway Way* and Suhayl Saadi's *Psychoraag*[1]

*Maggie Scott*

## Introduction

This chapter examines some of the ways in which Scotland's languages are used in twenty-first-century fiction to challenge metrovincial perspectives, in relation to Paul Gilroy's concepts of postcolonial melancholia and conviviality (2005). Post-devolution Scottish fiction provides a multitude of examples of local cultural references, knowledge – and especially language – that establish narratives within their own self-determined centres of power and place. Detectable in many such texts is a rejection of the local as 'parochial', often stridently assertive of specialised cultural knowledge. Such writing inverts traditional metrovincial paradigms, where the provincialism of the metropolis is allowed to dominate unchallenged. *Metrovincialism* is a 'mindset in which Scotland, Wales and Northern Ireland appear, to adapt a phrase, as "faraway places of which we know little"' (Jeffery 2007: 100)[2] the 'we' here being the entitled, blinkered metropolitan. London is foregrounded, everywhere else is increasingly marginalised by its distance from this assumed centre, and the cultures, languages and practices of 'the faraway' are dismissed, stigmatised or ignored. Blasting against this stifling hegemony are the energetic multilingual practices evident in the work of a growing number of contemporary writers, a non-exhaustive list of whom includes Alan Bissett, Karen Campbell, Anne Donovan, Bill Duncan, Matthew Fitt, Harry Josephine Giles, Jackie Kay, James Kelman, 'Wulf Kurtoglu', Tom Leonard, Liz Lochhead,

Chris McQueer, James Robertson, Suhayl Saadi and Irvine Welsh. Their works frequently reposition the local as the international, engaging with many of the varieties of language found in modern Scotland. This spectrum includes both 'broader' varieties of Scots, stereotypically associated with the working classes, and 'prestigious' forms of Scottish English, and also includes elements of Scottish Gaelic, Urdu, Panjabi, diverse English dialects, and inventive science fiction hybrid forms.

This multiplicity of voice has been used to articulate a wide range of perceptions of place and identity and engages directly with the lived experience of language in multilingual Scotland, yet tensions remain around the uses of 'non-standard', non-conformist language that by its nature challenges standard linguistic and cultural hegemonies. Saadi complains that '[m]ost mainstream anglophone writers and publishers cannot grasp this essential instability of language' (Saadi 2007: 31). He makes a passionate call for a more intelligent appreciation of writing that deviates from standard English, correlating literary linguistic diversity with cultural expression: 'whether one is talking about freedom for the peoples of Scotland, South Asia and the Middle East, or humanity as a whole [. . .] both a progressive politics and a meaningful literature must be about enabling the possibility of dissent against the sources of power' (Saadi 2007: 33). Non-standard language has the potential to act as a source of power for under-represented or marginalised identities, refuting hegemonies.

## The Scots Language: Realities and Fictions

Devolution saw the reopening of the Scottish Parliament in 1999, and since then the Scots language has increasingly gained recognition as a language, both from the governments of Scotland and the United Kingdom, and by its ground-breaking inclusion in the language questions for the census of 2011. Frustratingly, for those seeking a more 'progressive politics' that would reinvigorate Scotland's languages and cultures, devolution has delivered a mixed justice. Scots was afforded nominal respect through its inclusion in the European Charter for Regional or Minority Languages, ratified by the UK and Scottish Governments in 2001, but this did not trigger any immediate policy change (Millar 2006: 63). The 2011 census results demonstrated that over 1.5 million Scottish residents identified themselves as Scots speakers (National Records of Scotland 2011). Several studies have examined the census data in order to explore the difficulties

of its interpretation in relation to Scots, which presents a number of mixed messages, given that 62.3 per cent of respondents self-reported 'no skills in Scots' (see for example Macafee 2017; Sebba 2018). A key methodological problem is the lack of consensus regarding the definition of Scots, either within official discourse or the understanding of the general public (Sebba 2018: 6). Significant under-reporting is therefore likely to have arisen from the lack of a clear distinction between Scots and English, but also from perceptions that favour local dialect identity (e.g. Glaswegian or Shetlandic) over the label 'Scots' (Macafee 2017: 64). Macafee observes that higher numbers of people under thirty reporting greater levels of Scots usage 'is perhaps more indicative of a raised awareness of the language (perhaps as a result of changes in education) than of higher levels of skills' (Macafee 2017: 64). Despite the difficulties that have plagued the interpretation of the results, the inclusion of a question on Scots, and the data retrieved as a result, does seem to have had some positive effects, notably by including debates about the language in official and therefore 'normatively prestigious' discourses. As Mark Sebba argues: 'while arguably the census failed to enumerate that group [i.e. Scots speakers] unambiguously, it appears to have gone some way to establishing its legitimacy, not only at the state level, but also among the public' (Sebba 2018: 21–2).

## Scots Literature and Multilingual Scottish Literature

Curiously, with the exception of interventions such as Hames (2010) and Giles (Chapter 9, this volume), there is little appetite to position vernacular writing within experimental writing, even though the constraints the vernacular writer is required to operate within create a complex matrix of linguistic and cultural 'rules' which must be rigidly followed if the work is to succeed. It is a complex intellectual exercise to create and maintain plausible literary vernacular voices, devising and applying representational systems for languages such as Scots which have no standard spelling. Experimental writers such as Christine Brooke-Rose, working within lipogrammatical constraints such as the complete avoidance of the present tense in the novel *Amalgamemnon* (1984), are, at least in technique if not in motivation, doing very similar things, yet there is no mention of James Kelman or the Scots language in such compendious volumes as *The Routledge Companion to Experimental Literature* (2012). As Priyamvada Gopal notes in her examination of experimental

postcolonial poetry from India, the Caribbean and South Africa, 'hybridity as a weapon of discursive subversion appeared to be exemplified by the multilingual wordplay that became the currency of postcolonial literature's avant-gardism' (Gopal 2012: 183). Scots can act as a 'weapon of discursive subversion', but its power to articulate aesthetic and political possibilities may be harder to recognise, or even weakened, if Scots is perennially linked to a narrow conception of national identity and empowerment, that is, viewed as an exercise in 'nation-building'.

An explanation for this taxonomic lacuna may exist covertly within the likes of the well-known vitriolic discourses that erupted in response to James Kelman's *How Late it was How Late* (1994). Literary critic Simon Jenkins was so prejudiced in his comments that his attacks remain notorious; he defined the language as 'Glaswegian Alcoholic', labelling Kelman an 'illiterate savage' (1994). As Williams has noted, 'the history of Scots is not that of a neutral medium of communication, but instead a class-inflected history by which Scots increasingly comes to be associated with the uneducated, impoverished and (to Jenkins) negligible working class of Scotland' (Williams 1999: 224). By extension, then, the politics of writing in Scots has a tendency to render it more 'earthy' than 'avant-garde'.

Literature written in Scots can nevertheless be read as a literature of resistance, disengaging from normative standards through an alternative national language. Such resistance is agile in that, by turns, it can lament inequalities, state the obvious, ask difficult questions, promote the re-evaluation of power and laugh at its own jokes, whether or not all readers collectively ken the punchline. The readership does not always respond with the same linguistic agility. As Andrew Crumey argues, 'since *Trainspotting* Scottish public literary taste has been torn between the overly restrictive and the overly inclusive, reflecting the old dilemma of parochialism versus metropolitanism' (Crumey 2007: 41). Books written in whole or part in Scots are nevertheless frequently critically acclaimed, and are at least capable of reaching wide audiences. The intrinsic linguistic kinship between Scots and English facilitates accessibility. Writing in underrepresented styles also has the power to refute traditional hierarchies, comprehensively demonstrated in James Kelman's *You Have to Be Careful in the Land of the Free* (2004), as Berthold Schoene notes:

> By transplanting Scots into the world at large and allowing it to prosper into a world-literary code for unruly Scottish self-expression, Kelman contests English's megalingual distinction between 'a language that travels far

and one that travels little' (Pollock 2002: 18). It is this binarist discrimination that for centuries has secured the superiority of English over Scots or, more generally speaking, the language's standard forms over its less widespread socio-regional variants. If indeed 'language is a major means (some would say the chief means) of showing where we belong, and of distinguishing one social group from another' (Crystal 2003: 22), then what Kelman achieves in *You Have to Be Careful* is a point-blank demolition of Pollock's critical paradigm that vernacular writing is for the creation of small places rather than large worlds. Not only does Kelman's Scots usurp Standard English's exclusive claim to literary world-creation, it also asserts its speaker's identity as indisputably that of a citizen of the world. (Schoene 2009: 85)

The under-representation of Scots in written genres 'at home' also allows the language to perform very similar tasks within novels set in Scotland. Due to its well-documented marginalisation, Scots can function as a literary medium that easily channels the postcolonial melancholia Paul Gilroy identified within and throughout Britain. Gilroy identifies a post-imperial Britain in which 'a variety of complicated subnational, regional and ethnic factors has produced an uneven pattern of national identification, of loss and of what might be called an identity-deficit' (Gilroy 2011: 190). As I have argued elsewhere, the Scots language metaphorically invokes very real echoes of cultural subordination and silencing (Scott 2017). The same claim can be extended to Scottish Gaelic, which has undergone many social and political indignities (see for example Watson and Macleod 2010; especially the chapters by Colm Ó Baoill, Michelle Macleod, Kenneth MacKinnon and Robert Dunbar). Similar arguments can of course be made for non-standard varieties of language throughout the United Kingdom, especially the north of England, since, as Jeremy Scott argues, 'the voices of working-class people from Newcastle, Liverpool and Birmingham have been just as marginalised or patronised by "the establishment" as those of Glaswegians' (Scott 2009: 97).

Simultaneously, Scots and the other Scottish languages provide writers with vibrant, refreshing, experimental vehicles for a myriad of less visible worlds and less audible voices. This multilingual Scotland importantly connects with Gilroy's postcolonial *conviviality*, defined as 'the processes of cohabitation and interaction that have made multiculture an ordinary feature of social life in Britain's urban areas and in postcolonial cities elsewhere' (Gilroy 2005: ix). One modification is necessary here, in that, as in Kevin MacNeil's *The Stornoway Way*, literary representations of multiculturalism, cohabitation and

interaction are not restricted to imagined *cities*. Writing set in such under-represented places can also create a didactic space in which to challenge, educate and intrigue. Such works can both impart and (at times ludically) engage with local knowledge and language that may be unknown to the cultural outsider, thereby gently 'othering' the metrovincial reader.

Gilroy's *conviviality* bears some relation to the *cosmopolitanism* discussed by various cultural and literary theorists, but Gilroy's term is preferred here. One reason for this is that cosmopolitanism remains 'a highly malleable and multidimensional concept, leaving its specificities open to interpretation' (Shaw 2017: 2; see also Schiller and Irving 2015). Gilroy's concept remains comparatively more coherent, with current debates about conviviality continuing to take his original statement of ideas as their starting point. Sivamohan Valluvan provides the following qualification:

> Conviviality is a social pattern in which different metropolitan groups dwell in close proximity but where their racial, linguistic and religious particularities do not—as the logic of ethnic absolutism suggests they must—add up to discontinuities of experience or insuperable problems of communication. (Valluvan 2016: 209)

Valluvan usefully links Gilroy's conviviality with Ash Amin's idea of 'indifference to difference', drawing attention to the similarity of Amin's concept of *convivium*, the normalisation of cultural interaction (Valluvan 2016: 207). Amin argues that 'the challenge remains to make visible and widely endorse everyday convivium: its tacit pluralism, its practised and deliberative nature, its daily compromises, its pragmatic negotiation of uncertainty and risk'. Gilroy's acknowledgement that conviviality 'does not describe the absence of racism or the triumph of tolerance' (Gilroy 2005: xv) acknowledges that the mixing of identities may take place peacefully, or otherwise. In this respect his comments rhyme with those of Jackie Stacey, who asks:

> What might a cosmopolitan politics look like if it were not based upon a notion of openness to difference but instead upon an 'ethics of respect for the irreconcilable'? If our discomfort with the unfamiliar may in part draw its affective force from our own internal unknowability, then perhaps this might provide a starting-point for thinking through the importance of psychoanalysis for cosmopolitanism. This leaves us with the task of how to theorise an 'ethics of respect for the irreconcilable' in ways that might have wider political and cultural significance. (Stacey 2013: 49)

In her study of cultural interactions, Stacey observed that 'there was no participation in the group process without risking unpredictable and unknown consequences for others', and that 'moments or gestures of intended openness were [sometimes] precisely the ones the recipient experienced as the opposite' (Stacey 2013: 56, 57). It is therefore important to underline that conviviality is not a utopian vision of harmonious interactions, neither in mundane everyday encounters nor in a creative interpretative environment. There is a fear factor in encountering the unknown which has to be acknowledged, especially if it requires a re-evaluation of previously 'fixed' perceptions.

Suhayl Saadi's *Psychoraag* (2004) is a novel set in contemporary Glasgow, narrated by a young man named Zaf (Zafar), born in the city to parents who emigrated from Pakistan. The story takes place over a 24-hour period in which he reflects deeply on his and his family's lives, presenting a history of Glasgow and of colonialism that touches on multiple questions of perception. The DJ protagonist of *Psychoraag* expresses these ideas through musical metaphors as he works through his own struggles with Scottish and Asian identity: 'The songs were meldin into one another – they were losin their borders. For Zaf, if not for Scotland, the outside and the inside were mergin and that wis scary' (Saadi 2004: 195). Ashley argues that this statement attests to Zaf's search for 'an impossible multiculturalism, consistent with the spiritual or transcendent possibilities of the raag', and that 'this can only happen when borders dissolve and all dialectic disappears' (Ashley 2011: 132). Yet at this moment in Zaf's long narrative of one evening's intense introspection, he is clearly focusing on a liminal space where new realities are made possible. The thought of the outside and inside merging 'made him shiver as though a ghost had slipped from the stone [walls of his DJ booth] into his body' (Saadi 2004: 195). He makes a clear shift between the construct of an 'untranslatable' past, symbolised by the unsmiling photographed children being 'stared at a hundred years later by their uncomprehending descendants [. . .] and also by those who were not their descendants – by interlopers', to a detailed articulation of some of 'the ghosts of the past', from 'old women [. . .] who walked like jackknives' [*sic*] to 'Orange Marches', to 'green-jacketed Indians and Pakistanis [. . .] driv[ing] the big Irish Tricolour buses though the city streets' (Saadi 2004: 194–5). In other words, he himself is able to embody this temporally and culturally shifting knowledge.

Music is frequently used in both *The Stornoway Way* and *Psychoraag* (on the latter, see further Hoene 2015) – often in combination

with altered states of mind or perception – to bring in a momentary voice from another language, with lyrics marked out on the page as 'foreign' both by the conventions of spelling and the italics that further set them visually and conceptually apart. These form wistful reminiscences, hinting at the characters' lost pasts and innocence. In *The Stornoway Way*, as the main character wakens from an alcoholic slumber, a 'young radio voice is singing with angelic pathos "*Mo chridhe trom, s' duilich leam*" and her voice is so mournful and beautiful at the same time it almost feels right to be in this half-hallucinatory condition' (MacNeil 2005: 37). Readers are provided with a footnote to explain the phrase: 'from a beautiful Gaelic song and therefore typically difficult to translate. "My heart is heavy and I am sorrowful." Loses everything in translation' (MacNeil 2005: 37).

A very similar melancholy tone is struck by Zaf in *Psychoraag* when he announces: 'Time for a folk-song. / Oh, Punjab, *tuu meri dil toR*. [Urdu: 'you broke my heart'] / Oh Scotland, you, too, are breaking my heart. / Oh, Life, I am but a toy!' (Saadi 2004: 43). Zaf states that '[t]alking to yourself drove you mad' in reference to his attempts to synthesise the past and present, reminding readers of the title of his radio programme, *The Junnune Show*, *Junnune* being Urdu for 'madness; a trance-like state' (Saadi 2004: 195, 425). Some dislocation from normative perceptions is necessary in any reworkings of identity – ideally without losing one's mind – and the more frequent such encounters become, between the culturally new and familiar (then and now, self and other), both in life and in art, the more adept participants may become at navigating 'the stranger in ourselves and in others, as animated by other people's own invested histories' (Stacey 2013: 57). The suspension of Standard English narrative 'authority' arrests the normative protocols of realism, opening up various new possibilities.

In recognition of Gilroy's point that *conviviality* 'introduces a measure of distance from the pivotal term "identity", which has proven to be such an ambiguous resource in the analysis of race, ethnicity, and politics', I would introduce the further caveat that focus on *identity* rather than *race* allows fuller consideration of conviviality in complex, contested political spaces. Gilroy is primarily concerned with divisive applications of concepts of *race* and 'the damage that "race" and racism have done to democracy and hope alike' (Gilroy 2005: 151). He refutes the idea that 'racial differences are a self-evident, immutable fact of political life', noting the destructive effects of such deterministic thinking, and arguing instead for a 'postethnic' approach to identity (Gilroy 2005: 151). Gilroy describes himself

as 'black European', in refutation of deterministic racial labels that
would have discounted such an identity (Gilroy 2005: 151). How-
ever, in order to genuinely accept, celebrate and acknowledge the
complex, everyday, convivial lived environment, it is also necessary
to work against the discriminatory effects of labels that – like race –
encourage limited perceptions and stereotypes based on a person's
religion, politics, region, nation, class, gender, age, and so on. Para-
doxically, discourses of 'identity', intrinsically intended to be liber-
ating, are often hamstrung by their tendency to affirm a fixed and
limited conception of group belonging or cultural commonality,
thereby limiting rather than expanding the space of the convivial.
Literary representations of place may therefore provide an important
forum for reflection on the fluidity of language and culture, as well
as identity and race. In both *Psychoraag* and *The Stornoway Way*,
characters code-switch between forms of language, which may be
read as symbolic of contrasting facets of identity, yet which may be
more usefully understood as representative of 'postlingual' protean
Scottish identities.

This paradox acquires a specific difficulty in the context of con-
tested national identification, clearly evident in cases of casual metro-
vincialism. In the introduction to his 2016 book, *Contemporary
British Fiction and the Politics of Disenfranchisement*, Alexander
Beaumont states that his text

> is about fiction published in Britain, concerns itself mostly with the rep-
> resentation of London, and interrogates the way in which a Jamaican
> (Hall) and an Englishman (Gilroy), building on the legacy of a Welshman
> (Williams), challenged existing categories of British – but more specifically
> English – cultural identity. (Beaumont 2016: 29)

If the inherent problems, internal inconsistencies and unfortunate iro-
nies of the above comment are not immediately apparent, consider
whether this statement would be acceptable had this book on contem-
porary 'British' fiction chosen to concern itself mostly with the literary
representation of Glasgow, Belfast, Cardiff, or even Manchester, New-
castle or Leeds.[3] The capital city of the United Kingdom is of course
an important representational nexus of identity, and therefore a key
battleground in the culture wars, but all too often the telescope is posi-
tioned the wrong way around; in this instance, London is presented
as if unproblematically speaking for both 'England' and 'Britain'. Our
cultural discourses would be healthier if it were equally possible to
understand 'British' fiction through the lenses of London or Glasgow

or Manchester or Cardiff, but Britishness has a long history of being defined through its capital, dismissing the 'periphery'.

Saadi is also concerned with less abstract metrovincial perceptions when he states that 'too often, in the hallucinatory multicultural utopia of London, the work of the latest groovy writer of Asian origin comes to be worshipped by the (white) gatekeepers of the literary salons as little more than an innocuous bogus cipher for colonial redemption' (Saadi 2007: 31). Scottish literature's geographically and politically distinct contexts may offer an alternative platform from which to subvert dominant British paradigms. Michael Gardiner has argued that 'Scottish postcolonialism attempts to recover the potential for action which is buried within devolution; hence, postcolonial Scottish literary criticism must be committed to socio-political contextualisation rather than subscribing to timeless aesthetic standards' (Gardiner 2007: 46–7). It is therefore particularly fitting when Scottish multilingual texts directly confront their readers with political and representational questions: in Anne Donovan's *Buddha Da* the schoolchildren are shocked that the capital of Scotland in not in the atlas (Donovan 2004: 261); the title of chapter 1 of *The Stornoway Way* is a political instruction: 'Learn Your Own Way to Hold the Map' (MacNeil 2005: 15).

Scottish multilingual literature is well placed to further interrogate Gilroy's ideas, broadening his initial focus on England to review more fully the 'British' experience. The melancholic and the convivial inevitably coexist in literature that positions itself between the legacies of social, cultural and economic injustices and uncertain hybrid futures. Two novels that exemplify such imagined realities are *The Stornoway Way* (2005) by Kevin MacNeil and *Psychoraag* (2004) by Suhayl Saadi. Both texts illuminate elements of (postcolonial) convivial, contested Scotlands.

## Language and *The Stornoway Way*

Author Kevin MacNeil invokes several distancing effects to separate himself from the narrator of *The Stornoway Way*, 'R. Stornoway', whose pseudonym is alternately both part of a silly, very recognisably 'British' joke – '*Sliding Down Banisters* by arse-torn-away' (MacNeil 2005: xi)[4] – and a pun, explained to the reader on the closing pages where his pseudonym becomes 'Roman Stornoway' (MacNeil 2005: 242), and – just in case readers missed the pun, further explained – 'Romance torn away' (MacNeil 2005: 245). The reader is therefore

invited to 'understand' that the narrative voice should not be equated with that of the name on the cover of the book, but rather that MacNeil is acting in the role of 'editor' for another entity. As Jessica Homberg notes, '[t]his technique is vaguely reminiscent of James Macpherson's *Ossian*, a key text of the Gaelic Revival, since MacNeil also attempts to map a mythology for the Outer Hebrides here, albeit a dark and satirical one' (Homberg 2018: 63). Readers are warned from the outset that 'R. S.'s tone throughout the novel is unapologetic and opinionated', and that if they do not enjoy the book, they will have 'some kind of interesting reaction' (MacNeil 2005: x, xii). The author's note contains several drum rolls:

> Controversial as this book may be, it is none the less realistic. The Isle of Lewis generally does have a drink problem. Its culture is indeed conforming, both subtly and overtly, to the spread of globalization. It is a quietly vicious irony that R. S. – whose proud individuality and determination not to be culturally colonized are clear from the start – has written a book that is influenced at times by American culture and language. I wonder whether R. S. worked such designs into his book with a conscious and mischievous deliberation, in much the same way that he structured the book's flow around that bottle of whisky and its aftermath. (MacNeil 2005: x)

There is immediately a sense of playfulness and ambiguity about the text; readers are given a hint of what to expect and encouraged to think of the author sharing their curiosity, as both author and reader attempt to decode and analyse R. S.'s narrative as a 'discovered' artefact. All of these introductory features hint that the voice of the text should not be taken at face value, and that ontologically shape-shifting perspectives and wordplay are likely to continue. Nevertheless, some critics appear not to heed these messages. As Kirsty A. Macdonald points out, in response to R. S.'s ranting comments about 'Insular Lewis smotherhugged by global America' on seeing a young Lewis man in American clothing, 'Berthold Schoene argues that this passage invites the reader "to wonder if, in R. S.'s view, traditional Highland dress would make a more appropriate outfit", and criticises the novel in general for its provincial viewpoint' (K. A. Macdonald 2010: 146). Macdonald rightly points out that 'Schoene is guilty of overlooking a degree of self-consciousness within the text' and that R. S.'s 'tirade about globalisation and black pudding is just that – a rant from a hysterical narrator whom we are encouraged to view as hysterical and riven with contradictions and hypocritical views' (K. A. Macdonald 2010: 146).

Schoene levels a number of further criticisms at the text; for him, 'R. S.'s declaration of parochial pride look[s] somewhat vacuous and his invocation of Celtic sensitivity frustratingly clichéd' (Schoene 2007: 13). R. S. is certainly a troubled soul. Schoene continues to attack the character, taking his description of the United Kingdom as the 'Disunited Queendom' as testimony 'to little more than the protagonist's juvenile wit' (Schoene 2007: 13). He then turns his disdain to the author: 'by cultivating a hopelessly anachronistic self-image, markedly lagging behind that of the rest of contemporary Scotland, MacNeil's portrayal does not do Hebridean culture any favours' (Schoene 2007: 13). Reading R. S. too literally, and not puzzling over any possible relationship between his personal view of the world, his anger, negativity and fear, and his downward spiral into tragedy, seems myopic; there is an inevitability to the character's self-destruction, partially articulated in his political concerns. Clearly, R. S. has been viewed as a 'representative' Stornowegian, Gael or Scot by some metrovincial critics – but such reductionist analyses seem doomed to (re)create a form of 'quinoa kailyard', which imposes superficial readings and reduces characterisations to stereotypes. According to Homberg, *The Stornoway Way* 'outspokenly pursues a re-writing of common stereotypes' (Homberg 2018: 65), citing R. S.'s testimony that '*[t]his is the writing of adversity: cultural, personal*' (MacNeil 2005: xiv), and the comment in the 'Author's Note' that the novel 'describes a place that is much more recognizable to the average Stornowegian than the island paradise that tourist industry pamphlets glorify' (MacNeil 2005: x).

According to Schoene, 'the novel's greatest achievement is delegated to its footnotes, in which MacNeil successfully advertises the peculiar expressiveness of the Gaelic language as unrivalled' (Schoene 2007: 14). This is a deeply ironic comment, by which Schoene rather unfortunately makes himself the butt of the novel's culturally complex humour. MacNeil's footnotes do several things. Sometimes they provide truthful decodings of words commonplace on Lewis that the outsider might not understand – the earlier footnotes take this form, giving the appearance of a 'guide' to help and educate the reader-as-tourist. In the 'Author's Note', the phrase closing R. S.'s letter to 'Kevin MacNeil' is translated: '*Sin thu fhèin*: Gaelic. Literally "That's yourself." A friendly acknowledgement of the respect one person has for another' (MacNeil 2005: xv). On the first page of the 'Prologue, with Whale', 'the Minch' is translated as: 'the stretch of water between Lewis and the Scottish mainland', and we are also introduced to the Stornowegian word *blone* 'A female' (MacNeil 2005: 7). So far, so literal – *blone*

is indeed a local term for a woman. Then things become a little less 'touristy', with '*Union Jack Thalla's Cac*: Gaelic. A delightful phrase which doesn't particularly endear oneself to England's royal family' (MacNeil 2005: 17). This is a highly euphemistic interpretation of the phrase, and its presence on R. S.'s T-shirt is an allusion to a lyric from the punk song, 'Union Jack', written for the Stornowegian punk band The Rong, and recorded on the compilation album *Sad Day We Left the Croft* (1981). Malcolm Burns, who wrote the song, translates the phrase as 'Union Jack, go to fuck!', adding the apologetic caveat: 'we were young. The spirit was less nationalistic than republican and anti-imperialist and just loud, really' (Burns 2008).[5]

Nothing of this information is provided in the narrative, or in any of the notes, but the reference is there for readers to research. Is it a surprise to find that there were punk bands on Lewis? If so, maybe the novel works in part by setting readers up with one expectation only to subvert it. That is certainly what happens with the Gaelic footnotes as they evolve. We are initially told that R. S. 'shall be providing – free of charge – amongst these footnotes, instances of Gaelic words that prove just how contemporary a language Gaelic is' (MacNeil 2005: 17). However, this is not a simple, kind, guiding hand, but rather the beginning of a word-game that operates on several levels; R. S. continues: 'most of these words do not have an English-language equiv-alent', and urges 'non-Gaelic speakers to learn these words and drop them into casual conversation at sophisticated dinner parties, debates, business meetings and so on' (MacNeil 2005: 17). The genuine transla-tions continue: '*Glaoic*: Gaelic. Idiot. Moron. (Face it, we all know the feeling.)' (MacNeil 2005: 75), but they are increasingly interspersed with entirely invented comical translations of local place names:

Marbhaig: *a typing error, the consequences of which could be grave, e.g., instead of 'doing', 'dying'*. Lapsus calami, *but with an element of morbidity.*

Mealabost: *the practice of inventing futures for yourself (e.g., gold medal iceskater [sic.] who redefines the rules/attitudes – you know the kind of thing I mean).*

Mealabost eile: *the sure knowledge that such a future will never come to pass and never would in an infinity of possible universes.* (MacNeil 2005: 75)

For the avoidance of doubt it is worth clarifying here that place names are typically composed of two elements and commonly

describe either a landscape feature or built structure; they are usu-
ally literal at the original point of coinage, denoting for example:
'wheat field', 'brown hill', 'John's farm', etc. (Scott 2003). Meala-
bost, above, which often appears in its anglicised form, Melbost, is
a name of Old Norse origin: '*Melbólstaðr* "sand-bank farm"' (Nico-
laisen 1977: 114).

As the novel's wordplay intensifies, the reader may have to work a
harder to discern which notes are jokes and which are factual. (Readers
may be made *glaoics* by taking the game too seriously.) Interestingly,
many of the factual notes are notably international, as for example:
'*Drais*: Gaelic. Pants, unless you're American. Underwear' (MacNeil
2005: 46). Others are quickly discernible, at least in part, with recourse
to a dictionary or decent search engine, so it would be an error to
regard them as exclusionary. Rather, we are invited to engage. If R. S.
embodies the novel's 'self-obsessed interiority and irremediable postco-
lonial chaos', as Schoene argues, it seems deeply incongruous that he
should explain his culture in these markedly cosmopolitan offerings.
R. S. may be having a momentary lapse of reason, or at least continu-
ity, but an alternative reading suggests that the wordplay here signposts
the message of the novel as deliberately international and playfully self-
conscious. There is indeed a didactic element to the gamesmanship of
the narrator – it is clever and engaging, and perhaps, from the critical
responses, too complicated for the quinoa kailyard.

On the same page we are then teased with a Gaelic pun that is
*deliberately* not explained: '*Brùch*: Gaelic. A little wordplay there for
the Gaelic speaker. Otherwise it just ain't funny' (MacNeil 2005: 46).
In the main text, the Scottish fizzy drink 'Irn Bru' is rendered as 'Gaelic
*Irn Brùch*'. The word *Brùch* translates, appropriately enough, as 'belch'
(Maclennan 1981). MacNeil's comment that 'Otherwise it just ain't
funny' may also be a tacit acknowledgement that reading the book
may be an emotional trial for the *Leòdhasach*.[6] The ludic elements of
the text serve several functions; they undercut the traumas the main
character endures, but also position the novel as international, multi-
vocal and culturally convivial. As Johan Sandberg McGuinne argues:

> According to Schoene, *The Stornoway Way* 'is unattuned to the major-
> ity of new Scottish literature's experimentation with less isolationist and
> more cosmopolitan and "planetary" modes of narration.' Ironically how-
> ever, this statement disregards the fact that MacNeil's prose is in many
> ways characterised by creolisation, i.e. a constant mix of cultural differ-
> ences and similarities all around the world, and to dismiss *The Stornoway
> Way* as being the result of an isolationist approach to island life, is to
> misunderstand the purpose of the novel. (Sandberg McGuinne 2013)

At the end of the book there is a further reflection in the 'Acknowledgements' section, where 'Kevin MacNeil' thanks R. S. for his assistance, noting that: 'The distinction between lessons in literature and lessons in life often blurred during our meetings' (MacNeil 2005: 251). If 'Kevin MacNeil' is pupil to R. S. in this remark, the reader is also invited to engage in a didactic dialogue, playing the 'insider' or 'outsider' (or both) in the game. MacNeil creates many affective possibilities for the reader, depending on the knowledge they bring and their willingness to look beyond the surface. By engaging, the reader becomes part of the exploration of that contested, fragile, convivial space. The Acknowledgements also intriguingly mark the transitionary moment when we emerge from the constructs of R. S.'s world. At this moment, 'Kevin MacNeil' unmasks as Kevin MacNeil, in order to do such 'real-world' things as thank the Scottish Arts Council for the bursary that made the book possible (MacNeil 2005: 251). Readers formally bid farewell to R. S. with the closing dedication 'R. S. RIP' on the endpaper (MacNeil 2005: 255). This emphasises that the troubled character of R. S. is gone, leaving the reader to consider how (or if) to remember him.

## Language and *Psychoraag*

In Suhayl Saadi's *Psychoraag*, the narrator Zaf reflects on his personal history of the city of Glasgow and the journey of his emigrant parents from Pakistan, signposting elements of identity, context and perception through his use of many languages, including Scots, Scottish English and Urdu. An extensive and detailed treatment of the language of *Psychoraag* is provided by Rachael Gilmour, which draws attention to the text's 'uncanny language effects', which 'serve not only to compress distances of space and time, but to collapse distinctions between inside and outside, authentic and inauthentic, like and unlike' (Gilmour 2018: 82). This is true to an extent, but the novel is relentless in its references to cultural artefacts that will not be decoded instantly by all readers and are frequently left without context or explanation. Unlike the italicised words from languages including Urdu and Panjabi that are glossed and explained, readers are presented with the casual inclusion of specific Scottish cultural references such as 'the Galloway Irish'; his self-description as being 'like that guy in the poem, "Tam o' Shanter", ye know the wan, the *mahmoor* that almost spun wi Auld Nancy the Witch an then gave his name a *topee*'; the list of places visited by holiday-makers which ends with the comment 'Aye, they should rest and be thankful' (Saadi 2004: 76, 209, 190). To a reader who has

never heard of the Galloway Irish or 'Tam o' Shanter' these references may be a provocation to research and understanding, but only the reader who has already heard of the viewpoint on the A83 called 'Rest and Be Thankful' will understand the pun built into the oblique comment. Similarly, when Zaf notes that 'Glasgae rats were miles better' his sardonic remark is emphasised through his reference to the slogan adopted by the city's marketing campaigners in the 1980s, 'Glasgow's Miles Better' (Helms 2008: 86). As Katherine Ashley notes:

> [n]ovels like Saadi's extend Scotland's literary and linguistic borders further still; as a result, while Scotland may be a nation without a state, the 'intrinsically polyglot demotic' of its cities is increasingly being reflected in texts that privilege heteroglossia over the monologue that Standard (or standardized) English can be. (Ashley 2011: 137)

*Psychoraag* succeeds in extending Scotland's literary borders by utilising everyday cultural ingredients that already exist within the country's cultural resources yet are currently limited in their artistic representation. A glance at the linguistic data gathered through the 2011 census underpins the social realities of polyglot Scotland: 'more than 170 languages other than English are spoken in homes across Scotland' (Scottish Government 2015: 19). Question 18 asked: 'Do you use a language other than English at home?' and invited respondents who answered in the affirmative to 'please write in' their response, within a 17-character space provided. While the allowed space may have limited some of the responses for speakers of multiple languages and therefore missed some interesting knowledge of trilingual or multilingual households, the results nevertheless revealed evidence of more than 1,000 speakers of languages as diverse as Japanese, Nepalese, Turkish, Slovak, Welsh and Yoruba. The first, in order of rank by number of speakers was Scots, with more than 55,000; the third and fourth were Urdu and Panjabi, with more than 23,000 each (Scottish Government 2013). In making use of several of the languages represented in the census results, Saadi creates a novel that depicts an everyday linguistic conviviality of a Scotland that its multiculturally mobile inhabitants can recognise, but that is otherwise rarely represented in literature.

Saadi therefore succeeds in welcoming what Ian Brown identifies as 'the vitality allowed not only by bilinguality, but also the capacity many Scots, not just Scottish writers, have to operate interlingually between and beyond Scots, English and Gaelic, and into Polish and Urdu' (Brown 2007: 60). Brown provides examples of typical forms of code-switching between Scots and (Scottish) English in everyday

conversation; in multilingual communities this code-switching diversifies further, creating a markedly convivial soundscape. Saadi's writing also blends references to religion and culture, using Scots as the binding element:

> Harry glared at him. [. . .] You think we'll get a permanent licence? Ah don't think so. Not when the community itself cannae agree on which toilet tae use. Ye've goat wan MSP fightin another an wan mosque fightin the next mosque. An that's jist wan religion, fur fuck sake! Unless ye get yer ane act together, no one's gonnae look twice at ye. The Sikhs are the same. (Saadi 2004: 43)

In many of Zaf's exchanges there is no sense of an overarching 'artificial' unity or harmony across the wider or narrower communities the characters belong to. Yet these contestations serve to enact the genuine challenges of conviviality – not just that the culture is multifaceted, but that there are problems with how those facets relate to one another within their variously prescribed contexts. A substantial part of Zaf's narrative concerns the journey made by his parents from Pakistan. Notably, this part of the story is presented through the dominant, prestigious languages of those locational identities, English and Urdu:

> They had planned it like *daakoos* [bandits] – like spies, they had a complex multilayered scheme of deception, of sleight of hand. *Al-taqiyya* [religious dissimulation]. The British authorities had asked very few questions – Mother England needed labour like an old *sharaabi* [alcoholic] needs liquor – and Jamil had bought the car, his first, with most of his life savings. [. . .] They left no notes, no record of their passage. They would slip from this land and from their previous lives like fresh snakes from old skins. (Saadi 2004: 122)

Their departure from Pakistan is characterised as a defection and an escape – the elopement of two lovers running away from their country and their responsibilities, 'his wife and son, her husband, everybody's families' (Saadi 2004: 122). *All* of the relationships in the novel are complex, or problematised, rather than being funnelled towards a reductive schema awarding points for being pro- or anti-cosmopolitan, progressive, nationalist, etc. Zaf introspectively wanders through a list of long-established social and cultural difficulties, both global and local. He relates how his parents arrived in a Glasgow of 'Orange Marches where blood-spattered banners would be hauled from houses of God' (Saadi 2004: 195), a city blighted by sectarianism. The conviviality of

*Psychoraag* allows for confrontation, inequality and contestation; it does not attempt to euphemise or romanticise; it creates a space where Zaf can pour out his hopes and fears – and articulate the messy, uneven history of Glasgow's kaleidoscopic cultures. Saadi makes no attempt to resolve or 'stabilise' such contradictions, as *Psychoraag* articulates unresolved complexities that are key to conviviality, of 'living *with* differences' (Heil 2014: 318). Graeme Macdonald argues that:

> By presenting challenging questions concerning explicit and tacit forms of racism as a relatively sidelined or non-confrontational subject in devolved Scottish culture and society [. . .] novels [including *Psychoraag*] expose high levels of obduracy – in culture but also, crucially, in politics – hindering acceptance of a truly heterogeneous concept of Scottish identity. (Macdonald 2010: 90)

*Psychoraag* confronts various forms of prejudice and tribalism, including the anti-Scottish. A notable case in point is the advice Zaf's father Jamil receives when he arrives in England:

> People in London had warned Jamil that Scotland had never been properly civilised, that he would get there and find himself surrounded by savages clad only in sporrans and brightly patterned woollen skirts. Either that or he would instantly be attacked by lupine, unintelligible gangsters sporting darkened eyes and long silver blades. Beads, crosses and tea would do no good, they insisted, since the natives were irretrievably hard Calvinists who believed only in damnation. (Saadi 2004: 206)

There is a wry humour in this exaggerated characterisation of English prejudice against Scotland, the misunderstanding of the national garment, the kilt, as a 'skirt'; getting the language wrong, accidentally or on purpose, leads to greater ignorances, perpetuated in translation. The idea that Scotland might be known to the outsider by only its colourful clothing, and a smattering of clumsy history and vague barbarity, also places it on a continuum with all places that have been marginalised and patronised throughout the world, here connecting it with Pakistan.

## Conclusions

*The Stornoway Way* and *Psychoraag* speak directly to Scotland's attempts to grapple with its collective, multicultural identities by engaging with these questions through multiple linguistic modes

and voices. Both works speak to and articulate postcolonial legacies and are therefore anything but parochial in their social and political implications. The linguistic palimpsests of both novels are here understood – in part – as creative responses to the lived linguistic realities of Scotland in the late twentieth and early twenty-first centuries. They attest to the complex conviviality that exists between Scots, Scottish Gaelic, Urdu, Panjabi and other languages actively expressed on Scotland's streets and spoken in thousands of households throughout the country. As Rachael Gilmour notes, '[t]he Gaelic and Scots languages, with their histories of marginalization, suppression, and survival, serve in certain forms of Scottish cultural nationalism both as "native" symbols of Scottish exceptionalism, and as markers of Scotland's history of colonial oppression and resistance' (Gilmour 2018: 82). With the caveat that one need not be a 'cultural nationalist' to concur, her argument should be a commonplace, but criticisms are sometimes levelled at commentators who invoke historical inequalities and attempt to address them. For example, Stephanie Lehner finds a contradiction in Cairns Craig and Robert Crawford's attempts to 're-centre' Scotland, '*both* as the source of postcolonial literatures *and* as the very origin of the colonial cultural hegemony which it has had to resist' (Lehner 2011: 42). But there is no more a contradiction in seeing Scotland *both* at the heart of the British Imperial Project *and* at the margins of British power than in (the commonplace experience of) an Ayrshire coalminer losing his job during the Thatcherite era in one of the most powerful countries of the world. There is even an ironic linguistic parallel: Scots is a marginalised language, yet the Scots song *Auld Lang Syne* is an annual, convivial, international anthem of global friendship and community.

Lehner argues that Craig and Crawford 'recuperate a somewhat singular logic of national otherness' and run the risk of 'fal[ling] back onto the homogenising dichotomy between margin and centre' (Lehner 2011: 42). She dismisses their important arguments about power and inequality as forms of 'cataloguing of national culture over and against the imperial centre (whose hegemonic position this then affirms)' (Lehner 2011: 42) Puzzlingly, her argument appears to suggest that it is impossible to challenge any form of inequality without simultaneously reinforcing its hold. The solution offered instead is that 'the idea of [. . .] a totalising centre', a governing power-base or force, will 'melt into the air' if we invoke 'postmodern hermeneutics' (Lehner 2011:43). Postmodern blinkers may help to obscure a polarised sense of the powerful versus the powerless, yet this may not

be sufficient to intellectually excuse the academic from confronting imbalances of power.

Recognition of inequality should not inevitably underline or 're-inscribe' that inequality. As Gilroy puts it in his discussion of race, a 'detour through modern histories of suffering must be made mandatory' to acknowledge the inequalities of the past and 'provide an invaluable means to locate ethical and political principles that can guide the work of building more just and equitable social relations' (Gilroy 2005: 151). Identification of a problem should not reinforce it, but rather create opportunities to reconfigure ideas and attitudes, to the benefit of all society. The opposite assertion, however, occurs in the work of several commentators. Schoene's very literal reading of *The Stornoway Way* mocks 'the author's apparent failure to recognise that to identify oneself, however self-assertively, against some other culture's hegemony is not to extricate oneself from it but in fact to confirm the inescapabilty of its ubiquitous influence' (Schoene 2007: 13). By this logic, there would be no hope for those who seek to call out cultural oppression; the opportunity for a catharsis leading to a revitalised sense of identity would be denied. As discussed above, R. S.'s narrative is the rant of a hysteric, indeed of a hysteric who self-destructs; his demise is complete and should not be lightly dismissed, nor should it be assumed that MacNeil 'takes the side' of his nihilistic anti-hero. It is difficult to square Schoene's criticism of MacNeil with Schoene's own observation that 'a postcolonial disposition no longer signif[ies] lack and inferiority, but harbour[s] a resourceful flexibility' (Schoene 2007: 9). MacNeil's ludic text (not to be confused with R. S.'s narrative) can be read as manifesting the potential of exactly that resourceful flexibility; that R. S. fails to find hope does not suggest that others are condemned to the same fate. The key difficulty – both with Lehner's critique of Cairns and Crawford, and Schoene's misreading of MacNeil – is that the marginalisation of Scotland and aspects of Scottish culture is not a myth nor a construct that only exists in the mind of the so-called 'cultural nationalist'.

It is readily demonstrable that Scots and Scottish Gaelic are marginalised languages, within and outwith the country. Furthermore, Scots literature keeps finding its way into discussions about power and the periphery, whatever the theoretical perspective. When discussing James Kelman's work, the Warwick Research Collective begin by stating:

> It may seem counterintuitive, or even perverse, for us to propose now that our analysis of the literature of the European (semi-)periphery should also include discussion of the work produced by a contemporary writer

based in one of the most developed and powerful states of the modern world-system – the UK. Yet the work of the Scottish writer James Kelman is replete with features that we can immediately recognise as transcodings of the lifeworld of the (semi-)periphery: experience, built environment, lived space, and so on. (Warwick Research Collective 2015: 138)

Remarkably, the discussion does not proceed to examine the role of marginalised language as a political marker of the (semi-)periphery, instead focusing on Kelman's 'definitive spatial lexicon of urban peripheral zones' (Warwick Research Collective 2015: 138). By comparison, as Gilmour acknowledges, '*Psychoraag*'s Glasgow is asynchronous and uneven, defined by its past as an imperial metropolis as well as by its histories of colonization and resistance to English rule, and structured in the present as much by US-led global capitalist culture as by the ongoing dominance of London' (Gilmour 2018: 82). Saadi tells the story of one fictional individual whose life experience is complex and self-contradictory. Significantly, Zaf exists within a demonstrably real and plausibly represented linguistic context, yet Saadi's multilingual Glaswegian voice is a literary innovation. The key challenge therefore presented to the reader by this text is therefore didactic; it holds up a mirror to convivial realities that may not be represented in mainstream literature or other media, but exist, and invite cultural redefinition.

Following Marc Augé's definition of transculturation, 'that somewhat paradoxical individualised synthesis', Marie-Odile Pittin-Hedon argues that Saadi uses language 'as a tool for the transculturating process at work in his novels' (Pittin-Hedon 2015: 110, 112). Following Pittin-Hedon, we can indeed choose to read the character of Zaf as an embodiment of Augé's idealised, globally educated individual defined as 'a unique and original synthesis of the cultures of the world' (Gilmour 2018: 82). However, it would be more accurate to view him as a synthesis of (some) of the cultures of Scotland. Although his words may surprise readers less aware of Scotland's linguistic realities, his forms of expression are less synthetic than may be supposed by the outsider to the cultures he articulates. His language is representationally plausible, and mappable, geographically, socially and culturally; he is therefore both real and fictional, inviting a rethinking of Scottish conviviality. Similarly, we can read the story of 'R. Stornoway', through its language, as a cultural commentary on the 'duties' of Scottish Gaelic to preserve heritage, to educate and to entertain. The passive or naive reader runs the risk of becoming the butt of the text's jokes – of being 'othered' at the expense of their own ignorance, assumptions or certainty.

As Gilroy argues, '[w]e have been waiting for a more sophisticated and political understanding of cultural change, influence, and adaptation that can defend and explain the spontaneous tolerance and openness evident in the underworld of Britain's convivial culture' (Gilroy 2005: 131). He notes that elements of this understanding have emerged in comedy, noting particularly the subversive character Ali G, whose 'provocative early performances offered a satirical Rorschach blot in which even the most neurotic scrutinizers of the national psyche could discover their fears and their hopes' (Gilroy 2005: 132). It is perhaps to the works that should not be taken too seriously – those which play with 'absolute' notions of identity and place, tell conflicting truths that are all true, and encourage their consumers to laugh at themselves – that we should turn for inspirational ideas about convivial culture. (Caveat lector.) Amin argues that achieving an everyday convivium 'requires resolute commitment from progressive social forces to present the plural communal as both necessary and worthwhile' (Amin 2013: 7). Through their uses of language, and their very direct and unabashed provocations about contested cultures, *Psychoraag* and *The Stornoway Way* contribute to this debate; their protagonists alternately invite readers to join them in bemoaning, challenging and mocking a metrovincial centre that is simultaneously real and fictional.

## Bibliography

Amin, A. (2013), 'Land of strangers', *Identities* 20.1: 1–8. https://doi.org/10.1080/1070289X.2012.732544.

Ashley, K. (2011), '"Ae Thoosand Tongues": language and identity in *Psychoraag*', *International Review of Scottish Studies* 36: 129–50.

Beaumont, Alexander (2016), *Contemporary British Fiction and the Cultural Politics of Disenfranchisement*, Basingstoke: Palgrave Macmillan.

Bray, Joe, Alison Gibbons and Brian McHale (2012), *The Routledge Companion to Experimental Literature*, London: Routledge.

Brown, Ian (2007), *Scottish Theatre: Diversity, Language, Continuity*, Amsterdam: Rodopi.

Burns, M. (2008), 'Around Scotland – Tuesday September 23rd 2008: top highlight of BBC Alba'. Blog post. Retrieved from http://malkyburns.blogspot.com/2008/09/around-scotland-tuesday-23-september.html (accessed 4 September 2019).

Crowley, T. (1989), *The Politics of Discourse: The Standard Language Question in British Cultural Debates.*, London: Macmillan.

Crumey, A. (2007), 'The public image: Scottish literature in the media', in Berthold Schoene (ed.), *The Edinburgh Companion to Contemporary Scottish Literature*, Edinburgh: Edinburgh University Press, pp. 34–42.

Donovan, Anne, (2004), *Buddha Da*, Edinburgh: Canongate.

Gardiner, Michael (2007), 'Literature, theory, politics: devolution as iteration', in Berthold Schoene (ed.), *The Edinburgh Companion to Contemporary Scottish Literature*, Edinburgh: Edinburgh University Press, pp. 43–50.

Gilmour, R. (2018), '"Ah'm the man ae a thoosand tongues": multilingual Scottishness and its limits', in Rachael Gilmour and Tamar Steinitz (eds), *Multilingual Currents in Literature, Translation and Culture*, London: Routledge, pp. 81–105.

Gilroy, Paul (2005), *Postcolonial Melancholia*, New York: Columbia University Press.

Gilroy, Paul (2011), 'The closed circle of Britain's postcolonial melancholia', in Martin Middeke and Christina Wald (eds), *The Literature of Melancholia: Early Modern to Postmodern*, Basingstoke: Palgrave Macmillan, pp. 187–204. https://doi.org/10.16995/c21.14.

Gopal, P. (2012), 'The limits of hybridity: Anglophone postcolonial poetry', in Joe Bray, Alison Gibbons and Brian McHale (eds), *The Routledge Companion to Experimental Literature*, London: Routledge, pp. 182–98.

Hoene, C. (2015), *Music and Identity in Postcolonial British South-Asian Literature*, London: Routledge.

Jeffery, Charlie (2007), 'The unfinished business of devolution: seven open questions', *Public Policy and Administration* 22.1: 92–108. http://dx.doi.org/10.1177/0952076707071506.

Jenkins, Simon (1994), 'An expletive of a winner', *The Times* (London), 15 October 1994, p. 20.

Hames, Scott (2010), 'Kelman's art-speech', in Scott Hames (ed.), *The Edinburgh Companion to James Kelman*, Edinburgh: Edinburgh University Press, pp. 86–98.

Heil, Tilmann (2014), 'Conviviality: (re)negotiating minimal consensus', in Steven Vertovec (ed.), *Routledge International Handbook of Diversity Studies*, London: Routledge, pp. 317–24.

Helms, G. (2008), *Towards Safe City Centres?: Remaking the Spaces of an Old-Industrial City*, Aldershot: Ashgate.

Hoene, C. (2015), *Music and Identity in Postcolonial British South-Asian Literature*, London: Routledge.

Homberg, J. (2018), *'Colonised by Wankers': Postcolonialism and Contemporary Scottish Fiction*, Cologne: Modern Academic Publishing.

Lehner, S. (2011), *Subaltern Ethics in Contemporary Scottish and Irish Literature*, Basingstoke: Palgrave Macmillan.

Macafee, C. (2017), 'Scots in the census: validity and reliability', in M. R. McColl (ed.), *Before the Storm: Papers from the Forum for Research on the Languages of Scotland and Ulster Triennial Meeting,*

*Ayr 2015*, Aberdeen: Forum for Research on the Languages of Scotland and Ireland, pp. 33–67. Retrieved from https://www.abdn.ac.uk/pfrlsu/volumes/vol5-before-the-storm/

Macaulay, R. K. S. (2005), *Extremely Common Eloquence: Constructing Scottish Identity Through Narrative*, Amsterdam: Rodopi.

Macdonald, G .(2010), 'Scottish extractions: "race" and racism in devolutionary fiction, *Orbis Litterarum* 65.2: 79–107.

Macdonald, K. A. (2010),'From the Cairngorms to the Cordillera Real: representations of the Highlands and Islands in recent Scottish fiction', in J. Derrick McClure et al. (eds), *'What Countrey's This? And Whither Are We Gone?': Papers Presented at the Twelfth International Conference on the Literature of Region and Nation (Aberdeen University, 30th July–2nd August 2008)*, Newcastle: Cambridge Scholars Publishing, pp. 135–48.

Maclennan, M. (1981), *A Pronouncing and Etymological Dictionary of the Gaelic Language*, Aberdeen: Acair and Aberdeen University Press.

MacNeil, Kevin (2005), *The Stornoway Way*, London: Penguin.

Millar, R. M. (2006), '"Burying alive": unfocussed governmental language policy and Scots', *Language Policy* 5.1: 63–86. http://dx.doi.org/10.1007/s10993-005-5626-6.

National Records of Scotland (2011), Census: aggregate data (Scotland) [computer file]. In UK Data Service Census Support. Available at http://infuse.ukdataservice.ac.uk. (This information is licensed under the terms of the Open Government Licence. Available at http://www.nationalarchives.gov.uk/doc/open-government-licence/version/2 (accessed 4 September 2019).)

Nicolaisen, W. F. H. (1977), 'Early Scandinavian naming in the Western and Northern Isles', *Northern Scotland* 3: 105–21.

Pittin-Hedon, Marie-Odile (2015), *The Space of Fiction: Voices from Scotland in a Post-Devolution Age*, Glasgow: Scottish Literature International.

Saadi, Suhayl [2004] (2005), *Psychoraag*, Edinburgh: Black & White.

Saadi, Suhayl (2007), 'In Tom Paine's kitchen: days of rage and fire', in Berthold Schoene (ed.), *The Edinburgh Companion to Contemporary Scottish Literature*, Edinburgh: Edinburgh University Press, pp. 28–33.

Sandberg McGuinne, Johan (2013), 'The Gaelic mafia: issues of culture, language and resistance in Kevin MacNeil's *The Stornoway Way*', *Indigeneity, Language and Authenticity*, 1 June 2013. https://johansandbergmcguinne.wordpress.com/2013/01/06/the-gaelic-mafia-issues-of-culture-language-and-resistance-in-macneils-the-stornoway-way/ (accessed 19 March 2019).

Schiller, N. G. and A. Irving (eds) (2015), *Whose Cosmopolitanism? Critical Perspectives, Relationalities and Discontents*, New York: Berghahn.

Schoene, B. (2007), 'Going cosmopolitan', in Berthold Schoene (ed.), *The Edinburgh Companion to Contemporary Scottish Literature*, Edinburgh: Edinburgh University Press, pp. 7–16.

Schoene, B. (2009), *The Cosmopolitan Novel*, Edinburgh: Edinburgh University Press.

Scott, Jeremy (2009), *The Demotic Voice in Contemporary British Fiction*, Basingstoke: Palgrave Macmillan.

Scott, M. (2003), 'Scottish place-names', in John Corbett, J. Derrick McClure and Jane Stuart-Smith (eds), *The Edinburgh Companion to Scots*, Edinburgh: Edinburgh University Press, pp. 17–30.

Scott, M. (2017), 'Melancholia and conviviality in modern literary Scots: sanghas, sengas and shairs', *C21 Literature: Journal of 21st Century Writings* 5.1: 1–29.

Scottish Government (2013), 'Scotland's Census 2011 – National Records of Scotland: language used at home other than English', Edinburgh: Scottish Government. http://scotlandcensus.gov.uk/documents/censusresults/release2a/rel2A_Language_detailed_Scotland.pdf

Scottish Government (2015), 'Characteristics of recent and established EEA and non-EEA migrants in Scotland: analysis of the 2011 Census', Edinburgh: Scottish Government. https://www.gov.scot/publications/characteristics-recent-established-eea-non-eea-migrants-scotland-analysis-2011-census/

Sebba, Mark (2018), 'Named into being? Language questions and the politics of Scots in the 2011 census in Scotland', *Language Policy* 24. https://doi.org/10.1007/s10993-018-9488-0

Shaw, Kristian (2017), *Cosmopolitanism in Twenty-First Century Fiction*, London: Palgrave Macmillan.

Stacey, J. (2013), 'On being open to difference: cosmopolitanism and the psychoanalysis of groups', in Jackie Stacey and Janet Wolff (eds), *Writing Otherwise: Experiments in Cultural Criticism*, Manchester: Manchester University Press, pp. 45–60.

Valluvan, S. (2016), 'Conviviality and multiculture: a post-integration sociology of multi-ethnic interaction', *YOUNG*, 24.3: 204–21. https://doi.org/10.1177/1103308815624061

Warwick Research Collective (2015), *Combined and Uneven Development: Towards a New Theory of World Literature*, Liverpool: Liverpool University Press.

Watson, M. and M. Macleod (eds) (2010), *The Edinburgh Companion to the Gaelic Language*, Edinburgh: Edinburgh University Press.

Watts, R. (2011), *Language Myths and the History of English*, Oxford: Oxford University Press.

Williams, Nicholas M. (1999), 'The dialect of authenticity', in Ton Hoenselaars and Marius Buning (eds), *English Literature and the Other Languages*, Amsterdam: Rodopi, pp. 221–30.

## Notes

1. I would like to acknowledge my profound thanks to the reviewers for their extremely useful and constructive critiques of an earlier draft of

this essay, and to the conference delegates for their support, guidance and inspiration.

2. Jeffery credits journalist Joyce Macmillan 'for this terminology' (2007: 105, fn. 4).

3. That is, also very dubiously, taking 'Britain' as synonymous with 'the United Kingdom' as is commonplace in public discourse; Northern Ireland is frequently (and erroneously) labelled 'British' in just this way, even though it is not part of the Island of Britain, and the UK is literally 'the United Kingdom of Great Britain and Northern Ireland'. Despite these technicalities, a person from Northern Ireland will nevertheless carry a 'British' passport, and when athletes from Northern Ireland take part in the Olympic Games they do so as part of 'Team Great Britain'.

4. There are other variants for the book title in the pun, e.g. Nail on the Banister, etc.

5. Burns continues, 'You can hear the original at www.myspace.com/saddayweleftthecroft and judge for yourselves.'

6. Scottish Gaelic, 'a person from Lewis'.

# Scottish Audio- and Film-Poetry: Writing, Sounding, Imaging Twenty-First-Century Scotland

*Camille Manfredi*

Scotland has a long history of collecting material from its oral tradition, including Gaelic tales, lullabies, work songs, testimonials, languages and accents. Much of this oral tradition has survived to this day largely thanks to twentieth-century ethnomusicologists, folklorists and anthologists such as Lucy Broadwood, Marjory Kennedy-Fraser and John Lorne Campbell. We have come a long way since cylinder recordings and phonophotography. With the advent of the internet, the rapid spread of new communication technologies and the generalised use of portable devices, there has been an explosion in sound and video recordings of poetic works in Scotland, whether in the form of authorial readings, audio-texts or film-poems. Most of them are made available to the public thanks to flexible interfaces that present and translate data between visual, textual and aural modes. As a consequence, it has never been easier to access Scottish audio-poems and download them from the Scottish Poetry Library's online anthology, the BBC radio archive or official websites of contemporary poets and spoken word artists. However dynamic the publishing industry may be in Scotland, poets and artists are also often compelled to put their shoulder to the wheel and take an active role in the distribution and marketing of their works outside the existing, although rapidly changing, mechanisms of the conventional commercial nexus, with the internet generating a nexus of its own kind. This has led to the proliferation of digital archives and communicational, often cross-media apparatuses – such as book trailers – designed to encourage distribution, advertise the publications and establish spaces of discussion both on the local and global scales. By taking advantage of the

phenomenon of online social networking, many Scottish poets now keep an online journal or website, are active on Facebook, Twitter and Tumblr, or share videos of public readings, interviews, performances and the like on online platforms such as YouTube, Dailymotion or Vimeo. Just as they greatly contribute to the dissemination of poetic works in Scotland and beyond, the internet and digital technologies thus provide ever-new ways of making, storing and sharing artworks whose intrinsic hybrid nature is closely tied to the issues that are raised by the interference of the mechanical and the technological in the relationship between reader (or, rather, reader-viewer-listener) and meaning. Digital technology has induced new modes of production and, subsequently, new aesthetic possibilities that blur the traditional frontiers between literature and the visual arts, between project and object, but also between art and disciplines that are often considered as outside the artistic sphere, such as research and marketing. The present chapter looks at a selection of art forms and artworks that use technology to combine textual, graphic, musical and sound contents, and elicit new forms of collaboration between the audience, the text and its performance. The chapter examines how Scottish poetry has adapted to the paradigms of digital meshworks and real-time textuality, be it through sound, image or sound-image, and how this has enabled the poets to reinvent their art and, in the process, reach new audiences and communities. Whereas poetry has long been established as a form to be read in silence, the hyper-technological world we now live in makes it increasingly difficult to distinguish between aesthetic contemplation and communication, and between art and its reception. The great many audio-texts that have been produced since the nineties have given a whole new meaning to Benjamin's concept of technical reproducibility, and a whole new resonance to Mallarmé's argument that 'nothing will remain if it is not uttered'. The electronic recording of tales, poems and voices is not just about retrieving what might be facing the threat of oblivion, but rather about disseminating artworks, creating listening communities and reminding the listeners of the oral tradition these poems stem from, while taking advantage of the great asset of the aural format, that is, the capacity to capture the unscripted.

Since the publication in 1994 of her first collection of poems *Voes & Sounds*, former Edinburgh Makar Christine De Luca has been supplementing her published books with a strong aural dimension through companion tapes, CDs and now MP3s available free on the poet's official website. *Voes & Sounds* was dedicated to 'da young fok o Shetland to help keep [them] in [their] midder-tongue' and came

with a tape 'for those who find the dialect difficult to read'. The companion tape expands on the homophony between sounds heard and sounds as straits by complementing De Luca's own renderings with other spatialising stimuli in the form of field recordings of the sound of waves crashing on the shore or a traditional tune being played on the fiddle. In *The Soundscape*, the Canadian writer and founder of the World Soundscape Project Raymond Murray Schafer coins these background sounds 'keynote sounds' and 'soundmarks', the former being defined as 'sounds of a given place', of its geography and climate, and the latter as 'community sounds which are unique or possess qualities which make them specially regarded or noticed by the people in that community' (Schafer 1994: 101). A *Soothmoother* like me may first mistake these archetypal sounds for the sonic equivalent to local colour or for a repertoire of sonorous *topoi* and picturesque elements; and to some extent, they are. But most of all, they help 'territorialise' the text in ways that a map printed on the front page could not. The audio tape then aims at doing something that the book had only hinted at in its dedication and on its flyleaf. Rather than pointing towards a land that remains 'yonder', it seeks to provide the local listeners with a means of beholding their cultural soundscape and of imagining, through sound, an affective, affecting and embodied experience – or *sensus communis* – of a community gathered around the *midder*-tongue, within an open, inclusive and euphonic soundscape, that is, an ambience which would then be both medium and message, and next to which the scripted text appears almost redundant.

But sounding regional languages and accents may also turn into a political gesture and an act of linguistic disobedience, when the speaker relies on significant phonetic features as a mode of resistance, the same way Edouard Glissant viewed Creole literature as 'a kind of revenge by oral languages over written ones, in the context of a global civilization of the nonwritten' (Glissant 1989: 126). In *Unrelated Incidents* (1976) already, Tom Leonard urged his readers and, perhaps most importantly, his implied listeners and fellow speakers to work out the difference '-tween / yir / eyes / n / yir / ears'. When the poems in print consisted in an idiosyncratic phonetic transcription of the working-class Glaswegian voice, the CD *Nora's Place and Other Poems* released in 1996 by Sound House closes the loop by allowing that repressed voice (Leonard's 'disgraceful' language) to be heard rather than seen: the voice can then break free of the script that sought to constrain it. In 'Right inuff', by writing and reading against the normalisation of discourse, Leonard urges his readers-listeners to work out the difference between what the eyes see – a

poem striving for non-negotiable litanic and epiphoric perfection – and what the ears perceive – the speaker's shortness of breath and physical inability to perform the poem as it was written. The grain of the speaking voice, the energy it releases and the speaker's own breath thus generate their own stream of signifiers that operate at intonational and affective levels beyond or outwith the semantic and the scriptural. As the dyspneic audio-poem frees the text of both the norms imposed by the script and the 'grim literati's' insistent rebukes which – literally – stick in the poet's throat, the speaking, breathing voice asserts itself against the (dead) written form and the (deadly) linguistic denigration that affects, however ironically, the poet's own community and family. At the same time as it subscribes to the Derridian concept of 'phonocentrism', the audio-poem contends that the only 'living' language is that which is ensounded through patterns of stress, tempo and pitch, as well as through Leonard's use of metadiscursive formulas ('righ inuff'; 'ach well') and semantic-intonational discordances ('sacred' versus 'fuck').

By asserting the legitimacy of the individual voice outside the canon, Leonard writes and speaks to a class and voice warfare in which the scriptural is de-sacralised and the aural re-sacralised. The poem is also reterritorialised, only this time in what Charles Bernstein terms 'a space of authorial resistance to textual authority'. Bernstein continues:

> For while writing is normally – if reductively and counterproductively – viewed as stabilizing and fixing oral poetic traditions, authorial poetry readings are best understood as destabilizing, by making more fluid and multiform, an aural (post-written) poetic practice. [. . .] For in realizing, by supplementing, the semantic possibilities of the poem in a reading, the poet encourages readers to perform the poem on their own, a performance that is allowed greater latitude depending on how reading-centered the poem is – that is, how much the poem allows for the active participation of the reader (in both senses) in the constitution of the poem's meaning. (Bernstein 1998: 10)

It is impossible to mention the contribution of sound and voice to meaning without referring to Edwin Morgan's sound poems, many of which have now been recorded and anthologised in audio format. Take for instance Morgan's holographic poem 'The day the sea spoke', which features on the companion CD to *The Order of Things: An Anthology of Scottish Sound, Pattern and Concrete Poems* put together in 2001 by Ken Cockburn and Alec Finlay (Canongate Venture). The

theophany promised in the poem's title may only take place when ensounded, just as the poem can only perform its trick once read out loud. Another example of Morgan's 'imaginative and therefore fundamentally serious kind of play' is his well-known rendering of 'The Loch Ness Monster's song'. There again, whereas the title promises an aural hypotyposis, the audio cryptozoopoem is but an aural hoax that adds to the many fakes that have turned Drumnadrochit into a tourist trap and which – we can hear it if we can't read it – cause the persona much displeasure. The same focus on the acoustic and extra-lexical dimensions of poetry and the same interest in the onomatopoeitics of the Scottish voice – whether it is human or non-human – are at the core of Jen Hadfield's ornithophanic 'Burra Grace' and Rody Gorman's sound poem 'Ceileireadh / Twittering'. The latter also features in the companion CD to *The Order of Things* and may be listened to as a sonorous response to Morgan's 1965 'Chaffinch map of Scotland', in which Morgan mapped the dialectical variations of the word 'finch', itself an onomatopoeia, to translate sound into image, then image into space. The ornithophanic thread that runs through Gaelic folklore, music and poetry, and the repeated occurrences of birdsong in Scottish verbal, visual and sound poetry since the 1950s bear witness to a collective interest in the semiotisation of sounds through an onomatopoeitics that aims at restoring an emotional (here, aural) bond between the community and some pre-human, pre-historical proto-language – that which Bernstein terms a 'return to a more "vital" past' (Bernstein 1998:12) – through processes of transcription and vocalisation. By exploring the evocative potential of dialects and sounds of rural Scotland, the poets aim at reanimating their readers-listeners' perception of the diversity of the natural world and the land, a perception from which *something else* – a sense of connection, perhaps – might arise that we can hear without seeing, a reminiscence of Rilke's famous 'Gesang ist Dasein': the community's *ceòl*.

The same interest in the sound of place and spatiality of sound can be found in a number of contemporary Scottish artists' projects involving bioacoustics (when one sound is intentionally isolated, generally for identification purpose), nature recordings (where the background to the sound in focus includes biotic and non-biotic components of the sound environment), or the 'blind' acousmatic recording of all the sounds generated by the given location, freed of contextual or procedural considerations. I refer the reader (or listener, for that matter) to Glasgow-based sound artist Stephen Hurrel's aural landscapes and ambient soundworks such as 'Beneath and beyond' (2008), 'Dead reckoning' (recorded at the Cromarty marine

mammal research station in 2012) or 'Mapping the sea' (Barra, 2014). Beyond the sheer documentary perspective, these pieces seek to provide their audience with an immersive aural portal into places that they may never visit, and, one might argue, were never meant to, but that they are nevertheless able to engage with, to emplace – to imagine or ensound – themselves in. When we listen to such recordings – verbal or non-verbal, authorial renderings or sound-works – what we hear is more than just the North Sea, Glasgow, the monster or the bird. We may perceive, too, what pertains to the collective or the choral – the sound of place, the voice of those who inhabit it – and that occurs or, literally, *takes place* cross-media, in-between the scriptural and the aural. After Liliane Louvel's 'pictorial third', that is, the transaction processes and 'oscillation' between text and image (Louvel 2016), let us term this 'the aural third'. But what becomes, then, of these 'events *heard* not objects *seen*' (Schafer 1994: 99) when text, image and sound come together to make something else happen – an aural-pictorial third, perhaps – when poetry is both aurally and visually enhanced, when the poem is taken off the page and into sound, image and motion?

Between the 1950s and the late 1990s, Orkney-born avant-garde filmmaker Margaret Tait opened many new avenues for innovative work on the visual enactment of poetry, be it through *Hugh MacDiarmid: A Portrait* (1964) or her moving *Colour Poems* (1974). The film-poem – defined by Charles Bernstein as 'the cinematic extension of the poetry reading' (Bernstein 1998: 12) – has since emerged as a literary genre in its own right: filmed as it is recited, sung, slammed, performed or scripted, the poem does indeed become all at once textual and aural, visual and gestural. This not only profoundly modifies the way we perceive and receive the text; it also has us question the traditional distinctions between language and music and between poetry, speech and iconicity, not to mention the dichotomy between production and reception which is further collapsed by the technically induced illusion of immediacy that the internet allows today. While attempting to capture the performative and material dimension of the literary work into visual space, the film-poem takes poetry into the sphere of the more-than-verbal, and into what Gilles Deleuze terms the 'non-totalizable relation' between 'visual and sound images':

> What constitutes the audio-visual image is a disjunction, a dissociation of the visual and the sound, each heautonomous, but at the same time an incommensurable or 'irrational' relation which connects them to each other, without forming a whole, without offering the least whole. It is a

resistance stemming from the collapse of the sensory-motor schema, and which separates the visual image and the sound image, but puts them all the more into a non-totalizable relation. (Deleuze 1985: 256)

Many of the contemporary Scottish film-poets who are the focus of the following pages are particularly cautious to cement their practice within the disjunction between visual and sonorous dimensions. By playing out the conflict of faculties and the contrapuntal relationship between moving image and poetry, what they are working at is a form of aural-linguistic displacement that is brought about by the sound-image disjunction. What stems out of this 'irrational relation' could then well be another sense of the locale, possibly even another *sensus communis* grounded on the evocative power of the Scottish voice, accents and languages to break open the canon. As in poet and spoken word artist Stephen Watt's slammed *Rubik* (2014), Lesley Traynor's film-poem inspired by Gaelic poet Marcas Mac an Tuairneir's *Long-briste* (2018), or Roxana Vilk's short film and portrait of Rab Wilson *Poetry Like Buses* (2014), film-poems and film portraits provide material examples of the strategies used by filmmakers to make the poem-event heard and seen not as an attempt at suturing the gap between word, image and sound, but rather as the *product* of that disjunction. In his online manifesto, Scottish poetry filmmaker Alastair Cook contends that

[. . .] the Poetry-film should successfully bring the work to the audience through visual and audio layering, attractive to those who would not necessarily read the poetry. The film needs to provide a sub-text, a series of suggestions and visual notes that embellish the poem, using the filmmaker's subtle skills to allow the poet's voice to be seen as well as heard. The collaboration remains with the words. If this subtext is missing, the film resorts to being a piece of media, the reading of a text over discombobulated imagery, a superimposition.

Cook expands on this 'layering' to identify four main means of filming poetry:

The simple use of the graphic text of a poem, in part or whole, without any visual movement or film; the literal filming of a text.

The simple use of the graphic text of a poem, in part or whole, underlaid with visual movement, either animation of natural filmic elements; a visual film of text and audio; think Subterranean Homesick Blues by Bob Dylan.

Performance, by the poet or other, of the poem in a stage and audience context; a film of a poet at work.

The unabridged reading of a poem by the poet, or another, over a film that attempts to combine the poem with visual and audio elements; essentially the embodiment of William Wees's Poetry-film concept.[1]

A good case in point is Susan Kemp's 70-minute video documentary *Nort Atlantik Drift: A Portrait of Robert Alan Jamieson* (2014). The documentary was screened in Sandness as part of Shetland's film festival and was later aired on Scotland Mainland on the occasion of the 2014 Glasgow Film Festival.[2] *Nort Atlantik Drift* is partly composed of edited interviews with the poet, but the core material of the film is the original collection of poems and photographs that Jamieson published in 2007 under the same title. Similar to Christine De Luca's *Voes & Sounds* in the sense that it is a tribute to Shetland, its dialect and changing way of life, the collection is characterised by a decidedly inclusive take: written in the dialect, the poems are translated into English and supplemented by Jamieson's comments on the events, people and customs that have inspired them. In its scripted form already, the collection was all about transmission. The film portrait shows Jamieson – 'RAJ' – delivering his original poems from his late father's house, Sandness Methodist Church, the banks of a lochan, the hinterland or the shore. The film thus strives to re-contextualise Jamieson's poetry by simultaneously re-emplacing and re-ensounding it on the very sites that had given, in Jamieson's own words, the 'local poems' their 'local voice'. Accompanied by scenic captures of Shetland's coastal landscapes and on-site sonic tropes (the sound of the howling winds, crashing waves, crackling peat fire, ticking clock or bleating sheep), each reading is introduced by a silent image and bilingual intertitle. Jamieson is then filmed and recorded as he reads his piece on location, until a silent, scripted and translated version of the poem appears overlaid on the landscape. Even when they are not perceived simultaneously, text, voice and image are mutually dependent, with Kemp's *sense of* Shetland lying in-between, in one or several of the many interstices that emerge out of the overlapping, juxtaposition and displacement of the domains of difference Shetlandic/English, word/image/sound, on-site/off-site, at the juncture of which the locative vernacular of Jamieson's poetry embeds itself. Kemp attempts to recreate what she and Jamieson term the choral 'sound of Shetland' and the aural-visual interface through the oppositional-synergetic interplay of text-based vocal performances and non-semantic sounds within which Jamieson's poetry can really *take place*.

Another example of how film-poetry 'expands upon the specific denotations of words and the limited iconic references of images to produce a much broader range of connotations, associations, metaphors' (Wees 1984: 109) is Callum Rice's celebrated short documentary *Mining Poems or Odes* (2015).[3] There, Glasgow poet Robert Fullerton tells of how he discovered literature when he was 17 years old as he worked as a welding apprentice in the docks of Glasgow, and how, in his own words, he 'found his muse under a welder's mask'. As in Kemp's *Nort Atlantik Drift*, the film wavers between portrait (that is, an image that strives to be still) and performed poetry (a text that strives to be enacted). In *Mining Poems or Odes*, however, the word-sound-image relationship is not enacted on site, but in motion. Along with Fullerton's voice-over narrative and renderings of his poems, the film runs the welding-writing metaphor by repeating, as of the opening sequence, the visual motif of cascading sparks figuring the poet's 'wee ideas'. The film then succeeds in writing, imaging and sounding Fullerton's poetry all at once: the poems are filmed not as they are scripted or read, but rather as they are, both metaphorically and visually, welded into shape. Meanwhile, Glasgow is emplaced in the poet's voice and accent, in his texts and in images of the cityscape.

Cook's eight-minute film *Alba* (2014) belongs to the last of his four categories: 'the unabridged reading of a poem by the poet, or another, over a film that attempts to combine the poem with visual and audio elements'. *Alba* was commissioned by the group of artists Absent Voices as part of a collaborative art project titled 'Spoken spaces, sonic traces'. One of six film-poems aimed at celebrating post-industrial Greenock, *Alba* takes its title from a poem featuring in John Glenday's *Undark* (2015) in which sounds and voices feature prominently. Glenday's allegorical Scotland is, first and foremost, an utterance:

ALBA

Some say she looks like an old witch,
a dark caillich with a cat's tail of islands for hair.
Brine sluices the words from her cracked lips.
I say no. I say she's as fresh as these flakes
of schist and quartzite I gathered yesterday.

Some say she's barren: "Look how they scoured
her bairns from her womb with a dab of wool," they say,
"and them scarce hallways down the road to birth.

The four airts buried them.
Their cries will circle the earth like little storms."
I say no. I say she's poor but whole and strong,
and I've heard her children sing out in the half dark street,
barely a whisper before night.

Some say she's bad news, a temptress, a whistler on ships,
that the man who sleeps with her will wake one morning
at dusk on a hillside under the brisk rain, his pockets weighted with sand.
I say no. I say, look at me: I've slept with her all the nights of my life
and still each morning when I wake I find her tongue in my mouth.[4]

A film-poem but also a live musical performance, Cook's *Alba* com-
bines poetry, archive images and music.[5] For most of the duration of
the film, the soundtrack consists of an adaptation of Glenday's poem
into song by composer Luci Holland. In the opening and concluding
sequences, male and female readers 'from all over' (Scotland, one
might presume) recite the poem, their disembodied voices intersect-
ing and overlapping into a form of perpetual canon. As the poem
turns multivocal, the stanzas dissolve into a choral soundscape lean-
ing towards actual singing where lines repeat and break up differently
from what is seen on the page, with readers, apparently unaware of
each other, starting mid-way through the poem or picking lines at
random. Contrary to its scripted version, in the film-poem the text
never begins and never ends. It ceases being linear and graphic to
become palindromic, and is then able to morph into a sonic and
social – yet disjunctive – environment which dictates its own rhythm.
Liliane Louvel speaks of a 'spatio-temporal syncopation' generated
by the word-image (here, word-image-sound) relationship:

> The visible or visual image punctuates the text with or against it in its
> linearity or heterogeneity, producing a hybrid being worked at by the
> image in the mode of the fugue and the counterpoint, of the symphony
> or the concerto, or even of syncopation. The pictorial composition of
> the text is akin to a musical composition, with its harmony rules and its
> dissonances too. It is a punctuation, a tempo, linked to the poetic charge
> of the text; it is a rhythm. We can thus see the articulation of sight and
> hearing, image, text and music. (Louvel 2011: 179)

In terms of structure and composition, *Alba* is a fugue, with Glenday's
original text providing the film-poem with its exposition, central
episode (the song), repeat of the entry, and coda. Music (*Song of
the Clyde*), text, voice and image then work at each other in the

mode of the counterpoint. Our task as viewers-listeners is to look for that moment when the textual, the aural and the visual intersect and mingle into a polyphonic whole, when the poem is no longer just transducted, recited or sung, but moves beyond the textual into another work of art, which is now independent from the scripted version, but which nevertheless *responds* to it, or *converses* with it through the elaborate trialogue between the iconic, the aural and the textual.[6]

Another film-poet who excels in the art of sonic-visual-textual counterpoint is Roseanne Watt.[7] In *Quoys, Unst* (2014) for instance, Watt's own poem is the ghost of a long-gone voice, with the film-poem treading the tightrope between contraction and expansion of meaning, alignment and dis-alignment of words and image: if the voice cannot be heard, it will struggle to make itself seen. Indeed, as the verses and words appear and disappear on the screen, the poem makes repeated references to sounds ('whistled', 'sibilants') and voices that we will not get to hear, to fables that we will not be told. Meanwhile Watt's use of pulsating, kinetic typography – the *unheimlich* of the word/image/ motion relationship – (dis)places meaning in the imaginary interstitial space between text and image at the same time as between signifier and signified – in that space which expands between the object and the word. Apart from the muffled keynote sounds of the wind and waves and a couple of startling razor-sharp Larsen sound effects, the film is silent and functions like a slightly dissonant anechoic chamber. In this way, although the whole film-poem is about sound, the latter is displaced from the soundtrack to the tempo or 'punctuation' of the word-image relationship: to the friction between written and iconic forms, and between voice and noise.

Also by Watt, the film-poem *Between Islands* (2016) is part of a collaborative project devised by An Lanntair (Stornoway) involving writers and visual artists from the Western and Northern Isles. Like *Quoys, Unst, Between Islands* falls within the second of Cook's categories: 'the simple use of the graphic text of a poem under-laid with visual movement'. Watt's film-poem fuses poetry with spatial terminology in Orcadian, Shetlandic and Gaelic 'midder-tongues', words that were heard before they were transcribed. Neither a pronunciation guide nor a glossary of topological terms, *Between Islands* plays on the tension between presence and absence of voice, but also between legibility and illegibility of text: the film-poem is a soundscape for the viewer to voice out if they feel like it, while *Auld Lang Syne* is being played on the piano but without the lyrics, for the viewer to sing along. The in-between, which is figured by both the film-poem's title and the featured landscapes, then appears to await our voice to be sounded

into the social space – the space we hear, speak and sing in – that the whole project seeks to create, or recreate.

This last point leads me to Susan Philipsz's 2010 Turner-prize winner installation *Lowlands* (2008–10), for which the sound artist installed three different low-fi – that is, technologically anachronistic – versions of the sixteenth-century Scottish ballad on the underside of three bridges along the Clyde walkway in Glasgow. The installation was filmed before it was submitted to the Turner Art Committee and is now accessible online.[8] Both on and off site, disembodied and untrained, Philipsz's voice plays on the tension between the sounds and the sonic space delineated or 'contoured' by the song. Because it was sung and recorded in another time and space, 'Lowlands away' belongs, all at once, to the there and then of sixteenth-century Scotland, to the here and now of twenty-first-century Glasgow, and to what Jean-Luc Nancy, in *Listening*, terms 'the omnidimensional and transversate sonorous present':

> The sonorous present is the result of space-time: it spreads through space, or rather it opens a space that is its own, the very spreading out of its resonance, its expansion and its reverberation. (Nancy 2002: 13)

Refracted, diffracted and absorbed by stone and water, and further remediated by the film, Philipsz's soundwork is also a strange case of what Schafer coined 'schizophonia': a form of perceptional alienation stemming from the defamiliarising process of mediation and transduction. As with Cook's multivocal *Alba*, *Lowlands* plays on modulating repetitions, echoes and feelings of *déjà-entendu* to call for an affective response to the shared cultural reference of the song. Eventually, what the installation and film capture is the sound of collective memory, or, in Jonathan Sterne's words, the sound of the 'audible past' (Sterne 2003). *Lowlands* thus works at infiltrating a mnesic space into ordinary places – the underside of the George V Bridge in Glasgow, a computer screen – with a view to re-inhabiting them aesthetically, while the lyrics and almost palilalic repeats of the ballad pass down a matrix of shared memory. Again, from Nancy's *Listening*:

> [. . .] in semi-Lacanian terms, the visual is on the side of an imaginary capture (which does not imply that it is reduced to that), while the sonorous is on the side of a symbolic referral/renvoi (which does not imply that it exhausts its amplitude). In still other words, the visual is tendentially mimetic, and the sonorous tendentially methexic (that is, having to do with participation, sharing or contagion), which does not mean that these tendencies do not intersect. (Nancy 2002: 10)

The operative word here is 'intersect'. Nevertheless, the infinite possibilities opened by such 'intersections' of verbal, visual and sonorous components are all too often overlooked. On 10 March 2018 *The Independent* online edition published an article on audio books and NOA (News Over Audio) by Andy Martin, a Cambridge academic and regular contributor to the newspaper.[9] Martin recalls his delight listening to professional narrator Cathleen McCarron's 'lilting Scottish accent' which, he writes, 'speaks to [him] of steaming bowls of porridge, Highland Games, and leaping salmon, with just a dash of Rebus'. More arresting is the way Martin approaches the shift from visual to acoustic culture as a shift from *screen* to headphones, thus enforcing the disappearance not just of the page and the material book, but of the very concept of 'text', at least as it is meant by Martin, that is, words printed on a page in an actual, physical book – a definition that structuralists and post-structuralists worked hard at debunking. 'It's possible the age of the text is, if not over, at least entering the twilight zone', Martin concludes. In 1989 already, in his posthumous book *The Global Village*, Marshall McLuhan argued that just as the invention of the printing press had induced a change from an oral to a typographic culture, the advent of electronic culture may induce the exact opposite and tip us back into a world of sound, where aural senses predominate. This does not mean, however, that the text is on its last legs. A powerful shape-shifter, it proves more than able to meet the challenges posed by the digital turn, but also to use old and new technologies to its advantage. Although it can hardly be disputed that the exponential pace of technology is indeed changing the way literature is written, read, performed and disseminated, the new poetics of the interface urge us to think the relationship between text, screen and sound in terms that do not necessarily involve rivalry or preclusion. There is a possibility that the point of audio- and film-poetry is not to simply adapt to new habits and technologies, nor to yield to what Harold Bloom famously termed 'the tyranny of the visual'.[10] Neither is it to divert the readers from books: most of the poems quoted in this chapter exist in print, thus making it possible for the individual self to 'apprehend their aesthetic value' (Bloom 1994: 23) book in hand if they wish to. But it would be equally misleading to dismiss these art forms as mere book trailers and commercial apparatuses: what audio- and film-poets in Scotland seek most of all is to confront their art with other forms and media with a view to carving a space of their own out of a system – or 'canon' – which, because of the increased worldwide dissemination of art, can no longer confine their voices to a box on a map.

As is the case with many other nations, Scotland has a long oral tradition, and dialogues across forms and media have long been part of the artistic scene; the poets and artists that this chapter has approached prove particularly inventive when working at the plasticity of text through the mutual enhancement and, in Cook's words, 'organised symbiosis' (in Louvel's, 'syncopation') of text, sound and image. This chapter has approached but a few of the many possibilities offered by the text-sound and (moving) word-(moving) image relationship, and a few of the many ways Scottish poets and visual artists imagine, re-imagine and behold their cultural soundscapes. Examples have ranged from metaphoric or anamnesic aural landscaping to forms of enhanced and enacted textuality, with the aural and the visual providing the contextual, subtextual, paratextual, narrative and emotional elements that allow the text to enter the realm of the sonorous, to become symbolic-methexic – to become *contagious*. With the proliferation of cross-media practices, texts can now be read, seen, heard, even interacted with, not ignoring the potential for deviation and subversion they might provide when pushed to the condition of music or film. By exploring alternative modes of knowledge and dissemination of poetry, the poets and visual artists even partake in what Birgit Abels terms 'the emergence of social meaning(fulness) and hence, the formation of communities' (Abels 2016: 138) grounded on conversational art and relational aesthetics. When considering these artworks as part of a constant negotiation between images, texts, contexts, norms and media, we might finally approach them as strategic apparatuses insofar as they partake in the reconfiguration of both traditional and non-traditional, local and global paradigms of identity. To say that there remains a vast field of research to be explored here is an understatement.

## References

Abels, B. (2016), 'Music, in-between spaces and the sonosphere (or, a musicologist's very short introduction to relational skills)', in C. Granger et al. (eds), *Music Moves. Musical Dynamics of Relation, Knowledge and Transformation*, Hildesheim: Georg Olms Verlag, pp. 137–55.

Bernstein, C. (1998), 'Introduction', in C. Bernstein (ed.), *Close Listening. Poetry and the Performed Word*, New York and Oxford: Oxford University Press, pp. 3–26.

Bloom, H. (1994), *The Western Canon. The Books and School of the Ages*, New York: Harcourt Brace.

Cockburn, K. and A. Finlay (eds) (2001), *The Order of Things: An Anthology of Scottish Sound, Pattern and Concrete Poems*, Edinburgh: Canongate Venture.

Deleuze, G. [1985] (1989), *Cinema 2. The Time-Image*, trans. H. Tomlinson and R. Galeta, Minneapolis: University of Minnesota Press.

Glissant, E. (1989), *Caribbean Discourse: Selected Essays*, ed. and trans. J. M. Dash, Charlottesville: University of Virginia Press.

Louvel, L. [2011] (2016), *Poetics of the Iconotext*, ed. K. Jacobs, trans. L. Petit, London and New York: Routledge.

Louvel L. (2016), 'A reading event The Pictorial Third', *Sillages critiques* 21, uploaded 15 December 2016. http://journals.openedition.org/sillagescritiques/5015 (accessed 24 March 2019).

Nancy, J.-L. [2002] (2007), *Listening*, trans. C. Mandell, New York: Fordham University Press.

Schafer, R. Murray (1994), *The Soundscape: Our Sonic Environment and the Tuning of the World*, Rochester, VT: Destiny Books.

Sterne, J. (2003), *The Audible Past: Cultural Origins of Sound Reproduction*, Durham, NC: Duke University Press.

Wees, William (1984), 'The poetry film', in W. Wees and M. Dorland (eds), *Words and Moving Images*, Montreal: Mediatexte Publications.

## Notes

1. From Alastair Cook's website: http://filmpoem.com/about/ (accessed 3 April 2019).
2. The documentary is now accessible on the open access video-sharing website Vimeo. https://vimeo.com/86533135 (accessed 3 April 2019).
3. See https://vimeo.com/131406587 (accessed 3 April 2019).
4. The poem is also available online in scripted and audio forms: https://www.johnglenday.com/ (accessed 3 April 2019).
5. *Alba* debuted as a live musical performance at the Edinburgh Festival Fringe 2014 and also featured as a special release as a fully orchestrated piece, in a collaboration with composer Steve Brookfield. The original film recorded featured musicians Colleen Marie Nicoll (soprano), Katie Johnston (cello) and Sarah Becker (piano) with sound engineer Josh Sabin. The live 2014 Fringe performance featured Rachel Stewart (soprano), Justyna Jablonska-Edmonds (cello) and Sarah Becker (piano).
6. Also directed by Cook, see *MacAdam Takes to the Sea*, an abstract film-poem of Andrew Philip's eponymous poem published in *The North End of the Possible* (Cromer: Salt Publishing, 2013). The film was commissioned for the second Hidden Door festival in Edinburgh and was premiered on 23 October 2010: http://filmpoem.com/filmpoem-8-macadam-takes-to-the-sea/ (accessed 3 April 2019). Another example of film-poems which respond to other artists' works is Roseanne Watt's film-poem *Havergey*

(2017), inspired from John Burnside's *Havergey* (Rochester: Little Toller Books, 2017): https://vimeo.com/207904226 (accessed 3 April 2019).

7. Like Alastair Cook's, Roseanne Watt's film-poems are accessible on Vimeo: https://vimeo.com/roseannewatt (accessed 3 April 2019).

8. *Lowlands* By Susan Philipsz, filmed and produced by 47 Film for Glasgow International Arts Festival and Susan Philpsz: https://www.youtube.com/watch?v=UWeKzTDi-OA (accessed 3 April 2019).

9. Martin, A. (2018), 'Theatre of the mind: how audio is changing the way we use books – and the way they are being written', *The Independent*, 10 March. https://www.independent.co.uk/news/long_reads/audio-books-noa-eleanor-oliphant-wesolowski-voice-artist-a8246226.html (accessed 3 April 2019).

10. Interview on Charlie Rose in July 2000. To Rose's question 'What do you think is the single greatest threat to the future of reading?', Bloom replied: 'I used to believe, until fairly recently, that the greatest threat was both visual over-stimulation – television, films, computers, virtual reality, and so on – and also auditory over-stimulation, you know, what I call rock religion, MTV, rap, all of these mindless burstings of the eardrums. [. . .] But more recently, I have reached the very sad conclusion that what most threatens the future of reading is the [. . .] real possibility of the disappearance of the book. I begin to fear that what it means to be alone with a book [. . .] might almost vanish, that the technological overkill of the latest developments we are moving towards, the e-book sort of thing which Mr. Gates and others are proclaiming might perhaps put the book in jeopardy.' https://www.bookbrowse.com/author_interviews/full/index.cfm/author_number/631/harold-bloom (accessed 3 April 2019).

# Post-National Polyphonies: Communities *in absentia* on the Contemporary Scottish Stage
*Jeanne Schaaf*

On the contemporary Scottish stage, a range of different projects are based on the dialogue, or the interplay of different spatial scales (between the local and the global), of different modes of fostering hybrid communities of creators/spectators, and of different degrees of presence (real or virtual). These new modalities of *creation*, of *representation* and of *reception* on stage are part of a wider trend in the evolution of contemporary artistic practices. Yet in the last decade, they have flourished on the Scottish stage, challenging essential features of the representation of identity – be it generic identity or national identity.

One trend of participative aesthetics that fosters new communities is best exemplified by two plays by Scottish playwright David Greig. Commissioned by the Actors Touring Company, *The Events* premiered at the Edinburgh Festival in 2013 and stages the aftermath of a traumatic event and its effects on a specific local community: a choir. The peculiar quality of the experience emerges from the fact that only two actors are trained, they play the two mains characters, while the choir is embodied by an actual local choir of amateurs, unaware of the entirety of the plays' scripts. Similarly, *The Suppliant Women*, David Greig's rewriting of Aeschylus's *The Suppliants* (470 BC), premiered in Edinburgh at the Lyceum Theatre in 2016. It was directed by Ramin Gray in a co-production with the Actors Touring Company. This contemporary rewriting of the ancient play returns to the aesthetic features of Greek drama by including a traditional Greek chorus on stage: 50 non-professional, local volunteer women embody the chorus in each city where the show is staged. The two

immersive and delegated performances use a collective body of amateurs as choirs on stage. In doing so they multiply the voices on stage and foster new landscapes of belonging.

A second trend in contemporary Scottish drama, one that also relies on the participation of volunteers in the process of creation, challenges the very physical *presence* of the community, be it a community of actors, or the community of spectators. Intriguingly, these practices even come to question the presence of the stage itself. *The Great Yes No Don't Know Five Minute Theatre Show* was a project launched by the National Theatre of Scotland (NTS) and the Five Minute Theatre Show shortly before the 2014 referendum on independence. Conceived as a participatory experiment, it invited people around the earth to invent and perform a five-minute opinion piece on the question of independence. These heterogeneous productions were to be recorded and sent to the NTS – the short videos were then uploaded and live-streamed for 24 hours online. Participants as well as audiences were thus scattered across the globe, connected thanks to a shared virtual stage online. In the same vein, *Adam*, a play by Frances Poet, which was produced by the National Theatre of Scotland and staged during the Edinburgh International Festival 2017 at the Traverse Theatre stages the odyssey of a transgender person, who has travelled from Egypt to Scotland (Glasgow) in order to both seek asylum and transition from female to male. Once in Glasgow, she is at first rejected in her identity quest before finding support from a digital community online. Formally, this online community was featured on stage by a choir of transgender people who volunteered from around the world to take part in this production – and were assembled virtually on screen – to sing in unison on stage. This collective body sings *in absentia* and 'embodies virtually' new modes of belonging and new communities on stage.

Through their themes, but most importantly through their participative and disincarnated aesthetics, these four productions display challenging conceptions of space, of community and of presence. These changing paradigms on stage, ones that usher in new ways of representing a nation and its community, also account for changing practices in the field of theatre and can be read as fundamentally democratic for they give birth to a constellation of post-national voices.

A quick overview of recent research on contemporary artistic practices shows that the aforementioned experiments on the stage find their origins in a wider trend that has been enabled by various evolutions in the field. On the one hand the most striking transformation of the artistic landscape is due to the *'digital turn'* and the

proliferation of new technologies and new media which open up alternative spaces and allow different modes of expression. On the other hand, there is a tendency to develop what Nicolas Bourriaud calls the *relational* quality of art: he considers the artwork as 'social interstice' and defines relational art as 'an art taking as its theoretical horizon the realm of social interactions and its social context, rather than the assertion of an independent and *private* symbolic space' (Bourriaud 2002: 14). This definition of art as concerned with social interactions echoes what Claire Bishop has identified as the *social turn* in contemporary art (Bishop 2006). She explains this inclination in those terms: 'Artists are increasingly judged by their working process – the degree to which they supply good or bad models of collaboration (. . .) This emphasis on process over product (i.e., means over ends) is justified as oppositional to capitalism's predilection for the contrary' (Bishop 2006: 180). Yet she qualifies this definition and warns that art should remain an object in itself rather than a process.

More recently, Jen Harvie links all three terms (digital turn, relational art and social turn) in her book *Fair Play: Art, Performance and Neoliberalism* specifically dedicated to performance studies. In her study she investigates a trend that she identified as 'the recent proliferation of performance and art practices that engage audiences *socially* – by inviting those audiences to participate, act, work and create together; observe one another; or simply be together' (Harvie 2013: 1). After Bishop, she labels it *'delegated* performance' (Bishop 2008) and she questions its value as either fundamentally democratic or, on the contrary, serving a neoliberal agenda.

This double tendency of art to become increasingly digital and delegated (or social), if not both at the time, reshapes the very 'space' and 'form' of theatre; and several recent productions in Scotland address this revolution on stage. Through the presentation and analysis of four very recent plays, I wish to consider this shifting conception of 'community' in participative theatre practice as well as the evolving paradigms of presence on a digitalised staged. This formal, spatial and political evolution can be read as a form of *'devolution'* (echoing the political landscape of the nation) of two key features of the theatre. First the empowerment of audience becoming actor/co-creator means that the very distinction between performers and spectators is called into question and redefined according to new modalities. Second, the 'embodied' quality of theatre makes way for an increasingly mediated presence through the use of technology. It is these two 'essential' features of theatre – the distinction between a community

of creators and one of spectators, and the physical embodiment and presence of these communities – which are 'delegated' or 'devolved' in the performances under study.

It is my contention that this general trend of contemporary theatre is exemplified on the Scottish stage through projects which provide new representations of identity and, more broadly speaking, new representations of the nation, a nation staged as democratic, inclusive and post-national.

## Local Choirs: Rehabilitating the Greek Chorus

*The Events*, by David Greig, was first performed in 2013 at the Traverse Theatre in Edinburgh. The narrative structure of the play alludes to a terrorist attack perpetrated in Norway in 2011 by a white nationalist named Anders Breivik. This atypical production, partly devised as delegated performance, interrogates the notion of *community* when one is faced with such a traumatic event. In the play, Claire, the main character, plays a priest in charge of a small local and multicultural choir whose purpose is to promote integration and a feeling of belonging through the communal act of singing. It is within this community that a new member perpetrates a terrorist attack. As the sole survivor, Clair sets out on an impossible quest: to understand and make sense of the act of violence that hit her choir.

On a thematic level, the play explores the concept of community through the image of the choir: the unity of the collective body is dismembered through the intrusion of tragedy leading either to increased cohesion of the individuals confronted with adversity, or to a dissolution and disharmony between the members. However, it is rather on the formal level that this play stages odd mechanisms of 'togetherness', as it resorts to a return to the Greek chorus and its role as a civic body on stage. Indeed, the play is written for two actors, Claire and 'The Boy', who take on different characters in turn. The rest of the distribution is peculiar to each city where the play is staged, for indeed it is a local choir that is chosen to take part in each representation.

This community of singers is simultaneously associated to the creation and left out of it, relegated to the role of mere spectator of the drama. In fact, the selected choir (which has to be different every night, and in every city for the experience to be successful) receives a 'Choir Pack' conceived as a guide through the play for the participants. And yet this guide does not include the topic of

the play nor the script. The amateur choir will only discover the content of the play on the night of the representation. As the stage director Ramin Gray explains: 'They play the choir, the community, and a Greek Chorus – questioning Claire's actions and warning her about her destructive pathway. (. . .) ATC, in partnership with their tour venues, will meet the challenge of finding a different choir for every night the play is performed' (Actors Touring Company 2013: 3).

The hybrid quality of this delegated choir – both actor and spectator – is defined in such terms for the participants: 'the story weaves around you, often you will represent the community and act as spectators but sometimes you will act like a Greek chorus and of course, at other times you will sing: songs dear to your hearts and songs that we will write for you' (Actors Touring Company 2013: 3). Each choir – over 250 choirs around the world have already taken part in the experience[1] – has to choose a song that they will interpret to open the representation. This unique and personal song embodies the identity of each choir; as the choir pack explains: 'It should be typical of their repertoire and not exceptional –a real signature tune' (Greig 2013). This feature leaves room for local musical choices, or local inflections specific to each production. The *event* that takes place on stage thus acquires an enhanced local dimension: each spectator can imagine the event actually taking place 'here', at the heart of their community (Rebellato 2016). The members of the choir thus *actualise* somehow the representation, conferring to the moment a 'precarious additional immediacy to the event', as Dan Rebellato has argued (2016: 18).

The immediacy and the authenticity of the community of choir is amplified by their spontaneous reactions as they discover the action unfolding on stage. The choir becomes an intermediate body between actors and audience. Mirror of the audience, metonymical choir, it functions as a first spectator on stage, destabilising the binary opposition between the acting (from the Greek *drama)* and the seeing (from the Greek *thea)*, between actors and spectators. David Greig explains: 'I wanted the audience to watch the choir watching and experiencing the play – part of the play is the experience of watching the choir be affected.' Subjected to a real experiment, the choir participates (in)voluntarily in the staging of the following paradox: the inclusion of the authenticity of their reaction to the staging of a tragic event within the artificiality of the representation. Much like an ancient choir, it operates a Brechtian distanciation and invites a collective body of citizens on stage. Oscillating between distance and

empathy, the choir's presence intensifies the feeling of a shared event as Rebellato shows:

> The choir are often scattered across an upstage seating unit and their untutored spontaneity, sometimes watching the actors, sometimes reacting, sometimes catching each other's eyes and maybe sharing a private joke, provoked in me an anxious and persistent sense of risk (. . .) This intensified the liveness and liveness is a kind of temporal localness. It felt temporally local and that gave the whole performance a precarious fragility that intensified the sense of theatre's co-presence with its audience, our mutual dependency, the demands. (Rebellato 2016: 18)

Based on similar features, *The Suppliant Women* by David Greig is a rewriting of Aeschylus's oldest play *The Suppliants* in which the Danaids, the 50 daughters of Danaos, flee their home country in Egypt because they are threatened to be married to their cousins against their own will. They ask the King of Argos for asylum and protection. He is faced with the dilemma of either welcoming strangers into his realm or denying them protection and condemning them to injustice and exile. Weighing the risks of domestic and political conflicts to which it might expose him, the King of Argos is at first reluctant to take them in. He eventually decides to consult the people of Argos, unwittingly inventing the first act of democracy. The community votes that the Danaids deserve protection.

The themes developed in the play thus echo contemporary debates on the immigration crisis, exile, women's independence and the exercise of democracy. David Greig's version does not modernise the Greek version entirely. On the contrary, he keeps the overall prevalence of the female chorus. He reworks their complaint and their plea in order to have the whole partition sung *a capella* while the chorus pound the stage with their feet in choreography, giving rhythm to their speech and making their demand even more powerful and insistent.

Beyond the overtly political theme of the play, what is striking is the production's choice of cast. Embodying the political ideal of the play, each different production hires, in each city, a group of 30 amateur women who are briefly trained to master the songs and choreography of the Danaids. Partially conceived as 'community theatre' or 'delegated performance', the play is incomplete without the participation of citizens. As such, it rehabilitates the Greek chorus on

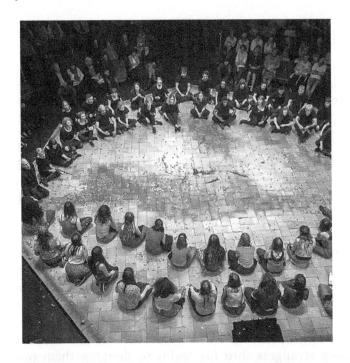

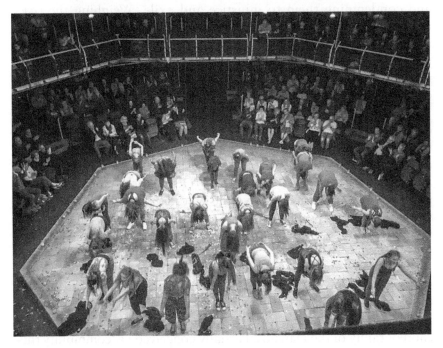

Figure 12.1  David Greig, *The Suppliant Women*, Manchester Royal Exchange Theatre. Photo: J. Schaaf, 2017

the contemporary stage. In his book *Public and Performance in the Greek Theatre*, Peter D. Arnott explains:

> In the disposition of the Greek theatre, the audience was closely related to the chorus. (. . .) Audience and chorus were different aspects of the Athenian public. The chorus was drawn from the public at large. Each year, a substantial body of citizens was selected—we do not know how—to participate in the coming festivals. The chorus members were unpaid volunteers, who undertook this service as part of their civic duty. (Arnott 1997: 23)

In a spatial reconfiguration typical of Greek theatre, the audience thus witnesses a play that is 2,500 years old and yet whose themes and means of production echo contemporary debates. Theatre and politics are brought together as the play calls for a civic engagement in the project. The women who sing in unison foster a new community, one invested with a 2,500 history of exile and of women's rights.

Beyond the overtly participatory and political aspect of the staging of the play, the spatial aspect is also to be taken into consideration. The fact that the amateur choir of women is local, and different in each new town, instils a sense of identification with the audience. There is a real sense of immediacy and proximity with the people on stage, who are literally taken from '*here*', as audience and chorus share a similar responsibility. This staging device was also used in the Royal Shakespeare Company's 2019 production of *Romeo and Juliet*, which included a choir of local children in each town it visited. In these productions, the choirs are fundamental to the performance and yet 'contingent' and plural, since they change in every city, giving a unique value to each production. Each choir is formed and then dissolved for the representation, hence there is no permanence of the cast. In each city, the *hic et nunc* (here and now) of the action becomes literalised. Real and fictional spaces are merged on stage, blurring the line between the fictional and the real. The participatory choir, or 'delegated performance', reinvigorates the democratic act in the political debate and gives a renewed sense of the *local* in each representation.

The local and 'delegated' aspect of the productions of *The Events* and *The Suppliant Women*, which enhance the sense of place, presence, and community, can be compared and contrasted with the 'global' and mediated aspect of two other recent productions on the Scottish stage: *The Great Yes No Don't Know Five Minute Theatre Show* (2014) and *Adam* (2017).

## Digital Choirs: New Global Communities *'in absentia'*

Shortly before the 2014 referendum, an experimental project redefined the spatial and physical boundaries of theatre through the dramatisation of the debate on independence. Produced by the National Theatre of Scotland, in collaboration with Five Minute Theatre, and co-curated by David Greig and David MacLennan,[2] *The Great Yes No Don't Know Five Minute Theatre Show*[3] was conceived as a large-scale community theatre which called for and depended on a civic commitment beyond national or theatrical lines. Indeed on the National Theatre of Scotland's website, the project was described as 'a series of live scenes, songs, skits, rants and dramas, as a democratic dramatic response to the theme of "Independence"',[4] which was meant to be 'created by anyone, for an audience of everybody'.[5] The citizens in Scotland and beyond were thus invited to express themselves politically and artistically on the matter of independence through the production of a five-minute piece of theatre. The sole requirements to be able to participate was to perform the piece in front of an audience. This delegated performance resulted in over 200 short plays and included the participation of 840 performers across eight different countries. These productions were taped by the participants and sent to the curators who selected a panel of plays that were then live-streamed on a virtual stage: a dedicated platform on the website of Five Minute Theatre. On 23 June 2014, 700 years after the first day of the Battle of Bannockburn,[6] there was a 24-hour streaming of these responses to the unfolding political events. Both the processes of creation and of diffusion were thus democratised, in the sense that everyone could participate, and everyone could watch the result online free of charge.[7]

Displaying a constellation of performances for a global audience, the focus of the project has been described by Trish Reid as more political than artistic: 'the focus of the project was less on the aesthetic quality or content of individual performances however than on providing a platform for the sharing of work that collapsed physical distance and was self-consciously inclusive' (Reid 2014: 113). The ambition of the installation was to give voice to a nation and bring together various competing or contrasting definitions of it through heterogeneous artistic productions. The page presenting the project reads:

> Your five minutes can be filled with whatever you want it to be. This can be whatever theatre means to you. You can write your own script, create a scene or a situation, it can have music or dance, a director and actors,

lighting and costumes or nothing at all. You can interpret it in any way you like, any style you like. It can be a thriller, a drama, a romance, a joke, a song, a monologue, anything. It can be on a stage, in a living room, a park, village hall, office, classroom, football pitch, the choice is yours. You are in charge. You decide what your five minutes are; you decide where to perform it, how to cast it and who the audience will be. It's your story; however you want to tell it.[8]

The expressions 'the choice is yours' or 'you are in charge', and the pervading presence of the pronoun 'you' resonate as a type of injunction to take part, to commit, to be engaged (politically as well artistically) in the redefinition of the nation.

The chosen pieces reflect the variety of the participants, and the diversity of society. Professionals from the theatre industry, amateurs, citizens alone or whole families, classrooms or friends, everyone was able to send over their contribution to the debate, performed and taped on a variety of different indoor or outdoor stages: a local bus in Fife,[9] a bridge in the countryside,[10] the top of Ben Bragghie in Golspie, at the foot of the statue of the Duke of Sutherland,[11] on the hills near Barcelona,[12] or in someone's living room. According to the curators of the project, this installation exists as a 'celebration of democratic and creative spirit in Scotland'.[13] In 2007, Steve Blandford already identified this specific tendency to produce a 'conversation' in arts about national identity in Scotland:

> the level of reluctance to accept any attempt to 'fix' a new post-devolutionary identity is stronger in Scotland. Again and again in the work of both theatre makers themselves and those that write about theatre practice, the recurrent sense is of a 'conversation' [in which what constitutes the nation is re-imagined] and virtually always that conversation uses the plural 'identities' rather than 'identity'. (Blandford 2007: 146)

Online participation becomes a mechanism to expand cultural democracy. It interrogates the notion of 'public space', its frontiers and its role and the extent to which online artistic activity can regenerate the national debate. There is a 'rhizomatic extension' of space (Toudoire-Surlapierre and Fix 2014: 17). The collective fictionalisation of the debate based on participative aesthetics avoids the emergence of one unique and centralising position on the debate. It fosters a digital choir characterised by its multiplicity and diversity both in form and content. In one interview, David Greig describes the ambition of the National Theatre of Scotland as a 'massive nation-wide political variety cabaret around the referendum'.[14]

This peculiar virtual choir can also be found in the play *Adam*, where it is not the sole aesthetic feature on which the production relies but rather one element included in a much more traditional play. It encapsulates the fleeting contours of a global community.

*Adam*, written by Frances Poet, produced by the National Theatre of Scotland and presented at the Traverse Theatre during the Edinburgh International Festival of 2017, also addresses thematic and formal questions of space and community. The play combines the use of verbatim theatre, autofiction and new technologies for dramatic and political aims. It originates in the authentic testimony of Adam Kashmiry, a transgender person born in Egypt and who sought asylum in Glasgow to avoid discrimination, violence and prosecution, as well as to transition from female to male. The story of his quest for rebirth is the object of this play which tackles the fluidity of identity on various levels: geographic (between Egypt and Scotland), of gender, but also theatrical, as the representation draws influence from various practices resulting in a hybrid installation.

The play draws inspiration from verbatim practice, as Adam's testimony is the original material with which the author Frances Poet wrote the play, reusing his voice. Moreover, Adam the character is played on stage both by Adam the 'real' person, conferring a peculiar authenticity to this tale, and by an actress, Neshla Caplan.

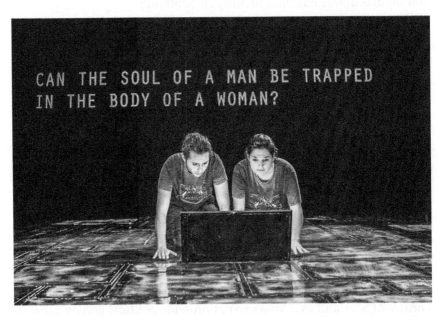

Figure 12.2 Frances Poet, *Adam*, Traverse Theatre. Photo: Sally Jubb Photography, 2017

Both actors share the character's double identity. More strikingly, the hybridity of the play comes from a virtual choir of transgender people from around the globe. In a scene entitled 'The Tree of Knowledge' the internet connects Adam with a constellation of other transgender people, a community sharing its experience and knowledge:

GLASGOW ADAM types a question, which appears on the screens.

The TV screens begin to flicker, sounds of static and distorted voices surge. Faces flicker on to the screen. Words become discernible.

Here are the faces of people who dare to share themselves on the internet. They are experience, they are knowledge, they are the understanding ADAM never had.

Fragments of testimony from trans people across the world morph into something musical. A global choir of experience and knowledge. It is beautiful but there is disharmony too.

GLASGOW ADAM is transfixed.

I. Am. Real. (Poet 2017: 27)

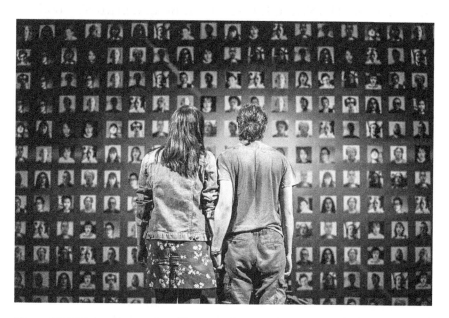

Figure 12.3 Frances Poet, *Adam*, Traverse Theatre. Photo: Sally Jubb Photography, 2017

The community is invited onto the stage via a giant screen. It is thus present and absent, real and virtual, embodied and disembodied, united and fragmented into a constellation of places. The peculiar quality of this installation is that the choir is not composed of actors who would have been taped and assembled as vignettes on a screen: the people on the screen are once again volunteers who have chosen to take part in Adam World Choir, conceived by Cora Bisset, the director of the play. Inspired by the work of Eric Whitacre, who creates connected virtual choirs around the world and has them sing in unison while geographically afar, Cora Bisset imagines a similar device to 'embody' the connected worldwide community of transgender people: 120 participants from the Netherlands to the United States of America, from Russia to Denmark, from Australia to Slovenia, give voice to the project. The National Theatre of Scotland explains: 'In a world first, Adam features a 120-strong, international digital world choir of trans individuals from across the globe which has been uniquely integrated into this remarkable multimedia production.'[15] This choir becomes the digital symposium which accompanies Adam in his quest. In this case, new technology allows for the visibility of this community on stage and materialises the interconnection of individuals across physical or geographical boundaries.

The website dedicated to the Adam World Choir reads: 'THE ADAM WORLD CHOIR IS A PROJECT THAT KNOWS NO GENDER, NATIONAL OR CREATIVE BOUNDARIES'.[16] Both in form and content, the play abolishes any fixed conception of identity and embraces porosity, fluidity and hybridity at all levels of the creative process. What is being celebrated on the National stage of Scotland is a new 'gendernation'[17] – a portmanteau word coined by the NTS that refers to a generation defining itself beyond the frames of gender or nation.

The presence of the virtual community on stage, singing in unison across borders is, of course, yet another contemporary Greek chorus. Gérard Delanty has identified three features of such virtual communities:

> First virtual community empowers people (. . .). Second, virtual community is held to be more democratic than other forms of communication (. . .). Third, is a postmodern-inspired argument that virtual communities are more experimental and innovative with respect to new identities and can create new kinds of experience which traditional communities cannot achieve. (Delanty 2010: 147)

The notions of empowerment, of democracy and of experiment are key to the way these plays reshape the idea of community. Borders

or physical distance no longer hinder feelings of belonging – and thanks to new technologies, new landscapes of belonging emerge. Arjun Appadurai describes the apparition of global diasporas, which he calls 'ethnoscapes':

> As groups migrate, regroup in new locations, reconstruct their histories, and reconfigure their ethnic projects, the ethno in ethnography takes on a slippery, nonlocalized quality, to which the descriptive practices of anthropology will have to respond. The landscapes of group identity – the ethnoscapes – around the world are no longer familiar anthropological objects, insofar as groups are no longer tightly territorialized, spatially bounded, historically unselfconscious, or culturally homogeneous (. . .) (Appadurai 1996: 48)

Ethnoscapes thus create new communities, new choirs, both more local (*The Events* or *The Suppliant Women*) and more global than the nation: they work horizontally, in constellation, in networks, regardless of the any type of border. These projects illustrate the ambition of the Scottish stage to open up a space – be it physical or virtual – for the *vox populi*, or new polyphonies across borders.

The disembodied quality of such theatrical devices revolutionises the very notion of presence and questions the future of the actual body on stage. It is a common assumption indeed, that, no matter the variety of forms and shapes that the theatrical object can take, one parameter never changes: the physical co-presence in a shared space of actors and spectators. However, as these innovative projects show, new modes of representation, of presentation and presence emerge on the contemporary stage. A new spectrum between presence and absence reshapes representation: either through participative immersion (as in *The Events* or *The Suppliant Women)* or through the ghostly digital presence *in absentia* of what Daniel Sibony calls the 'spectr-actors' (Sibony 1996: 20, quoted in March 2011). The theatrical representation allows room for modes of creation, presentation and/or mediation of the collective presence. In his book *Presence in Play: A Critique of Theories of Presence in the Theatre*, Cormac Power calls for a rethinking of the very notion of presence as essential to the theatrical genre:

> a discussion on presence in the theatre should focus on the particular ways in which the theatrical medium constructs objects of attention, and how these objects of attention are presented to an audience. In other words, presence may best be seen as a function of theatre—theatre is a place where different levels of presence are manipulated and played with—rather than an (essential) attribute. (Power 2008: 175)

Through the radical reshaping of the space/place on stage/as a stage, theatre is literally de-formed and hybridised; it invents and invites new communities on stage. Truly protean and refusing any essentialist conception of the genre (or of the nation), these productions of the Scottish stage illustrate the unlimited possibilities and variations when it comes to representing the nation. From the emergence of local and ephemeral communities to the increased visibility of existing global and digital communities, the Scottish stage addresses key questions about how to rethink the modalities of 'being together' and 'doing together' in a post-national area.

To conclude, these projects foster a debate on identity and community through various degrees of participation and involvement but always in an interstitial or in-between space. On the one hand *The Events* and *The Suppliant Women* invite local communities on stage to act as citizens – both in the plays and in real life. Through the musical aspect of the choir, they transcend language and reinvigorate the sense of the 'here' (the local scale) of the action unfolding on stage. On the other hand *The Great Yes No Show* and *Adam* produce global and virtual communities assembled on real or virtual stages to materialise a digital choir, a *vox populi*. While the bodies are absented on stage, what remains is the dissonance or harmony of a collective voice.

This double tendency shows that theatre constantly rethinks its own shape and identity as a genre. It reinvents itself at the crossroad of absence – of text, stage, director or even actors – and enhanced presence – of a collective body of citizens on stage, involved in the representation. The political implication of these new types of delegated performances on the Scottish stage is threefold: first, they federate the participants around a shared object of interest and stage landscapes of belonging – be it new one or existing one; second, they fill the public space with daring political propositions addressing questions of identity in its largest meaning; and, finally, they contribute to giving voice to a polyphonic nation. The redistribution of the traditional roles in the theatre allows anyone to become co-creator, co-actor or spect-actor. In the specific context of Scottish identity, one wonders whether this type of projects reveals a certain defeat of more traditional forms of political involvement. Do these projects compensate for a certain perceived disenchantment with traditional spheres of political discourse and action? Has the theatrical space given itself the mandate to re-energise and re-enchant political participation through the staging of new collective bodies?

# References

Actors Touring Company (2013), *The Events*, Choir Pack.

Appadurai, Arjun (1996), *Modernity At Large: Cultural Dimensions of Globalization*, Minneapolis: University of Minnesota Press.

Arnott, Peter D. [1989] (1997), *Public and Performance in the Greek Theatre*, London: Routledge.

Bishop, Claire (2006), 'The social turn: collaboration and its discontents', *ArtForum* 44.6: 178–83.

Bishop, Claire (2008), 'Outsourcing authenticity? Delegated performance in contemporary art', in Claire Bishop and Silvia Tramontana (eds), *Double Agent*, London: ICA.

Blandford, Steve (2007), *Film, Drama and the Break-Up of Britain*, Bristol: Intellect.

Bourriaud, Nicolas [1998] (2002), *Relational Aesthetics*, trans. Simon Pleasance and Fronza Woods, Dijon: Les Presses du Réel.

Delanty, Gérard [2003] (2010), *Community: Key Ideas*, London: Routledge.

Greig, David (2013), *The Events*, London: Faber and Faber.

Harvie, Jen (2013), 'Fair play: art, performance and neoliberalism', Basingstoke: Palgrave Macmillan.

March, Florence (2011), *Relations Théâtrales*, Montpellier: L'Entretemps.

Poet, Frances (2017), *Adam*, London: Nick Hern Books.

Power, Cormac (2008), *Presence in Play: A Critique of Theories of Presence in the Theatre*, Amsterdam and New York: Rodopi.

Rebellato, Dan (2016), 'Local hero: the places of David Greig', *Contemporary Theatre Review* 26.1: 9–18.

Reid, Trish (2014), 'Staging Scotland: National Theatre of Scotland and shifting conceptions of Scottish identity', in Huw David Jones (ed.), *The Media in Europe's Small Nations*, Newcastle: Cambridge Scholars Publishing, pp. 105–21.

Sibony, Daniel (1996), 'Spectateur, spectracteur. La Position du spectateur aujourd'hui dans la société et dans le theatre', *Du théâtre* 5: 45–52. (Quoted by Florence March in *Relations Théâtrales*, Montpellier: L'Entretemps, 2011.)

Toudoire-Surlapierre, Frédérique and Florence Fix (eds) (2014), *Un théâtre en quête d'espaces? Expériences scéniques de la limite*, Dijon: Éditions Universitaires de Dijon.

## Websites

Actors Touring Company: http://www.atctheatre.com/blog/the-events-mix-tape

Five Minute Theatre: http://fiveminutetheatre.com/news

*The Great Yes No Don't Know Five Minute Theatre Show*: https://vimeo.com/channels/greatyesno

Theatre as democracy, *Culture Laser*, David Greig discussing the *Yes No Don't Know Show* project: http://culturelaser.podomatic.com/entry/2014-06-19T09_42_45-07_00

## Notes

1. Actors Touring Company: http://www.atctheatre.com/blog/the-events-mix-tape
2. David Greig's own contribution to *The Great Yes No Show*, a tribute to David MacLennan, who had passed away shortly after the beginning of the project, remains famous. Entitled '*Letter to David*', it reflects upon the origins and the ideology of the project. It can be accessed on Vimeo: https://vimeo.com/99324058
3. We will now refer to the show as *The Great Yes No Show*.
4. *The Great Yes No Don't Know Five Minute Theatre Show*, National Theatre of Scotland: http://fiveminutetheatre.com/news
5. The National Theatre of Scotland produced a video trailer for the project: https://www.youtube.com/watch?v=hyqysP0fIJo
6. The date of the production appears to be highly significant as it was the 700th anniversary of the first day of the Battle of Bannockburn (23–24 June 1314), a key date for Scottish national identity and independence.
7. Many performances are available on Vimeo: https://vimeo.com/channels/greatyesno
8. http://fiveminutetheatre.com/take-part/
9. https://vimeo.com/channels/greatyesno/98524889
10. https://vimeo.com/channels/greatyesno/98524890
11. https://vimeo.com/channels/greatyesno/98553229
12. https://vimeo.com/channels/greatyesno/100227570
13. David Greig's comment on *The Great Yes No Don't Know Five Minute Theatre Show*, National Theatre of Scotland: http://fiveminutetheatre.com
14. Theatre as democracy, *Culture Laser*, David Greig discussing the *Yes No Don't Know Show* project: http://culturelaser.podomatic.com/entry/2014-06-19T09_42_45-07_00
15. https://www.nationaltheatrescotland.com/content/default.asp?page=home_Adam
16. http://www.adamworldchoir.net/projects.html
17. Ibid.

# Where Words and Images Collide: Will Maclean's Intertextual Collaborations

*Lindsay Blair and Donald Blair*

## Introduction: Word and Image

The present chapter is going to address the issue of word and image, the much-contested possibility of the generation of meaning from a combination of these two different types of representation. The words of Michel Foucault in *The Order of Things* epitomise the perceived and generally accepted dichotomy:

> [T]he relation of language to painting is an infinite relation. It is not that words are imperfect, or that, when confronted by the visible, they prove insuperably inadequate. Neither can be reduced to the other's terms: it is in vain that we say what we see; what we see never resides in what we say. And it is in vain that we attempt to show, by the use of images, metaphors or similes, what we are saying. (Foucault 1970: 9)

Yet, Foucault's analysis of Diego Velasquez's *Las Meninas* as metapicture – as though pictorial representation were a form of discourse on the nature of representation itself – is now well known (Foucault 1982: 3–16). In addition, his extended conversation with Magritte on words and images in *This Is Not a Pipe* is imbued with the resolution to redefine the 'reality' to which words and images refer (Foucault 1982). W. J. T. Mitchell in his comprehensive *Picture Theory* seems to go along with Foucault, so that both, in their different ways, are committed to finding ways to speak about word and image: Mitchell's text is an extended analysis of the ways that images and words collide (Mitchell 1994).

However, Mitchell admits that the hope that a way might be found to speak about an arena of meaning in which the two kinds of representation might coalesce is somewhat utopian: 'The "scientific" terms of the otherness are the familiar oppositions of semiotics: symbolic and iconic representation; conventional and natural signs; temporal and spatial modes; visual and aural media' (Mitchell 1994: 156). The fact then that the two sign systems 'refer' to the world in opposite ways suggests that any overlap between systems would be coincidental – the fact that words are bound by conventional symbols which have only an arbitrary relationship with the referent but are bound in a deterministic way to a grammatical system is clearly utterly opposed to an iconic sign which relates to the referent by mimesis. When he goes on to investigate the practice of ekphrasis, Mitchell finds little to suggest genuine coalescence between word and image in either the misguided efforts of the early Romantic speculation of John Keats's 'Ode on a Grecian Urn' or the late Romantic satirical 'homage' of Wallace Stevens's 'Anecdote of the Jar'.

There is no question for Mitchell but that the 'word-image' relationship may be spelled out quite simply in terms of dominance:

> The 'self' is understood to be an active, speaking, seeing subject, while the 'other' is projected as a passive, seen and (usually) silent object . . . like the masses, the colonised, the powerless and voiceless everywhere, visual representation cannot represent itself; it must be represented by discourse. (Mitchell 1994: 157)

## The Modernist Grid

Just to emphasise what may seem to be an absolute impasse, we might look back to Rosalind Krauss's essay, 'Grids' from 1979, where she highlights the significance of the grid. The hierarchical model noted by Mitchell above is directly countered in Krauss's interpretation of the art movements of the twentieth century. These movements assert, above all, the autonomy of the visual. The grid for Krauss is primarily the distinctive format of an aggressively anti-literary rhetoric:

> The grid announces, among other things, modern art's will to silence, its hostility to literature, to narrative, to discourse. As such, the grid has done its job with striking efficiency. The barrier it has lowered between the arts of vision and those of language has been almost totally successful in walling the visual arts into a realm of exclusive visuality and defending them against the intrusion of speech. (Krauss 1979: 50)

Krauss goes on to develop a complex theoretical paradigm for the relationship of the grid and a repressed mythic impulse, but the significant point for us here is that she identifies a kind of rhetoric of the grid which eschews any link with literature, narrative or discourse.

## Framing Reality

As opposed to the historical/psychoanalytical perspective of Krauss, we could cite the philosophical position articulated by Jacques Rancière:

> The real as such does not exist. What does exist is a framing or fiction of reality. Art does not do politics by reaching the real. It does it by inventing fictions that challenge the existing distribution of the real and the fictional. Making fictions does not mean telling stories. It means undoing and rearticulating the connections between signs and images, images and times, or signs and space that frame the existing sense of reality. (Rancière 2009: 49)

Rancière, then, refers to 'framing' rather than to the grid. It is the idea of 'framing' which Rancière proposes here as the proper domain of art, that we wish to draw upon in this essay. Scots contemporary artist Will Maclean experiments with all kinds of devices – boxes, cabinets, contraptions, scientific 'instruments', totem-like constructions, large canvases with panels and insertions, installations and assemblages – to order the things of his world. These are very literal 'framings' but they are not just literal: they are equally, and more importantly, re-imaginings. As part of a culture which has largely been represented as peripheral 'other' to a 'centre' located in London, Maclean endeavours, throughout his work, to reassert a sense of an 'articulate image', that is, an image which expresses struggles from below. He speaks from a culture, largely an oral Gaelic culture, whose voice was inaudible to an English-speaking hegemony. The narrative that preoccupies Maclean is the narrative, above all, of a dispossessed people, but the language of the dispossessed is *re-configured as image* in Maclean's work. In reference to the quotation from Mitchell (above) we may see how Maclean's work would line up in opposition to the conventional paradigm articulated by Mitchell: 'the silent object . . . the masses, the colonized, the powerless, the voiceless' are reflected in the way the visual image must await the interpretation of the word for it to mean something. The image speaks in Maclean's work as the voice of the repressed 'other' but embodied, 'framed' not

in a minority language but as dissenting voice in a majority visual language dominated, according to Krauss, by the grid. Maclean's work resounds with voices; it is replete with murmurings, snatches of story, bardic utterance, memoirs, whisperings, memories to which he responds as interlocutor from another time. Forever alert to these voices from below, Maclean could never have erected a grid in front of what has been to him his carrying stream.

Through an investigation into the collaborations between Maclean and a number of Scottish poets we will find all kinds of ways of 'undoing and rearticulating the connections between signs and images' as Rancière has it. We will see shifting equivalences between word and image and the redistribution of the real. Maclean has spoken many times, in interview, of the vital importance of the poetic tradition to his work, to his notion of the self, to his sense of place, to his sense of connection. In relation to Krauss's point about the grid's hostility to narrative (above), Maclean has spoken of the pressure upon him to conform to a pervasive and apparently all-encompassing formalism. Speaking of his student years in the catalogue accompanying the exhibition *Will Maclean: Collected Works 1970–2010*, he describes his experience to fellow artist, Sandy Moffat: 'In my postgraduate year I was free to experiment in "abstraction" as it was called but it did not work for me' (Maclean 2011: 55–6). Maclean was always concerned with subject matter, with narrative, with the vernacular.

A little later in the conversation with Moffat, Maclean responds to Moffat's question about the influence of his reading matter:

> It is a huge question. I suppose it is the sum of parts that include the collections of the Highland folklorists, J. F. Campbell, R. C. Maclaglan and Alexander Carmichael, the poetry of MacLean, George Campbell Hay and Angus Martin, the painting of Giorgio De Chirico, William McTaggart, Amselm Kiefer, and the sculpture of Joseph Cornell, Fred Stiven and H. C. Westermann. Then the 'art of the sailor' and the people of the seaboard tribes. Alexander Mackenzie's *History of the Highland Clearances* (a book my father said should always be, with the bible, at my bedside), Donald Macleod's *Gloomy Memories* and later James Hunter's *Making of the Crofting Community.* (Maclean 2011: 57)

The list encompasses elements of narrative gathered about the notion of a Highland place and the people of that place, of seagoing journeys and expeditions, of poetry connected to the West Coast of Scotland, and of art and sculpture associated specifically with the symbolic world of Surrealism. Word and image as representative of the two opposing

semiotic systems – the symbolic and the iconic – coexist adjacent to one another in Maclean's list, without a trace of hierarchical indication.

Giorgio de Chirico and, most importantly, American Surrealist Joseph Cornell are invoked when we think about the formal framing devices employed by Maclean. Maclean uses a central cage structure with fractured whitened surface in *Voyage of the James Caird [2] South Georgia* (2011) and employs a wooden cigar-box container to house whaling industry 'found objects' in *Objects of Unknown Use: Harpoon Box* (1987). In these shallow box interiors a narration emerges, and the artist engages in an imaginative reconstruction in a way that distinctly resonates with a Cornell box construction. Formally, Maclean alludes to Surrealism, but the subject-content of his artwork alludes to a reframing in the Rancière sense: Maclean is excavating, as archeologist, the material of the folklorists, he is reconfiguring, reframing and converting into the 'speaking image' of cultural memory.

Maclean speaks in interview of the origins of his interest in poetry: firstly, of the influence of an aunt who read poetry to him as a child. He recalls staying often at her house in Kyleakin on the island of Skye and remembers particularly her reading selections from *Peacock Pie* (1913) a book of children's poems by Walter de la Mare. Secondly, he recalls the frequent visits of his first cousin, Sorley MacLean, to his aunt's home and the stirring of an interest in poetry and in Gaelic (Maclean 2018). Maclean's relationship with his past echoes that of Sorley MacLean for whom songs and stories continually haunt the present just as in the Orcadian poet Edwin Muir's poems; there is that sense of a visible world once evoked in poetry flickering somewhere behind the screen of the Reformation and the Word. Maclean (W) is acutely aware of the denial of image post-Reformation. In Muir's poem, 'Scotland 1941', after recounting the elements of his own pastorale in highly visual terminology, he writes:

> But Knox and Melville clapped their preaching palms
> And bundled all the harvesters away,
> Hoodicrow Peden in the blighted corn
> Hacked with his rusty beak the starving haulms,
> Out of that desolation we were born. (Muir 1965: 34)

Muir's vision of a present desolation – a severance from a hallowed past finds an echo in Maclean's vision. That sense of an imagery clothed in poetic guise attacked and derogated in the declamatory prose of the Scottish Reformation reverberates throughout.

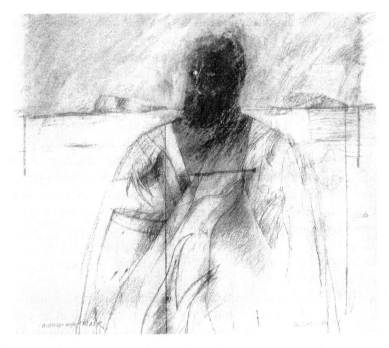

Figure 13.1 *Minister with Mask*, 2011. Source: W. Maclean

## Fearful and the Fearless

Cairns Craig offers a bleak summation of the Scottish imaginary in his analysis of the Scottish novel in 1999. In the chapter entitled 'Fearful selves' he presents an account of Scotland's fictional heroes through the nineteenth and twentieth centuries as either God-fearing or fearsome in their fearlessness: in his analysis of the novels of Robin Jenkins he writes: 'the intense, inescapable structure of the conflict of the fearful and the fearless in the Scottish novel negates any notion of progressive history: humanity lives under the curse of the unending repetition of the same inescapable dialectic' (Craig 1999: 57). The need for a reframing of reality could not be starker than here in Craig's penetrating analysis of the modern Scottish novel. Craig's analysis, however, is not wholly pessimistic – he has always believed that a realignment with its past will allow Scotland's culture to flourish once more. Since his work on the novel, Craig has gone on to write incisively on the need for Scottish culture to represent itself rather than to accommodate fashionable academic paradigms. He writes of a distinctive vision pre-dating the so-called 'Enlightenment'

and then flourishing in Scotland throughout the nineteenth century and into the twentieth as a 'self-enlightenment'. He finds in Scottish culture a propensity for cross-fertilisation, translation in every field of human endeavour epitomised in the likes of Patrick Geddes and his Scottish garden 'of every possible kind' at Montpellier. Craig replaces outdated accounts of Scottish Essentialism with the notion of a nation which has developed 'through its capacity for cultural export, translation and assimilation' (Craig 2009: 52).

It may seem as though we have moved far from Mitchell and Rancière and Krauss but if we return to Krauss and the grid, we find that she explains the point that the pervasive and lasting power of the grid lies in its capacity to conceal a concern for the sacred beneath its 'scientific' appearance. Behind what would seem to be an absolute rejection of spirit in its materialist opacity, the grid actually offers a refuge for religious emotion. Krauss expands on the notion:

> The peculiar power of the grid, its extraordinarily long life in the specialized space of modern art, arises from its potential to preside over this shame: to mask and reveal it at one and the same time. In the cultist space of modern art, the grid serves not only as emblem but also as myth. For like all myths, it deals with paradox or contradiction not by dissolving the paradox or resolving the contradiction, but by covering them over so that they seem (but only seem) to go away. (Krauss 1979: 54)

Krauss makes the point concisely in relation to the grid and Modernism. For Maclean, however, history, and especially Highland history, is far too real for it to be dissolved into myth. The emphasis upon folklorists in Maclean's list (above) testifies to his interest and investment in a vision which sees beyond the material world into a world of spirit. The grid, in other words, as it may be employed by Maclean would openly admit to the presiding power of spirit – revealed either in symbol for the artist, or in metaphor for the poet.

What is notable about the collaborations Maclean has with the poets is their diversity. Maclean has no fear of a loss of identity as he encounters the poets with their very distinct languages. Douglas Dunn with his elevated classical articulation, Kenneth White's minimal Zen utterances, John Burnside and his 'hauntologies', Angus Martin's idiosyncratic Kintyre idiom or Sorley MacLean with his bardic Gaelic solemnity. The fear of loss of identity is nowhere to be seen. Yet this sense of a hopeless pathology, a debilitating neurosis, an inferiorism is the spectre that runs through literature and critical analysis alike in the Scottish canon.

## Sorley MacLean

*Sabbath of the Dead* (1978) is one of Maclean's most powerful political art statements. It is his large painted box construction which takes its title from Sorley MacLean's 'Hallaig' (1954). The piece is comprised of four sections: the piece of driftwood lying along the lower compartment and the three panels above with the hills of Raasay stretched across all three, and in the central panel, the upstretched crab's claw fixed to wooden boards.

The opening lines of the poem in Sorley MacLean's English translation from the original Gaelic are as follows:

> The window is nailed and boarded
> Through which I saw the West (MacLean 1999: 226)

These lines reverberate throughout the piece. We see the nails and the boarding in the central section of Maclean's sculpture. However, we see through the panels to the hills of Raasay – while this is a grid, it is a grid which admits a sight of the world beyond. It is of course a world beyond in Sorley MacLean's poem – as Duncan Macmillan has it: 'It is a congregation of ghosts, of absences in an empty land' (Macmillan 1992: 45). And this is the point: Maclean's grid allows access to the world beyond the visible. It is a world which cannot be seen by the eyes alone but must be accessed through the imagination. The world of the hills of Raasay is divided up in Maclean's image, and this is the point – the point made by Rancière – that it is in the reframing, the re-articulation of the 'signs and space that frame the existing sense of reality' that the artist makes us view things differently, by 'inventing fictions that challenge the existing distribution of the real and the fictional'. Especially as it is exemplified in the mountain landscape, Maclean forces us to confront and question the whole tradition of the Picturesque and the Sublime in the Highlands of Scotland.

Maclean has gone on to collaborate with a diverse range of poets. A select list of Maclean's work with poets includes the following:

Meg Bateman, *A' Chrannghall*
John Burnside, *Tayside Inventory* and *A Catechism of the Laws of Storms*
Nuala Nì Dhomhnaill, *The Language Issue*
Valerie Gillies, *Chanters Tune, St Kilda Waulking Song*
Seamus Heaney, *Death of Sweeney* and *Sweeney Drinking*

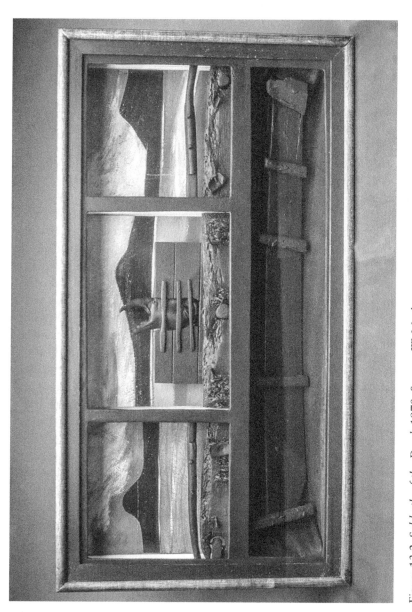

Figure 13.2 *Sabbath of the Dead*, 1978. Source: W. Maclean

David Kinloch, *Pipe Organ*
Norman MacCaig, *Thorn Tree*
Hugh MacDiarmid, *On a Raised Beach*
Sorley MacLean, *Screapadal*
Aonghas MacNeacail, *All that came in that one coracle*
Angus Martin, *Herring Relics* and *Dancers*
Derick Thomson, *Strathnaver*
Ian Stephen, *A Semblance of Steerage* and *Buoyage*
Kenneth White, *The Island Road*

Maclean's suite of etchings, *A Night of Islands*, was commissioned and published by Charles Booth-Clibborn of Paragon Press in 1995: 'Maclean took about six months to select the texts, his aim being "to find poems which had a Gaelic origin but had an imagery open enough to allow me to make an independent print image rather than an illustration"' (Elliot 1995:154). Maclean chose to evoke the essence of each poem in his etchings rather than to illustrate particular elements.

Two of the poems were specifically commissioned from the poets: 'The loss of Gaelic' by Meg Bateman and 'Trio' by Valerie Gillies. Four poems had been written earlier in the twentieth century: Angus Martin's 'Dancers', Sorley MacLean's 'A Highland woman', Derick Thomson's 'Strathnaver' and George Campbell Hay's 'Adam's clan'. Two poems were based on folktales collected by John Francis Campbell from Islay 'The king's fish' from the published collection of 1802 and 'Fraoch' from the collection of 1862. The poem 'Elegy to Captain Ferguson' was written by John Maccoddrum in the early eighteenth century and 'The author of this is the Bard McIntyre' from *The Book of the Dean of Lismore* in the early sixteenth century. Maclean has already begun his own poetic 'map' which is perhaps more rhizome than history: the poems are selected according to a gathering of constellations related especially to seafaring and a sense of place. He responds just as fervently to the words from the sixteenth century as to the words of his own contemporaries.

We might point to one or two elements which will characterise Maclean's distinctive response to the poems. The etchings themselves are mysterious and resistant to superficial readings – they resemble poems in their use of schemes and tropes. This is because of the way that they impose an extreme regularity on their material in the use of repetitive form or pattern which is equivalent to the way that regularising schemes in poetry work by the imposition of rhyme, rhythm and other sound patterns. They also exemplify in their images the extreme irregularity or deviance we expect of the tropes in poetic discourse.

So, if we look at one example, at the etching accompanying the poem 'Dancers' by Angus Martin, we are required to 'read' the traces of the actual ring net itself which has been fed through the printing press as part of the whole.

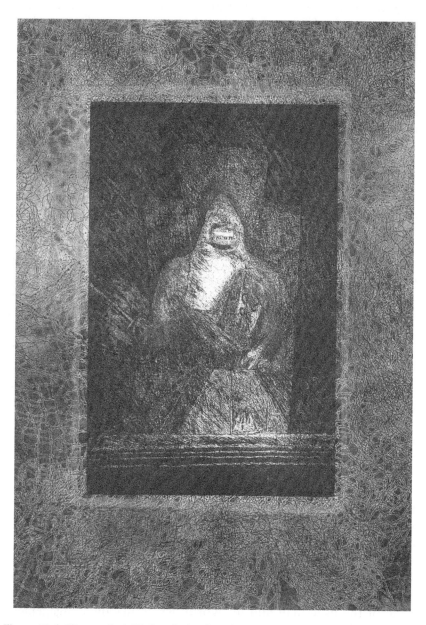

Figure 13.3 'Dancers', *A Night of Islands*, 1991. Copyright: Will Maclean and Paragon/Contemporary Editions Ltd

The relation between the two plates requires that we read the two different spatial configurations at the one time. There are echoes here of one of Maclean's early influences, the Surrealist Cornell discussed earlier, who would also incorporate the frame as part of the narrative. In a work such as this we are required to read the whole image but with two different strategies. We need to read meaning in the pattern in the outer plate but then simultaneously to read the oil-skinned figure in its illusionistic space in the inner plate. Martin's poem has a lighthearted lilt and a lift to it which finds something of a counterpoint in the glowing apparition in Maclean's haunting image. There is no sense at all in which the etching acts as illustration: it is as though the poem acts only as the place of departure. The etching refers back to an earlier artwork *In Memoriam Skye Fisherman*, 1989, which commemorates the artist's uncle William Reid who was a ring net fisherman. The image resounds semiotically through much of Maclean's work, as in *Log Book II, Winter Voyage*, 1986.

But the image seems to have risen somehow out of the *anima mundi* as much as out of something personal. Although we are using a term borrowed from W. B. Yeats, the term can be applied with equal validity to many in the Scots/Gaelic bardic tradition: to Sorley MacLean, Derick Thomson, Hugh MacDiarmid, George Campbell Hay, Sidney Goodsir-Smith, George Mackay Brown and many others, and it is to this bardic tradition that Will Maclean belongs. Scotland's lyric voice is permeated throughout with the voice of the folk and would sit comfortably within the boundaries set for the form within Theodor Adorno's essay 'On lyric poetry and society' (Adorno [1958] 1991). Adorno writes of the essential connection between poetry and society: 'the lyric work is always the subjective expression of social antagonism' and then later, 'a collective undercurrent provides the foundation for all lyric poetry' (Adorno 1991: 45). Whilst this definition would seem in many developed cultures to be a contradiction in terms, in Scotland the sense of 'hybridity', 'the folk voice', 'mutations from below', 'heteroglossia' continue to reverberate.

In terms of the image of the fisherman, we could invoke 'the fisher king' from T. S. Eliot but this would be to marginalise Scotland's own cultural awareness of mythology (Eliot 1973). George Campbell Hay, George Bruce, George Mackay Brown, even that great early modernist W. S. Graham in his 'The nightfishing', could not elude the insistence of the fisherman myth and its concomitant imagery. John Burnside is amongst the most recent innovators drawn to the image of the fisherman and his world. Maclean's own engagement with the fishing industry was there even before he became an artist.

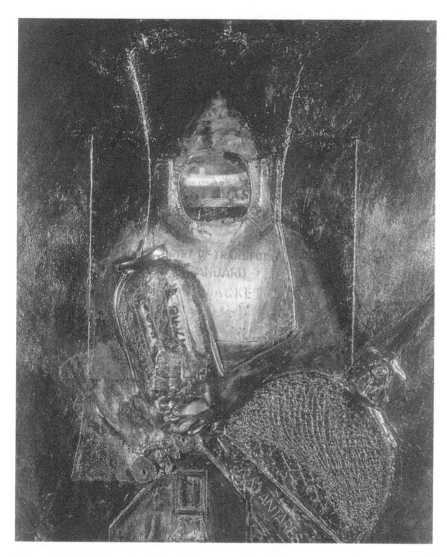

Figure 13.4 *In Memoriam Skye Fisherman*, 1989. Source: W. Maclean

He worked on a ring net fishing boat in the waters off Skye when he was a boy and, of course, his uncle, William Reid, was a fisherman. But it was the collaboration with Angus Martin on the exhibition *The Ring Net* in 1978 which was to be his most significant work dedicated to the subject – this was a comprehensive research project which culminated in an installation at the Third Eye Centre in Glasgow and formed the basis for Martin's book, *The Ring Net Fishermen*, in 1981.

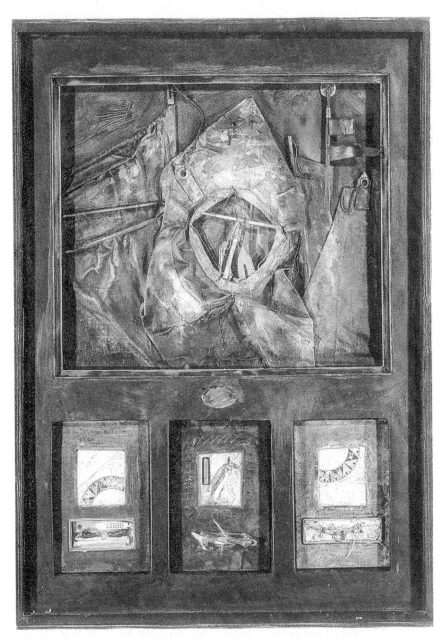

Figure 13.5 *Log Book II, Winter Voyage*, 1986. Source: W. Maclean

Maclean spoke, in interview, of his distaste for specific commissions where he was presented with a text and asked to illustrate it. When he spoke of the collaboration with Kenneth White, he was clear about the empathy between poet and artist from the outset.

White had been commissioned by the RSA to write a number of poems, which was to become the collection entitled *The Island Road* (2013), and to select an artist to work with; he selected Maclean. Maclean said that the first line of White's poem mentions 'Shore Street' in Inverness and that is where Harbour House was located where he lived from 1947 until 1963. His father was harbour master there. Maclean brings to the image/concept/signified multiple connotations of the world which White signifies in the poem but the signified here is considerably more than the signifiers of White's text.

The sense of formal rhythmical movements in a sequence, as in the development of a piece of music, activates the words of White's poem. The words are deliberately uncluttered by adjectival embellishment, they float gently upon the watercolour paper within the frame. Most of the words are monosyllabic – there is a deliberate avoidance of abstraction – something of White's adherence to a creed of imagism is echoed in Maclean's subtle but intense accompaniments. That White has persevered in a kind of high modernist lyric idiom is remarkable: his voice is of a distinct minor literature within a major one, as Gilles Deleuze would have it in his *Kafka, Towards A Minor Literature* (1975):

> Since the language is arid, make it vibrate with a new intensity. Oppose a purely intensive usage of language to all symbolic or even significant or simply signifying uses of it. Arrive at a perfect unformed expression, a materially intense expression. (Deleuze 2001: 1600)

And so it has proved in the growth of the Geo-Poetics community which has developed from White's writings.

If we look in detail at the section of White's poem entitled 'On Iona' which is made up of nine short lines, the poet urges us not to linger at the abbey but to walk to the shore to experience the world without cultural mediation of any kind – be that architectural, religious or linguistic:

On Iona

Turn your back on the abbey
its liturgy and its litany

go down to the shore.

walk there
over the redlichened rock

listen
to the *speek-speek* of the oystercatcher
and the *scree-scree-scree*
of the black-tipped gull

When William Carlos Williams was writing his early poetry in praise of the worlds he encountered on his rounds in Rutherford, New Jersey he saw things that had not been 'seen' in poetry before or as MacCaig would have had it 'How extraordinary ordinary / Things are' (MacCaig 1966: 33). Marianne Moore equally turned her back on the conventions of poetry describing the characteristics of her own poems as 'a kind of collection of flies in amber, if not a cabinet of fossils' (quoted in Kenner 1977: 108). This attitude rejects historical nostalgia. We see that same rejection in White. He uses the word as 'sound-image' in a remarkably successful way: we almost hear the seabirds and a sense of the haptic in the word 'redlichened'.

In White's 'Down Loch Ness' Maclean's watercolour accompanies the minimalism of the poem with its own minimalisms in form and colour.

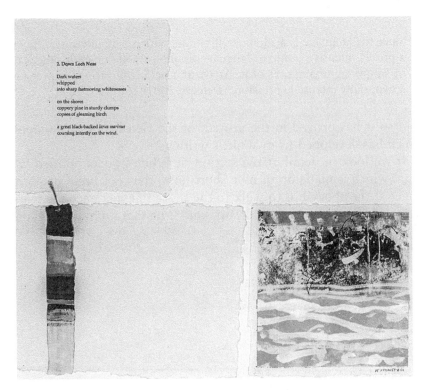

Figure 13.6 'Down Loch Ness' from *The Island Road*, 2013. Source: W. Maclean

Down Loch Ness

Dark waters
whipped
into sharp fastmoving whitenesses

on the shores
coppery pine in sturdy clumps
copses of gleaming birch

a great black-backed *larus marimus*
coursing intently on the wind

Just as White strives to turn the word into thing without elaboration
so too does Maclean restrict palette and composition. He does little
more than indicate forms emerging against a background without
detailed delineation or perspectival effects. There is a kind of paral-
lelism, a formal cohesion between the pieces, and, again, the scale of
poem and watercolour and litmus paper all suggest belonging to a
sequence. We have to be alert and in the moment as the great black-
backed gull and the white spume of the waves symphonise against
the hills beyond.

Maclean, as discussed earlier, is best known for his assem-
blages, box constructions and light reliefs and it is one of the gen-
uinely distinctive features of his work that the relationship with
the 'real' in semiotic terms is so diverse. It ranges from the purely
'indexical' as in the objects in the boxes, which are literally a part
of the real, to the iconic/metaphorical relation of so many sculp-
tural pieces to the almost purely symbolic/conventional element in
these collaborations with White. A few strokes can reference the
real in one of these watercolours without any need for embellish-
ment as in the treatment of the gulls or the waves, for example.
Returning to Rancière, if it is in 'the undoing and re-articulation
of the connection between signs and images' that we are to chal-
lenge the distribution of the real and the fictional then we can find
in White and Maclean's 'word-image' collaboration a questioning
of the representational codes in poetry and art. Again, as we think
back to Maclean's affinities with Surrealism, we find in the works
of Breton, Ernst and Cornell, especially, in the experimentation
with the frame, the receptacle, the installation a progressive,
thrusting dynamic which questions every aspect of categorisation
and display.

The most recent of Maclean's 'word-image' collaborations has
been with John Burnside in the Art First publication *A Catechism of*

*the Laws of Storms* (Burnside and Maclean 2014). Maclean recounts the gestation of the project:

> I came across some dis-bound copies of the Pictorial World of 1883/4 and at the same time I was interested in the theory of the *Laws of Storms* – how to navigate a sailing ship in a tropical storm. I found two books – *The Sailor's Horn Book* and *The Revised Catechism of the Laws of Storms*, made some collages with Ernst and Doré to guide me . . . I gave them titles and then gave them to John who wrote the astonishing poems for them. Only one did not work for me so I changed the image to work with the poem. (Maclean 2015)

The connection between the two men is quite natural. Maclean's Highland affiliations draw him inexorably to the edges of the known world both physically and metaphorically. Burnside's poems walk the line between this world and another world – sometimes a world akin to Eliot's *Four Quartets* which speaks of an unredeemed history which is always present but sometimes a world more sinister and less cerebral – a sense that the ordinary, the normal, the everyday, the quotidian, the suburban is being stalked by a kind of predatory anti-life. The Surrealist reverberations within the plates are startlingly foregrounded in Burnside's poems. The collages fuse distances in a peculiarly flattened space and Burnside finds a number of tropes which echo these displacements or disturbances. Sometimes in an unlikely change of register or point of view to the conceit of:

> Now our sister, who died at birth,
> has grown into a pretty
> spinster in the local afterlife.

The tone is jaunty and slightly Jane Austen-ish were it not for the 'who died at birth' or the word 'afterlife'. It is the unexpectedness of the contrapuntal image/tone juxtaposition that jolts us as we read, that forces us into 'writerly' readers as Barthes might have it. The correspondence in style with Maclean's collage is remarkable.

Maclean is offering this suite of works – as he says, 'with Ernst and Doré to guide me' – as a token of the affinity he felt with the two artists. The disorientating juxtapositions of the collages seem to conform to the earliest definition of montage made by Breton which went on to form the basis of the definition of the Surrealist image in *The First Surrealist Manifesto* (1924):

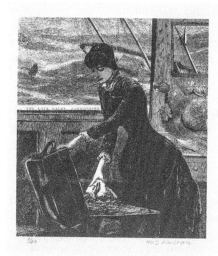

The Late Gales Foundering II

Bad luck to bring a Tarot card on board
and pin it to your bunk;
    but worse,

this habit of packing too soon, so the wait
grows fateful, a future of storms

and ruin that might so easily have been
avoided.
    Then again,

to be unready when the moment comes,
no Queen of Wands or Fool to bargain with,

the suitcase empty when the fog rolls in
and no safe passage, while the house grows cold

around you - that's another kind of luck
and, either way, you never get to choose.

No matter what you think, the storm
is logic in itself and loss

is governed by a law you cannot write
in ledgers
    though the shunt and sway of it

is masterly
and bright as any morning -

Figure 13.7 *The Late Gales Foundering II*, 2014. Source: W. Maclean

> It is the marvellous faculty of attaining two widely separate realities
> without departing from the realm of our experience, of bringing them
> together, and drawing a spark from their contact . . . and of disorien-
> tating us in our memory by depriving us from our frame of reference.
> (Breton 1921)

In Maclean's constructions, however, it is the process of conjuring up
a sense of the 'second sight' or nightmare imaginings of family mem-
bers of the fishermen. What Maclean seeks is not so much incongrui-
ties 'drawing a spark' but more of a thread of visions common to
fisherfolk. We see familiar Surrealist tropes such as the disembodied
hand reaching up out of the water in *La Mer de la jubilation* from
*La Femme 100 têtes* (1929) by Ernst and up out of a suitcase in *The
Late Gales Foundering II* (2014) by Maclean.

We see, in the same Maclean collage, unexpected congruities
between the corseted, trussed-up Victorian woman in her silky
gown and the feathered large bird perched immediately behind
her. We might recall the words of Barbara Maria Stafford in *Visual
Analogy* – her ambitious project which seeks to re-establish the
validity of the mind's analogical faculty:

> This uncanny visual capacity to bring divided things into unison or span
> the gap between the contingent and the absolute illustrates why analogy
> is a key feature of discernment. As perceptual judgement, it helps to

form ideas of elusive sensuous qualities and ephemeral emotions. Not surprisingly, then, forging synaesthetic leaps is crucial to child development as well as to the insights of scientific discovery. Inspired inferences knit perceptiveness to conceptualization by collecting the dispersed manifold into a whole. (Stafford 2001: 28–9)

Two of the figures which recur in the image bank for Maclean's work are the window and the ship. Sometimes when we look at his work we are reminded of the great nineteenth-century symbolist tradition as described by Eitner:

> It is perhaps not wholly unreasonable to regard the divorcement of the visual from the poetic imagination as a central crisis in nineteenth-century art. The inability to achieve a natural unity of form and idea was the curse of painters from David onwards. It was responsible, in part, for their frequent aberrations into painted literature on the one hand and into decorative formalism on the other. Seen in this context, the symbolical imagery of the time, such as is exemplified by the open window and the storm-tossed boat, assumes a certain significance . . . they represent an effort to restore the identity of image and meaning and strive for an art in which pictorial form is the hieroglyphic of feeling and thought. (Eitner 1955: 37)

In the collaboration with Maclean, Douglas Dunn's poems, 'Garden didactics' and 'Chateau Dairsie', enunciate a kind of Augustine formality whilst simultaneously revealing, through that veil, honesties about dubious preferred readings of nature by the Romantic poets and the supposed pleasures of retirement and seclusion. A kind of balanced, rhythmical poise is interrogated from within. A querulous tone is crystallised in the line 'the wearied uselessness of art' (Dunn and Maclean 2012: 12). There is an integrity here reminiscent of Edwin Muir and a subtlety that makes that other more celebrated rumination on a world without God, 'Sunday Morning' by Wallace Stevens read as rhetorical flourish.

Dunn's poems in this selection exemplify his talent for ironical reflection on both 'The Great Tradition' of English literature and on himself in approximately equal parts:

> Gardens are for wise ones, the long-in-the-tooth
> Who opt out of push, 'spin', and ambition (Dunn and Maclean 2012: 10)

where any sense of satisfaction or complacency in the above is counterbalanced by:

Here's where the worldly melts in earth and compost
Wheel-barrowed weeds and watering can (Dunn and Maclean 2012: 10)

and where the conclusion turns wryly upon itself just in case the phrase 'the work of man' may seem too rhetorical (Dunn and Maclean 2012: 10).

When we study the relationship between sign and space in Maclean's images of Dunn in his garden at Dairsie, we are aware of the question of framing. The garden space itself becomes a part of the meaning of the image rather than something that can be read into. Figure and ground have to be read as integrated whole. The image also brings us to the poems with a sense of that which may elude hermeneutics in its synthetic as opposed to analytical purpose. Rather than a pulling apart, the image presents a particular kind of harmony – the particular subjectivities of the poet become not so much 'renewed' or 'transfigured' in the way that they are conceptualised within Eliot's *Four Quartets*, for example, so much as literally a part of the pattern created by the image.

Figure 13.8 Douglas Dunn at Dairsie, *A Whisper to the Muse*, 2012. Source: W. Maclean

The screen print of Dunn in his garden at Dairsie looks almost like a negative; the image emphasises the textures of undergrowth and foliage and the shirt of the poet – Dunn's face is obscured in shadow as he stands before a tree in one image whilst in the other he retreats in silent scrutiny of pathside borders and the tree takes centre stage. This is not just an elimination of personality, in the Eliot sense, but an impression of the poet fading into distances, receding into a background.

Duncan Macmillan's introduction to the Irish/Scots collaborative project, *An Leabhar Mòr* (2002), detects in the project the renewal of a visual/text combination from an early connection between the two cultures:

> in the early medieval period as the carved stones and crosses of Scotland and Ireland and the illuminated books whose forms they echo bear eloquent witness, the Celtic world had a visual tradition that was second to none. (Macmillan 2002: 12)

From this historical perspective he confidently asserts the meaningful combination of word and image. Having noted some of the most successful illustrations in the collection, he writes:

> Indeed illustration is not really the word to describe such partnerships, and in the illuminated books of Europe before the advent of printing and the Reformation that it in part precipitated, that was how the relationship of text and picture worked. In the result, word and image are indivisible. They project unity, not duality. (Macmillan 2002: 9)

Most particularly relevant, for our purpose here, are the Maclean responses to two poems in the collaborative project: one by Nuala Nì Dhomhnaill and the other by Aonghas 'Dubh' MacNeacail. The image which accompanies Nì Dhomhnaill's *'Ceist na Teangan'* is like the trace of something: there is an element of Klee and the vision of the child, a sense of both the adventurous wonder of life and equally of its fragility. The delicate assymetrical and spontaneous style of the image places emphasis upon the sensibility of the seeing subject. The image responding to MacNeacail's poem, *'na thàinig anns a' churach ud'*, however, belongs to a different epistemological system altogether (see Figure 13.9, *'na thàinig anns a' churach ud'*). Maclean uses the familiar shape of the ring net fishing boat which now figures as coracle; in defining its lines, its compartments, its skin coverings and its material 'thingliness', Maclean places emphasis here wholly upon the object. We concentrate on the object as thing seen rather than on the seeing subject.

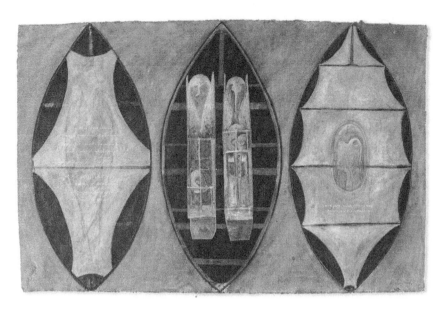

Figure 13.9 *'na thàinig anns a' churach ud'*, 2002. Source: W. Maclean

These last two images reinforce the notion of Maclean's willingness to adapt the frame. As we saw earlier, we can relate this to Craig's re-envisioning of Scottish culture as one particular illustration of a culture which thrives on adaption and improvisation in the process of 'self-enlightenment'. Maclean's constant interrogation of the frame – the picture frame, the box construction, the museum cabinet, the reliquary as well as the classification/assembly and modifications of the objects within – these interrogations and re-classifications are unquestionably analogous to the manipulation of elements that Craig enumerates in *Intending Scotland*. There is something of a 'deterritorialised' position that Maclean occupies here. He sets out from within the culture of the modernist hegemonic grid, to offer a minor, subversive counter-voice. That is, he uses framing devices which are grounded in Surrealism and recognisably modernist but he uses them to reinterrogate accepted historical narratives. What Maclean foregrounds in his collaborations is the number of counter-voices in Scotland; instead of seeing this as a lack of unisonance, we see in it a positive sense of dissonance – or, as Craig has it in *Intending Scotland*, 'embodied argument'. Maclean does not try to homogenise the 'languages' of his poet/collaborators but rather in his visual encounters with them he bodies out their differences.

## Conclusion

We began this chapter by looking at Krauss's essay 'Grids' and we wish to return to the subject at this point. Krauss finds in the grid a schizophrenia – that behind the apparent 'scientism' of the grid there lies the urge towards the symbolic. Behind the grid lies the (repressed) window into a world. Whilst on the surface the grid projects a rejection of the spiritual, the pronouncements of some of its most notable adherents, like Agnes Martin, for example, are replete with a kind of mysticism, a sense of the 'other worldly', almost as though the grid could enable a Transcendentalist impulse behind its ostensible materiality. Whilst the twentieth century would seem to have sealed the divorce of the poetic from the visual imagination the desire for the reconciliation of art and poetry remains, and in Maclean's poetic collaborations we find the possibility of unexpected 'becomings'.

## References

Adorno, Theodor [1958] (1991), 'On lyric poetry and society', *Notes to Literature, Vol 1*, New York: Columbia University Press.

Breton, André (1921), 'Preface', in *Exposition Max Ernst*, Paris: Galerie au Sans Pareil.

Burnside, John and Will Maclean (2014), *A Catechism of the Laws of Storms*, London: Art First.

Craig, Cairns (1999), *The Modern Scottish Novel*, Edinburgh: Edinburgh University Press.

Craig, Cairns (2009), *Intending Scotland: Explorations in Scottish Culture Since the Enlightenment*, Edinburgh: Edinburgh University Press.

Deleuze, Gilles (2001), 'What is a minor literature', in Vincent B. Leitch, (ed.), *Kafka, Towards a Minor Literature* in *The Norton Anthology of Theory and Criticism*, New York and London: W. W. Norton, pp. 1598–1601.

Dunn, Douglas and Will Maclean (2012), *A Whisper to the Muse*, Lugo: Edizioni del Bradipo.

Eitner, Lorenz (1955), 'The open window and the storm-tossed boat: an essay in the iconography of Romanticism', *The Art Bulletin* 37.4, December: 281–90.

Eliot, T. S. [1954] (1973), 'The waste land', in *Selected Poems: T. S. Eliot*, London: Faber and Faber, pp. 51–74.

Elliot, Patrick (ed.) (1995), 'Will Maclean: A night of islands', in *Contemporary British Art in Print*, London: The Paragon Press, pp. 154–9.

Foucault, Michel (1970), *The Order of Things*, London: Tavistock Publications Limited.

Foucault, Michel (1982), *This Is Not a Pipe*, Berkeley: University of California Press.

Kenner, Hugh (1977), *A Homemade World: The American Modernist Writers*, London: Marion Boyars.

Krauss, Rosalind (1979), 'Grids', *October 9*, Summer: 50–64.

MacCaig, Norman (1966), 'An ordinary day', in *Surroundings*, London: Chatto and Windus.

MacLean, Sorley, (1999), *O' Choille gu Bearradh/From Wood to Ridge: Collected Poems*, Manchester and Edinburgh: Carcanet/Birlinn.

Maclean, Will (2011), 'Will Maclean in conversation with Sandy Moffat' in *Will Maclean: Collected Works*, ed. Selina Skipworth, London: The Fleming-Wyfold Art Foundation, pp. 55–65.

Maclean, Will (2015, 17 April), conference [email] to L. Blair.

Maclean, Will (2018, 16 May), interview with L. Blair, Tayport, Scotland.

Macmillan, Duncan (1992), *Symbols of Survival: The Art of Will Maclean*, Edinburgh: Mainstream.

Macmillan, Duncan (2002), 'Scottish and Irish visual art', in Malcolm Maclean and Theo Dorgan (eds), *An Leabhar Mòr/The Great Book of Gaelic*, Edinburgh: Canongate, pp. 7–15.

Mitchell, W. J. T. (1994), *Picture Theory: Essays on Verbal and Visual Representation*, Chicago and London: The University of Chicago Press.

Muir, Edwin (1965), *Edwin Muir Selected Poems*, ed. T. S. Eliot, London: Faber and Faber.

Rancière, Jacques (2009), *The Emancipated Spectator*, London: Verso.

Stafford, Barbara Maria (2001), *Visual Analogy: Consciousness as the Art of Connecting*, Cambridge, MA: The MIT Press.

# Erasure and Reinstatement: Gray the Artist, Across Space and Form

*Rodge Glass*

## Witnessing: The Unfinished Nation

In his home country, Alasdair Gray's art is highly visible. Though much essential work is elsewhere, its presence is most evident in Glasgow, the place he spent his life. In terms of the visual practice, much of that life was dedicated to doing two things. The first was preserving, in pictures and words, Glasgow's disappearing past. The second, also conducted across space and form, was imagining Scotland's possible futures, seeing as he did Scotland as a place with the unfinished business of national self-determination. In this chapter, I wish to look at the possible future, the unfinished present, also at the disappearing past. When studying Gray's visual archive that past is critical, not least because until recently the artist's own work has been disappearing too. Not that visitors to today's Glasgow would know it. In the West End, where he lived until he died in 2019, Gray now seems inescapable. His work is not reserved for locals. You do not have to seek it out. Thousands witness it every day, simply by travelling there.

In the following chapter, I will argue that Gray's art has consistently suffered erasure of various kinds, for decades being – unlike his widely celebrated literary output – largely neglected, replaced or destroyed. Using his murals – now an integral part of Gray's Glasgow – as case studies, I will then trace how the twenty-first century has seen a radical reinstatement of Gray's visual practice into the landscape. Some artists run from their early work. Not this one. For Gray, what appeared to be new was nearly always deeply rooted in the past. Themes reoccurred. Emblems reappeared. Figures resurfaced. The artist sought to reinsert his marginalised or lost works into his city once more, in new contexts, for new futures. He was always this way. Only now, even in death, he has an audience.

With Gray's murals, witnessing is a good place to start. Seeing what the work looks like, close up. Considering its concerns and influences, also its commonalities with the artist's other visual, textual and hybrid work. During a Kelvingrove Art Museum exhibition in 2014–15, an Alasdair Gray West End walking tour directed visitors to the artist's most viewed murals. Let us begin this study of the landscape by taking a walk in that landscape. Witnessing Gray's art in station, pub staircase, doorway and auditorium, as it is seen by visitors.

## Hillhead Subway

Those disembarking Glasgow's subway at Hillhead will notice the first mural on our mini-tour greeting them on arrival, emerging as they rise towards ground level. Showing Hillhead in 2011, it stretches 40 feet across the station's back wall, Gray's original pen drawing transferred onto ceramic tiles by collaborator and fellow artist Nichol Wheatley. The central section constitutes a panorama of the surrounding streets, replete with names sketched into the roads in Gray's handwriting, pointing out the University of Glasgow, Botanic Gardens and other landmarks. At the map's edge are a workman in hi-vis vest, elderly woman in headscarf and some pigeons, scanning the scene. 'Hillhead 2011' is a good introduction to the area, also to the artist.

Visitors will notice the mural contains portraiture, text and landscape. In this way, it is typical of Gray's public works, each element in dialogue with the others. Multiple paired vignettes feature too, under the heading 'ALL KINDS OF FOLK'. These are labelled with knowing identities, suggesting who you might meet round these parts. 'QUEER FISHES. FABULOUS PRANCERS. GREEDY RAPTORS'. The intermingling of human and animal is another familiar trope, with the artist in the frame too. American journalist Evan Fleischer described this in *The New Yorker* as 'an image of a young Alasdair Gray writing while staring at his own head, which appears to have been decapitated from a second body' (Fleischer 2015). That image, drawn in 1967 while writing his novel *Lanark*, sits on the artist's desk looking up at its maker, above the label 'HEAD CASES', the image duplicated so that in fact four Gray heads are portrayed. Fleischer notes Gray's murals 'convey a kind of muffled laughter', humour being particularly evident in that multiple self-portrait, suggesting a self-deprecating acknowledgement of the artist's process. But it is also an indicator of several identities, working concurrently. This is the heart of Gray's

creative approach. Here, the 'FINANCIAL WIZARDS' are presented as banker-spiders – stern, moustachioed heads centred in two webs, absurd stick legs sprouting from ears, cheeks and chin. Their emblem originates from the character Sir Arthur Shots in Gray's little-known novel *McGrotty & Ludmilla* (Gray 1990). The 'LUCKY DOGS' hail from his early story 'The comedy of the white dog', later collected in *Unlikely Stories, Mostly* (Gray 1983). This mural is peppered with recycled imagery, repurposed for a new context. Meanwhile, as is common in Gray murals, the accompanying text contains advice, this time for passengers rushing by: 'Do not let daily to-ing and fro-ing / To earn what we need to keep going / Prevent what once felt when wee / Hopeful and free'. Viewers may sense that muffled laughter, also a tangible sense of the unfinished individual, shaped by the past but looking to the future.

## Arcadia Stairwell

The next stop on our tour is The Wee Pub, the first entrance down bustling, cobbled Ashton Lane. This is one part of the Ubiquitous Chip, a Glasgow institution also containing a brasserie and Scottish cuisine restaurant. In fact, this venue houses three Gray murals[1] but today our focus is on 'Arcadia', housed in the unassuming stairwell between The Wee Pub and brasserie. First painted in the late 1970s, it was updated incrementally in 1980, 1981, 2000 and 2006. For this artist, all pieces are in a state of continual flux. Even new work is rooted in the old.

In its present incarnation, 'Arcadia' covers four walls and a ceiling. The artist's poetry intertwines with a natural background featuring a cloudscape, pattern of trees and multiple portraits. Some alone, looking outward. Others seated together, eating. Though painted decades ago, as of 2020 there are six portraits – including pub manager and chef – showing people who still work here. The collage of captured present moments sits under the words 'To Tom Leonard'.[2] This is newly poignant since the recent passing of both men, the great radical poet and the artist. A close friend of Gray's for decades, Leonard is just one of those counted among the ever-growing, disappearing past the artist sought to preserve in his work. In a narrow sense, 'To Tom Leonard' refers to Gray's poem, a twenty-first-century addition reproduced in full on the largest wall, but its placement at the centre of the piece suggests the words also speak to the whole.

In 2017, Associate Editor at *The Paris Review* Caitlin Love noted, in an online piece accompanying a new Gray interview, that 'his paintings [. . .] carry multiple perspectives'. 'Arcadia' shows these coexisting effectively, an approach that can be traced back to his earliest works, which often had multiple vanishing points. Also, to key oil paintings such as 'Cowcaddens in the Fifties' (1964), a technique Gray has referred to as 'bent perspective' (Gray 2010: 118). But bent perspective is evident in his murals too, just in a different way. In work created across decades, the artist has made a regular feature of presenting different historical moments in a single space. First, the mural reflects its landscape. Then that landscape alters over time. Then the mural is updated, reflecting changes around it, for example through the addition of new portraits, their juxtaposition with older ones suggesting new resonances. Then more time passes, and the relationship between the mural and its landscape alters again.

Visitors who know Gray's habit of celebrating other artists may expect those featured to be cultural figures, and some are, such as the Canadian poet Dennis Lee. (Gray quoted Lee so often that his line 'Work as if you live in the early days of a better nation', itself so strongly suggestive of Riach's 'unfinished business of home' (Riach 2005: 240), is now engraved into the Canongate Wall of the Scottish Parliament, as if it were Gray's own.[3]) But other portraits, such as that of pub regular Vince Edkins, will be familiar only to those who know the pub's life, past and present. Amidst the idyllic landscape suggested by the mural's title sits Ronnie Clydesdale, the original owner of The Chip, as he was in 1977. A nearby portrait of Chris Kefalas raising a glass in the year 2000 is quite the contrast among the hairstyles of the 1970s and 1980s. This technique, of mixing locals with outsiders, past with present, is something the artist has since returned to, on a bigger scale.

## Òran Mór Auditorium

Òran Mór is a large ex-church situated at the end of the Byres Road just a few minutes' walk from Hillhead station and the Ubiquitous Chip. This cultural centre includes a concert venue-cum-theatre, restaurant and pub. Its upstairs auditorium features Gray's largest work. Despite its size, it is the artist in miniature.

On arrival, visitors will notice the artist's bagpipe-playing, upright lions on the walls just beyond the threshold, under the translation of 'Òran Mór', meaning 'the big song' in Gaelic. They stand over

greetings rendered in twenty-four languages, each lettered underfoot in Gray's own font, Òran Mór Monumental. Hebrew 'hello' paired with Arabic 'hello'. Mandarin 'goodbye' with Tibetan 'goodbye'. The juxtaposition is no coincidence. Now, let us take the spiral stairs to the auditorium. More than any other piece, it is Gray's legacy. Started when the artist was already in his seventies, it represents the culmination of a life in art. It draws on decades of influence and practice, erasure and reinstatement, with some of its most distinctive fragments being rooted in disappeared murals. Re-imagined here, as if for the first time.

Visitors entering the auditorium will notice a rainbow in the centre of the eastern gable, between two arches. This arcs above a portrait of Gray's Bella Baxter from his novel *Poor Things* (Gray 1992), here renamed Bella Caledonia, a Scottish heroine depicted with tartan draped over her arm, holding a thistle. The words 'LET US FLOURISH BY TELLING THE TRUTH' accompany her. But that textual message, adapted from 'Let Glasgow Flourish', the motto on the city of Glasgow's coat of arms, is one of multiple instructions. Above them, visitors will see Gray's vast night sky, containing zodiac figures and contrasting shades of blue clearly demarcated in cloudscapes backgrounding messages on the beams: 'BETTER NATION / FOR EVERYONE. ALL WHO WORK / WELL HERE'. Again, looking to the unfinished nation. Opposite Bella, above a balcony sitting on top of the auditorium's bar, is another world.

If visitors climb one more flight of stairs they can witness the auditorium from the gallery above. From this vantage point, they will be close to Adam and Eve who are entwined at the centre of a globe. They are portrayed among animals, each figure gazing upward at the stars and the text writ large on beams. 'WHAT ARE WE?' sits above 'ANIMALS THAT WANT MORE THAN WE NEED. WHERE ARE WE GOING?' above 'OUR SEED RETURNS US TO DEATH'S REPUBLIC'. The theme is, like most Gray murals, the Triumph of Death. The location is part-natural, part-industrial – both Glasgow's West End and the Garden of Eden, rendered in exquisite greens and blues. The approach is to mix the fantastic and realist as if they belong together.

Close to Adam and Eve, framed by two cherubs climbing out of skulls, is a midwife ushering a child into the world. Above them, a huge earth goddess dominating the figures below. Framing them all, on the north and south walls, are reproductions of both sides of a bridge over the West End's River Kelvin, including two statues – one signifying Philosophy and Inspiration, the other Peace and War. Across from these,

visitors approaching the balcony will see Bella surveying all below her, including a series of portraits walking along the walls. As with Hillhead Subway, these portray 'all kinds of folk'. In this context, the folk are those who make this building function – Òran Mór employees, drawn at Gray's artist's desk then presented on framed mirrors. The owner and funder of the enterprise, Colin Beattie, warrants the same space on one of these mirrors as 2007's bar staff, 2008's cleaners, the chefs, also theatre-makers including Scotland's ex-Makar, Gray's long-time friend Liz Lochhead. Also included are Nichol Wheatley and assistants Robert Salmon and Richard Todd, each on a designated artists' mirror. But Gray himself only warrants a partial portrait, half his face out of frame. This foregrounds the joint effort, urging viewers to perceive him as just one of many working towards a common goal.

This juxtaposition – figures from biblical landscapes, intermingled with Gray's characters and contemporary Glaswegians – is what gives the auditorium its charge. By presenting them together, he suggests the commonalities shared by Adam, Eve, Bella and the West End's head-cases, rather than accentuating their differences, encouraging worship or marginalisation. I have called Gray a democratiser, something I believe is clearest in his large visual statements. Even their location and availability matters. These key works are not in collectors' homes or entrance-fee museums, but painted into free-to-enter, public spaces. Gray's auditorium here has become the most prominent example of this.

Òran Mór is now a significant part of Scottish culture, across music, literature, art and theatre. From plays to gigs, performers have been as diverse as Amy Winehouse and Gray himself, playing Lucifer in an all-author read-through of his play *Fleck*. The auditorium holds regular events from the personal to the political. If you want your wedding here, there is a two-year wait. Some attendees to these occasions know who painted the walls. Others don't know Gray's name, nor think of the auditorium design at all. Rather, it is simply part of their cultural landscape. As is Gray. At the same time, his work points both to the disappearing past and the unfinished business of the future.

## A History of Erasure

A casual visitor to Glasgow might imagine, from this whistle-stop tour, that our subject's visual practice has always been an integral part of the landscape of his city. But it has not always been this way. Fifteen years ago, when I was embarking on Gray's biography, the reality was different. Then, Òran Mór was just opening its doors and

his night sky was in early development. Meanwhile, despite working in it all his life, his visual practice was virtually absent from the city. During the second half of the twentieth century, few galleries had showed Gray's work, and those who had were local, small scale. Sometimes he self-funded exhibitions, notably paying for one in 1986 by selling his diaries to the National Library of Scotland. At most of his exhibitions, just one piece was sold. Many times, Gray had to approach his first benefactor, Professor Andrew Sykes, who bought paintings whenever the artist needed money. He needed money often.

Meanwhile, few voices inside the art world were prepared to interrogate Gray's visual practice, or praise it, something I came across when writing my book. Gray had no art agent. He routinely referred to himself as 'one of those interesting second-raters'. There were some supporters though. Glaswegian painter Lucy McKenzie was a young, internationally recognised artist inspired by Gray's 1970s murals, his influence reflected in her own early work. But even as recently as a decade ago, she was a rarity. Serious critique was rare too. There was work in public collections, such as the Hunterian and Collins Gallery, both in Glasgow. Also, the Smith Gallery in Stirling. But these works were considered marginal not just in terms of contemporary British art, but Scottish art too. Gray said so himself.

A decade on from my Gray biography being published, I realise now that I could have done better. I had been drawn, like many others, to Gray through his literature first. I had no background in the visual arts and lacked the confidence to interrogate it as I did his books. I could have tried harder to immerse myself in the art world, searching out supporters who were surely there. But I found that most enthusiasts keen to discuss his visual practice were already admiring of the literature, more interested in books than pictures. Either that, or they were friends of the artist. I found this process so frustrating that I included 'Yes yes but is it any good?', a tantrum of a chapter. But it was rooted in something real. That there seemed, during my years of research, an odd void where I had assumed Gray's artistic reputation would be. His literary reputation seemed to dominate.

Given this lifetime of marginalisation, there seemed, at the turn of the century, little prospect that anyone would ever write a detailed critique of Gray's visual practice. So he set about doing it himself. This eventually became *A Life in Pictures* (Gray 2010), an auto-pictography now widely considered one of his most remarkable publications, and another example of a twenty-first-century work rooted in the twentieth. It documents Gray's visual archive, walking

first-person through the life, from early influences such as Blake, Beardsley and Kipling to latter-day work in Òran Mór, exploring the gestation, process and intention of key pieces. The archive in *A Life in Pictures* is vast. It comprises hundreds of life studies, figure sketches, landscapes, murals, graphic work and illustrations. It includes sixty years' worth of imagined things. Necessarily, any summary will be reductive, but patterns can be identified. These show that for most of his working life, with a few notable exceptions such as 'Arcadia', Gray's public works were being erased as fast as he could produce them.

There were reasons for this. Gray always worked far from the commercial art world, without financial security or professional help. His archive grew chaotically, pieces lost, forgotten or unacknowledged. Meanwhile, as argued by curator Elspeth King in *Alasdair Gray: Critical Appreciations*, the twentieth century was unkind to many Glasgow-based practitioners, it being impossible to make a living from art without leaving the city. It was especially difficult for Gray given that, as a muralist, he had 'no market for his creativity' (King in Moores 2002: 107). He may have, as King stated, 'seen the future in the restoration of the medieval practise of commissioning works of art, a system in which artists were engaged and rewarded as other journeymen'. But for many years, few others were interested in making that future a reality. Perhaps it is not surprising that a working-class Glaswegian with no desire to leave home, no market and little audience would be working first in poverty, then obscurity. But it is a kind of erasure. What is surprising is that eventually, as in the medieval tradition he identified, Gray would be commissioned to create big public works. He would be rewarded financially like any other journeyman. Erasure would slowly, eventually be undone. Though it would take a lifetime.

## Made and Unmade

Gray started at Glasgow School of Art in 1952, working towards a Diploma in Design and Mural Painting. This was an unfashionable specialism, both then and now, with Gray being described by current *Guardian* art critic Jonathan Jones as 'a rare modern exponent of an art that was seen as the noblest branch of painting in the seventeenth and eighteenth centuries' (Jones 'On the wall', in *The Guardian*, 2009). Jones also labelled his work 'quirky'. This sums up the view taken by many observers since Gray's art school days. That

he was quirky, certainly. Promising, definitely. But fantastically out of touch. In 1954, the Scottish-USSR Friendship Society in Belmont Street was looking for a mural. They asked Percy Bliss, Alasdair's art school Head, for a recommendation. Bliss had seen Gray's potential and suspected he would work without pay.

The work was titled 'Horrors of War', a combined Glasgow crucifixion and apocalypse that took as its theme 'man's inhumanity to man'. It also depicted the Fall of the Star Wormwood from the *Book of Revelations*, interpreted here as a prophesy of nuclear war. In the artist's words, this was intended to be an answer to '*Brueghel's Triumph of Death* landscape, also Dürer's *Apocalypse* woodcuts' (Gray 2010: 61), though it also bore the influence of nineteenth-century writer and illustrator Aubrey Beardsley and the paintings of fifteenth-century Dutch master Hieronymus Bosch. Gray was young, inexperienced and dissatisfied with the result, one much later described by Edwin Morgan charitably as 'a jagged and colourful panorama' (Morgan in Crawford and Nairn 1991: 64). But his ambition was clear, as was the subject matter that would always occupy him: large-scale, hybridised biblical scenes, relocated to modern, industrial Glasgow.

In a sign of the future, 'Horrors of War' had an opening ceremony despite being unfinished. Another sign was that it was ignored. (A brief mention was made the early morning edition of the Glasgow *Herald*, but no more.) It would be a long time before this piece received any serious attention. Indeed, this came more than three decades after 'Horrors of War' was completed, and long after it was destroyed.[4] Unfortunately, few ever got to judge it for themselves. Still, it was useful. Gray practised his *Triumph of Death* for the rest of his life.

Gray's next mural was in Greenhead Church of Scotland, Bridgeton, in south-east Glasgow. The ceiling was called 'Six Days of Creation', the wall 'The Seventh Day of Creation – Eden and After'. Started in 1959, this process was later immortalised in *Lanark* – a novel about the impossibility of surviving as an artist in Scotland. As with most future murals, Gray worked unpaid over long, erratic hours, often sleeping on site. But the work was a leap forward. That had been cluttered, many competing ideas battling for attention. This was the opposite, being both thematically consistent and aesthetically coherent, each day of creation interwoven with the next, the seventh a contrast to the drama of the first six. This was a portrait of humans and animals living in harmony before the Fall. God overlooked the scene, His creations free under the Tree of Life.

In 1960 Gray took time off Greenhead Church to work on 'The Firmament', a cloudy ceiling mural in Belleisle Street Synagogue on Glasgow's South Side. Until much later, this was his only paid mural,

others employed to fill in between Gray's 'fierce pattern', which was, he said, 'intended to blend with the Hebrew script on the marble tablet' (Gray 2010: 79). In 1961, Gray also painted 'Jonah and the Whale', a text and picture mural telling the story of Gray's favourite biblical book in a private flat in Glasgow's West End. This was done for friends Rosemary and George Singleton. The same year, he also painted designs for the CND nightclub at the Edinburgh Festival, where he met his future wife Inge. This shows that the Greenhead Church period was full of activity. However, most work created lived only for a short time. Five years after he completed 'Jonah and the Whale', for example, new owners covered it over with wallpaper. Belleisle Street Synagogue was soon knocked down. A pattern of erasure was being established.

Greenhead Church was finished in 1963, virtually unnoticed. Given its location, and unknown creator, perhaps that was to be expected. In fact, the little attention the mural did receive was unwelcome. The artist remembers the service of dedication thus:

> Tom Honeyman, former Curator of Glasgow Art Galleries and Museum and certainly its best, spoke highly of the work, but no art critic reported it. One newspaper mentioned it because the tall Garden of Eden panel depicts Adam with a darker skin than Eve, also because I had said I was agnostic, which produced a small ATHEIST PAINTS GOD headline. (Gray 2010: 114)

This result was a shame. A shame, also, that Greenhead Church was destroyed to make way for a motorway in the early 1970s. All that remains now is a selection of photographs taken when the mural's colours were already tarnished by damp, by which time the building was derelict. The photos give a sense of the work but cannot convey the true scale of it, nor the relationship of the details to each other.

In 1965, Gray got another commission from the Singletons. Asked for something in black and white, he painted a four-metre-high, untitled phantasmagoria in the stairwell of their new home at Kelvin Drive. This did not have an overarching theme, instead containing what Gray has since called 'a brooding earth goddess drawn in Hollywood cartoon style' (Gray 2010: 128) similar to the earth goddess in Òran Mór. This also contained a number of smaller figures recycled from earlier works. The artist explained he was again inspired by Albrecht Dürer, the fifteenth- and sixteenth-century German painter and printmaker, responding here to his engravings *Melancholia* and *The Great Fortune*. Though this mural was not erased, again it was in a private building. Again, it was seen by few.

Another soon-to-be neglected mural was his 25 ft x 4 ft 'The Falls of Clyde', painted in 1969, in what was then the lounge of The Tavern pub in Kirkfieldbank. This natural landscape showed the Clyde River flowing from its source towards the town of Lanark. In an indicator of the artist's reputation, Gray had to agree that if owner James Campbell didn't like the result, he could simply paint over it. Happily, it did please Campbell. But as with most other Gray murals, it soon lay mouldering anyway. Again, it was wallpapered over. Again, few mourned its loss. Though this mural too would have a future life.

## Part-Made, Part-Unmade

By the end of the 1960s, having established a small reputation as a playwright and writer for radio, Gray's literary life was changing. But artistic work still brought in little or nothing. In the early 1970s, publicity around Greenhead Church's destruction led to a commission from the similarly-named Greenbank Church south of Glasgow's River Clyde. Though he was paid, the new mural based on the biblical Book of Ruth was beset by common Gray problems. Lengthy delays. A frustrated congregation. That said, this mural included warm, welcome depictions of Gray's friends and family – his son Andrew, friends Philip Hobsbaum, Tom Leonard, Liz Lochhead, Archie Hind and the American-British writer Anne Stevenson. As elsewhere, the biblical and the contemporary intermingled. Next was 1974's Palacerigg conservationist mural, featuring the landscape depicted under another tree of life, this time an oak tree. As ever, struggling with deadlines, Gray finished painting this minutes before the opening of the Nature Reserve it was part of, having taken a break from Greenbank, where he was feeling unwelcome. As discussed in *A Life in Pictures*, it was only years later, bumping into the minister's wife, that he discovered another artist had been commissioned to finish the job Alasdair started, his completion money going elsewhere. Gray had not even known about its official opening. Not quite erasure, but a kind of disappearance, nonetheless. And another sign of the lack of value put on Gray's visual practice.

## Gray Studies

In 1981, Alasdair Gray was fifty. After decades of working in obscurity, suddenly he became a fêted literary artist, his sprawling, experimental debut novel *Lanark* receiving widespread acclaim that soon

transformed the author's life. From this point on, the gulf between the reception to his literary and visual practice widened. By the mid-1980s, articles and critical chapters on Gray's oeuvre began to be published. Soon, chapters became books.

The first of note was *The Arts of Alasdair Gray*, edited by poet Robert Crawford with Thom Nairn, then-Managing Editor of literary magazine *Cencrastus*. Crawford and Nairn did dedicate an entire chapter to his visual practice, commissioning the Scottish art critic for *The Guardian*, Cordelia Oliver. This retains value today, not least because it explores the visual practice through interrogation of the artist's major works, murals included, rather than focusing on illustrations contained in his books. It was a rare piece of critical depth which took the visual practice seriously, and on its own terms. Crawford is Glaswegian, and knew of Gray's art from growing up there, so it seemed natural to include it in a book discussing his work. That said, *The Arts of Alasdair Gray* was a sign of things to come. Crawford and Nairn's project was commissioned as part of Edinburgh University Press's *Modern Scottish Writers* series, so writing was its primary focus, with chapters written by the likes of Edwin Morgan, also Randall Stevenson, now Professor of Twentieth-Century Scottish Literature at the University of Edinburgh, and an early-career Cairns Craig.

So Gray had been noticed in Scottish literary academia, but no one was commissioning a book on his visual practice. This was the start of another pattern, then – the visual work gaining limited critical attention it would otherwise have not received had it not been produced by the man who wrote *Lanark*. But this praise had consequences. Art was now one small room in a house of literature. Over the next ten years, Gray's reputation as a writer inflated considerably. In the decade following *The Arts of Alasdair Gray*, he became widely translated, won further literary prizes and published at speed, with the collection *Unlikely Stories, Mostly* (Gray 1983), also novels *1982, Janine* (1984) and *The Fall of Kelvin Walker* (1985) cementing his reputation.

An updated assessment, *Alasdair Gray: Critical Appreciations* was published in 2002, edited by Phil Moores. Again, art was a small part of the whole. Chapters were mostly written by literary critics, long-established supporters such as historian Angus Calder and Philip Hobsbaum, also major novelists such as Jonathan Coe and Will Self, reflecting Gray's growing reputation in England. Again, the book contained much worthwhile critique, with space found for the many forms Gray's creative practice has taken over the years. There were chapters on poetry, the minor novels, his non-fiction and one

on his literary influence by Kevin Williamson, founder of Rebel Inc. However, though Gray's artwork peppered this book, considered discussion of the visual practice was again limited to a single chapter – this time written by Elspeth King, a long-time supporter who had secured him a crucial post at the People's Palace nearly a quarter of a century earlier as Artist Recorder. The opening of her chapter demonstrates how little she felt perceptions had changed since the late 1970s:

> The art of Alasdair Gray is as original and as creative in its conception and execution as his novels, short stories, plays and poems. Sadly, this is a view that is not widely shared, otherwise this piece would be being written by a professional art historian, our galleries would be rich with Gray's works, and his international reputation as a muralist in his native land would be as secure as that of Diego Rivera in Mexico and John Singer Sargeant in the USA. (King in Moores 2002: 93)

In the introduction to *Critical Appreciations* Will Self noted Gray's 'integrated politico-philosophic vision' (Self in Moores 2002: 1), but largely this book reflected the wider neglect King identified. Her frustration was evident as she critiqued Gray's notable absence from major collections, decrying several ways he was currently being misrepresented, or absented, in the Scottish National Portrait Gallery. By then working as Director of the Stirling Smith Art Gallery and Museum, King was a notable exception – a vocal supporter of Gray's visual practice in the art world in a time when 'Alasdair Gray, writer, [is] the only aspect of the man that is understood.' (King in Moores: 94). Twenty years later, King's turn of the century assessment reads as prescient.

In the years since, this pattern of assessments has become more nuanced. As a new generation of artists grew up in Gray's literary Glasgow, the value of his visual practice started being reappraised, by artists as well as critics. His own generation of supporters and friends, once marginal, were now dominant, even senior, cultural figures. (Gray had met Liz Lochhead on a train in the early 1970s when they were both unknown art school graduates. Forty years later, she was Scotland's Makar, the national poet.) Meanwhile, the Òran Mór auditorium had helped recontextualise Gray for a new generation. However, examples of the visual practice being assessed on its own terms, independent of the literature, were still rare.

Camille Manfredi's *Alasdair Gray: Ink for Worlds* (Manfredi 2014) grew out of the first International Alasdair Gray Conference

at the University of Brest, France, in 2012. Like the conference, the volume collating the papers largely focused on his literature, but it reflected the interests and perspectives of a European-wide field, with a more developed, nuanced sense of Gray the artist evident in chapters discussing his various interleaving worlds. A contributing chapter interrogating Gray's optical illusions was written by Liliane Louvel of the University of Poitiers, a professor in 'word and image studies'. Also notable was a chapter written by Sorcha Dallas. Now Gray's art agent, Dallas's chapter documented ambitious attempts to foreground Gray's visual practice and order his extensive archive during their first five years working together.

*The Arts of Alasdair Gray, Critical Appreciations* and *Ink for Worlds* all contain valuable insights into Gray's oeuvre. There are also several other single-author, book-length studies that have made contributions to critical understanding, including Stephen Bernstein's *Alasdair Gray* (Bernstein 1999) and Gavin Miller's *Alasdair Gray: The Fiction of Communion* (Miller 2005). But most of these had three crucial things in common. First, they all trained much more heavily on literature than art in terms of their focus, some exclusively. Second, they were all written or edited by literature specialists. And third, with the exception of *Ink for Worlds*, they were written in a time when the reputation of one dwarfed the other. Even when Gray appeared in books expressly designed to explore 'the phenomenon of the multiply gifted' (Friedman and Wronoski 2014: ii) Gray's art has been presented in the context of his writing.

*The Writer's Brush* (Friedman and Wronoski 2014) marked exhibitions of writer-artists in New York and Massachusetts in 2007. Amongst a glittering cast, this publication features paintings by Aldous Huxley, Mina Loy, Louise Glück and Derek Walcott. Gray's inclusion in itself is notable, given the focus on writers well-regarded in the US. However, even in this niche context, Gray does not fit. In his introduction, Joseph McElroy discussed the approaches of those featured, distinguishing those writer-artists keen on 'coupling across arts' (the few) from those seeking a 'departure from one for the other' (the many) (Friedman and Wronoski 2014: vii). As presented here, Gray is, appropriately, in the former camp. But it is curious that both examples of Gray's visual practice in *The Writer's Brush* are notable for being extracted from his own books. Not only that, but both examples contain text intended to be read in a narrative context.

The first of these, here called 'Domestic conversation', shows the same two figures twice, with differing text below. It is presented as a single silkscreen print dated 2006, though readers of Gray's

*Unlikely Stories, Mostly* (Gray 1983) will recognise it as two con-
nected short stories.[5] In Gray's collection, the first picture is called
'A likely story in a nonmarital setting'. A brief exchange of dia-
logue shown below constitutes the entire tale. The second story,
figures reversed, expressions identical, is called 'A likely story in a
domestic setting'. In this, the same trick is applied, with different
dialogue below.

The other example in *The Writer's Brush* is Gray's 'Leviathan',
closely based on the frontispiece to Hobbes's seventeenth-century
non-fiction work of the same name. This will also be familiar to
Gray's readers, being the single-page illustration starting Book Four
of *Lanark*, central inscription modified. In later editions, 'Leviathan'
was used as the book jacket, so associations with *Lanark* are strong.
These details do not negate the value of the works as stand-alone
pieces, but it is relevant that, rather than present Gray oil paintings
or details from a mural, the editors chose art housed in his literature
to present Gray to American readers. Wronoski did not intend to be
insulting – but his Afterword was also telling, in that it contextual-
ised *The Writer's Brush* as:

> an exhibition of visual works by intelligent, thoughtful, sometimes even
> brilliant artists who, for the most part, don't have the technical where-
> withal, or perhaps more importantly, the habit of or ready facility for
> visual thinking, to bring their ideas to fruition in a work of art. (Friedman
> and Wronoski 2014)

Or in other words, it is made up of interesting second-raters. Even
the book's title prioritises the literary, the visual portrayed primarily
as an extension of the textual. Nothing in the short paragraph sum-
marising Gray alphabetically in *The Writer's Brush* between the etch-
ings of Günter Grass and the pen drawings of Cuban poet Nicolás
Guillén, suggests readers should consider him otherwise.

## Sorcha Dallas, Partly

Recently, things have changed. But how? It is wise to be suspicious
of neat narratives. I am not about to suggest the change in reception
to Gray's art has been down to one person, though I will come to the
contribution of that person shortly.

By the start of the twenty-first century, anything produced by the
'small, bespectacled, grey-bearded deity' (Self in Moores 2002: 2)

was considered valuable by his growing, devoted following, as well as being noted by the Scottish press. By the turn of the century, generations of Scottish Literature and Glasgow School of Art students had grown up with Gray as part of the cultural landscape. Also, since the 1990s the sheer numbers of readers who had grown to value Gray's visual practice after first encountering it in his books had grown exponentially. One example of that development in action was the international success of award-winning novel *Poor Things* (Gray 1992), a playful, illustrated satire of Victorian literature which featured multiple portraits, not least one of heroine Bella Baxter. As suggested by her elevated presence in Òran Mór, this figure has since been widely used as a symbol of the pro-independence movement. Then there was *The Book of Prefaces* (Gray 2000), vast, colourful and ornate. Both were works of integrated word and picture. Each featured multiple illustrations, designed exquisitely in Gray's distinct, clean lines. As Elspeth King put it, 'Each publication by Gray is as much a work of art as it is a work of literature' (King in Moores 2002). The more impactful those publications were, the more his reputation as a visual artist crept forward.

Either side of the millennium several more books, theses and critical works were published, the *Edinburgh Companion to Twentieth-Century Scottish Literature* (Brown and Riach 2009) just one of several recognising Gray as a true renaissance man. Then there was the flourishing of Òran Mór, offering focus, coherence and scale that had been lacking previously, followed by the Hillhead Subway commission. By the time of Kevin Cameron's BBC documentary, *A Life in Progress* in 2014 the disparity between the two forms, literature and art, was less noticeable. Gray was filmed up the scaffolding in Òran Mór. Finishing the Hillhead Subway mural. Discussing his process from his studio. Things were changing. That same year, already a figurehead due to his political books *Why Scots Should Rule Scotland* (Gray 1992 and 1997) published a couple of decades ahead of their time, Gray prominently and controversially featured in the Scottish Independence Referendum campaign, advocating once more for completing that unfinished business of self-determination. Each of these things alone means little, but when put together they constitute a cultural, generational and political shift that has contributed to a change in perception of the visual practice.

Among these many contributing elements, I believe the greatest catalyst since the turn of the century has been Sorcha Dallas approaching Gray in 2007, the artist finally acquiring his first art agent at a youthful seventy-four. Herself a graduate of Glasgow School of Art, Dallas

was intimately acquainted with both the visual practice and Gray's influence on younger artists, many of whom had been inspired by his use of Glasgow as his subject. Dallas believed that here was an artist too long neglected, who the public would respond to if only they could see his work. It is no coincidence that in the twelve years she represented Gray, the last twelve years of his life, his artistic reputation was transformed. Major exhibitions. Retrospectives. Sales. International recognition. The artist in the landscape of his city as never before.

Sorcha Dallas had others on her books in 2007 but soon made Gray her only artist. Since then she has dedicated years of time and energy to finding and cataloguing Gray's huge, disparate output, then presenting it in innovative ways in places previously shut to him. One of those ways was putting Gray under new light. Another was allowing the work to be seen in its own right, rather than simply as an addendum or footnote to books the artist has also produced. As she put it in *Ink for Worlds*:

> My main aim was to recontextualize Gray's visual work, to show it is as unique and autonomous as his literary works and to make a wider public aware of the incredible body of work spanning over 65 years. The key to this would be promoting it through exhibitions and events as well as ordering his visual material and creating an online resource through which to experience it. (Dallas in Manfredi 2014: 172)

This was what Elspeth King had been calling for.

Initially, Dallas prioritised cataloguing the archive. This meant searching out lost works, photographing everything and dealing with previous attempts at archiving, as she explained: 'Many of the works he had made had been photographed, but they were of varying quality, some on slides, some poor-quality photos and a few high res jpegs' (Dallas in Manfredi 2014: 173). Gray's famously chaotic working practice made this undertaking a huge challenge, as did the sheer size and diversity of the work. (By 2014, Dallas stated 1,000 works had already been logged.) This attempt to contextualise the work developed further in the next few years, resulting in major retrospective exhibitions of the artist's visual practice in Glasgow and beyond, seeing him featured in galleries in which previously he had been unwelcome.

During the early years of Dallas and Gray's working relationship, there were several key breakthroughs. Much to the amusement of some who had followed Gray for decades, the septuagenarian was featured in the 2008 Frieze Art Fair in London, which arts journalist

Tim Cornwell, writing in *The Scotsman* at the time, referred to as 'Britain's youngest, hippest and wealthiest celebration of contemporary art'.[6] Two pieces, 'Inge in bed' (1961) and 'Two views of Katy Mitchell' (1980) were featured. In the same *Scotsman* article, Gray's influence on Lucy McKenzie was mentioned by his new art agent. Soon after, supporters began to pop up in UK galleries, which then bought Gray into their collections – Arts Council England and the Scottish Portrait Gallery among them. Sarah McCrory, now a curator at Goldsmith's, University of London, included him in her top picks in *Art Forum*. *Frieze* co-editor Jennifer Higgie was now a prominent supporter of Gray's work too. For years, he could not buy a review. After decades of total absence from art magazines, suddenly he could not keep up with the notices. In 2012, the 'City Recorder' exhibition at the Gallery of Modern Art in Glasgow raised Gray's profile further in his own city, focusing on his People's Palace period. By training attention on a brief, critical two years and excluding literary work, a much more coherent picture of the artist emerged. Thirty-five years after their creation, Gray's representations of Glasgow's disappearing past were finding an appreciative audience.

In 2014–15, to coincide with Gray's eightieth birthday, Dallas's plans were ambitious. Working with major galleries across the artist's city, she devised The Alasdair Gray Season, a series of exhibitions with differing foci. As well as a Kelvingrove Art Museum exhibition 'From the Personal to the Universal', which was particularly well received (not least by the *Frieze* Deputy Editor, Amy Sherlock), Glasgow School of Art, Glasgow Print Studio and Glasgow's Museum of Modern Art also held Gray exhibitions, meaning the artist dominated his city like no other. The 'Spheres of Influence' shows were particularly interesting, being rooted in those that had influenced Gray (Beardsley, Blake, Gauguin) but also in the work of a younger generation he had influenced, such as Stuart Murray and Hanna Tuulikki.

The Kelvingrove exhibition showed perceptions were changing. It took place in the temporary basement gallery space but saw an explosion of interest that makes a mockery of the fact that Gray was ignored by places such as this for decades. It wasn't until I visited this exhibition myself – moving through Gray's Glasgow Art School work from the 1950s, onto his Artist Recorder portraits of politicians, friends, the media, the unemployed – that I felt I could appreciate Gray's visual output without feeling the unspoken pressure of literary context. The only words here were arced around the figures being portrayed. Even these helped me see Gray in new ways. One of his pieces, of his son Andrew aged seven in his then-home in

Kersland Street, seemed familiar and unfamiliar all at once. Then I noticed the words, 'Drawn 1972. Painted 2009.' Which made me think of the Ubiquitous Chip, and 'Arcadia', and Tom Leonard, and unfinished business. Every rendered image was waiting for fresh contexts. As ever, Gray recording the disappearing. Juxtaposing the real and the unreal, the known and the unknown. And always open to new, complementing perspectives.

After the eightieth birthday celebrations, Alasdair lived for another five years, seeing more of Dallas's plans put into action during that time. He had two exhibitions in London. Recently, work was purchased by Tate London and exhibited there. This is symbolic of the progress that has been made. And it means that many more people will be able to witness Gray's visual practice, far from Glasgow, than ever before.

## A Pattern of Reinstatement

Let us finish by returning to the murals. Here, too, there is a pattern. In the twenty-first century, works began to be discovered and restored. This has happened in two distinct ways. First, in new murals, such as Òran Mór, where Gray chose to reproduce images, or versions of images, that first appeared in murals since lost or destroyed. Second, this has been seen in old works that have been restored by the artist himself, literally putting his images back into the space they had been erased from. Or in a new place entirely.

'Horrors of War' no longer exists, but fifty-seven years after that original launch, a detail from this was reproduced and included in the exhibition at Kelvingrove Art Museum along with critical context. Also, the garden of earthly delights Gray first conceived of in this piece was re-attempted in 'Arcadia' at the Ubiquitous Chip.

'The Firmament' in Belleisle Street Synagogue was never put back together – fragments of the ceiling were returned to the artist's door after the building was knocked down, in case he wanted them. (He did not.) But the cloudscapes evident here have reappeared in various forms across Gray murals and paintings since. You can see them on the ceiling of 'Arcadia'. They crash across the Òran Mór night sky.

The Greenhead Church murals are long gone too, as we have seen. However, parts have been reinserted into the landscape. Adam and Eve share the same embrace in Òran Mór as they did in Greenhead Church. Again, Adam is depicted black, Eve white. Forty years later, no one complained.

In the case of 'Jonah and the Whale', this was discovered by new owner Sian Holding in the early 2000s. Gray restored this himself, offering to do so after Holding phoned him to explain she had found his creation under wallpaper. This restoration was documented in Kevin Cameron's earlier Gray film *Unlikely Murals, Mostly* (2006).

'The Falls of Clyde' was also discovered forty years after Gray first painted it, by the new owner of what had become The Riverside Bar and Restaurant. Andy Boyle found it 'after stripping off layers of paper put over it by several owners',[7] then invited the artist back to restore the work. The original was greatly damaged due to water penetration, especially on the left of the landscape. Throughout, its colours were faded and its surface full of holes. Also, there were no complete photographs of the original. Few sketches survived. So the restoration was also making the mural anew, Gray and Richard Todd painting the 2009 version based on memory and recent photographs of the landscape.

'Arcadia' in the Ubiquitous Chip was restored and updated repeatedly, for the last time in 2006. Now they will remain unfinished.

Gray and his assistants worked on the Òran Mór auditorium from 2004 for many years afterwards. In his last few years he could no longer climb the scaffolding and progress became occasional. But right up to the last year of his life, Gray worked on new portrait mirrors from home.

The untitled black and white phantasmagoria mural painted in 1965 for the Singletons was also recently rediscovered. Adapting it into a new piece in 2018, a reworked inkjet print was developed with fine artist and Gray assistant Lin Chau, then exhibited in The Lighthouse, Scotland's Centre for Design and Architecture, in Glasgow's city centre. The piece, previously unseen by the public, is now titled 'Facsimilization', given a name over half a century after it was first created.

In Cameron's *Unlikely Murals, Mostly*, Gray stated, 'I like the idea of spending my old age restoring murals I began when I was young.' These murals have been my primary focus in this chapter and are of critical importance in terms of Gray's visual practice. But as we have seen, the murals have only ever been part of the picture.

Alasdair Gray lived to be eighty-five, confined to a wheelchair for his last few years after recovering from a life-threatening fall in 2015. He worked more slowly in his latter days but continued to produce from home. In 2018, Canongate published *Hell* (Gray 2018), a poetic translation of the first part of Dante's *Inferno*, with *Purgatory* following weeks before his death (Gray 2019) and the

final part of the trilogy, *Heaven* (Gray 2020), published in the year after his death. Meanwhile, Canongate have recently published *Of Me & Others*, his life's collected non-fiction, in paperback for the first time (Gray 2019). There was a painting on the easel, incomplete, until the end. This thought returns me to Riach's unfinished business, both personal and national. Gray was always engaged in both. Documenting the past, altering the present, looking to the future. But now he is finally being seen as both artist and writer, as Elspeth King claimed he deserved, and as Sorcha Dallas has worked for, with his visual practice finally appearing widely in galleries while also being an integral part of Glasgow's landscape, once again being viewed differently in the context of his passing. It is a long way from Belmont Street, Glasgow to the Tate. After all these years – could it be? – that something like equilibrium is breaking out?

## Bibliography

Bernstein, Stephen (1999), *Alasdair Gray*, London: Associated University Presses.

Brown, Ian and Alan Riach (2009), *The Edinburgh Companion to Twentieth-Century Scottish Literature*, Edinburgh: Edinburgh University Press.

Crawford, Robert and Thom Nairn (eds) (1991), *The Arts of Alasdair Gray*, Edinburgh: Edinburgh University Press.

Friedman, Donald and John Wronoski (2014), *The Writer's Brush: An Exhibition of Artwork by Writers*, New York: Anita Shapolsky Art Foundation.

Glass, Rodge (2008), *Alasdair Gray: A Secretary's Biography*, London: Bloomsbury.

Glass, Rodge, Stuart Kelly and Allan Massie (2018), *Alasdair Gray June 2018–Jan 2019*, London: Viktor Wynd Museum of Curiosities.

Gray, Alasdair (1981), *Lanark: A Life in 4 Books*, Edinburgh: Canongate.

Gray, Alasdair (1983), *Unlikely Stories, Mostly*, Edinburgh: Canongate.

Gray, Alasdair (1984), *1982, Janine*, London: Bloomsbury.

Gray, Alasdair (1985), *The Fall of Kelvin Walker*, Edinburgh: Canongate.

Gray, Alasdair (1990), *McGrotty & Ludmilla*, Glasgow: Dog & Bone.

Gray, Alasdair (1992), *Poor Things*, London: Bloomsbury.

Gray, Alasdair (1992), *Why Scots Should Rule Scotland*, Edinburgh: Canongate.

Gray, Alasdair (1997), *Why Scots Should Rule Scotland 97*, Edinburgh: Canongate.

Gray, Alasdair (2000), *The Book of Prefaces*, Edinburgh: Canongate.

Gray, Alasdair (2010), *A Life in Pictures*, Edinburgh: Canongate.

Gray, Alasdair (2018), *Hell*, Edinburgh: Canongate.

Gray, Alasdair (2019), *Purgatory*, Edinburgh: Canongate.

Gray, Alasdair (2020), *Heaven*, Edinburgh: Canongate.

McGuire, Matt (2009), *The Palgrave Modern Scottish Literature*, Basingstoke: Palgrave Macmillan.

Manfredi, Camille (ed.) (2014), *Alasdair Gray: Ink for Worlds*, Basingstoke: Palgrave Macmillan.

Miller, Gavin (2005) *Alasdair Gray: The Fiction of Communion*, Amsterdam: Rodopi.

Moores, Phil (ed.) (2002), *Alasdair Gray: Critical Appreciations and a Bibliography*, London: British Library.

Riach, Alan (2005), *Representing Scotland in Literature*, London: Palgrave Macmillan.

*The Paris Review*, No. 219, Winter 2016, Alasdair Gray interview, 'The art of fiction'.

## Webography

'On the wall', Jonathan Jones, *The Guardian*, 5 April 2009. https://www.theguardian.com/travel/2009/apr/05/murals-graffiti-alasdair-gray (accessed 27 February 2019).

Amy Sherlock review, 'From the personal to the universal', *Frieze*, 12 March 2015. https://frieze.com/article/alasdair-gray (accessed 27 February 2019).

'How Alasdair Gray re-imagined Glasgow' by Evan Fleischer, *The New Yorker*, 26 August 2015. https://www.newyorker.com/books/page-turner/how-alasdair-gray-reimagined-glasgow (accessed 26 February 2019).

'Drawing and imagining' by Caitlin Love, *The Paris Review*, 3 February 2017. https://www.theparisreview.org/blog/2017/02/03/alaisdair-the-artist/ (accessed 27 February 2019).

Alan Taylor review, *Of Me and Others*, 2019, *The Herald*, 23 February 2019. https://www.heraldscotland.com/arts_ents/17454302.book-review-of-me-and-others-by-alasdair-gray/ (accessed 27 February 2019).

## Notes

1. Two others are in the restaurant: one water-damaged piece featuring wildlife and plants behind the indoor pond, another double portrait either side of a mirror by the entrance.
2. There is no portrait of the poet here, though he is a recurring motif in Gray's work, both visual and textual.
3. 'Arcadia' used to contain this Lee quote, above the poet's head. In a later incarnation, that was painted over.
4. 'Horrors of War' was assessed in Scottish art critic Cordelia Oliver's chapter in *The Arts of Alasdair Gray* (Oliver in Crawford and Nairn 1991: 22–36).

5. These images originated in a 1970s unfinished film sequence collaboration between Gray and Liz Lochhead in the titled 'Now and Then', intended for BBC producer Malcolm Hossick. The series includes a picture titled 'But I Dare You', later used for stories discussed here. Models were Doreen Tavendale and Russell Logan, later married.
6. Tim Cornwell, 'Our Alasdair's HOT at FRIEZE', *The Scotsman*, 6 October 2008.
7. The Riverside Restaurant History, available at http://www.spanglefish.com/theriverside/index.asp?pageid=169814 (accessed 10 March 2019).

# Transforming Cultural Memory: The Shifting Boundaries of Post-Devolutionary Scottish Literature

*Carla Sassi*

## Introduction

'Post-devolutionary' covers a span of more than twenty years, and while its contemporaneity does not allow – as for all events and periods which are still unfolding before our eyes – for a fully detached and comprehensive view, it has lasted long enough to reveal a number of distinctive patterns and directions. It is worth pointing out by way of premise that such a label, widely used by critics and foregrounding an inextricable imbrication of the country's political and cultural lives, has taken centre stage in the Scottish literary debate for at least since the 1980s. As Scott Hames observes, 'recent Scottish fiction and its critical reception are strongly conditioned by ongoing constitutional debate' – an 'inter-meshing' that may be 'occasionally stilted', but that nonetheless 'has much to do with our own historical moment' (Hames 2017: n.p.). It is worthwhile to point out that like all 'posts' – from postmodern to postcolonial[1] – even the 'post' in post-devolutionary is problematic and ambiguous. A 'post' signals a looking forward that is simultaneously a looking backward, it accounts for a shift of some kind that is nonetheless reluctant to let the past go – new but not quite (yet) really new. 'Post-devolutionary' indeed looks back at one of the most meaningful moments of Scotland's modern history – the return of the parliament at Holyrood – a moment that represents the achievement of a century-long political and cultural project, and that, for many, gestures forward to Scotland's political independence and the demise of the United Kingdom. The 'forward' side of the term – what lies beyond devolution – is however wrapped up in uncertainty,

even more so today, after two consecutive deeply unsettling political events – the failed indyref of 2014 and the victory of Leave at the 2016 EU referendum – that have profoundly changed Scottish as well as British society, and whose full impact, at the time of writing this chapter, cannot yet be assessed.

By opting for the post-devolutionary label, rather than for a neutral century-based periodisation, the present chapter embraces the contradictions of a Janus-faced discourse, using it as a lens through which recent developments in Scottish writing can be fruitfully assessed. The article thus also acknowledges Scottish literature's ongoing engagement with forms of national belonging – an engagement that, as compared to pre-devolution expressions, appears to be taking new, if not always clearly traceable, directions. As we shall see, nostalgia and radicalism, lines of continuity with the recent past and new modes of thought and expression often coexist.

To assess how post-devolutionary texts engage with, and indeed re-imagine – possibly 'dissolve' – conventional ideas of the nation, I will refer to recent re-conceptualisations of the notion of 'memory' as constitutive of national identity. It is worth remembering here, that it was Ernest Renan, in one of the first theorisations of the modern nation, who famously explained how constructing a national narrative always entails a selection of elements perceived as representative and ennobling, as well as the suppression of other elements, seen as incongruous or undesirable.[2] Suppressing or marginalising what is perceived as unsettling is indeed very much at the heart of any national tale, no matter how fluid and open, or monolithic and closed this purposes to be. Memory, then, both supports and undermines constructions of national identity, as the inevitable re-surfacing of the suppressed and of the contested will question and sometimes even replace the established truths of the present.

The kind of 'memory' I will engage with in the present article, however, is not that constitutive of more conventional, 'Romantic' constructions of nation – that memory-as-history/myth, famously evoked, among others, by Homi Bhabha.[3] I will instead refer to the wider notion of 'cultural memory,' defined by Jan Assman as 'the store of knowledge from which a group derives an awareness of its unity and peculiarity' and shaping its self-image (Assmann 1995: 130). This is indeed a dynamic store, even more so in the contemporary age – 'not so much a reservoir in which images of the past are gradually deposited', Ann Rigney explains, but rather 'the historical product of cultural mnemotechniques and mnemotechnologies [. . .] through which shared images of the past are actively produced and

circulated' (Rigney 2004: 366). It is a store that includes memories of (historical) events, ritualised practices, as well as those 'materialities' – objects or places – that 'have an active role to play in the production of memory [. . .] linking people to each other across generations' (Rigney 2017: 474). Shaped by 'individual' as well as by 'collective' memory (Craps et al. 2017: 167), cultural memory is seen here as a fluid and transformative/transforming practice, very much in line with a vast body of re-conceptualisations in memory studies since the early 1990s. In the past three decades or so, memory has indeed lost its 'longstanding reputation as an objective, reliable, measurable and predictable cognitive system' and has come to be seen as 'a relational concept in a discursive field' and thus 'subject to the same changes that affect the entire field' (Brockmeier 2002: 5, 7).

If we take this fluid idea of cultural memory as centrally constitutive of national identity, we become fully aware of the transformative potential of the nation as a construction, and thus we learn to question the deeply ingrained conviction that nationalism is a fixed 'ideology' or 'belief-system'.[4] Cultural memory, and by extension ideas of national identity, are indeed not fixed and absolute, but rather constantly assessed and shaped through acts of remediation. In particular, recent theorisations have highlighted the central role played by artistic and literary expressions in such continuous process of production and honing of national/cultural memory. Rigney, for example, in pointing out the central and only too often neglected role of literary texts in actively shaping (and not simply reflecting) cultural memory, has pointed out the intrinsic vicariousness of such memory, 'in the sense that it involves memories of other people's lives that have been mediated by texts and images' – it is thus always 'inherited' (Rigney 2004: 367). Literary texts, by selecting or recalling memories, by reshaping and re-interpreting them, and finally by sharing them across (and beyond) the national community, mediate local or individual memories, 'both living and inherited,' and make them 'converge into a common frame of reference' (Rigney 2004: 373).

Having provided this concise theoretical premise, in the next two sections I will turn my attention to a number of Scottish contemporary literary texts that signal a meaningful new paradigmatic shift in their relation to Scotland's cultural memory, and indeed to ideas of Scottish national identity – a shift that may be seen equal in its importance to that marked in 1981 by the publication of Alasdair Gray's *Lanark*. Like all shifts, it has carried with it a plurality of perspectives, and I have chosen to focus on two that today appear particularly relevant. The shift from a memory-as-history paradigm

to a markedly literary one, and a new commitment to the materiality of the local – a celebration of ecological immanence so to speak, that may have important repercussions on ideas of Scottishness.

## From Memory-as-History to Memory-as-Literature

Throughout the nineteenth and twentieth centuries history has represented a powerful red thread across debates on Scottish literature and re-imaginations of the Scottish nation. From Walter Scott's problematic history-as-nation-(re)building to Edwin Muir's haunting vision of history-as-hiatus, from Hugh MacDiarmid's triumphant reappropriation of historical memory to Alasdair Gray's postmodernly shifting vision of history-as-a-nightmare, the discourse of history has permeated the Scottish literary imagination in many different, often conflicting, ways. History has been seen as lost in amnesia and militantly retrieved, it has served as romanticised reverie or recuperative counter-narrative, it has been perceived as inescapable nemesis or a gateway to an estranged future. In what follows, I will try to chart what already seems an epochal (albeit gradual) move away from the historical imagi-nation. Each of the two 'pairs' of texts I am going to discuss charts a discreet shift from cultural memory shaped by historical memory to a cultural memory whose object is literature or literariness – a cultural memory brought into flux through the texts themselves and their referential possibilities. Both pairs also mark, within them, a meaningful political turning point in Scotland's recent political history. The first pair includes a pre-devolutionary text and its post-devolutionary remediation – Alasdair Gray's *Lanark: A Life in Four Books* (1981) and its stunning stage version by David Greig, *Lanark: A Life in Three Acts*, premiered at the Edinburgh International Festival in 2015. The second pair takes into account two novels published six years apart by the same author – James Robertson's *And the Land Lay Still* (2010), investigating Scotland's history from World War II to the end of the century and devolution, and published shortly before the indyref campaign started gaining momentum (following the landslide victory of the Scottish National party in the Holyrood elections of 2011), and his *To Be Continued . . . or, Conversations with a Toad* (2016), a Gothic and labyrinthine narrative set four weeks after the hurtful debacle of the Scottish independence referendum in 2014, and published two years on from it.

The first pair stages a dialogue across two epochal moments in Scotland's recent history, each reflecting on each other. Gray's

*Lanark*, depicting a scenario that must seem much closer to readers in the 2010s than it did to its original audience – that of a global, highly bureaucratised 'Institute', secretly controlling, exploiting and disposing of cities and individuals on behalf of an elusive, transnational capitalist elite – represents one of the most estrangingly original expressions of modern Scottish literature. It has also been considered as a literary manifesto, heralding a new age in Scottish writing as well as that cultural/political awakening that eventually led to devolution. A specific cluster of themes and images takes centre stage in the novel: amnesia and the impact that memory loss has on the (lack of) imagination of the place, and thus on its inhabitants' in/ability to shape their future. 'If a city hasn't been used by an artist not even the inhabitants live there imaginatively' (Gray 1981: 243), Duncan Thaw (the protagonist of the realist storyline, set in 1950s Glasgow) tells us. Lack of (cultural) memory will not allow us to see the possibilities of the future and thus to enact them.

Recent research on the cognitive system has indeed demonstrated that remembering and imagining are intricately related, and that remembering the past and imagining the future take place in what has been termed as the 'remembering–imagining system'. When this system is compromised, as a consequence of brain damage or psychological illnesses, the future cannot be effectively imagined.[5] It is *Lanark*'s fantastic storyline, set in Glasgow's twin city, the fictional Unthank, that engages explicitly with modern Scotland's malaise by depicting its protagonist's haunting inability to remember. Lanark's loss of memory mirrors his country's historical amnesia, and his attempts to retrieve it and to change the city's future are matched, in the novel's realistic chapters, by Duncan Thaw's quest for a new artistic language apt to produce a re-presentation of the same city. *Lanark*'s relationship with historical/cultural memory is complex. On the one side, then, Gray's can be seen as a recuperative project aiming at restoring Glasgow's awareness of its post-Union history, spanning from its role as imperial city in the eighteenth and nineteenth centuries to its status of impoverished industrial periphery in the 1950s. Both the fantastic and the realist storylines indeed share numberless references to the many eighteenth-century Scots – politicians, entrepreneurs, Enlightenment philosophers and scientists – who were instrumental in the cultural and political development of the city. Furthermore, both storylines identify Glasgow's nineteenth-century monumental Necropolis, with its 'tomb-glittering spine' (Gray 1981: 243), as a central, deadly symbol of the city's imperial history, a history that seems indelibly inscribed in its present and throwing an

ominous shadow on its future.[6] It is no mere chance that Lanark is 'funnelled' from Unthank into the underground world of the Institute while visiting the Necropolis, which thus stands out as the forgotten and invisible link connecting past and present. On the other side, however, even though engaging anxiously with lost memory thematically, at a structural level the novel constantly undermines the historical method as a viable means of enquiring about reality. The two parallel and intersecting planes of the narrative, the reshuffling of historical periods, the defiance of chronological order through a rejection of a progressive chapter-sequence structure, all combine to foreground the impossibility of historiography as progressive teleology. *Lanark* can thus be said to articulate a nostalgia for history – the retrieval of historical memory is a desire which can never be fulfilled.

Greig's play is not the first Scottish literary work to engage intertextually with *Lanark*. Iain Banks's *The Bridge* (1986), although creating a distinct fictional universe, echoes both *Lanark*'s split between realistic and fantastic plots, and its amnesiac main character. But while *The Bridge* arguably stems from the same cultural and political context as *Lanark*, largely sharing its agenda, Greig's piece discreetly moves out of it. On the one side, the play is explicitly constructed as a 'faithful' adaptation whose main aim is to honour and memorialise Gray's masterpiece, on the other, it programmatically distances from it, presenting itself as both a new landmark and a template for the complex paradigmatic shift that characterises post-devolution Scottish literature. In what follows I will refer both to the 2015 production, as I remember it,[7] and to the play script.

The production, a *tour de force* running at three hours and 40 minutes, included two intervals and involved a team of ten actors, featuring Sandy Grierson, an actor with a 'Modigliani face' as *The Guardian* reviewer put it, 'that can look either very young or very old, cast in the twin roles of Thaw and Unthank'.[8] It also involved a number of spectacular multimedia moments heightening the emotional impact on the audience, and managing to recreate to an unexpected level Gray's fantastic literary and visual inventions. The play's declared aim was to 'bring the novel to the attention of a wider audience'. 'If we don't do it, nobody else will', Greig said, 'so there's a little bit of ego, but also a sense of responsibility. Alasdair is old. His achievement needs to be recognised. The book is a big part of this culture and needs a moment in the sun.'[9] Along similar lines, the 'Note on the text' in the play script invite us to identify *Lanark* as an icon and a compass of contemporary Scottishness. The novel is here

described as 'a talisman of Scotland', to which both the playwright and the production's director Graham Eatough have referred to throughout their careers by taking up its 'bold invitation to experiment and play' (Greig 2015: 5). The desire to 'preserve' and transmit 'faithfully' Gray's masterpiece to a majority of contemporary viewers who have not read it, is already evident in the play's title, announcing a close rendering of the novel, with 'a life in four books' dutifully translated into 'a life in three acts'. The very length of the play, stretching well beyond the ordinary limits of the genre, is suggestive of an almost mimetic desire to recreate Gray's work in its wholeness. The dialogues adapt and compress the two intertwined storylines, capturing effectively the main themes of the novel – amnesia, illness, social control, globalisation, and the abjection of the self in a capital-driven and forcedly forgetful society. Lanark speaks and acts on the stage, while images and clips of films from Duncan's 'real' life flow in rapid succession on the gigantic screen at the back of the stage, overlapping with each other – snapshots of Glasgow, the sea and the Scottish countryside, clips of 1950s saturated-colour documentary films of Scotland, and even Gray's allegorical drawings from the novel, all contribute to simulate the process of the difficult and fragmentary recovery of the protagonist's memory, as well as the playwright's effort to recreate the original text.

The desire to both militantly preserve and creatively reshape cultural memory through a literary work is in fact what Greig's and Gray's *Lanark* have in common, but the two authors' approach is quite distinct. While Gray engages with the problematic de/construction of historical memory – postmodernly embracing the literariness of memory – Greig reifies the literary text as the pillar of cultural memory, replacing memory-as-history with the memory of literature and art. In the play, Lanark decides to become a writer – a choice that represents one of the few deviations from the original text (where Duncan, not Lanark, becomes a visual artist, rather than a writer). The excerpts from his never-to-be-completed book evoke some of the canonical scenes of Gray's novel by deploying a number of the actual words/sentences of the original text.[10] Such excerpts work both as metonymic cameos of the novel's imaginative fictional prose, and as a subtle strategy to convey the 'materiality' of cultural memory. Gray and his book thus become indeed a 'physical' presence, a presence that reaches its climax with the appearance of 'Mr Gray' in person at the end of the play, when the main character stages a rebellion against his creator. Gray is summoned by a pained and furious Lanark, who has just discovered

that his fate is doubly sealed – by the author of the novel via the 'faithful' author of the play:

> **Lanark:** Who wrote this!
> WHO WROTE IT!
> **Neville Dare:** It's not really written, as such.
> **Kate Whizz:** It's adapted.
> **Keith Troy:** In truth, it's semi devised.
> **Lanark:** What?
> **Pat Anubis:** From the book.
> **Lanark:** What book?
> **Pat Anubis:** *Lanark*.
> [. . .]
> **Eric Viper:** The script is based on Alasdair Gray's book.
> **Keith Troy:** Few liberties here and there but — (Greig 2015: 190)

On the stage this is one of the most strikingly inventive scenes, with Gray's gigantic, god-like head projected onto a screen, dwarfing his character as much as the audience. Lanark tries to rebel by producing the ending he has devised in his version of the story, where both he and Unthank not only survive but prosper. What Mr Gray has imagined, however, cannot be unimagined, and death, in the laconic note the author leaves to his grieved character, 'is the best ending. Without death even love turns slowly into farce' (Greig 2015: 195). While stressing the monumental value of Gray's novel, this scene signals a subtle fracture between Gray's and Greig's respective imaginations: Lanark's urge to rewrite the story, to imagine a different ending, is indeed the same urge experienced by the audience, and arguably by Greig himself. The celebration of *Lanark* as a milestone of Scotland's cultural memory also implies that it is a thing of the past – it still speaks to a contemporary audience, but does not fully represent it any longer. Very much like *To Be Continued . . .*, as we shall see, Greig's text pinpoints change, and hovers on the edge of the new, without mapping it out.

The second pair of texts I wish to analyse stages a similar bifurcation of approaches to cultural memory. A bifurcation that is all the more meaningful in the light of the relatively short span of time that separates them, and of the fact that, beside being written by the same author, they focus on two consecutive and deeply interrelated periods.

James Roberston's commitment to the historical novel as a genre and to the cause of Scotland's political independence is well known. From his first novel, *The Fanatic* (2000), set in eighteenth-century

Scotland, and with the exception of *The Testament of Gideon Mack* (2006) – a contemporary rewriting of James Hogg's *The Private Memoirs and Confessions of a Justified Sinner* (1824) – all his novels, up to *The Professor of Truth* (2013), take history as their main concern and the lens through which the nation is examined and re-imagined. As for *And the Land Lay Still*, this is indeed, in Scott Hames's words, 'probably the most ambitious historical fiction to emerge from Britain this century', focused as it is on a period whose social and political scene has largely remained unrepresented, so as to be totally or partly unknown to most readers. *And the Land Lay Still* 'often feels less like a novel "about" history than one "doing" history', Hames continues, 'producing as it goes the story it seems to be recounting', and carrying 'within itself the problem of national historical recovery it sets out to represent' (Hames 2017: n.p.). And while this is a novel that goes a long way to challenge, as Marie-Odile Pittin-Hedon rightly observes, 'the static division between the historically accurate [. . .] and the fictional and mythical', history, or history-as-myth, remains its central concern, 'in a geographical and cultural context in which the past is precisely a function of a mythic narrative' (Pittin-Hedon 2015: 58). The titanic effort undertaken by Robertson in retrieving and narrativising the lost memory of Scotland's recent past is directly proportional to the novel's strong projection onto the country's possible near future. Even here, the connection between remembering the past and imagining the future is indeed tight, not unlike in Gray's *Lanark*, but while Gray's novel, with its doomed ending, ultimately declares both history and the future an impossibility, *And the Land Lay Still* is characterised by an impetus forward, an opening up of possibilities rather than any definite conclusion. 'Trust the story' (Robertson 2010: 128) Jean Barbour, a teller of folktales, tells Mike, a son trying to capture the meaning of his father's legacy as a photographer and recorder of British history in the second half of the twentieth century. This sense of 'trust in the story', slowly emerging and revealing itself, is reinforced in the open ending, where Mike is ready to pick up the story threads he has collected: 'How do you introduce someone who never knew her father to her grandfather? [. . .] He doesn't yet know. But the connections, more of them even than he can know or imagine at this moment [. . .] the connections will be made, and he understands that it has fallen to him to make them' (Robertson 2010: 671).

In *To be Continued . . .* Robertson embarks on an altogether different journey, even though lines of continuity with his previous work and with *And the Land Lay Still* are still quite evident – namely strong intertextual links with archetypical narrative frameworks of

modern and contemporary Scottish literary texts, and a concern for the 'possibility of (re)generating a progressive identity for Scotland in the wake of devolution' (Philip 2011: 171). In Robertson's words, this is a novel designed to offer the reader 'not a trivial experience but one that [is] light, not one where you have to engage all your deep philosophical thinking'[11] – the above-mentioned themes, recurring in his fiction, are indeed revisited here from a comic and light angle. However, underneath the comedy and the seductive fantastic inventions – first and foremost the talking Scottish toad, Mungo Forth Mungo – there runs a subtly unsettling and disturbingly 'Gothic' vein, arguably more unsettling than the Gothic tropes deployed in Robertson's previous work. Above all, in contrast with *And the Land Lay Still*, it foregrounds a note of distrust in the possibility of weaving the threads of the story – of 'doing' history.

Written in the wake of the Indyref and set five weeks after its outcome, the novel focuses on a main character in the grip of a middle-age crisis, who possesses all that 'a man newly turned fifty can reasonably desire, other than a job, a partner and confidence in the future' (Robertson 2016: 7) The failed referendum does not take centre stage as an historical event, but in its wider, largely metaphorical impact on the life of Douglas and the narrative itself – the blurring of the boundaries between the real and the imagined. 'I feel I do not have a good grip on reality. Or that reality does not have a good grip on me' (Robertson 2016: 7), the main character, Douglas Findhorn Elder, admits at the very beginning of the novel, often reiterating this point in the course of the narrative. Divided into three untitled parts (as titles are replaced by the black-and-white drawing of a toad), subdivided into unnumbered sections whose titles are not suggestive of either consequentiality or chronology, this is a novel that seems to give up referentiality and to refuse to establish any definite meaning, thus withdrawing in a realm of pure, self-referential literariness. It also gives the impression of giving up being a story, as it indeed develops like the romp through the Highlands undertaken by its protagonists – an unpredictable movement across a space whose 'geography [. . .] is not to be trusted' (Robertson 2016: vii) – or like Douglas's attempt to write a novel in the hope of bestowing meaning on his direction-less life, and ending up continually changing his mind about its subject.

The novel's lack of direction, its giving up storyness, however, does not imply at all a nihilist or escapist stance – a lack of purpose. The epigraph, after all, a quotation from Warty Bliggens the toad, a character created by US humorist Don Marquis (1878–1937), is

eloquent: 'do not tell me / that there is not a purpose / in the universe / the thought is blasphemy' (Robertson 2016: vii). The novel seems rather to embrace or move towards a different order, away from historical discourse and closer to a post-human literariness, as implied by Mungo the toad in his 'lecture', at the end of the novel, where he sizes down human achievements by juxtaposing them to 'toad-ness':

> With all your libraries full of books and universities full of accumulated knowledge, your internet and roads and railways and great cities, you think you are here to stay. You have no idea! You have barely arrived. We, our ancestors, have been around a hundred times longer than you, a thousand times longer. You may think you have made an impact, but your leavings will be superficial. Fire and ice, wind and flood will wipe them away [. . .]. (Robertson 2016: 322)

If Mungo's lecture makes us readers, beside Douglas, smile, it also makes us aware of post-human perspectives and planetary aeons that dwarf the very concept of (human) history. The closing image – a cloud 'moving and thinning' and the 'light of the moon, or even one star, coming through to greet' the characters (Robertson 2016: 323) – marks indeed a turning away from human history, and aptly introduces the next section of this chapter.

## Dissolving Identities? Wandering and Wondering by Land and Sea

A literary expression that is gaining more and more visibility and popularity is one that records movements across Scotland's landscapes, and does so in a hybrid language, breaking down and recombining literary genres and discourses. These are texts that create a kind of cultural memory in its own right – a memory that focuses on the intersection of human and post-human, with the 'wanderer' recalling his/her movement through the landscape, and the landscape retaining the traces of his/her passage. Here the mind *is* the landscape, and memory takes on a different structure and value. Indeed, as American writer Rebecca Solnit has memorably observed, 'the mind too can be imagined as a landscape', taking the form of 'caverns, glaciers, torrential rivers, heavy fogs, chasms that open up underfoot, even marauding wildlife bearing family names' (Solnit 2006: 53). Memory of place/space is different from memory of time. It is, first

of all, more tangible and more lasting. As Solnit observes, 'you can't go back in time, but you can return to the scenes of a love, of a crime, of happiness, and of a fatal decision' – places thus 'become the tangible landscape of memory, the places that made you, and in some way you too become them'. 'They are what you can possess', Solnit continues, 'and what in the end possesses you' (Solnit 2006: 117).

Of the many forms that memory-as-space can take, that associated to the action of wandering through the landscape, of not having a definite aim or purpose other than noting or listening to the environment, is particularly relevant here. Wandering is, among other things, about fashioning and refashioning your identity according to Solnit, who appropriates Virginia Woolf's idea that 'getting lost [is] not a matter of geography so much as identity, a passionate desire, even an urgent need, to become no one and anyone, to shake off the shackles that remind you who you are, who others think you are' (Solnit 2006: 16). Kathleen Jamie in her wanderings on Scottish hills, along similar lines, wants to relearn the way she learns – she wants 'to notice, but not to analyse. To still the part of the brain that is yammering, "My god, what's that? A stork, a crane, an ibis?"' 'Sometimes', she explains, 'we have to hush the frantic inner voice [. . .] and learn again to look, to listen.' Openness and receptiveness are for Jamie the essential qualities that the post-Wordsworthian wanderer must display when faced with meaningful encounters: 'you can do the organising and redrafting [. . .] later, but right now, just be open to it [. . .] – hold it in your head, bring it home intact' (Jamie 2005: 42). Wandering and the wonder of discovery are celebrated also by Robert Macfarlane, whose intersecting lexical and territorial explorations disclose the deep affinity between the act of writing and the act of walking, and the act of reading and the act of observing. 'Books, like landscapes, leave their marks in us', Macfarlane suggests, 'mostly, these marks are temporary: we close a book, and for the next hour or two the world seems oddly brighter at its edges [. . .]. Certain books, though, like certain landscapes, stay with us even when we have left them, changing not just our weathers but our climates' (Macfarlane 2016: 12).

Wandering, getting lost in the landscape is about gaining or expanding one's identity, as much as it is about losing it – 'the question then is how to get lost' Solnit explains, 'never to get lost is not to live, not to know how to get lost brings you to destruction, and somewhere in the terra incognita in between lies a life of discovery' (Solnit 2006: 14). Victoria Whitworth's encounter with the landscape and seascape of Orkney is represented in similar terms

in her gripping memoir, *Swimming with Seals* (2017). Her identity changes through and within the fog-wrapped landscape, where she loses sense of direction and of self. 'When you are lost in fog you use your senses differently. It's not just sight that's muffled; sound is also estranged', Whitworth explains, 'it's a balancing act [. . .]. Sense of scale is lost. That roar could be the surf at the bottom of the cliff, or just the beating of your own heart.' When the fog lifts and clarity of vision is restored, 'you see the old world with new eyes. It has never looked so beautiful, and so uncanny.' Change affects simultaneously the landscape and the hiker's identity: 'how did I get here?' she asks, 'this isn't where I was when the haar came in. This isn't where I'd planned to be' (Whitworth 2017: 19–20).

The three texts I am going to briefly discuss in this section – Malachy Tallack's *60 Degrees North: Around the World in Search of Home* (2015), Amy Liptrot's *The Outrun* (2016) and Ian Stephen's *Waypoints: Seascapes and Stories of Scotland's West Coast* (2017) – are as markedly local as they are absolutely global. Their focus on Scotland's landscapes, sometimes on tiny portions of them – micro-terrains – or on sections that straddle across or connect with other countries, makes them part of a wider global search for new declensions of the self and for new social and economic patterns countering the environmental degradation of our planet. Like other texts, even beyond Scotland and the Anglo-American world, which similarly engage with ecology, their quest entails experimentation with connected forms of engagement with the post-human: writing and walking, telling stories and navigating, trespassing the boundaries that define genres and nations and thus disclosing new territories, within and without the human mind. Hybridity of genres here mirrors a deeper ontological hybridity – these are texts that weave life stories with scientific treatise and travel accounts, as well as with philosophical reflections and historical annotations. In all three texts, trespassing borders of all kinds is not a mere act of transgression, but is conducive to new forms of continuity, new epistemologies and new identities. Hybridity also undermines the storyness of the story, with its anthropocentric bias, replacing it with a narrative which grows and expands unpredictably, shaped by encounter and interaction with the environment, through the observer's movements across space.

In *60 Degrees North* the themes of nostalgia and 'home' take centre stage, if only to be problematised. 'It was homesickness that made me go' (Tallack 2015: 4), Shetland-born Tallack explains, looking back at the journey accounted for in his 'travelogue' as a response

to the death of his father. The interruption of the father-son rela-
tion – in itself a form of grounded identity – brings the need for
the author to question and re-ground his sense of belonging. Thus
Shetland becomes the starting and end point of a long inner and
outer exploration, a circular movement embracing the planet and
crossing through the regions that, like Shetland, lie across the north
of the 60th parallel – 'a kind of border, where the almost-north and
the north come together' (Tallack 2015: 3–4). The author chooses to
move westward, 'with the sun and with the seasons', according to a
'planetary' pattern, and thus travels 'to Greenland in spring, North
America in summer, Russia in autumn and the Nordic countries in
winter' (Tallack 2015: 6). Embracing the wider north, beyond and
across national demarcations, is declaredly a way of gaining a new,
more open and relational perspective on his own identity as a Shet-
lander – an identity that is now 'connected to a world that is more
interesting and more mysterious than the one to which the islands
are usually bound' (Tallack 2015: 3).

Tallack's may appear as a properly planned journey, develop-
ing along an abstract border, in a man-defined geographical zone,
rather than an aimless wandering. And yet, this first impression
soon gives way to the awareness that the author's progress is not set
up as being continuous or linear, but unfolds unpredictably since its
inception, when the map – the very human tool for capturing and
taming the landscape that has a central role in triggering his desire
to travel – reveals its inherent inadequacy and 'instability'. Before
departure, Tallack tries to identify the line of the 60th parallel run-
ning across his native island, but the static cartographic abstrac-
tion seems unable to capture the complex movement of the island's
coast: 'as I peered over the edge of a steep scree slope', the author
recounts, 'the map's clean lines were shattered into stones and grass
and waves. The angle of the cliff and the jutting rocks prevented
any kind of certainty' (Tallack 2015: 12). What we witness here
is a conflict between human representation of the landscape and
the landscape itself, a conflict that pushes the author's spatial per-
spective beyond the representational frame of the map. Tallack's is
indeed a journey not *along* but *beyond* the map – its value lying in
the instability and uncertainty he seeks for and relishes as a travel-
ler. It is the not-knowing his direction and yet treading on that the
author most often celebrates: 'I thought about that label – "modern
pilgrim" – and wondered if it could apply to me. I hoped not, for the
mawkishness of it made me wince. But still, the question lingered.
There I was, treading a long road towards where, exactly? Looking

for what?' (Tallack 2015: 192). In this perspective, unlike a pilgrimage, whose meaning – the destination – is pre-established, Tallack's journey acquires meaning only retrospectively, once it has come full circle – 'the world turned and I turned with it, circling from home towards home again until I reached, inevitably, the back of my own head' (Tallack 2015: 1). By following the rhythms and embracing the 'instability' of the landscapes he encounters, Tallack subtly redefines homecoming as an act of planetary identification.

Amy Liptrot's *The Outrun* is about a similar movement across space, and a similar attempt to constitute a home lost through trauma. In Liptrot's case the trauma is represented by a family history of depression and a personal history of addiction to alcohol. Her return to her native Orkney, after a painful spell in London as a teenager, marks the beginning of her healing, the two-year-long process accounted for in her kaleidoscopic narrative. There is nothing romantic or idealised about this process, which is recorded from a detached and often strictly scientific perspective, disclosing a growing interconnection between her body and the landscapes and seascapes of the islands.

Liptrot's journey to recovery centres on a specific microcosm, both a space of seclusion, clearly delimitated, and a space of limitless freedom, bordering with infinity, 'where the grass is always short, pummelled by wind and sea spray year-round' (Liptrot 2016: 2) – 'the outrun' is a borderland, caught between sky, sea and water, the domestic and the wild:

> [. . .] where the ewes and their lambs graze in summer after they are taken up from the nursery fields. It's where the Highland cattle overwinter, red and horned, running out under the huge sky. [. . .] This land is the furthest reaches of a farm, only semi-tamed, where domestic and wild animals co-exist and humans don't often visit so spirit people are free to roam. (Liptrot 2016: 2)

Liptrot scans the islands both physically and virtually, recording details scrupulously and intensely. In a way that is not dissimilar to Tallack's, she does not use maps to predetermine her journey, but rather employs them to chart and visualise her movements across space:

> I'm building a map, within the limits of the island, revealing the lines I am drawn along. Overlaid on satellite maps, a story emerges. [. . .] Cross-referencing the shoreline with the Ordnance Survey map in my

pocket, Google Maps on my phone and my physical and visual experi-
ence, I am locating myself, putting the correct names to the inlets and
outcrops around the North Hill. (Liptrot 2016: 185)

Material locatedness is obsessively central in Liptrot's narrative and
foregrounds an idea of identity expressed and produced through a
physical relation with the island spaces. This is especially evident in the
physical identification with the Orcadian landscape conveyed by the
extensive use of body–landscape metaphors, superimposing elements
of the islands' environment onto the author's body and vice versa:

> In grandiose moments, high on fresh air and freedom on the hill, I
> study my personal geology. My body is a continent. Forces are at
> work in the night. A bruxist, I grind my teeth in my sleep, like tectonic
> plates. When I blink the sun flickers, my breath pushes the clouds
> across the sky and the waves roll into the shore in time with my beat-
> ing heart [. . .]. (Liptrot 2016: 220)

By the end of the narrative, it becomes clear that her identity cannot
be severed from that of the place she has returned to: healing her hurt
self involves grasping a new wholeness, where the archipelago's life
and her mind and body inextricably cross-reference each other.

*Waypoints* stands as the summa of Ian Stephen's career as a poet,
writer, artist and sailor, born in Stornoway and still living on Lewis.
This is a long autobiographical hybrid narrative, constructed around
the chronological story of the boats that he owned (and 'loved') in
the course of his life. Each chapter is titled after the name of a boat,
and each chapter weaves personal stories and reflections on the arts
of sailing and writing with stories of navigation in the Hebridean
archipelago, quotations from Scottish literary texts, folk knowledge,
songs and legends from the Hebrides, scientific information and sail-
ing techniques. 'Much of my work', Lewis-born Stephen explains at
the beginning of *Waypoints*, 'took as its subject the topography, the
built structures or the people of the islands where I was born and
raised' (Stephen 2017: 2).

Orientation at sea is shown to be as precarious and unstable
as the land is in the previously analysed texts, and as often rely-
ing more on close observation than on maps or nautical tools:
'usually we remained in sight of land, so you knew your position
from recognising points' Stephen remembers of his early days as a
sailor, 'I was taught to locate a position over the seabed by observ-
ing points on land and holding them in line, or allowing a gap to

open' (Stephen 2017: 1). Identifying 'waypoints' allows him to 'sense' his way (Stephen 2017: 4) through the water and a continually shifting landscape/seascape, where 'the observed geography never looked the same' (Stephen 2017: 8). 'Navigation is not an exact science', Stephen explains, and one can never be sure of one's exact position – 'the line you have travelled will always waver, influenced by wind and tide as well as your own steering' (Stephen 2017: 7).

Stephen 'senses' his way through the Hebridean sea in the same way as he weaves the islands' stories, lists their flora and fauna and creates his own poetry – there is no pre-established pattern and rule. The 'accidental' quality of his nautical and poetic wanderings owe declaredly to folkloric patterns of repetition and variation – there is a continuum linking the ability to observe and respond to a changed environment to that to adapt a story for a new audience. Topography and geography become thus inextricably linked to the stories that tell (about) them. Indeed, as Stephen declares, 'some stories lose their relevance if detached from the place name that fixes them in this world' (Stephen 2017: 225).

The Hebridean sea and its stories constitute a landscape in a constant state of transition, a space Stephen can inhabit and navigate his way through in an embodied sense, but never fully capture or 'possess'. Identity is here at the same time grounded in the materiality of the sea and the words of folklore tradition and situated in fluid flows of meaning.

## Conclusion: On the Edge of the New

Nationalism is a protean 'ideology' that has been characterised by a diversity of discourses across different countries and historical-political contexts, but that only too often has been seen as fixed and unable to change. Post-Union Scottish literature has represented an extremely interesting case study throughout the modern age up to the present day by offering an example of a rapidly evolving imagi-nation. The developments discussed in the present chapter in particular point towards a quite radical turn, moving beyond the rooted nexus between history and nation. If devolutionary Scottish literature often foregrounded an expression of nationalism that was locally defined and globally entangled,[12] but still revolved around an idea of memory-as-history, post-devolutionary writing seems to be moving towards an idea of cultural memory that is firmly rooted in literariness, and thus self-consciously a

'construction', and/or in memory-as-space – in the materiality of ecology and its matter/energy flows, and thus beyond a unilaterally anthropocentric control over things. The model of cultural memory that is emerging from these texts foregrounds a new, more unstable and flexible – and consciously so – idea of national community.

## References

Appiah, Kwame Anthony (1991), 'Is the post- in postmodernism the post-in postcolonial?', *Critical Inquiry* 17.2: 336–57.
Assmann, Jan [1988] (1995), 'Collective memory and cultural identity', trans. John Czaplicka, *New German Critique* 65.
Bernstein Stephen (1999), *Alasdair Gray*, Lewisburg, PA: Bucknell University Press, pp. 39–44.
Bhahba, Homi (1990), *Nation and Narration*, New York: Routledge.
Brockmeier, Jens (2002), 'Introduction: searching for cultural memory', *Culture & Psychology* 8.1: 5, 7.
Conway, Martin A., Catherine Loveday and Scott N. Cole (2016), 'The remembering–imagining system', *Memory Studies* 9.3: 256–65.
Craps, Stef, Astrid Erll, Paula Mcfetridge et al. (2017), 'Roundtable on moving memory', *Irish University Review* 47.1.
Goring, Rosemary (2016), 'A rambunctious romp through the Highlands with James Robertson: author interview', *Sunday Herald*, 7 August 2016. http://www.heraldscotland.com/arts_ents/books_and_poetry/14667004.A_rambunctious_romp_through_the_Highlands_with_James_Robertson__author_interview/ (accessed 10 May 2020).
Gray, Alsadair (1981), *Lanark: A Life in Four Books*, Edinburgh: Canongate.
Greig, David (2015), *Lanark: A Life in Three Acts*, London: Faber & Faber.
Hames, Scott (2017), 'Narrating devolution: politics and/as Scottish fiction', *C21 Literature: Journal of 21st-Century Writings* 5.2. https://doi.org/10.16995/c21.20.
Jamie, Kathleen (2005), *Findings*, London: Penguin.
Liptrot, Amy (2016), *The Outrun*, Edinburgh: Canongate.
Macfarlane, Robert (2016), *Landmarks*, London: Penguin.
Philip, Martin (2011), 'Dialectics of maps and memory: James Robertson's "mythohistoriographical" art', *Scottish Literary Review* 3.2.
Pittin-Hedon, Marie-Odile (2015), *The Space of Fiction: Voices from Scotland in a Post-Devolution Age*, Glasgow: Scottish Literature International.
Renan, Ernest (1887), *Discours et conférences*, Paris: Calmann Lévy.
Rigney, Ann (2004), 'Portable monuments: literature, cultural memory, and the case of Jeanie Deans', *Poetics Today* 25.2.
Rigney, Ann (2017), 'Materiality and memory: objects to ecologies. A response to Maria Zirra', *Parallax* 23.4.

Robertson, James (2010), *And the Land Lay Still*, London: Hamish Hamilton.

Robertson, James (2016), *To Be Continued . . .*, London: Hamish Hamilton.

Ross, Peter (2015), 'Alasdair Gray's *Lanark* hits the stage: "it's wild and heroic – if we fail, we fail"', *The Guardian*, 19 August 2015. https://www.theguardian.com/stage/2015/aug/19/david-greig-graham-eatough-adapting-lanark-alasdair-gray-edinburgh-royal-lyceum-citizens-theatre (accessed 10 May 2020).

Sassi, Carla (2018), 'Entangled (k)nots: reconceptualizing the nation in Scottish devolution writing', in Eileen Pollard and Berthold Schoene (eds), *British Literature in Transition, 1980–2000. Accelerated Times*, Cambridge: Cambridge University Press.

Solnit, Rebecca (2006), *A Field Guide to Getting Lost*, Edinburgh: Canongate.

Stephen, Ian (2017), *Waypoints: Seascapes and Stories of Scotland's West Coast*, London: Bloomsbury.

Tallack, Malachy (2015), *60 Degrees North: Around the World in Search of Home*, Edinburgh: Polygon.

Whitworth, Victoria M. (2017), *Swimming with Seals*, London: Head of Zeus.

## Notes

1. See for example Kwame Anthony Appiah's famous article 'Is the post-in postmodernism the post- in postcolonial?' (Appiah 1991).
2. 'L'oubli, et je dirai même l'erreur historique, sont un facteur essentiel de la création d'une nation': Ernest Renan, 'Qu'est-ce qu'une nation?', in *Discours et conférences* (Paris: Calmann Lévy, 1887), pp. 277–310.
3. 'Nations, like narratives, lose their origins in the myths of time and only fully realize their horizons in the mind's eye. Such an image of the nation – or narration – might seem impossibly romantic and excessively metaphorical, but it is from those traditions of political thought and literary language that the nation emerges as a powerful historical idea in the west' (Bhahba 1990: 1).
4. Terms commonly used by theorists of the nation, from Anthony D. Smith to Benedict Anderson and beyond.
5. Martin A. Conway, Catherine Loveday and Scott N. Cole (2016), 'The remembering–imagining system', *Memory Studies* 9.3: 256–65.
6. See Bernstein (1999: 39–44).
7. I will refer to the production presented at the Edinburgh International Festival in August 2015, at the Royal Lyceum Theatre. No recording is available; however, a trailer produced by the Citizens Theatre, Glasgow can be accessed online, offering a glimpse into the kaleidoscopic quality of the production in object: 'Lanark: a life in three acts', Citizens Theatre YouTube Channel. https://www.youtube.com/watch?time_continue=12&v=HpSFU_smEQk

8. Peter Ross (2015), 'Alasdair Gray's *Lanark* hits the stage'.
9. Peter Ross (2015), 'Alasdair Gray's *Lanark* hits the stage'.
10. Compare, for example, the scene at the beginning of Chapter 2 in Gray's novel ('He ran with his gaze on the skyline, having an obscure idea that the day would last longer if he reached it before the light completely faded. The wind rose. Great gusts shoved at his back making it easier to run than walk. This race with the wind toward a fading dawn was the finest thing he had done since coming to that city', p. 11), with the excerpt from Lanark's book in Greig's play ('Lanark: "Lanark ran toward the dawn with his gaze on the skyline. Having the obscure idea that it might last longer if he reached it before the light completely faded. The wind rose. Great gusts shoved at his back, making it easier to run than to walk. He felt this race . . . this race towards the fading dawn was . . ."', p. 25).
11. James Robertson, quoted in Goring (2016): 'A rambunctious romp through the Highlands'.
12. Carla Sassi (2018), 'Entangled (k)nots', pp. 192–208.

# Notes on Contributors

**Timothy C. Baker** holds a personal Chair in Scottish and Contemporary Literature at the University of Aberdeen. He has published widely on contemporary Scottish and American writing. He has recently completed projects on Scottish Gothic and twenty-first-century animal fiction, while his current research is focused on representations of climate change and the natural world in contemporary women's writing.

**Donald Blair** is an independent scholar. He was appointed by SQA to be a part of the Scottish Qualifications Design Team for Scottish Studies and Scottish Language Studies. He co-authored (with Lindsay Blair) 'An exploration of place and its representations: an intertextual/dialogical reading of the photographs of A. B. Ovenstone and the novel *Gillespie* by John MacDougall Hay', *International Review of Scottish Studies*, Vol. 41.

**Lindsay Blair** is Reader in Visual Culture and Theory at the University of the Highlands and Islands and Co-Convenor of the SILK (Society, Identity, Landscape, Knowledge) Research Cluster. She has published extensively on the aesthetic affinities and intertextualities in the art of Will Maclean, and on the visual culture of the Highlands and Islands of Scotland.

**Harry Josephine Giles** is a poet from Orkney. Their PhD on the possibilities of science fiction poetry for minority language literature became the verse-novel *Deep Wheel Orcadia* (Picador, 2021). *Tonguit* (Freight Books/Stewed Rhubarb, 2015) was shortlisted for the Forward Prize for Best First Collection, and their second book, *The Games* (Out-Spoken Press, 2018), for the Edwin Morgan Poetry Award.

**Rodge Glass** is Senior Lecturer in Creative Writing at the University of Strathclyde. He is the author of three novels, and his book

*Alasdair Gray: A Secretary's Biography* (Bloomsbury, 2008) won the Somerset Maugham Award for Non-Fiction in 2009. He has written several articles and chapters on Gray and is the convener of Making Imagined Things: The 2nd International Alasdair Gray Conference in 2022.

**Scott Hames** is Senior Lecturer in Scottish Literature at the University of Stirling. His research is mainly about politics and literary culture. Publications include *The Literary Politics of Scottish Devolution: Voice, Class, Nation* (Edinburgh University Press, 2019) and (as editor) *Unstated: Writers on Scottish Independence* (Word Power, 2012). He is currently leading the Scottish Magazines Network.

**Fiona McCulloch** is currently an independent scholar and online literature tutor for City Lit. She was Lynn Wood Neag Distinguished Visiting Professor of British Literature at the University of Connecticut in 2015. Her books include *Contemporary British Children's Fiction and Cosmopolitanism* (Routledge, 2017), *Cosmopolitanism in Contemporary British Fiction* (Palgrave, 2012) and *Children's Literature in Context* (Continuum, 2011).

**Kevin MacNeil** is a lecturer in creative writing at the University of Stirling. A prize-winning novelist, playwright, screenwriter, poet and editor, he was born and raised in the Outer Hebrides. His books include *The Brilliant & Forever* (Birlinn, 2016) and (as editor) the two-volume collected stories of Iain Crichton Smith and the Jorge Luis Borges/Adolfo Bioy Casares-selected *Robert Louis Stevenson: An Anthology* (Polygon, 2017).

**Camille Manfredi** is Professor of Scottish Studies at the University of Western Brittany, Brest. Her published work includes the monographs *Alasdair Gray: le faiseur d'Ecosse* (Presses Universitaires de Rennes, 2012) and *Nature and Space in Contemporary Scottish Writing and Art* (Palgrave Macmillan, 2019), as well as the edited volumes *Alasdair Gray: Ink for Worlds* (Palgrave Macmillan, 2014) and *Brittany-Scotland: Contacts, Transfers and Dissonances* (CRBC, 2017).

**Glenda Norquay** is Professor Emerita in Scottish Literary Studies at the Research Institute for Literature and Cultural History, Liverpool John Moores University. Her books include *Robert Louis Stevenson, Literary Networks and Transatlantic Publishing in the 1890s* (Anthem, 2020), *Robert Louis Stevenson and Theories of Reading: The Reader*

*as Vagabond* (Manchester University Press, 2007), and (as editor) the *Edinburgh Companion to Scottish Women's Writing* (Edinburgh University Press, 2012).

**Marie-Odile Pittin-Hedon** is Professor of British Literature at Aix-Marseille Université (AMU). She is the author of *The Space of Fiction: Voices from Scotland in a Post-devolution Age* (Scottish Literature International, 2015) and the editor of *Women and Scotland: Literature, Culture, Politics* (Presses Universitaires de Besançon, 2020). She has written widely on contemporary Scottish writers from Alasdair Gray to Jackie Kay and Jenni Fagan.

**Amy Player** is a graduate assistant and doctoral candidate at the University of Lausanne. Her research focuses on contemporary nature writing in Britain, with a specific focus on the writing of Kathleen Jamie, Robert Macfarlane and Jay Griffiths. Her interview with Kathleen Jamie was published as the introduction to Jamie's first publication in Italian, *Falco e Ombra* (Interno Poesia, 2019). Her other research interests include ecocritical theory, intermediality and magic realism.

**Carla Sassi** is Associate Professor of English Literature at the University of Verona, specialising in Scottish literature and postcolonial studies. She is the author of *Why Scottish Literature Matters* (Saltire Society, 2005), *Caribbean-Scottish Relations: Colonial and Contemporary Inscriptions in History, Language and Literature* (Mango, 2007) and *The International Companion to Scottish Poetry* (Scottish Literature International, 2015).

**Jeanne Schaaf** explores the representation of space, place and nationhood in contemporary Scottish drama (the subject of her PhD at Sorbonne University, where she lectures in English literature and language). She is the translator of *Ciara*, a play by David Harrower, and has published criticism in the journals *Observatoire de la Société Britannique*, *Sillages Critiques* and the *International Journal of Scottish Theatre and Screen*.

**Maggie Scott** is a senior lecturer in English language and literature and Associate Dean (Academic) in the School of Arts, Media and Creative Technology at the University of Salford. Her research focuses on historical lexicography, onomastics and the Scots language, with a particular interest in perceptions of the uses of Scots

in post-devolution literature. A former historical lexicographer for Scottish Language Dictionaries, she is joint editor (with Professor Thomas Clancy) of the *Journal of Scottish Name Studies*.

**Silke Stroh** is a senior lecturer in English at Münster University, specialising in postcolonialism, diaspora studies, and the relationship between minority issues and national identity. She is the author of *Uneasy Subjects: Postcolonialism and Scottish Gaelic Poetry* (Rodopi, 2011) and *Gaelic Scotland in the Colonial Imagination: Anglophone Writing from 1600 to 1900* (Northwestern University Press, 2017) and (as a BDG network member) co-editor of *The Black Diaspora and Germany* (Edition Assemblage, 2018).

# Index

EU Authorised Representative:

Easy Access System Europe Mustamäe tee 50, 10621 Tallinn, Estonia

gpsr.requests@easproject.com

Printed and bound by CPI Group (UK) Ltd, Croydon, CR0 4YY

27/05/2025

01885072-0004